# PRAISE FOR GEORG

George Masa arrived as a stranger to the Great Smoky Mountains, adopted them as his home, and then—through his photographic artistry and untiring dedication—inspired others to preserve them as a national park. But until now, much of his personal story was lost to history. Through a remarkable achievement in biographical research, Janet McCue and Paul Bonesteel have filled in the gaps and finally give this hero of the national park idea his due.

~Dayton Duncan and Ken Burns, *The National Parks: America's Best Idea*

Deeply researched, intimately written, this book uncovers the complex life of a Japanese man who chose to live far away from his home country and the West Coast Japanese community and dedicated his life to capturing the beauty of the Great Smokies and the Appalachian Trail.

~Kazuhiro Oharazeki, associate professor, Seinan Gakuin University

McCue and Bonesteel have, in essence, accomplished a feat similar to that of their subject. Like Masa, they have endeavored to map a great wonder of this world through careful exploration and precise vision. This examination of a life often steeped in mystery serves as a touchstone for understanding the deep complexities of race, culture, society, and landscape in America during a period of deep national and political unrest. Masa's story, though one of a man of awe-inspiring talent and even greater ambition, still reminds us that the immense beauty of our natural world is always in direct competition with the threat of mankind's savage civilizations.

~Annette Saunooke Clapsaddle, author of *Even as We Breathe*

I've been fascinated with Masa since I was a teenager immersed in backpacking and photography. What little I could find out about him back then left only an impression of an intriguing foggy figure, always a sidekick in the shadow of Horace Kephart. This meticulously researched book helps pull Masa into the spotlight and rightfully credits him for his important contributions to the history and culture of the Southern Appalachians. It also very interestingly places him not only in the mountains he loved but also in the context of Asheville in the twenties and thirties—a vibrant small city with all the brightness and darkness of the time.

~Charles Frazier, author of *Cold Mountain*

Extensively researched and well written, George Masa: A Life Reimagined *is an impressive achievement. Janet McCue and Paul Bonesteel have done an excellent job of finding and digging deep into all known source material on Masa, and the resulting book is an engaging biography of this famed photographer of the Great Smokies.*

~Kevin W. Young, author of *The Violent World of Broadus Miller: A Story of Murder, Lynch Mobs, and Judicial Punishment in the Carolinas*

*In the summer of 1933, my maternal grandfather, George M. Stephens, helped to build George Masa's coffin on my grandparents' back porch in Asheville. He and Masa, comrades in the early Carolina Mountain Club, shared a love of the Great Smoky Mountains that had seen them along many trails together. This last sad office of friendship came down through my family's lore as a mark of honor—and it makes me particularly glad to celebrate McCue and Bonesteel's excellent research.* George Masa: A Life Reimagined *brings back a highly influential advocate for our southern mountains and their preservation. My grandfather would have been so pleased, as I am, and as many readers will also be.*

~Elizabeth Kostova, author of *The Historian, The Swan Thieves, The Shadow Land,* and *1927: The Good-Natured Chronicle of a Journey* (co-authored with Anthony Lord)

*Thanks to the extraordinary research and writing of Janet McCue and Paul Bonesteel, the mysterious early life of George Masa will be better understood. They have been as persistent and thorough in this project as Masa himself was in recording, in his photography, the grandeur of the Smoky Mountains. Masa was also instrumental in the effort to preserve the pristine beauty of the mountains as a national park. Against formidable odds, the immigrant Masa dedicated himself to the splendor of his adopted land. This biography is a timely salute to his timeless achievement.*

~Robert Morgan, author of *Boone: A Biography*

*This book is a success on so many levels: the story of a deeply compelling individual; a window onto the creation of Great Smoky Mountains National Park and the Appalachian Trail; and a triumph of dogged research to finally solve the mystery of who George Masa was and how he came to this part of the world. It is a fascinating read and a priceless contribution to the history of the Smokies.*

~Philip D'Anieri, author of *The Appalachian Trail: A Biography*

*Of the many people responsible for the Great Smoky Mountains National Park, George Masa's contribution is surely the most poignant and intriguing. This biography is long overdue, and thanks to the diligence and talent of Janet McCue and Paul Bonesteel,* George Masa: A Life Reimagined *proves worthy of its subject. An essential addition to the story of the park's creation.*

~Ron Rash, author of *Serena*

George Masa: A Life Reimagined *is a long overdue look at a man possessed of a beautiful obsession: photographer Masa sought to experience, capture, and share his adopted landscape before it was altered by the hands of men. Masa's journey from Japan to the United States and his oft-mysterious life in Southern Appalachia is not merely about a man coming to America to make his way but rather about America itself. Anyone who has ever relished the joys of the Great Smokies is indebted to the talents of George Masa. We are now equally indebted to McCue and Bonesteel, who painstakingly worked to breathe new life into the story of this inspiring man.*

~Denise Kiernan, *New York Times* bestselling author of *The Girls of Atomic City, The Last Castle,* and *We Gather Together*

*Through patience, perseverance, and relentless research, Janet McCue and Paul Bonesteel have pulled back the veil that hid details of George Masa's life from previous biographers, including us! They have revealed an unexpectedly complex man who sought simplicity through immersion in the natural world around him, combined with a commitment to capturing its beauty on film. Perhaps even more importantly, Masa helped to save his beloved Appalachian mountain landscapes for future generations to enjoy.*

~Ren and Helen Davis, authors of *Land of Everlasting Hills: George Masa, Jim Thompson and the Photographs That Helped Save the Great Smoky Mountains* and *Blaze the Appalachian Trail* [University of Georgia Press, 2025]

*At long last George Masa has received the biography he has long deserved. Photographer, trail scout, tireless advocate for the Great Smoky Mountains National Park, Masa is a fascinating, but not well-known figure outside of the Asheville, North Carolina, area that he called home during the last decades of his complex life. With this biography, readers finally have the full story of that life, from his childhood in Japan to his early years in America on the West Coast, and finally his life in Western North Carolina. Drawing on previously unpublished sources, Janet McCue and Paul Bonesteel have reconstructed Masa's life with all of its ups and downs, joys and sorrows, helping us understand Masa in ways we have not been able to before.*

~T. Mills Kelly, author of *Virginia's Lost Appalachian Trail*

*McCue and Bonesteel's painstaking reconstruction of the complex life—both inner and outer—of an early Japanese American is a revelation. It reminds us—at this moment when resistance to migration has reared its head again—of the value of immigrants in bringing fresh vision, skills, and experiences to our familiar American landscape, allowing us to see through them beauties and essentials that we might not otherwise recognize and preserve.*

~Daniel McKee, professor of Asian Studies at Cornell University

*Photographers and national park enthusiasts may think they know George Masa, appreciating his role in documenting the Great Smoky Mountains and in the creation of the Great Smoky Mountains National Park. But who was George Masa? Sparked by the find of a trove of letters written by the enigmatic mountaineer and photographer, authors Janet McCue and Paul Bonesteel set out to shed light on this very private figure. Using the letters as a framework, the authors tell a story of adventure and misadventure, triumph, and tragedy, on an intensely personal level. Through the words of the man himself and those who knew him best, George Masa comes alive—his life truly reimagined—in the pages of this book.*

~Judy Russell, genealogist and photographer

*A stunning biography of George Masa that chronicles the rise of a mysterious Japanese photographer to a place in the pantheon of iconic figures in the history of the Great Smoky Mountains.*

~Ken Wise, author of *Hiking Trails in the Great Smoky Mountains*

*A skillfully researched, riveting tale of hardships and tragedy, scandals and heartbreaks—all defied by George Masa's mantra, "Never surrender."*

~Bruce E. Johnson, historian

*George Masa remains an enigma, but this highly readable and well-researched book fills many gaps in his life story. It's a classic tale of an immigrant to America, seeking to establish a new life, earn a living, and make a home—but with surprising complexities. Masa faced discrimination and suspicion, yet he worked hard and pursued his dreams. Janet McCue and Paul Bonesteel have excavated many sources offering invaluable details and skillfully placing the man in the context of his times. This book sheds light on Masa's personality, his friendships, his photographic artistry, and his untiring efforts to help establish Great Smoky Mountains National Park. It is a story that will hold you until the end.*

~Rose Houk, author of *Pictures for a Park: How Photographers*
*Helped Save the Great Smoky Mountains*

*George Masa is remembered as a talented professional photographer and an enthusiastic mountaineer, and this new book helps develop a more complete picture of Masa's early life and his lasting influence in our region as a passionate proponent for the creation of Great Smoky Mountains National Park. On behalf of Biltmore, we appreciated the opportunity to share some of Masa's photos from our historic archives—images we still use today to show-case the timeless beauty of the estate with its century-old gardens and grounds.*

~Chase Pickering, vice president of Biltmore House Guest Experience and Operations

*Janet McCue and Paul Bonesteel's aptly titled biography* George Masa: A Life Reimag-ined *seems particularly appropriate given the title of Bonesteel's acclaimed 2002 film* The Mystery of George Masa. *Although many mysteries remain, the authors' tenacious and exhaustive archival research provides exciting new information about Masa's life, his work, and his relationships. Masa moved easily in the circle of millionaires, country clubs, and fancy hotels of Asheville's "boom" years, but he also knew intimately another world of racism, prejudice, and the extreme poverty of the Depression. McCue and Bonesteel "reimagine" this world, revealing to readers the inescapable hardships for immigrants to this country. Most importantly, the book documents Masa's vast contributions to the place he came to love. Every visitor to the Smokies, every hiker on the Appalachian Trail, every artist attempting to convey the beauty of these mountains is in his debt.*

~Mae Miller Claxton, professor of English, Western Carolina University,
and co-editor of *Horace Kephart: Writings*

*Master photographer, intrepid adventurer, intense promoter of the Great Smoky Mountains National Park and the Appalachian Trail, and man of mystery, George Masa has long deserved a biography of this depth and quality. Exhaustively researched and beautifully written, Janet McCue and Paul Bonesteel have produced a deserving narrative of Masa's life of accomplishment and adventure.*

~Daniel S. Pierce, professor emeritus, Department of History,
University of North Carolina at Asheville, and author of
*Corn from a Jar: Moonshining in the Great Smoky Mountains*

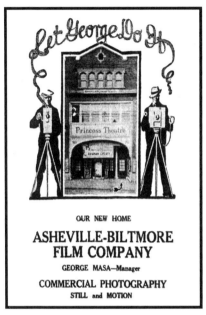

Advertisement for George Masa's Asheville-Biltmore Film Company as it appeared in the *Asheville Times*, February 14, 1926

*When we go alone into the high mountains*
*we sometimes enter days of transcendence*
*when everything is in its ordained place...*
*when each river...valley...mountain...*
*even the blue dome of the sky itself...*
*are at once distant yet clearly a part*
*of an interrelated whole arranged*
*in bright patterns that spiral*
*upward into yet another*
*sort of heaven.*

~George Ellison,
from the poem "Shining Levels"
in *Permanent Camp: Poems, Narratives*
*and Renderings from the Smokie*s (2012)

# GEORGE
# MASA

*A Life Reimagined*

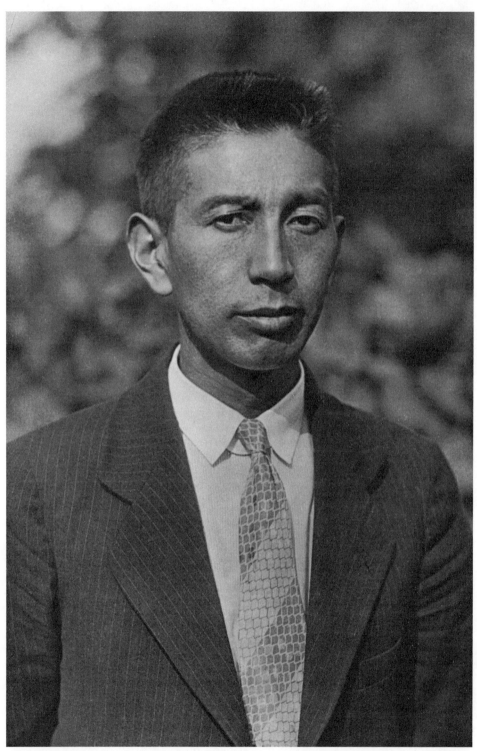

George Masa, early 1920s. *Buncombe County Special Collections, Pack Memorial Public Library, Asheville, North Carolina*

GEORGE
# MASA

*A Life Reimagined*

## Janet McCue · Paul Bonesteel

Written by Janet McCue and Paul Bonesteel
Edited by Frances Figart and Aaron Searcy
Cover and book design by Lisa Horstman

1 2 3 4 5 6 7 8 9

Published by Smokies Life, Gatlinburg, TN
ISBN 978-1-7370351-3-8 (paperback)
ISBN 978-1-7370351-8-3 (ebook)
Library of Congress Control Number: 2024941773
Printed in the USA

Smokies Life is a nonprofit organization that supports the educational, scientific, and historical programs of Great Smoky Mountains National Park. Our publications are an educational service intended to enhance the public's understanding and enjoyment of the national park. Learn more about our publications, memberships, and projects at **SmokiesLife.org**.

*Front cover image: George Masa on Blackstack Cliffs, circa 1932, just off the Appalachian Trail near Bald Mountain, Tennessee. For more than 30 years, the exact location of this photo has been incorrectly attributed to Greybeard Mountain until photographer David Huff correctly identified the spot in 2024 with the help of Charlie Boss. The photo was taken by Hugo Strongmiller, and it has been digitally altered for reproduction.*

*Back cover image: George Masa at the Biltmore Estate, circa 1920s, with two view cameras and a motion-picture camera.*

*Both photos courtesy of Buncombe County Special Collections, Pack Memorial Public Library, Asheville, North Carolina.*

*The typefaces in this book are Le Monde Livre, designed by Jean François Porchez in 1997, and Soleil, designed by Wolfgang Homola in 2011. The printing and binding is by Sheridan Printing, Chelsea, MI.*

## Dedications

To Robert J. Kibbee who invited me to explore the world with him—
on foot, loupe in hand, by his side for five decades.

*~J. M.*

To George Ellison, whose boots hiked these trails and whose eyes,
words, and poetry were filled with curiosity for the people, living
things, special places, and mythology of the mountains.

*~P. B.*

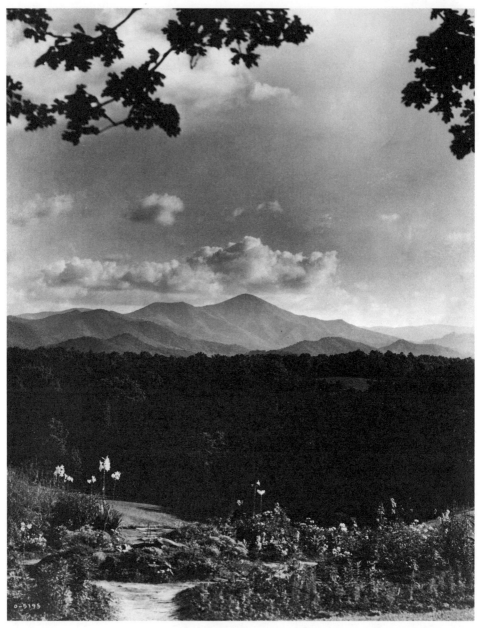

Mount Pisgah as seen from the grounds of Asheville School in Asheville, North Carolina. Photo by George Masa. *Buncombe County Special Collections, Pack Memorial Public Library, Asheville, North Carolina*

# CONTENTS

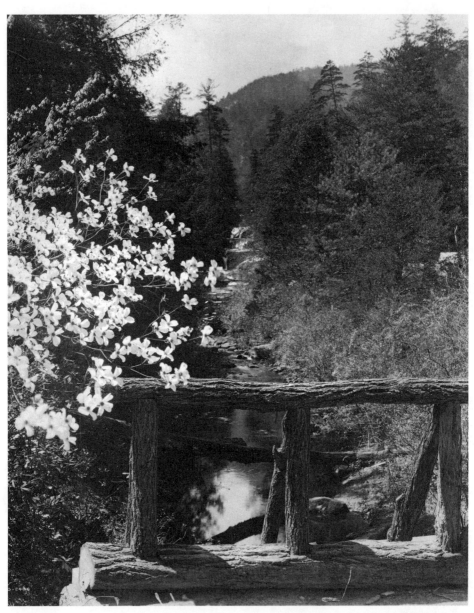

Dogwood and stream at Bottomless Pools in Lake Lure, North Carolina. Photo by George Masa.
*Buncombe County Special Collections, Pack Memorial Public Library, Asheville, North Carolina*

## INTRODUCTION

In the 1920s and early 1930s, hikers in the Great Smoky Mountains were likely to encounter a friendly, energetic Japanese man on the trail. This congenial figure might have been burdened with a pack containing a heavy camera, tripod, and accompanying equipment. Or he might have been pushing the front wheel of a bicycle connected to handlebars with an odometer attached—a cyclometer, which he used to meticulously measure trail mileage. And, likely as not, he would have been accompanied by men and women, his friends, who frequently hiked with him and who knew him as George Masa.

Masa revealed very little personal information about himself, however, even to his closest friends. As a result, his life became a story of the known and unknown, always shrouded in elements of mystery. Born in Japan, he came to the United States in 1906. But in actuality, his known life began when he came to Asheville, North Carolina, in 1915 to work at the Grove Park Inn. Masa's friends knew about his birth in Japan, his initial employment at the Grove Park Inn, and his growing prominence as a photographer but little else. His first nine years in the country remained lost to history until recently, when the diligent research of the authors of this book discovered the story of these years and much more.

I don't recall when I first became aware of George Masa; however, my interest was piqued as I passed Masa Knob during my Appalachian Trail outings and found infrequent references to him in works on the Great Smokies. What is certain is this: I wanted to know who he was! In the mid-1990s, Robert Brunk invited me to write an article for a publication he was planning, and this presented the ideal opportunity to pursue my interest in Masa. "George Masa: The Best Mountaineer" was published in 1997 in the first volume of *May We All Remember Well: A Journal of the History and Cultures of Western North Carolina*.

Important in my quest to know Masa was the time I shared with two people who had a personal connection. I will forever be indebted to Barbara Ambler Thorne for sharing her recollections. She was a close friend of Masa's who frequently hiked with him in the Smokies and is often present in his photographs. She told me that, because Masa was more concerned with photography than with eating, he carried limited food in order to bring along all his camera equipment on their outings. Smiling, she said, "He would take little cans of caviar—the smallest cans—and we used to laugh at him. The rest of us would have ham sandwiches, and we would feed him." Also, I treasure a pleasant time with Jeanne Creasman Lance, who entertained me with discussion about Masa when he lodged with her father and mother, Oscar and Effie Creasman, in Biltmore Village. During my visit, she showed me an exquisite Japanese fan that was a gift from Masa to her mother. Such experiences personalized him for me, yet I desired to know more. Now, Janet McCue and Paul Bonesteel have fulfilled my desire. Their compelling biography, *George Masa: A Life Reimagined*, portrays Masa's life in its entirety, including the life we never knew—one which held secrets beyond imagination.

Although Masa was unassuming and reticent about his background, he was outgoing and highly motivated. He had high personal expectations and possessed a strong sense of commitment. These characteristics proved crucial in his life—the life we know—and to his accomplishments. Notwithstanding, he faced discrimination, business hardships, and health problems and was challenged by competing business and volunteer demands, all of which were

intrinsic parts of his life. Nevertheless, he persevered and never surrendered to these challenges.

Although photography was Masa's vocation, his avocation was hiking in the mountains of Western North Carolina, often blending photography with his outings. He earned the reputation of being an artist who captured exquisite scenes of his beloved mountains, especially the Great Smokies. And, in addition to his photographs, he hiked untold miles and developed an intimate knowledge of the Western North Carolina mountains. Also, he possessed technical capabilities in trail measurement and mapmaking that proved vital in his work.

The Great Smoky Mountains National Park movement gained momentum in the 1920s. And Masa became an enthusiastic and respected advocate, who played an important role in the effort by sharing his knowledge and his photographs with actively involved volunteers like himself, with federal officials, and with those seeking images to accompany periodical articles about the future park. His advocacy also fostered contact with others who shared his dedication to the Smokies. One of the most prominent, Horace Kephart, with whom he developed a close friendship, wrote compelling articles articulating the rationale for preserving the Great Smokies as a national park. Kephart's influence and eloquent words and Masa's contributions and dramatic photographs became important elements in the fabric of the park movement.

When the National Park Service began to research, record, and standardize the place-names within what was to become Great Smoky Mountains National Park, Masa and Kephart proved invaluable to the North Carolina nomenclature committee. The two were tireless in their work identifying the names of mountains, ridges, streams, and other landmark features in the Smokies—a task that often involved reconciling names that were confusing or ascribed to more than one place. Masa was tireless in this work, which relied heavily on his technical skill set, including his ability to make meticulous maps. And, when necessary, he conducted research and made personal reconnaissance trips to clarify and photograph landscape details.

Late in his life, on February 16, 1933, Masa received a letter from his friend Arno Cammerer, associate director of the National Park Service, referring to him as "the best mountaineer on the North Carolina side." Today, Masa is among those honored as founders of Great Smoky Mountains National Park.

The Appalachian Trail movement, well under way in the 1930s, was led by Myron Avery, who was focused on selecting the Appalachian Trail route and securing its completion. Masa engaged in this effort with the same commitment that he devoted to the national park movement. His knowledge of the mountains, photographic talents, technical ability, capacity for research, and penchant for accuracy were ideal qualifications. Additionally, he engaged in exploratory hikes to resolve trail questions. Ultimately, Avery relied on Masa as his unofficial regional consultant, seeking trail routing information, landmark photographs, and nomenclature details, and he asked him to proof his work for accuracy.

Masa's contributions went beyond conducting fieldwork, attending Appalachian Trail Conference meetings, and assisting Avery, however. With Avery's urging and Kephart's assistance, he formed the Carolina Appalachian Trail Club in Asheville (which merged with the Carolina Mountain Club in 1931) to promote the marking, measuring, and maintenance of the Appalachian Trail. The Carolina Mountain Club, which celebrated its hundredth anniversary in 2023, has remained dedicated to the care of a section of the AT since its founding.

Masa was a professional photographer; however, the details of his career have been largely overshadowed by his involvement in the creation of Great Smoky Mountains National Park and the Appalachian Trail. His career had its professional beginning when he left the Grove Park Inn in 1918 and formed a partnership with Herbert Pelton, an established Asheville photographer. From this beginning, he managed a photography business that operated under various names until his death in 1933.

A number of other income-producing endeavors received Masa's energy and initiative during his career. He made early Asheville newsreels; served as a camera operator for silent films made in and

around Asheville; operated as a freelance photographer for news agencies; made photographs for the Asheville Post Card Company, plus some postcards of his own; sold images from his collection; and was employed as the official photographer for the Asheville Chamber of Commerce. Such was his reputation that leading businesses and individuals in Asheville and elsewhere commissioned him for photographic assignments when only his artistic eye and professional skills could satisfy their demand for images of highest quality and appeal.

Masa literally focused a lens on the area and presented Asheville and Western North Carolina to the nation through his images. These appeared in *National Geographic,* the *New York Times, American Forests,* the *Architectural Record,* and many other publications. His Asheville Chamber of Commerce images were widely publicized in countless promotional brochures, booklets, and publications touting the wonders of Asheville and the region. Likewise, the Asheville Post Card Company made regular use of his images. In fact, if you examine ephemera of this era, you may well be admiring Masa's photographs. Perhaps most importantly, Masa's body of work compellingly portrays the area's history in the 1920s and early 1930s, and this contribution is a vital part of his legacy.

As an immigrant, Masa dealt with significant challenges. He faced anti-Asian legislation and targeting by the Bureau of Investigation as well as the Ku Klux Klan. That he endured these assaults and still managed to have a successful career is a testimony to his perseverance and persistence as well as to those who believed in him and his talents. Because of his spirit of perseverance, millions can follow in his footsteps, go into the woods, and "come back strong."

Masa fulfilled his commitments to the Great Smoky Mountains National Park and Appalachian Trail movements at the expense of business and eventually his health. Also, the Great Depression took its toll, and he experienced an emotional loss when Horace Kephart was killed in a tragic automobile accident. At the end of his life, Masa rented a small room in the home of Asheville-based dentist Dr. Hugh May, which is where he was living when he became ill and was placed

in the Buncombe County Home and Sanitarium. He died there penniless on June 21, 1933. The Carolina Mountain Club, Masa's surrogate family, saw to his burial in Asheville's Riverside Cemetery, handled his affairs, and eventually placed a simple marker on his grave. And in 1961, the club succeeded in having a landmark in the Great Smokies named for him. Masa Knob stands on the shoulder of Mount Kephart, figuratively joining these two friends forever.

Attention to Masa faded over the years. But around the turn of the century, renewed interest and research led to the rediscovery of details about his life. My article, "George Masa: The Best Mountaineer" was one of the sources that interested filmmaker Paul Bonesteel in Masa. His research resulted in significant new discoveries, which he showcased in his excellent film *The Mystery of George Masa.* This film, which aired on PBS in 2003, brought Masa broad public attention.

In 2009, the Ken Burns series *The National Parks: America's Best Idea* featured the Kephart-Masa friendship to depict the movement to create Great Smoky Mountains National Park. As a result, Masa and Kephart received national recognition through this excellent and visually appealing series.

On February 16, 2011, President Barack Obama, in his remarks on America's Great Outdoors initiative, highlighted Horace Kephart and George Masa as "ordinary Americans who devoted their lives to protecting the land that they loved." He described theirs as "a wonderful story. Two men, they met in the Great Smoky Mountains of North Carolina—each had moved there to start a new life. Horrified that their beloved wilderness was being clear-cut at a rate of 60 acres a day, Horace Kephart and George Masa worked with other members of the community to get the land set aside."

Then, in 2019, Great Smoky Mountains Association (now Smokies Life) published the award-winning *Back of Beyond: A Horace Kephart Biography*, in which co-authors George Ellison and Janet McCue featured Masa in the chapter "Congenial Comrades," further enlightening readers about his life. The following year, McCue and Bonesteel partnered to begin work on the book about Masa that you are presently holding.

McCue and Bonesteel are uniquely qualified to write this first comprehensive Masa biography, and we owe them a debt of gratitude for their contribution. Their individual paths to Masa and the twists and turns of their collaborative research represent a fascinating story in itself.

Janet McCue enjoyed a career as a Cornell University librarian specializing in library administration and digital library development. It was through her husband, Robert Joseph Kibbee Jr., that she learned of Horace Kephart in the early 1970s. His well-worn copy of *Camping and Woodcraft* inspired two "city kids" to undertake regular trips to the Smokies for backpacking treks to navigate the wild, and, according to McCue, "Kephart's directions on building a fire or setting up a camp gave us confidence that we could do it, too." One such trip took them to Kephart's last permanent camp at the Bryson Place on Deep Creek. McCue dug deeper into Kephart—and also discovered his friend Masa—through her graduate studies in library science at the University of Michigan and then in her first job at Cornell, which holds many Kephart family connections. Years later, in the 1990s, a research leave led her back to Kephart and Masa and ultimately to her collaboration with George Ellison.

In the 1990s, filmmaker Paul Bonesteel happened upon an article about Masa by columnist Rob Neufeld in the *Asheville Citizen-Times*, then found my article "George Masa: The Best Mountaineer." Hearing Masa's story of photography, filmmaking, exploration, struggle, and triumph, he couldn't ignore a number of striking parallels in his own life. Like Masa, Bonesteel moved to Asheville seeking to live in the mountains and create media for passion and profit. His first office in Asheville was in the same building where Masa opened Plateau Studios above what had been Smith's Drug Store on Pack Square. Like Masa, Bonesteel had been hired by the Grove Park Inn and Biltmore Estate, working for the descendants of the Vanderbilts. He has traversed the rivers, trails, and streams of Western North Carolina and has "often felt the primal urge to get out of the office and to the high country to get 'balsam air' because indeed it is 'good to me all the time.'"

Together, McCue and Bonesteel learned a great deal about Masa from letters that passed between him and his friends, colleagues, and employers during his time in Asheville. Although this information added important details to Masa's known life, his unknown life, the one he never revealed to his closest friends, remained a mystery. That is, until 2022, when the two decided to revisit a certain trove of correspondence that had initially resurfaced more than a decade prior.

After Masa's death, the May family found a cache of letters in Masa's room written in Japanese. Although no one in the family read the language, they saved the letters because they appreciated the beauty of the *kanji* characters. Following the release of Bonesteel's *Mystery*, May descendants alerted him to the existence of these letters and provided him with a photocopied set. In 2007, Bonesteel commissioned a translation, although some sections of the photocopies were hard to read. A fragmented storyline and numerous names made content difficult to understand and contextualize. One thing was clear, however: the letters recounted someone's painful childhood, chronicled an immigrant's journey, and attempted to explain a shameful episode.

In spite of subsequent searches by the descendants of the May family, the original copies of the letters were never found. Using software to enhance the legibility of the 2007 photocopies, Bonesteel and McCue commissioned a modern transcription of the letters and a second translation in 2022. They came away with a fascinating story and a litany of questions. Was this correspondence written *by* Masa or sent *to* him from someone else? Was it possible to identify the people whose lives the letters chronicled?

Working with a team of researchers both in the United States and Japan, Bonesteel and McCue have found many answers to these questions. Yet some questions will always remain about the dedicated but private Japanese photographer who captured the hearts of so many, especially in his adopted home.

*George Masa: A Life Reimagined* powerfully brings Masa's remarkable life into focus in all its compelling dimensions and appropriately

captures the breadth and importance of his legacy, which remains relevant today. It is truly a model of biographical excellence and destined to become a classic.

Horace Kephart observed that Masa did "all this exploring and photographing on his own hook, without compensation but at much expense to himself, out of sheer loyalty to the Park idea and a fine sense of scenic values. He deserves a monument." Janet McCue and Paul Bonesteel have finally provided that monument with *George Masa: A Life Reimagined.*

~William A. "Bill" Hart Jr.

*Editors' note: William A. "Bill" Hart Jr. knows the Smokies well. He was one of the authors of* Hiking Trails of the Smokies *(1994) and served 12 years on the Great Smoky Mountains Association board of directors, including four as board chair. His pioneering study "George Masa: The Best Mountaineer," inspired renewed interest in the photographer. His book* 3000 Miles in the Great Smokies *(2009) delighted readers and explorers. The Bill and Alice Hart Collection at the University of North Carolina at Asheville is a testimony to their long-standing interest in Western North Carolina and Great Smoky Mountains National Park.*

George Masa crosses Raven Fork Creek at Three Forks in the Great Smoky Mountains with a trail-measuring wheel. *Jewell King scrapbook, Wilson Special Collections, University of North Carolina at Chapel Hill*

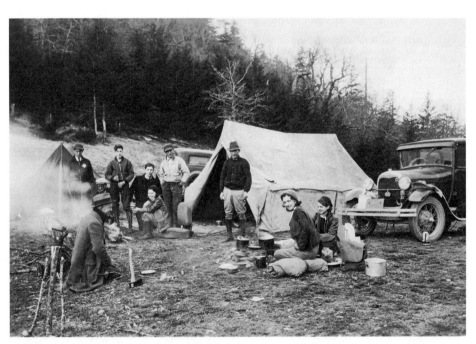

The Carolina Mountain Club camping at Indian Gap. Photo by George Masa.
*Wilson Special Collections, University of North Carolina at Chapel Hill*

# NOTE TO READER

## Names

There are various names associated with George Masa. During his early years in Asheville, the photographer was known by several Anglicized versions of a Japanese name—e.g., Masaharu Iizuka, George Iizuka. Newspaper reports and documents sometimes used variant spellings of his name, including Masabara, Iizurka, and Massa. His birth name and the name he used while living in Japanese communities on the West Coast were different as well. In general, throughout this book, we have chosen to use the name he selected as his professional name in the 1920s—George Masa. We refer to other versions of his name (e.g., birth name or nicknames) at appropriate points in the narrative but hope the reader will understand the context and intentions for those choices.

## Translations

Throughout the book, we have used English translations of the Japanese found in Masa's diary, correspondence, or in Japanese language newspapers.

## Dates

In Japan, records for birth, death, marriage, divorce, and adoption are kept in a family *koseki*. Access to these family registers is restricted to family members listed on the *koseki*, direct descendants of those listed, or to lawyers retained for legal reasons, such as inheritance. Because of Japan's strict privacy rules, the authors had no legal means to access the *koseki* that recorded Masa's life events. Through Meiji University, we were able to verify a birthdate for the man we know as George Masa: April 6, 1885. In this biography, we have calculated Masa's age based on this date—i.e., Masa was 48 when he died on June 21, 1933.

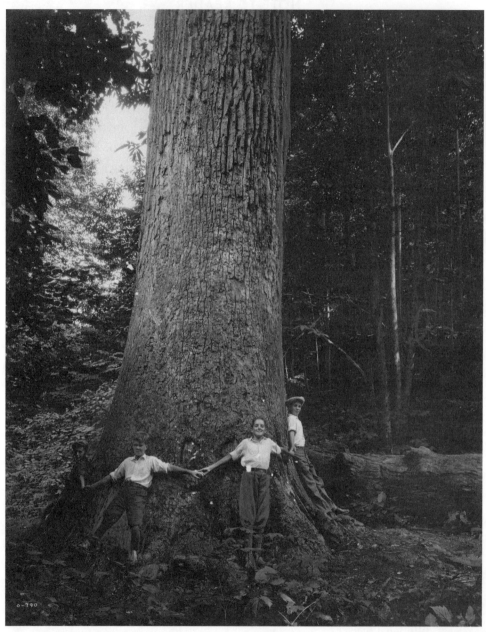

A George Masa photo labeled "Largest Poplar tree in Great Smokies." *The Hart Masa Collection, Hunter Library, Western Carolina University*

# PROLOGUE

*An occasional breeze floats through the room, bringing with it the scent of fields and farmyards nearby. But most of the time the air is still and the room quiet.*

*A lone window provides Masa with a slanted view of sunlight and a faint understanding of day or night, but now the days and nights all blur together. Each breath is shallow, and any attempt to go deeper produces a sharp pain.*

*He is aware of the nurses coming and going as well as the incessant coughing of other patients on the ward. He remembers his friend Margaret who had sat by his side for a few days, chatting about her work, recalling stories from their time together in the Smokies with Kephart, sharing her disbelief that their mutual friend had died. Fellow hikers from the Carolina Mountain Club check in on Masa regularly while his friends George McCoy and Glen Naves chronicle in the Asheville newspapers the condition of the "well-known photographer and outdoorsman."*

*Masa had been sick for weeks, and by mid-May 1933, the situation was serious. A brief rally had given his friends hope. But when he relapsed, they had no choice but to take him to the Buncombe County Home and Sanitarium on the outskirts of Asheville, North Carolina.*

*There are moments when Masa thinks to himself: "I might not make it." He can feel his usual energy and fight slipping away. Hours or maybe*

1

*even days pass. He opens his eyes to see bright sunlight touching the moun-
tains through the window. In that moment, he wants to leap out of bed, grab
his boots, and hit the trail. But his next breath reminds him of his condition;
he feels the weight of his own body holding him in place.*

*A nurse comes in bringing tea and a biscuit. She speaks with a bright-
ness that matches his hope for recovery. But as she helps him bend forward,
the room begins to spin, and he sinks back onto his pillow.*

*The kindness of the nurse reminds him of his sister-in-law, Shigeko.*

*He remembers faces across an ocean, a sacred, snow-covered moun-
tain. Memories of his Portland friends, his baseball career, sweep over
him. The* Oregon Daily Journal *called him a "splendid fielder" when he
made that sensational catch for the Mikado baseball team. Did his hand
still tingle with the sting of the ball?*

*Too soon the regrets seep in. He was played a fool by people he
trusted, forced to leave the West Coast because of their trickery, his
shame. The weight of the past hits him again as he thinks about all that
has transpired since leaving Portland two decades ago, since boarding
the SS* Doric *to leave Japan. His eyes water. There are things he needs
to explain.*

*"Please. Send for Barbara for I have something important to say to
her," he says with a tug on the nurse's sleeve.*

*Over the years, Masa and Barbara Ambler have hiked many trails
together. The 30-year-old woman born and raised in the Asheville area and
the friendly, yet private, 48-year-old Japanese man enjoy a bond cemented
by a shared passion for the mountains, the beauty and poetry of the natural
world, and the camaraderie of the Carolina Mountain Club. Yet Barbara
has never been able to penetrate the barrier Masa erected between his pres-
ent and his past.*

*In fact, none of Masa's friends know much about his life before he
arrived in Asheville. He has said his mother and father are dead, a brother
and sister lost. He has spoken to them of college in Japan but says he has
no ties to his homeland anymore. He has shared that he once dreamed of
becoming rich through silver and gold mining. But photography and his love
for the mountains and landscape around Asheville and the Great Smoky
Mountains eclipsed those grandiose ideas.*

*Masa understands why his friends are so curious, but he'd always had his reasons for keeping his past to himself. He has come a long way to this hospital bed where he now lies dying.*

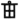

It was late in the day when Barbara Ambler got the call. "Mr. Masa would like to see you," the nurse said to the young woman. The sanitarium being ten miles away, she resolved to go the following morning. But by then it was too late. George Masa had died of pulmonary tuberculosis in the early morning hours of June 21, 1933.

"One thing that broke my heart which I did which was wrong," the 92-year-old woman confessed to historian William A. Hart Jr., was not going to the sanitarium when the nurse called on June 20. Her decision, so logical and practical, was one she regretted for the rest of her life.

What might Masa have told Ambler on the evening before he died?

What mysteries might be unraveled in the process of researching a person's life?

Less than a week after Masa's death, Glen Naves of the *Asheville Citizen* wrote to the Japanese ambassador to tell him that the brilliant photographer, advocate for the Great Smoky Mountains National Park, and avid hiker who scouted, mapped, and marked the southern portion of the Appalachian Trail had died. Naves enclosed newspaper articles that included Masa's Japanese name, Masaharu Iizuka, "as nearly correct as I can ascertain" and basic details of Masa's past in Japan—information friends had gleaned over the years. Naves trusted that this background would lead the Japanese authorities to Masa's family in Japan:

> *The purpose of this letter is to interest some member of the legation in an effort to locate if possible, the relatives or relative, if any, that survive Mr. Masa. It is my opinion that if he left any relatives, they reside in Japan. It would interest me very much to learn their identification and place of residence. . . . He was indeed a genius.*

Naves' letter, written June 27, 1933, began the quest for George Masa's family, a search that continues into the 21st century. After scanning dozens of microform reels at the Ministry of Foreign Affairs to locate Masa's passport application, our research team in Japan discovered not only Naves' letter but the results of the investigation by the Tokyo police, which concluded, "The above-mentioned person is not registered under our jurisdiction, nor is there anyone at Meiji University, and therefore the whereabouts of his family is unknown."

James Atlas asserted that the biographer's purpose is to show what "other factors—beside genius" contribute to the making of an artistic life. What factors influenced the man we know as George Masa to come to this country? What motivated him to dedicate the last decade of his life to protecting the landscape that had become his adopted home? Who were his friends, his betrayers?

This biography attempts to reveal the "other factors" that motivated the energetic and likable young man who arrived in Asheville in 1915. Like thousands of other Japanese immigrants, the person we know as George Masa landed initially on the Pacific Coast where he lived for almost a decade in various cities with large Japanese populations, including Seattle and Portland. But unlike many other Japanese immigrants, Masa moved to the booming city of Asheville in North Carolina where only two Japanese persons were listed in the 1910 census.

He was ambitious, imagining "a great future, a castle of success." Undeterred by the hurdles individuals or governments put in his way—including a spate of anti-Asian legislation in the 1920s—Masa "worked like hell, studied like hell, and got good reputation" with his newfound community.

Masa was an outsider who made inroads into the wealthy enclaves of Asheville through his photography. Hired by the Vanderbilts to photograph their estate, Philip S. Henry to showcase his new art museum, and Douglas Ellington to document his striking

architectural wonders, Masa and his unmatched photographic skills were in demand throughout the region.

"Quiet and retiring in nature with most people, George was talkative with me," Naves wrote, "and friendly and humorous often in our conversation." Naves along with Horace Kephart, George M. Stephens, Barbara Ambler, and a handful of others formed deep friendships with Masa. He had a wider circle of friends in the hiking community, including Appalachian Trail visionary Myron Avery, and close relationships with officials in the National Park Service. Friends appreciated "his kindness, his gentleness, his reliable wisdom as a guide, his knowledge and appreciation of the wealth of beauty and wonder to be found in our mountains."

"Masterpieces of camera art" is how Naves referred to Masa's scenic photography. Masa's photos, along with the persuasive prose of his friend and fellow hiker Kephart, brought the hidden beauty of the Smokies to the attention of the nation. Masa's masterpieces appeared in local publications as well as in prestigious journals and popular magazines.

Kephart, who knew Masa best, puzzled over the whys. Why would a man, not even naturalized, not even permitted to be a United States citizen, dedicate himself to the Smokies? Masa deserved a monument, Kephart asserted, for "all this exploring and photographing and mapping, on his own hook, without compensation but at much expense to himself, out of sheer loyalty to the Park idea and fine sense of scenic values."

Like Kephart, we puzzled over what drove Masa—an immigrant who endured scrutiny from the Bureau of Investigation in 1918 and harassment from the Ku Klux Klan in 1921, then the collapse of the economy, his business, and his health in the early 1930s—to dedicate himself to national initiatives, in particular the establishment of a national park in the Smokies and the development of the southern portion of the Appalachian Trail. This biography focuses on the contributions of George Masa, his legacy, and his artistry. It also reflects our own journey of discovery, piqued by a decades-long curiosity about Masa. "Never surrender," Masa asserted in 1931. The

conviction not only reflects his perseverance and dedication then but continues to inspire our own today.

Like us, Asheville civic leader George M. Stephens believed Masa deserved a monument. Writing to the head of the North Carolina National Park, Parkway, and Forests Development Commission, Stephens asserted that naming a mountain peak "Masa Knob" would be an action that would reverberate around the world:

> *Because recognition when clearly deserved spurs others to high public service, I join those who appear before you in supporting honor for George Masa. The good that it can do will reach people around the world. It can say that all men are brothers when they work to preserve the beauty of Nature.*

# The Early Years
## *1915–1921*

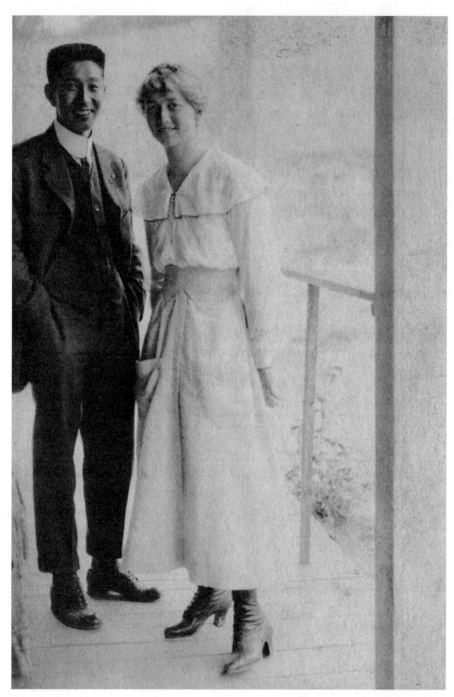

George Masa with a guest of Asheville's Grove Park Inn. *Buncombe County Special Collections, Pack Memorial Public Library, Asheville, North Carolina*

## CHAPTER ONE

### *Launched Out on an Adventure Today*

*"Launched out on an adventure today."*

~George Masa, diary entry,
January 16, 1915

What moves a person to leave all that they have known for something new, something different, something adventurous? The man we've come to know as George Masa had many reasons for leaving Japan and just as many rationales for his bold departure from the West Coast in 1915. One essential element in that mix of motivations must have been hope—hope for a new beginning or perhaps greater success, deeper fulfillment.

In mid-January, the 29-year-old man "launched out on an adventure." Masa wrote that declaration in Japanese *kanji* characters. Sometimes jotting down notes in Japanese, his native tongue, and sometimes writing in English, his adopted language, Masa seemed

to move comfortably between those two worlds, chronicling his cross-country excursion from the West Coast to the East in a 4×3-inch faux-leather diary printed and published in Tokyo.

He was a handsome man of average height, slim and athletic. His intense eyes were alert and keen beneath straight dark hair, keeping him sharply aware of his surroundings and the company he kept. His full lips were ready to soften into a smile or break into a grin. Neat in appearance and meticulous in his recordkeeping, Masa set off on his odyssey. As he left Los Angeles, California, he recognized his West Coast life was now over; a new life was about to take shape.

Embarking on this adventure required funds. On Monday, January 18, to Masa's relief, he "finally received a substantial amount of money today." Masa provided no inkling of the source, but we do know that the infusion of cash allowed him to buy a $13.50 train ticket for the first leg of his journey from Los Angeles to San Francisco along with a warm overcoat for the trip. His careful recording of the cost of everything from a stamp to a newspaper, a meal on the train to a tip for the cabin attendant, suggested a limited budget for his winter journey. The train he boarded in San Francisco—most likely the Southern Pacific—was headed to Ogden, Utah. Flush with cash, Masa purchased a berth for the first leg of the long overnight train journey. Only rarely on his eastward trip would Masa remark on a sight—"a church covered in snow"—or reveal his own feelings: "Didn't feel like writing today for I haven't seen much." The $15 knee-length wool coat he'd purchased came in handy as Ogden was "covered in snow and windy." When the train doors opened at the Denver depot, "snow blew in and piled inside the train." Kansas, where it was "extremely cold," was no better, and even St. Louis was so cold he felt as if his ears "would be torn off." On Saturday, January 23, Masa departed St. Louis for New Orleans, the last leg of his trip, and perhaps, finally, the end of wintry weather.

For the past decade, Masa had lived on the West Coast in cities with large populations of Japanese immigrants. Maps of *Nihonmachi* or Japantowns in Seattle and Portland depict a vibrant community filled with Japanese shops, boardinghouses, grocery stores, laundries, and restaurants. Masa had lived and worked in these communities, bathed

in a public bath or *sento*, perhaps enjoyed a cup of *sake* at a favorite bar-restaurant. As he disembarked from the train into the bustling city of New Orleans, Masa was likely exhausted from his week-long train journey and maybe a bit disoriented. Although Japanese immigration to the United States reached its highest levels between 1901 and 1907, the 1910 US census recorded only 20 Japanese people living in New Orleans. It was likely an unnerving experience for Masa as he arrived in this new, multicultural environment infused with French, Cajun, Spanish, Caribbean, Creole, Black, and White influences.

Masa jotted down names and street addresses in his diary— Carondalet, Julia, Decatur, St. Charles—as well as a few businesses in New Orleans. One of them, St. Vincent Hotel at 801 Decatur Street, might have provided his first room and his first lead on a job. Both a hostel and a job-finding agency, the St. Vincent Hotel and Free Labor Bureau run by the Catholic Church provided housing to "thousands of unsheltered and unemployed who lived in or passed through New Orleans in the 1910s and 1920s."

On Monday, January 25, he set off to look for employment agencies. Frustrated, he wrote, "Doesn't this city have any decent agency?" A few weeks later, he would post his own advertisement, spending 60 cents for a three-day listing in the New Orleans *Times-Picayune*. "Japanese student wants position to work for good rich family," read the ad in the "Situations Wanted" section of the newspaper. Although this type of advertisement might have yielded some results in West Coast cities, Masa received no job offers from wealthy New Orleanians.

On Tuesday, he moved into a room, "expensive," as he described it, at $2.50 per week, but he had privacy and his own space in a new city. Masa mailed what is translated as a "business letter" or a report of some kind, noting it in his diary as "the first." He would continue to send two letters a week per his diary while his ledger listed repeated purchases of writing pads, envelopes, and stamps. We know neither the content nor the recipients of these regular reports.

Masa kept careful accounts of all his living expenses during his six-month stay in New Orleans—a nickel for breakfast, a quarter for a bath once a week. His ledgers reveal his precarious finances: a balance

of 20 cents on February 4; a dollar income on February 5, a hint that he might have found work as a day laborer of some kind. On February 10, he either found regular work, or more money may have come in the mail, as he added a hefty sum of ten dollars to his balance.

Masa listed various prospects in New Orleans, perhaps leads that the employment agencies had suggested, or jobs the enterprising immigrant shrewdly unearthed. Mentions of the New Orleans Engraving and Electrotype Company and Panama Photo Engraving could indicate he had some experience with engraving or etching photographs for printing. Years later, he would sell his photography studio to a man who ran an engraving company and continued this enterprise alongside Masa's photography. If Masa secured a position at Labat's Hotel, another establishment on his list, his experience there might have led him to later opportunities at Asheville's Grove Park Inn.

Did Masa have a social life? His diary reveals a few tidbits: a walk in a park, a visit to a museum. On occasion, he splurged on ten-cent tickets to the cinema. From the clues in the notebook, however, it's clear that his weakness was baseball. Throughout the South, professional baseball teams made their rounds as part of their pre-season exhibitions. "Cleveland vs Pittsburg play in New Orleans," Masa wrote in one entry. Perhaps he took in a game in the city's new Heinemann Park, which boasted ten thousand fans on its opening day in April 1915. Despite his meager finances, Masa willingly paid the ten cents for a ticket to watch some games, 50 cents to attend another. Tucked in the corner-fold of his diary is a yellowed newspaper clipping listing the team training camps for the American, National, and short-lived Federal league. We don't know if Masa ventured down to the various training camps on the list, but we can infer that he was an avid baseball fan from the number of tickets he purchased and the nickel sodas he enjoyed while watching the games.

Photography also intrigued him. Whether Masa trained or had experience in Japan or the Pacific Northwest is unknown, but his diary documents his interest in the profession. Early in February 1915, Masa wrote to the Illinois School of Photography in Effingham, Illinois, expressing his eagerness to become a student. Run by

entrepreneur and photographer Lewis H. Bissell, the school was prominent in its field, enrolling students from around the world, including Japan. Masa continued corresponding with the school for the next several months but did not make the commitment to attend, perhaps deciding after he'd calculated the costs on the back of an envelope that it was beyond his means. He also inquired about textbooks, specifically one on three-color techniques and another title recommended by the school. We don't know whether he purchased the textbooks in New Orleans, but developing his photography skills was clearly something he was contemplating. Years later, photographic instructional books such as *Picture Taking and Picture Making* and *The Photography of Colored Objects* were part of Masa's business inventory. Photography had exploded in the early 20th century as a hobby, an art form, and a professional service. The process for publishing photos in newspapers and magazines had become easier, and by then, the use of professional photography for portraits, advertising, and public events was quite common. But like any profession, photography required technical training and mastering many specialized facets of knowledge. In New Orleans, Masa seems to have been exploring, if not pursuing, this expertise in earnest.

*National Geographic* was also on his reading list. Maybe on his train journey or perhaps in his New Orleans rooming house, Masa jotted down a bibliography of magazine articles relating to mountains and scenic destinations. His list of the highest mountains, those situated mainly in the western states, hints at an affinity for mountainous terrains and perhaps an interest in mountain climbing, since he also listed the elevations on that same page of his diary. In February, Masa tried his hand at *haiku*, a traditional Japanese poetic form. Unfortunately, the condition of the diary pages makes it difficult to transcribe or translate his early attempts at poetry.

Although Masa recorded relatively little in his diary from March to July 1915, one senses a growing frustration in reading his scattered notes and occasional accounting. He expresses his irritation at the unfairness of his employment situation and being forced to work when others refused to show up. He complains about his landlord, "a

nasty guy indeed." Providing no specific reasons, Masa began making plans to leave New Orleans, writing, "Now I have to raise money, for I have just enough for traveling and not a penny extra."

On Saturday, July 10, he "said goodbye to Mr. Leech"—perhaps a neighbor, an employer, or a contact at an employment agency—and left New Orleans on a train bound for Atlanta and then Asheville. Masa had an interview at one of the newest and grandest hotels in the country.

Across one page of his diary, Masa practiced perfecting his signature, perhaps cementing his identity. A half dozen times, he scrawled in his distinctive cursive, "G. M. Iizuka." On another page of the diary, it seems that he might have been tabulating his age. A string of dates from 1884 to 1915 correlates the years in the Japanese imperial calendar with the Gregorian calendar used in the US. Was he practicing the Anglicized name he would use in Asheville? Calculating his age? Having confirmed the basics, Masa might have felt all set for any employment application he would need to complete for a position at the Grove Park Inn.

As the train traveled north through Mississippi, Alabama, and Georgia, Masa witnessed violent lightning and thunderstorms, exclaiming in his diary that he had "never seen such a scene in my life!" Whether Masa knew much about his destination—Asheville, North Carolina, and the Grove Park Inn—is unclear, but when he arrived on the afternoon of July 10, 1915, he could not have guessed how this decision would impact his life. Set on a plateau and surrounded by the worn and somewhat rounded Blue Ridge Mountains of the Southern Appalachian chain, Asheville was certainly the most modern city in the western part of North Carolina. In many ways, though, it was still transitioning into the 20th century.

The imposing stone hotel was a few miles from the train station, halfway up the slope of Sunset Mountain. Masa's interview was scheduled for Sunday, July 11, at 11:50 a.m., one day after his arrival in Asheville. The hotel would have been buzzing with guests, some checking in

or out, others being seated for lunch in the elegant and light-filled dining room, while young people headed out for a round of golf or a game of tennis.

His eyes might have traveled to the enormous porch on the west side of the lobby, which looked out over Asheville and the Blue Ridge Mountains. On a clear day, the Great Smoky Mountains would have been visible on the far horizon with layers of green mountains and whitish-grey clouds dancing along the ridges. Guests relaxed on wicker rocking chairs; flower-filled vases perched on hand-crafted wooden tables. The inn was the essence of American success and possibility. Inspirational quotes from Thoreau, Emerson, and Jefferson were inscribed on stones embedded in the massive fireplaces. A Dutch proverb proclaimed: "The gem cannot be polished without friction, nor man perfected without trial."

Masa was impressed:

> *I visited Grove Park Inn in Asheville at 11:50 a.m. and had an interview with the manager, Mr. Seely, and the assistant manager, Mr. [illegible]. To make a long story short they took me. They are supposed to decide where to station me at 2:00 p.m. tomorrow. The hotel is huge, true to its claim to be the biggest in the world. Such an elaborate, magnificent building.*

Fred Loring Seely might have smiled when he saw Masa, as the young Japanese man appeared to be exactly what he had ordered from the employment agency, a polite, hardworking exotic novelty. That Seely invested his time in interviewing a worker whom he intended to hire for the laundry room of the hotel reflects his fastidious attention to detail. Masa was only one of around a hundred employees at the Grove Park Inn, but Seely saw each staff member as another element critical to the hotel's success and smooth operation. It was management's responsibility, Seely believed, "to know the character of the people we have in our employ."

Newspapers proclaimed the Grove Park Inn to be finest resort hotel in the world when it opened in 1913. Although that description

may have been embellished with some hyperbole, there is no doubt that the hotel was—and still is—impressive. The entire structure is made from massive rough-cut stone, some chunks weighing as much as ten thousand pounds, hauled from Sunset and other nearby mountains. The Great Hall soars with 30-foot-high ceilings and two immense fireplaces. Using hundreds of laborers and only mules, wagons, ropes, and one steam shovel, the crew constructed Seely's fireproof design in just one year. It was a building that redefined Asheville. The bar for opulent and newsworthy structures had been set ridiculously high by George Vanderbilt with his Biltmore Estate in 1895, but Seely and his father-in-law, pharmaceutical magnate Edwin Wiley Grove, met that standard with their striking new hotel. From the handcrafted chairs and copper lighting fixtures furnished by the artisans at the Roycroft campus in East Aurora, New York, to the guest bedroom furniture built locally by White Furniture Company in Mebane, North Carolina, each crafted piece in the hotel had been conceived, selected, and approved by Seely himself. As Bert Hubbard, founder of Roycroft, proclaimed, "Grove Park Inn is Fred Seely from top to bottom."

Bruce Johnson documents the history of the Grove Park Inn as well as its struggles and renaissance in his fascinating book, *Built for the Ages* (1991). He also delves into the dynamics of the two headstrong men, Seely and Grove, who financed and built the Grove Park Inn and whose business and personal interests throughout their lives intersected, coalesced, tangled, and ultimately fractured.

Grove had made millions with a treatment for malaria and other maladies with his eponymously named Grove's Tasteless Chill Tonic. In a very short time, he evolved from a small-town pharmacist to a man of wealth and influence, flexing that power throughout his lifetime. Born in 1850, he apprenticed as a young man in a pharmacy in Paris, Tennessee. Ambitious, focused, and entrepreneurial, Grove developed a formula for disguising the bitter taste of quinine—the only known protection from the rampant disease of malaria—into a relatively tasteless tonic. His Paris Medicine Company soon outgrew its Tennessee home, and Grove relocated the firm to St. Louis, Missouri, where his laboratories continued to build new products

and pioneer novel manufacturing techniques for delivering medications. When his doctors recommended that the businessman spend some of his time relaxing and recuperating from bouts of bronchitis and exhaustion, Grove came to Asheville, North Carolina. Unable to abide by his doctor's orders for R and R for long, Grove bought land, seized opportunities, and invested heavily in the booming city. Today, Grove is acknowledged as the "Father of Modern Asheville."

Seely was a self-taught man. Brilliant, driven, and seemingly successful in whatever field he put his mind to—engineering, chemistry, architecture, newspaper publishing, and hotel management—the young entrepreneur was a match for his father-in-law. Born in 1871 in Monmouth, New Jersey, Seely began working for a pharmaceutical company in New York City as a teenager. He met Grove while employed at Parke, Davis & Company, another pharmaceutical firm in Detroit, Michigan. Impressed by the young man, Grove offered him a position at his company in St. Louis in 1898. That same year, Seely married Grove's daughter, Evelyn. The newlyweds moved to Asheville where Seely was put in charge of the Tasteless Quinine Company, a new subsidiary of the Paris Medicine Company. When Grove experienced some health problems, Seely was put in charge of both the St. Louis and Asheville plants, which he ran successfully. With supplies tight, Grove sent the couple on a five-month trip to Java, Ceylon (Sri Lanka), and India to secure new contracts for quinine. A few years later, Seely left his father-in-law's firm and moved his young family to Princeton, New Jersey, where he briefly attended classes at the university. Academic life did not seem to suit him, so he tried a new direction. With Grove's financial backing, Seely founded a newspaper, the *Atlanta Georgian*, in 1906. The paper, a personal and political passion for Seely, also became a mouthpiece for social causes important to him—prohibition, corruption in government, and abusive convict labor practices in the South—but six years later, Seely sold it to newspaperman William Randolph Hearst who added Atlanta to his growing media arsenal.

Itching for a new challenge after the sale of the *Atlanta Georgian*, Seely shifted his interests to architecture. Although his father-in-law

had enlisted plans from several architects, each failed to submit draw-
ings that reflected Grove's vision of creating "an Inn worthy of the
mountains." Seely succeeded. Inspired by Yellowstone's Old Faithful
Inn, design elements from some of the architectural sketches submit-
ted earlier, and his own vision, Seely set to work developing a plan that
reflected elegance and simplicity of design. On July 12, 1913, Secretary
of State William Jennings Bryan delivered remarks at the grand open-
ing banquet of the Grove Park Inn. He asserted that the wonderful hotel
was "not built for a few, but for the multitudes that will come and go."

As Masa began to settle in, he recorded his initial thoughts about
Asheville and his aspirations for the job: "As this is a mountainous
area, it will be cool enough to require a blanket in the autumn. No
mosquitos! An excellent place to live. Nothing can be better now if
only I get a job and make a lot of money."

While Asheville still had an agricultural backbone in the sur-
rounding coves and river valleys, it was evolving into a cosmopolitan
city, in large part due to investments from government, entrepre-
neurs, tourists, and the business community. Visitors came to Western
North Carolina both for its scenic location and the perceived health
benefits of its air and water. Since the middle part of the 19th century,
Asheville and areas nearby such as Hot Springs, with its geother-
mally heated water, had become escapes and therapeutic retreats.
Sanitariums both large and small, formal and casual, dotted the
ridges of Asheville. With their open windows and sleeping porches,
some clinics offered clients an escape from fatigue, addictions, and
other ailments. Others specialized in treating patients suffering from
tuberculosis and various communicable diseases.

On his first day, Masa might have picked up one of the local Ashe-
ville papers and caught up on the national and local news. Rumblings
of war dominated the newspapers. Two months earlier, a German tor-
pedo had struck the RMS *Lusitania* killing 1,198 passengers and crew,
including 128 US citizens. The German explanation for the attack was

woefully inadequate, and front-page headlines warned of the gravity of the situation. American troops were not yet actively engaged in the war, which raged on various European fronts. Would the loss of lives and Germany's failure to admit liability be the catalyst for the United States to enter the war? The US reaction to the provocation was being closely watched and debated.

Another headline that might have caught Masa's eye was the mining revival in full swing across the country. "Colorado already shows an increase in gold output," one Asheville news item proclaimed. The social page announced the presence of North Carolina governor Locke Craig and his wife Annie Burgin Locke at a weeklong anniversary gala for "the dancing set," while fashion pages described the "decorously short new skirt"—revealing just a touch of ankle—for the dog days of summer.

The governor's presence in Asheville was significant for another event: the meeting of the North Carolina Good Roads Association. Governor Craig, who also chaired the State Highway Commission, would provide the opening address at a three-day meeting scheduled for later that week. Infrastructure, including both the construction and maintenance of roads and highways through the mountains and connecting to major cities, was of critical importance to the business-progressive boosters of Western North Carolina, particularly as more and more tourists opted for automobile travel over railroad excursions.

When Masa reported for work on Monday, July 12, the assistant manager told him that he'd been assigned as "an ironing man" contingent on the successful completion of a two-week apprenticeship. Seely had agreed to pay Masa's salary "while he learned to do pressing and valet work in a dry-cleaning establishment downtown." Eager to start and happy to receive a five dollar advance of his wages, Masa headed downtown to look for lodging. Although he thought it might be challenging to find a good place to live, Masa found a room after talking to a fellow employee—"an elderly lady working quietly there

and asked her to take me in." In two days, he had landed a job, been paid, and found lodging "just right for me." Life in Asheville was all "quite interesting and exciting," he wrote.

It did not take Masa long to master the tools of the laundry room—by his second day on the job he was "using an iron all alone." Nor did it take much longer for management to recognize his talents. Friendly and energetic with passable English language skills, Masa soon was also working at the bellman's service desk. His deferential manner as he interacted with guests, moved luggage into suites, and unpacked bags impressed the guests and presumably Seely. Johnson wrote that Seely was "adamant in his belief that the men who patronized the Grove Park Inn expected peace and quiet." Writing to his father-in-law two years after the inn opened, Seely reported that the hotel was attracting the right class of people—mostly "old-fashioned businessmen . . . most of them, tired out, and some of them nervous with poor stomachs." To maintain a level of tranquility, staff wore rubber soles on their shoes, and guests were encouraged to do the same; only hushed voices could be used in the Great Hall as quiet was maintained after 10:30 p.m. Elegant meals featured fresh produce and local ingredients, but no alcohol was served. Men were allowed to smoke, although it was unacceptable for women to do so in public rooms at the Grove Park Inn. Dogs were forbidden, and management dissuaded parents from bringing young children to the hotel.

Although Seely stressed serenity at the inn, he also provided plenty of healthy entertainment. During the day, guests could bowl, play golf or tennis, or go hiking or horseback riding in the surrounding mountains. Evening entertainment included music recitals and educational lectures.

It was into this life of leisure that Masa found himself cast. Johnson highlights some of the millions of guests, celebrities, and tourists who have enjoyed the comforts of the Grove Park Inn for a day, a week, or a month. Over the years, US presidents Wilson, Coolidge, Hoover, and Franklin Roosevelt vacationed at the inn. Business leaders such as Henry Ford and Thomas Edison were guests while Enrico Caruso and Will Rogers entertained. The clientele of the Grove Park

Inn were rich and among the most well-traveled people in the world. Later, in the 1920s, Asheville, along with Hot Springs and Palm Beach, would become frequent destinations for the "sporting set," the young, wealthy, and "careless" class that F. Scott Fitzgerald characterized in *The Great Gatsby*. But in the early years before the United States entered the European conflict, the clientele was more the wealthy and perhaps weary businessman and his family.

As the weeks turned into months of employment, it was apparent that Masa was more than a valet. Photos from these first few years at the inn show him smiling with guests and other staff, accompanying visitors on journeys away from the inn by car, taking walks to scenic vistas, and lounging under trees with groups of guests—appearing much more like a friend than an employee. His apparent comfort in the company of these elite and experienced travelers might have seemed surprising, but Masa often exceeded people's expectations of him.

Masa initially boarded in downtown Asheville but later moved to employee lodging, likely Sunset Hall, "a two- or three-story dormitory Seely built for hotel staff who could not travel home each night and for servants traveling with wealthy guests," according to Johnson. Masa soon requested a larger room for study and "photographic purpose." The interest in photography that Masa had expressed in New Orleans had come with him to Asheville, blossoming into a sideline enterprise. Within 18 months of his arrival in North Carolina, Fred Seely described Masa as having "developed into or was a most expert photographer" leaving some question in Seely's mind as to whether Masa had been self-taught or formally schooled in the techniques.

Early images show him holding or operating a variety of cameras, probably owned by the guests he was accompanying and whose negatives he would also develop, or "finish," and print. Seely had a keen sense for the value of promotional images and owned at least one higher-quality camera model, possibly an Eastman Kodak known as a Kodak No. 1 Autographic Junior. In several photos, Masa is also captured holding this model camera. Likely he intrigued Seely with his ability to serve guests as well as support the larger goals of publicizing the Grove Park Inn and its amenities.

Given Masa's proficiency both with using cameras and processing film at the Grove Park Inn, it is likely he had gained some experience in Japan or elsewhere in the US with the cameras of the day before arriving in Asheville. The introduction of the Kodak "Brownie" in 1900 made photography possible and affordable for many; for the elite guests of the inn, photography had become an essential part of the travel experience. The guests often created extensive photo collections and scrapbooks of their adventures, and occasionally, a guest or one of their friends would snap a photograph of Masa.

Masa had been excited when he arrived in Asheville, believing the city to be "an excellent place to live" with its mild climate, absence of mosquitos, and miles of hiking trails in the surrounding mountains. Advertisements for a narrow-gauge train transporting tourists to Mount Mitchell promised that visitors would be "bewildered by the scenic grandeur of the rugged mountains" from atop its 6,711-foot pinnacle. The city center bustled with dance bands brought in from Atlanta, two cinemas showing the latest films, and even a hometown baseball team, the Asheville Tourists.

At the opening ceremonies of the Grove Park Inn, owner Edwin Grove proclaimed, "A man never grows too old to build castles and dream dreams." Like Grove, Masa had aspirations. When he landed in Asheville in 1915 as a 30-year-old, Masa intended to get a job and "make a lot of money." He had accomplished the first of his goals, but his assigned tasks—laundry, luggage, valet work—were often tedious and his paycheck paltry. Photography was engaging, but as a sideline enterprise, it, too, was not terribly lucrative. The contrast between his status and that of the guests was stark. He was not wealthy, nor did he have the means to make a lot of money. If he possessed skills in other trades or professions, there is no immediate indication of those either.

His diary has no record of him corresponding with anyone from his past during his first year in Asheville, nor are there any more records of "reports" being sent as had been done in New Orleans. For reasons known only to himself, Masa needed and appreciated being a new person in a new place. Disconnected from his past, he had

hopes for his future. Like Grove, he believed that he was capable of building castles and dreaming dreams. All he needed was the means to make it so.

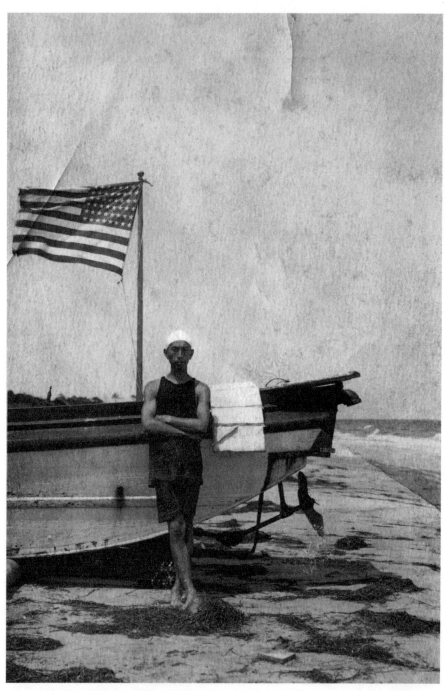

George Masa at Old Port Comfort in Hampton, Virginia, 1918. *Buncombe County Special Collections, Pack Memorial Public Library, Asheville, North Carolina*

# CHAPTER TWO

## *So Far Away from My Purpose*

*"As you know, am a student who has an ambition, who wishes good future,
and I know, I am not the man who suitable the position as valet,
it is so far away from my purpose."*

~George Masa to Miss L. Scott, May 4, 1917

Masa was restless. At 32, he had aspirations and ambitions far exceeding his position at the Grove Park Inn. Surrounded by luxury, serving a wealthy clientele whose clothes he pressed and delivered, and whose trunks and luggage he might have unpacked, Masa was all too aware of the limitations of his status. In May 1917, he submitted his resignation; it was the second of at least three attempts to leave his employment at the inn. The previous year, he had almost moved on, but something—either his finances, some indecision about his next steps, or a change in circumstances at the Grove Park Inn—had stifled the urge to leave his job.

In the two years Masa had been working at the inn, he had hand-painted signs for Seely's palatial personal residence known as Overlook, labored in the inn's laundry room and served as a valet, photographed guests, and even outfitted his own darkroom and photo-finishing space. But Masa's expectations stretched beyond the laundry room and further than a sideline photography enterprise. As he explained to Seely's secretary, Miss L. Scott, in November 1916 when he first resolved to leave, there were a host of reasons. First among them were his aspirations. He saw himself as a student, one with dreams. Although initially eager to work at the Grove Park Inn, he had come to realize the job "not suit to me, I know it." Masa packed a great deal of frustration into his short note to Scott. Not only did he dislike "work by the order," but he found fault with the captain of the bellmen, who had "no system." Although he had a litany of irritants, the real driver was his ambition: "I will tell you why I am going to leave here. As you know, am a student and imagine great future, the castle of success, so I wish, going to the purpose." That "castle of success" was the American dream—and Masa was a believer.

His initial plan in 1916 was to head to a metropolis where "I will get job easy and there are more chances for study." Although Masa may have overestimated his ability to secure a good position in a large city, he felt confident in his talents, believed his experience was solid, and hoped for a strong recommendation from Seely. He told Miss Scott that he was sorry to leave the inn but knew there were more opportunities in a city larger than Asheville. By sending his written intent to leave, however, Masa's request triggered an alarm in Fred Seely—not the glowing recommendation Masa had anticipated.

Even before the United States entered World War I in April 1917, the country was fearful of infiltrators, espionage, and sabotage. This anxiety went hand in hand with demands to "purge the country of these foreign intriguers and punish their domestic sympathizers." Seely—more engaged than most in both the national and international political scene—had become suspicious of Masa's activities. Proud of the reputation of his hotel, Seely knew he could not have infiltrators or spies on his staff. He also had plenty of friends and colleagues with whom he could consult about the issue.

Seely's political connections ran deep. He was close friends not only with the politician and former secretary of state William Jennings Bryan but also with the president. He and Woodrow Wilson had been neighbors during Seely's student days at Princeton in 1902. Later, he actively campaigned for Wilson's presidential run. Bryan had even convinced Seely to join Henry Ford's infamous mission to broker a peaceful end to the conflict in Europe. Ford's "Peace Ship" flotilla included the steamships *Oscar II* and *Frederick VIII* and carried 83 delegates, 54 reporters, 50 technical advisors, 18 college students, and three photographers. Given its lack of official imprimatur from the president or Congress, the divergent aims of the delegates, and a cacophony of voices, it's not surprising that Ford's civilian mission failed to end the European conflict. The historian Barbara Kraft wrote that the press saw Ford and his passengers "as a Don Quixote accompanied by an assemblage of Sancho Panzas." Seely was more diplomatic in his assessment. As he explained to the *Asheville Citizen* in January of 1916, "Somebody in Europe is going to want it [peace] within a very few months and when this time comes, any commission working to that end, no matter how small or how humble, is going to be able to save a large number of lives simply by being able to start the negotiations." Seely trusted that his friend Bryan could be the one who could successfully negotiate a peace deal.

Another of Seely's political connections was with A. Bruce Bielaski, head of the Bureau of Investigation (later the FBI). When Seely learned from his secretary that Masa planned to leave the Grove Park Inn, he wasted no time in contacting Bielaski. Seely wrote that he was perplexed by his employee's actions. Masa had been "very persistent about coming here," and the Grove Park Inn had trained the man, but now he intended to leave—just a year after being hired. What also roused Seely's suspicions, though, was Masa's talent: "He has become very proficient and has further developed into, or was, a most expert photographer and is far more brilliant than we had any reason to suppose." Puzzling to Seely was why a man fixated on spending "most of his spare time taking and developing pictures, making records, etc. . . . now is talking about leaving." Seely added

that Masa had "quite a collection of records in his room which certainly were not made just for the fun of it." He also enclosed a letter that Seely believed proved Masa "is well educated."

Seely not only revealed his suspicions but also articulated his own contradictory impressions of his employee. He had recruited him for the laundry, but Masa turned out to be an expert photographer. Seely might have supposed Masa was uneducated yet discovered that he was brilliant. Since Masa boarded at the Grove Park Inn's "officers' quarters," it's likely that the staff and the management had access to his record books, but given the Japanese characters, no one on the staff could read them.

Two weeks after writing the bureau, Seely got his reply. Bielaski, having failed to find someone with the right language skills, offered to send a "local officer, located near Asheville" to scout out the situation. Yet in the interval between Seely's letter and Bielaski's response, Masa revised his plans and decided to stay. Given this turn of events, Seely called off the investigation, telling Bielaski to "let the matter drop for the present," and promised to let the chief know if the situation changed. Without more clues, one can only guess at Masa's motivations for staying. Perhaps he got wind of Seely's suspicions. Maybe Miss Scott or another colleague convinced him to remain.

Seely's zeal in spotting what he believed to be suspicious behavior likely led to his appointment as president of the local chapter of the American Protective League (APL), a volunteer organization established in March 1917 by President Wilson and encouraged by Chief Bielaski. Its purpose was to root out and investigate anyone considered a threat to the United States. Considered an auxiliary organization to both the Bureau of Investigation and the Department of Justice, it aimed to supplement the work of local and national law enforcement and "enforce patriotism and stifle dissent." According to the 1917 *Annual Report of the Attorney General of the United States*, APL membership, which was "carefully guarded," included "leading men in various localities who have volunteered their services for the purpose of being on the lookout for and reporting to this Department information of value to the Government and supplement law enforcement at the local and national level."

Although the initial emphasis was on German, Austrian, and Hungarian sympathizers, the APL applied its mandate broadly. Volunteers were on the lookout for suspicious behaviors—particularly in hotels, restaurants, railroad and bus stations, and in union shops. Prejudice against Asians and a volley of legislation aimed at Chinese and Japanese immigrants also heightened tensions in the United States, starting on the West Coast and Hawaii and spreading eastward. Xenophobic fears fueled the Gentlemen's Agreement of 1907 limiting Japanese immigration to the United States, the Alien Land Law forbidding noncitizens from owning property in California, and a Supreme Court ruling prohibiting Japanese people from becoming naturalized citizens. Culminating with the 1917 Immigration Restriction Act and the National Origins Act of 1924, lawmakers and the highest courts of the land effectively banned Japanese immigration to the United States.

Given that the Grove Park Inn regularly hosted important political and industrial leaders as guests, Seely felt he could not let his guard down nor let the reputation of the inn be tarnished. When Masa "settled down," Seely relaxed. But Masa's restlessness persisted. Six months after his initial resignation letter, he hatched another plan. Rather than move to a metropolis, this time he would head west and maybe even strike it rich. Again, he was driven by the yearning for better opportunities than his current situation offered:

> As you know, am a student who has an ambition, who wishes good future, and I know, I am not the man who suitable the position as valet, it is so far away from my purpose. I intend [sic] International Correspondence School and getting lessons of Metal prospector's course, so I made up my mind go to Middle West States where more convenience, there are more chance.

Ever the optimist, Masa told Miss Scott, "If God favor me, I will find some mine." Although there is no evidence that Masa read Horatio Alger's rags-to-riches books, it's certain he believed in the "gold rush" myth. Like many an immigrant, Masa had come to the United States looking for opportunity and the chance to apply his skills and intellect

to build his own "good future." He was willing to take chances, willing to strike out on his own. Every day, he witnessed success. Not only did it radiate from the elegant clientele of the Grove Park Inn, it shone in Seely's residence, Overlook, situated on Sunset Mountain. Inspired by the design of an English Gothic monastery, Overlook was a massive stone structure with castellated walls and towers—a veritable "castle of success." The 20,000-square-foot home, built by many of the same stone masons and craftsmen who had constructed the inn, featured 32-foot ceilings in the great room, beams from a 14th-century ancestral home in Ireland, and stones from the Tower of London and Blarney Castle embedded in one of the massive fireplaces. The door to Seely's office featured 12 hand-carved wooden panels depicting biblical scenes. With its commanding views over Asheville, Overlook was a statement to Seely's ego and to his success, making a lasting impression on locals as well as visiting presidents and titans of industry. Masa might not have known for certain where he would find his own "more chance," but he would seize the opportunity to head west and make his fortune in the mining industry. If Masa's aspirations about his Colorado venture were unrealistic, his hopes were boundless.

In April 1917, Seely purchased Biltmore Estate Industries, an educational and manufacturing enterprise nurtured by George and Edith Vanderbilt. Following her husband's death, Edith's financial situation—her modest inheritance and the extensive expenses related to the estate—prompted her to sell Biltmore Estate Industries. Although the original goal for Biltmore Estate Industries was to be self-sustaining, it had never quite achieved that status, requiring regular subsidies from the Vanderbilts to stay afloat. Allowing it to fail could have devastated the community. Biltmore Estate Industries purchased wool from nearby farmers; weavers used looms fashioned by Biltmore woodworkers; and instructors trained Western North Carolina residents who became carvers, spinners, and weavers known for the excellence of their work. Like similar initiatives, including the Roycrofters in upstate New York and the Arts and Crafts movement in England, Biltmore Estate Industries was devoted to fine craftsmanship and an integrated economy. The Grove Park Inn reflected

that ethos. Seely had decorated and equipped the inn and his home with handcrafted furniture, lighting, and metalware from the Roycroft studios in East Aurora, New York; Grove Park Inn guests were served fresh local produce, including milk from the Biltmore Dairy. Biltmore Estate Industries' mission was a natural extension of Seely's commitment to his guests at the Grove Park Inn.

In an extensive ad placed in the *Asheville Citizen* on April 14, 1917, Seely explained his rationale for the purchase of Biltmore Estate Industries and his commitment to Mrs. Vanderbilt's vision. Believing that the estate industries complemented the pledge to high-quality craftsmanship already integrated into the mission of the Grove Park Inn, Seely also asserted that his extensive business experience and the efficient sales, shipping, and office management of the Grove Park Inn would ensure Biltmore Estate Industries' success and expansion. Seely assured his audience that he intended to retain the management and the employees of Biltmore Estate Industries as well as to support its educational focus. In addition, on land adjacent to the Grove Park Inn, he intended to erect "modern artistic buildings" for the various enterprises. Although Biltmore Estate Industries' work would be done in different surroundings, he promised that he would not "rob the Industries of the charm and sincerity that have made them what they are." Seely would give them a stronger business infrastructure, a wider market, new buildings, and a new name—the shorter moniker "Biltmore Industries." His testimony ends with a pledge:

> I promise that the same degree of honesty and sincerity shall always be found in these products and am printing this advertisement because I feel that any public enterprise like this deserves the confidence and assistance of our home people, and that my friends and fellow-citizens who have helped me so much in the development of my work here deserve to know the conditions that permit the taking over of an enterprise like the Biltmore Industries.

Seely made good on his promise. Over the next few years, the reputation of Biltmore Industries blossomed, the number of artisans

swelled, and customers from Helen Keller to Eleanor Roosevelt were wearing Biltmore homespun.

Masa's expertise and artistic sensibility—his painting, lettering, carving, and photographic skills—closely aligned with the Biltmore vision. His talents persuaded Seely of his worth. Although we know of no surviving examples of Masa's carvings or signage, various invoices and correspondence reveal the range of his work for Seely's home, the Grove Park Inn, and Biltmore Industries. A photo archived at the Buncombe County Public Library and taken by Julia Etta Brookshire, a trusted employee of Biltmore Industries, shows Masa carving a small squirrel for a "squirrel bowl," a curio with oak leaves and acorns circling the nut bowl. Two carved squirrels serve as handles. The photo shows Masa seated with his carving tools in the foreground, a stuffed squirrel on his desk serving as the model, and the Grove Park Inn visible through the open window.

In accordance with the plan he had been hatching, Masa resigned from the Grove Park Inn in May 1917 to seek his fortune. His itinerary involved taking the train via the Santa Fe route, stopping over to see a St. Louis baseball game, and then heading directly to Colorado Springs. Masa most likely did not leave Asheville with a recommendation in hand since he later wrote to Seely from Colorado repeating the request and updating him on his trip. Masa explained that it was likely he would get a position at a photo studio, which would leave him enough time for his lessons in prospecting. Seely replied to Masa's letter, hoping to tempt him to return east: "I hope you will soon have enough of your visit so you can come back and go to work. If you do not like it out there you must write me at once."

From the few details available about his short-lived western adventure, Masa seems never to have enrolled in a mining program, nor to have found his fortune in a gold mine. Instead, he hoped to rely on his photography skills to pursue a job at the Photo Craft Shop. Run by commercial photographers Charles Auld and Harry

Standley, the shop offered a range of services including hand-colored landscapes and lantern slides as well as art and photography supplies. Located on the busy North Tejon Street, the Photo Craft Shop shared a storefront with a corset shop and needlework emporium. Days after his arrival in Colorado, "George Masa Iizuka" completed a draft registration card listing his occupation as photographer and his address at 210 South Weber, a ten-minute walk from the Photo Craft Shop where he claimed to be working. For some reason, he also shaved off a few years of his age, bringing it down to 28 with a declared birth date of January 18, 1889. He listed his birthplace as Tokyo. The United States had entered the European conflict in April 1917 and imposed a draft the following month. On June 5, 1917, the United States mandated the first of three draft registrations, requiring all men between the ages of 21 and 31 to register. The draft registrar described George Masa Iizuka's physical appearance as a person of medium height and build with brown eyes, black hair, and no visible disabilities.

Masa arrived in Colorado on May 26 according to his letter to Seely on May 27, but by mid-June, he was ready to leave. On June 10, he wrote to Seely requesting a position at the Grove Park Inn and "a couple months wages in advance." From this correspondence, one intuits that Masa's job at the Photo Craft Shop might not have materialized or may not have been satisfactory. Had he actually been *offered* a position at the Photo Craft shop, or was it wishful thinking on his part when he completed the draft registration card? If he had been offered a position, why was he leaving the job so soon? Was the war or the draft registration a prompt to head back to the safety net of the Grove Park Inn? Whatever the circumstances, two weeks after his arrival in Colorado, Masa was ready to head back to Asheville. He had not found his "castle of success" out west.

Instead, he told Seely that he had spent all his money on a vacation and "had a good time seeing the beauty of Nature." We know from his correspondence with Seely that Masa did some exploring of the mountains surrounding his western home base. Disappointed that deep snow prevented a climb up Pikes Peak, Masa told his former boss that he tackled Cameron Cone, a challenging hike with significant

elevation gains, not far from Colorado Springs. A few weeks later, Masa was still exploring Colorado but was anxious to hear from Seely:

> *I had fine time for 'hiking' sure the country is Wonderful, Grand, as it is says 'Nature's Beauty Spot.' I am wanting some good news from you to go back to work. Didn't you find out a position for me yet? Will you give me a vacation one month of July in every year? If you will, please write to me also enclosed check as I told you, I will be back to do work.*

In reply, Seely reiterated his interest in having Masa return and offered a one-month summer vacation—two weeks of which would be paid, the other two weeks at Masa's expense. When Masa had left the Grove Park Inn in May, Seely had contacted an employment agency to send him another "Japanese man" but told Masa that he was willing to forego that decision if Masa telegraphed him at once. He also offered to send him an advance on his wages to cover traveling expenses.

No longer suspicious, Seely was offering enticements for Masa's return: a new position, an advance on his wages, a paid vacation, and a $40 check to cover expenses for his trip east. Masa was back on the job at the Grove Park Inn within weeks. If Seely's turnaround is bewildering, so too are Masa's actions, for soon after Masa returned to Asheville, his restlessness returned.

For the past two years, Masa had been grasping at possibilities for his own American dream. He had ricocheted from the idea of moving to a larger city with more opportunities in 1916 to becoming a prospector in Colorado and studying mining engineering in May 1917. That summer, one of his colleagues at the Grove Park Inn encouraged him to talk to the owner of a barber shop in downtown Asheville and consider barbering school. Perhaps because he hoped to work in the Grove Park Inn barber shop, Masa asked Seely to cover the hundred-dollar cost of the course as well as his room and board in Atlanta. As far as we can tell, Masa never enrolled in those Atlanta programs. Barbering, like prospecting, was another dead end.

Boarding at the Grove Park Inn also had become tiresome. Masa had been itching to move out of the inn's housing, first posing the question to Seely's secretary in February 1918: How much would Seely pay him "by the week without room and board?" Knowing Miss Scott's skill at gauging Seely's mood, Masa suggested she make the request "when you find his feeling is fine." But Masa's plans to leave the confines of the officers' quarters may have set off more alarms for Seely. When Frederick Handy, an agent of the Bureau of Investigation, made a courtesy call on March 16, 1918, to introduce himself to Seely, the newly appointed head of Asheville's branch of the American Protective League, Seely asked Handy to investigate his employee, George Iizuka. Seely had learned—perhaps from another employee—that Masa had a cache of maps, sketches, and photographs in his room. Seely also suggested that Handy delve into why Iizuka made so many extended trips into the countryside. Feeling that he had nothing to hide, Masa readily agreed to let Handy search his room. He showed him the geological survey maps he'd acquired and explained his interest in outdoor life. It's impossible to know if Masa understood how his hopes and dreams for his future—and, in fact, his freedom—hung in the balance. The suspicion of being a spy accompanied by evidence was plenty to predicate an arrest during these tense war years. But Masa was unperturbed by Handy's intrusion and seemed to put the agent at ease. Handy reassured Seely and then summarized his visit and his findings for the district office in Wilmington, North Carolina:

> *I found nothing of a suspicious character other than the fact that he had a large number of geological survey maps of a great many states of the Union, mostly the mountainous states, and his explanation of his possession of these, seems reasonable, that is, that he was very fond of outdoor life and that he had secured the maps for the purpose of mapping out routes which he might follow in taking hikes through the country. I found no sketches made by Iizuka nor any photographs of a suspicious character.*

Though Seely was now appeased, Masa remained frustrated— perhaps at himself for vacillating between staying or leaving the

Grove Park Inn—but certainly frustrated at the lack of opportunity. Seely's suspicions likely added to his dissatisfaction. Masa's expectations and his ambition were propelling him to succeed, but he was "still so far from his purpose" and seemingly incapable of channeling his aspirations in a single direction. As a young man he had left Japan to come to the states—for adventure and "good fortune." The Grove Park Inn was Seely's "castle of success"—not his. Neither mining, barbering, wood carving, nor photo finishing were satisfying his ambition nor fulfilling his quest for adventure. His short excursion to Colorado gave him a taste of the Rockies but did not sate his desire to see more of the country. Perhaps he also felt time slipping away, still without a career that would help him reach his goals.

A new guest, G. E. Elia, checked into the Grove Park Inn in May of 1918, arriving in a dark maroon car, "foreign style," Seely observed in a letter he wrote to Chief Bielaski at the Bureau of Investigation. Elia's chauffeur was also a foreigner, another man in the entourage was an electrician, and the third a guide, "seemingly a native, he [Elia] had picked up in Charlotte to pilot him over here." Suspicious of this heavy-set middle-aged man with white hair and a Van Dyke beard—nothing "like any Italian I have ever seen"—Seely began documenting Elia's movements. He reported that Elia traveled with six military tents, six horses, and two automobiles. "Distinctly German" was Seely's read on the man.

Masa came to a different conclusion. So, too, did Vera Ward, who handled telegrams and worked at the hotel's newsstand. In June 1918, Masa and Ward left the Grove Park Inn, signing on with a new boss, G. E. Elia, the mysterious newcomer to the region.

Giovanni Emanuele Elia was wealthy, some might say ostentatious. He was unconventional—traveling with a stable of high-priced racing horses as well as several expensive automobiles. In addition to reserving rooms in hotels, Elia set up elaborate camps that included "an electrical and ice making plant." A dozen employees took care of the

horses, the cars, and the camp, including staffing a 24-hour security watch. Elia was gregarious, hobnobbing with the other guests at luxury hotels where he reserved rooms for himself and a few of his staff when he wasn't at his camp.

There was something about the man, something about the turmoil roiling the country after the United States declared war on Germany, that made people wary of the stranger. Elia claimed to be an officer in the Italian navy and claimed to have invented a submarine mine. Yet people whom he encountered thought differently. Both the Internal Revenue Service and the Bureau of Investigation began receiving a trickle of letters from guests and hotel personnel airing their suspicions about the eccentric Elia. Leonard Tufts of the Carolina Hotel, a resort in Pinehurst, North Carolina, wrote that "several of our guests have made the remark that they do not think his broken English sounded like an Italian, but more like an Austrain [*sic*]." A few weeks later, a group of guests from the hotel followed up with their own concerns, stating to Agent Gifford of the Bureau of Investigation that Elia's "accounts in regard to himself did not hang together. At times he spoke with a decidedly German accent, while at other times he seemed to try and disguise this accent." A steady stream of accounts regarding Elia flowed into the bureau, several referring to his "pronounced German physiognomy and most pronounced German accent." Much like Seely, one observer came to the conclusion that Elia was "utterly unlike any breed of Italian I have ever come in contact with." The matron and chaperone at the Riding School at the Carolina Hotel gave a different investigator, Agent Jackson, an earful. Not only did he have lots of guns, but she believed that he refused to hire any Americans. Plus "he lived more luxuriously than any of the New York people."

Although initially reluctant to enter the fray, the United States declared war on Germany on April 6, 1917. More than two million American men were drafted, most of them shipped overseas to join the Allied forces. Considered the deadliest conflict in history, an estimated nine million soldiers were killed in World War I between 1914 and 1918 with twice as many wounded. Civilian casualties were just

as devastating with close to 10 million people, primarily in Europe, dead from bombardment, starvation, and disease. The Great War struck closer to home when German U-boats made bold forays into US waters, targeting ships all along the coast. The German navy sank four Allied ships off the coast of North Carolina in spring 1918 and another four in mid-August. An enemy long-range minelayer submarine planted mines across the shipping lanes north of Cape Hatteras. North Carolinians were on high alert. Elia's accent along with his knowledge of mines and naval strategies led to wild speculation. Did Elia have something to do with "supplying a base for this submarine" attacking US vessels, asked the matron at the Carolina Hotel? Was Elia a spy? Was he an Austrian posing as an Italian naval officer in order to communicate with the enemy? Was his electric generator machine supporting a communication channel? Was he orchestrating the attacks off the coast?

The bureau began investigating G. E. Elia in late 1917. Dorsey Phillips, an agent from the Wilmington, North Carolina, office, talked to other guests at the Carolina Hotel including a member of the US Naval Advisory Board, who confirmed that Elia was a commander in the Italian navy, that he had invented a submarine mine, one that was being used by the US Navy, and that Elia was a man "to be trusted." The agent acknowledged that Elia was a puzzle, that folks were distrustful because of his "eccentric ways," but concluded after his thorough inspection of Elia's elaborate camp that "he was not doing anything of a suspicious nature." In his opinion, Elia was "just an eccentric man with more money than he knows how to spend, and likes the life of camping." But to quell any doubts, Phillips suggested that the bureau confirm his account through the Italian consulate.

After checking out of the Grove Park Inn in Western North Carolina, Elia headed east and moved his camp to Old Point Comfort on the Virginia coast. Located on a high bluff with "twelve miles of water front practically in every direction," this camp, like Elia's earlier ones, was extensive and elaborate. As was his custom in Pinehurst and Asheville, Elia also booked rooms—this time at the elegant Hotel Chamberlin, nine miles from Old Point.

Chief Bielaski sent a local agent from the Norfolk office in July 1918 to interview Elia, who at this point must have harbored his own suspicions about the unrelenting attention of the Bureau of Investigation. Nonetheless, the agent reported that Elia was "very courteous" and open to providing details about his background. Elia reiterated that he was a retired commander of the Royal Italian Navy, the inventor of the submarine mine now being used by the US Navy, and that he was now developing a new submarine detection device for the war effort. With one factory in London and another in Italy, Elia anticipated a third being built in the states. When the agent requested a close inspection of his equipment, Elia demurred, averring that permission could be granted only through an order from the secretary of the army. The agent reported that Elia had "a high-power dynamo which could easily generate enough for a low wave wireless" that would not be picked up by the government, that the plant was protected by an armed guard with regular four-hour watch rotations, and that the workmen admitted that "they have nothing to do except to be on guard, eat and sleep." The agent concluded that there is a "general air of mystery about both himself and his associates." Included in the agent's report was a listing of the 14 employees at Elia's camp—one of them, Miss V. V. Ward, was from Asheville; another employee was from "Tokio—Geo. Iizuka."

Seely soon got wind of Masa's whereabouts. Penning an outraged letter to Bielaski, Seely complained that, six weeks after Elia checked out of the Grove Park Inn, Iizuka left giving no notice along with Ward, who went to work as secretary for Elia. Seely reminded Bielaski that he had reported Iizuka to the bureau and one of its agents had investigated him four months ago. To jog Bielaski's memory of George Masa Iizuka, he provided this summary:

> *He came here about three years ago, and for the last year and a half has been very active and very expert at photography, and he has maps of all this territory, and spent all of his Sundays and spare time tramping and photographing, had tramped all over the Biltmore Estate, and in fact, everywhere else.*

*He was very sly with his work, and in short, one Sunday morn-
ing when he seemed to think everybody would be away from
my house, I saw him photographing the place from all angles.
My place is located on top of Overlook Mountain, as you prob-
ably remember.*

Not only were these actions suspicious from Seely's point of view,
but he'd also found Masa with two German men from Cincinnati
who claimed that they were getting "instructions in photography"
from him: "This Jap is about the slyest and most intelligent it has
been my privilege to run into for sometime. He is one of the most
experienced photographers I know of, and is thoroughly expert at
map work and everything of that kind."

Seely segued easily from Masa to hammer home his point about
Elia. He was convinced there was a nefarious plot being hatched in Elia's
camp, with both Ward and Iizuka part of the scheme. From Seely's per-
spective, all the ingredients for success were there. As an engineer, Elia
had the technical knowledge, Masa brought mapping and photography
skills to the endeavor, while Ward could manage the communications.
No matter the navy's perspective, Seely insisted, "There is not the slight-
est doubt in my mind as to Mr. Elia's purpose, and I firmly believe he
has communicated with the U-Boats, and he had a part in arranging
their bases in Florida." Seely admitted that he disliked showing "any
lack of respect for the conclusions of the Navy Department" but felt
that they were sorely mistaken about Elia and his intent.

Masa had a very different narrative about his excursion with
Elia's entourage. Writing to Mrs. G. Brown, an employee of the Grove
Park Inn, he apologized for not having corresponded sooner and sent
his regards to the staff, recounting his itinerary and the swell time he
was having: "Am very fine still having grand time very nice vacation."
Throughout July and early August, he told his Grove Park friends,
he'd been "swimming, fishing, riding, canoeing, all outdoor sport."
In a photo from the trip dated July 27, 1918, Masa looks like a college
student enjoying his summer adventure at the beach in Grand View.
Dressed in a bathing suit and cap, his slim body leaning against a

boat and his muscular arms crossed, Masa looks the picture of health in this image now housed at the Buncombe County Public Library Special Collections. To give Mrs. Brown a flavor of the opulence of his surroundings, Masa included an illustrated brochure highlighting the Greenbrier resort and the town of White Sulphur Springs, West Virginia, apparently another stop on Elia's East Coast tour. Both the Greenbrier and the Chamberlin were resorts rivalling the grandeur of the Grove Park Inn and, for Masa, worth writing *home* about. Masa ended his note with a prediction: "I think, may be, I will see you pretty soon and tell you how I am having a grand time."

Mrs. Brown must have shared Masa's handwritten letter since Seely forwarded it, along with the brochures, to Bielaski. Wearing his American Protective League hat, Seely had alerted the APL and the Bureau of Investigation to the dangers posed by his former employees: "In the event a raid is made, I trust Iizuka and this Ward girl will not be allowed to get away, for they certainly should be held."

Seely was dogged in his pursuit of Elia, certain that he was a foreign agent and confident that Elia's accomplices, Iizuka and Ward, were colluding with the enemy. Each time Masa had attempted to leave the Grove Park Inn, Seely's radar went up. Masa was a puzzle to him—brilliant, talented, friendly—but "sly," sociable with Germans, assiduous in his recordkeeping, and exhaustive in his photographic documentation. Perhaps Seely was not used to having employees leave the Grove Park Inn, particularly ones who provided such value to his guests. From his perspective, he had bent over backwards the previous year to give Masa a new position, advanced him his wages, offered a summer vacation at half-pay—all perks to entice Masa to return from Colorado and resume his work at the inn. Seely felt betrayed by Masa's departure and infuriated by the way he left, giving no notice. That he departed with Elia, a traitor no doubt, was even more galling.

Seely's letters, the bureau's interviews and correspondence with hotel guests, and the official agent reports are included in the Bureau of Investigation's microfilm collection. Listed under "Iizuka, One," the case file (103402) is included in the "Old German Files," a compilation of reports, cases, correspondence, and photos that detail both

real and perceived threats by German aliens or those people reported as suspicious, primarily during the period of World War I. In addition to the extensive documentation related to Elia and his purported accomplices, Iizuka and Ward, the files provide ample evidence of the fears prompted by war, paranoia related to "the other," and qualms about unfamiliar accents, physiognomy, and habits.

One last record in the bureau's files seems to wrap up the ten-month investigation of Elia, Iizuka, and Ward. In September 1918, Bielaski received a two-page letter from Roger Welles, rear admiral and director of naval intelligence. It was the confirmation that Bielaski—and presumably Seely—needed for the bureau to finally close its books on the Elia case and, by extension, the Iizuka and Ward inquiry. One might wonder whether Seely's credibility with the APL or the Bureau of Investigation suffered as a result of this wild goose chase. The navy's letter acknowledged that Elia seemed mysterious but assured Bielaski that he was "absolutely harmless, absolutely loyal, and is working for what he considers the benefit of the Allied cause, giving his own money and his own time to develop an invention for the suppression of the submarine menace. . . . As far as this office is concerned he is considered perfectly loyal."

The *Enciclopedia Italiana di Scienze, Lettere ed Arti* refers to Elia as a man of the sea, an inventor, and a patron. Born in Turin in 1866, he began his naval career as an 11-year-old boy. Later, as a captain in the Royal Italian Navy, Elia invented a mine used by Allied forces during World War I. A lever-type device, the Elia Mine, which was laid on the sea bed, detonated when struck by a submarine. He was not a German saboteur, nor an Austrian spy. Vice president of the Royal Geographical Society and designated a count in 1926, Elia was indeed a celebrated Italian citizen.

After leaving Old Point Comfort, Elia traveled to Washington, DC, since Rear Admiral Welles wrote that Elia had been spotted in the office of the secretary of the navy. George Masa may have accompanied

him on that trip for we know that the photographer was in DC in the fall of 1918. The timing, however, was unfortunate.

Masa's visit to the nation's capital coincided with the return of the 1918 influenza. The virus had erupted in the spring, faded in the summer, but roared back in the fall. John M. Barry in his engrossing book, *The Great Influenza: The Epic Story of the Deadliest Plague in History* (2004), captures the medical, political, economic, and military facets of the pandemic while documenting its devastation:

> *The lowest estimate of the pandemic's worldwide death toll is twenty-one million, in a world with a population less than one-third today's. That estimate comes from a contemporary study of the disease and newspapers have often cited it since, but it is almost certainly wrong. Epidemiologists today estimate that influenza likely caused at least fifty million deaths worldwide, and possibly as many of one hundred million.*
>
> *Yet even that number understates the horror of the disease, a horror contained in other data. Normally influenza chiefly kills the elderly and infants, but in the 1918 pandemic roughly half of those who died were young men and women in the prime of their life, in their twenties and thirties.*

Although the disease ran its course over two years, Barry notes that "two thirds of the deaths occurred in a period of twenty-four weeks, and more than half of those deaths occurred in even less time, from mid-September to early December 1918." It was during the apex of the disease that Masa "caught 'Flu' got in hospital about one week."

It's unknown how Masa contracted the disease. Was he staying at a crowded hostel or lodging house during his trip? Traveling with Elia and staying in a hotel with other staff? If so, were others in the Elia entourage sick as well?

> *On Saturday, September 21, the first influenza death occurred in Washington, D.C. The dead man was John Ciore, a railroad*

*brakeman who had been exposed to the disease in New York four days earlier. That same day Camp Lee outside Petersburg, Virginia, had six deaths, while Camp Dix in New Jersey saw thirteen soldiers and one nurse die. . . . On Sunday, Sept. 22, the Washington newspapers reported that Camp Humphreys (now Fort Belvoir), just outside the city, had sixty-five cases.*

Barry's book discusses the factors that exacerbated the situation. As the country entered the war, the number of soldiers mushroomed from tens of thousands to millions, barracks were overcrowded and undersupplied, industries doubled down for wartime production, and workers were packed into shared living quarters. And, as would occur a century later with the COVID-19 global pandemic, politics and denial played significant roles in the spread of the disease and the ill-preparedness of the country.

Masa's condition was serious enough that he was hospitalized for a week. He recorded later that this was at "Memorial," most likely Sibley Memorial Hospital, founded by the Methodists, or Garfield Memorial Hospital, a charity facility. October 1918 was the deadliest month in American history, and surely Masa was fortunate to survive, though the ordeal possibly compromised his lungs.

Following his hospitalization, Masa returned to Asheville in October 1918. But he did not return to work at the Grove Park Inn. One can only guess at the cold shoulder Masa might have encountered from his former boss. Having toyed with the idea of barbering, mining, and wood carving, he finally found his niche—full-time photography under the direction of Asheville photographer Herbert Pelton. Pelton had been a successful photographer in Asheville as early as 1906, taking portraits and business photos and frequently making use of a large-format camera, a Cirkut, for panoramas. The camera actually panned while in operation, pulling the film along with it in order to create an exposure that could extend to five feet. Ideal for capturing landscapes and large group gatherings, the Cirkut was used for real estate photos as well as pictures of lumber mill crews, school children, and business groups.

From Masa's perspective, the new job at Pelton was like an internship. As he explained to Seely, "I having [*sic*] job at Pelton Studios and learned so many things all branches of photography, beside this I still have Kodak finishing business." Sometime during the previous year, Masa also had formalized the name of his Kodak enterprise. Adopting the name of the Colorado photo studio where he had applied for a job, he opened his own Asheville version, "The Photo Craft." He listed an extensive suite of services on his professional letterhead, advertising "photographic work of every description," including "Kodak work, enlarging, copying, coloring, designing, lettering, lantern slides, landscape photos."

His position at Pelton did not last long, but by all accounts, it was successful. Ben Porter, a photographer and Pelton biographer, suggests the experience likely provided Masa the tipping point to push him forward on his own less than a year later:

> *There could have been some technique and some technical areas that Masa was still learning. Certainly, Masa was photographing already, but in terms of refining his craft, I think Pelton could have helped a lot because Pelton's images were, in terms of craft, very sharp, very well printed—and they are to this day. But more than that, I bet Masa was absorbing some of the business knowledge needed to open and run his own operation. Pelton already had 15 years of experience doing that at that point, and you can be the world's greatest photographer, but if you don't have the business experience to keep yourself running, then it's all for naught.*

But it wasn't only his employment news that Masa wanted to share in this note to Seely. Once again, despite how many times Masa had left Seely, he also hoped for a loan from his former employer. It was not the first time Masa had called on Seely for financial support. In February 1918—before he left the Grove Park Inn for the first time—Masa had enlisted Seely's secretary for help in securing a loan from the boss: "And let me have loan two hundred dollars

from his pocket and I will pay back 10 month after the date with regular interest." If that amount was too much, he would settle for a hundred dollars with a five-month repayment schedule. Whether Seely complied with either of these requests is unknown, but this time Masa needed a three-hundred-dollar loan (what would amount to more than five thousand dollars today) for six months in order to enlarge his workroom. If he failed to repay the loan, Masa suggested that Seely "just put me in your shop and work till the debt pay back." He also promised to do "all small lettering at free and sign painting, wood carving by special design at the lowest charge."

Had Masa even been aware of Seely's suspicions? Did he know that his former employer had reported him to the Bureau of Investigation? Now that the war was over, the APL disbanded, Elia cleared, and Masa back in Asheville, had Seely softened? Had Masa apologized for leaving Seely in the lurch when he departed with Elia? Given the steady stream of correspondence between Seely and Masa in 1919, it seems likely that the two had reconciled. Whatever remaining strains might have persisted, Masa brushed them aside—and presumably Seely did as well. Masa was now an independent entrepreneur who required the deeper pockets of his former boss. Seely, for his part, could still utilize Masa's wide range of artistic skills. If Masa were to succeed in Western North Carolina, he needed to maintain strong ties to Seely, the Grove Park Inn, and Biltmore Industries.

In December, Masa asked to borrow Seely's camera. He had ordered his own camera five weeks earlier, but it had not yet arrived: "I believe you don't mind ask you that, if you use your camera not much please rent it to me till I will get mine, sure I will handle it very carefully."

In this same December 1919 letter, Masa also revealed to Seely that he had left Pelton Studios with the intention of launching his own enterprise, "Plateau Studios." This new venture, on the second floor of the Smith's Drug Store building, was in the heart of the Asheville business district, Pack Square. With this larger space, Masa could consolidate the photo-finishing services he'd offered previously in the Morsell building and expand into a full-service photography studio.

There is no information as to why Masa abandoned "The Photo Craft" business, perhaps because of potential licensing issues with the name. But starting Plateau Studios required more capital than Masa had, making Seely's loan of three hundred dollars—if, in fact, realized—very important to help pay the rent and outfit the new workroom and office space. Now that he was fully on his own, he needed insurance, telephone, and utility services, as well as office help, which he began advertising for in the newspaper.

In return for Seely's help, Masa promised to do "anything photographic work as you wanted at minimum charge because you gave me great favor." We don't know how many "great favors" Seely provided throughout Masa's life, but there is evidence that Seely was a regular benefactor, providing financial loans, equipment, and even hand-me-down suits made of Biltmore cloth to the enterprising and sometimes struggling photographer. Seely's quiet generosity would later be heralded in a profile and obituary that appeared in the *Asheville Citizen-Times*. The newspaper stated that Seely was "one of the principal contributors to charitable causes but the general public probably learned of no more than half of his gifts." One suspects that the numerous "great favors" that Masa received throughout his life were part of that unsung legacy.

In five years, Masa had gone from the laundry room at the Grove Park Inn to launching Plateau Studios in the heart of downtown Asheville. Plateau Studios would leave a lasting mark on both Masa and Asheville, as many of Masa's photos from this studio preserved the early years of Asheville's booming 1920s.

Masa had also shifted his living arrangement, having moved from employee housing at the Grove Park Inn to the bustling household of Oscar Creasman, a fellow wood-carver Masa had befriended at Biltmore Industries. The contrast between the two living situations could not have been sharper. No longer secluded on the landscaped lawns of the Grove Park Inn, Masa, the new boarder, now found himself surrounded by a houseful of kids—with five children ranging in age from 5 to 18 according to the 1920 census. The family of Oscar and Effie Creasman lived in a "cottage" on Brookshire Street in Biltmore

Village, a model community designed to evoke an English country hamlet. Constructed to house the workers on the Biltmore Estate, the village was intended as a planned community where people could live and work. All the amenities and services—stores, church, school—were within walking distance, and an electric streetcar line connected the community to the downtown. Masa seemed to revel in the comfort of the close-knit Creasman family. Photos reveal a smiling Masa horsing around with the kids, grinning on a handmade go-cart, posing with the children in a fountain at the Biltmore Estate, and surrounded by Creasmans on the front porch of their Brookshire home. The eldest, Blanche, did color work, and later, another child, Blake, provided a range of photography assistance for Masa through the 1920s and into the early 1930s.

There was one final step in Masa's professional transformation: his name. With the formation of Plateau Studios, he simplified the various monikers he had been using. On an insurance application completed for the Phoenix Mutual Life Insurance Company on November 3, 1919, he listed his previous occupation as "artistic painter," his current, "photographer," and curiously, his name as "George Masa Honma." This is the only use of "Honma" on any official document. At the Grove Park Inn, he'd been known as George M. Iizuka. His letterhead for Photo Craft read the same, while his draft registration indicated his name as George Masa Iizuka. For his new venture at Plateau and thereafter, he would simply be George Masa.

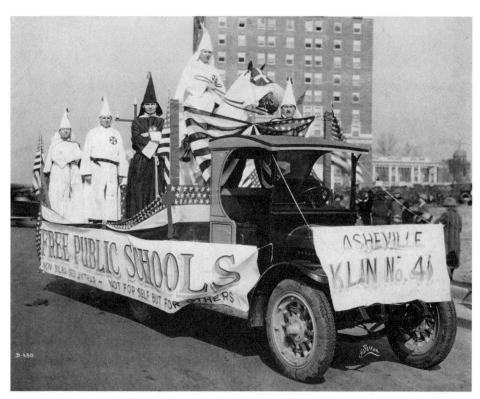

A Ku Klux Klan parade float as it appeared in the pages of the *Asheville Citizen* on November 12, 1924, with the caption: "Asheville Klan No. 40 entered a float in the Armistice Day parade advocating free public schools and the Klansmen were unmasked for the first time in the public eye of Asheville." Photo by Herbert Pelton. *Buncombe County Special Collections, Pack Memorial Public Library, Asheville, North Carolina*

## CHAPTER THREE

### Blame Where It Is Not Due

*"But this Jap—his deeds may be dark, and his deeds may be black, but let us not censure him to such an extent as to lay blame where it is not due."*

~J. W. Haynes, chief counsel,
as reported in the *Asheville Citizen*, December 1, 1921

"George must be burning the midnight oil," a friend might have chuckled as he passed by Smith's Drug Store on a mid-November night in 1921. The glow of the lamps in Masa's studio, located above the pharmacy at 1 ½ Biltmore Avenue, meant he was hard at work.

The studio was spacious enough for his darkroom, a worktable, gallery display, filing cabinets, and a desk for one of the assistants who did Masa's correspondence and office management. Having honed his technical skills as a Kodak refinisher in Herbert Pelton's studio the previous year—and soaked up some of the climate of Asheville's business environment—Masa was rightly proud of having opened his

own establishment: Plateau Studio in the heart of Pack Square. "Let George Do It" proclaimed the advertisement he had placed in local magazines and the two prominent newspapers, offering "photography in all its branches still or animated."

Maybe George was finishing up a backlog of paperwork that night or hanging some portraits out to dry. He might have been processing and printing film that had been dropped off during the day at Smith's Drug Store downstairs. Whatever the task, he would not have anticipated the eruption that would soon upend his life and agitate tensions throughout the city.

In the early morning hours of Thursday, November 17, 1921, a squad of police department men stormed Plateau Studio and arrested Masa. One member of the force also represented the Ku Klux Klan. Accused of "making or keeping on hand for sale nude and obscene photographs of women," Masa was stunned by the charge.

Over the course of the next two weeks, the *Asheville Citizen* provided extensive coverage to the trial and the subsequent hearing surrounding his arrest. The charges against George Masa were the catalyst for the police court proceedings, but the press coverage revealed the deeper tensions roiling the city of Asheville in the early 1920s. His case became a forum for examining the role of the press and the impact of the Klan while the reputation of a number of Asheville's high school girls who had performed in a school play—initially an undercurrent in Masa's trial—surged into a tsunami that animated the subsequent hearing before the mayor and the board of commissioners. Although some of the larger social and political issues muffled the specifics of Masa's case, it was clear from the press coverage that a plot had been hatched against Masa and that agents had attempted to bribe witnesses. What also seems evident is that Masa had his own cadre of supporters.

Powering Asheville's industrial and building boom required able-bodied workers—including an influx of immigrants and African American men who were effectively shut out of better-paying

jobs in the Deep South. The historian Kevin W. Young argues in his 2024 book *The Violent World of Broadus Miller* that the social conditions of the early 1920s made Asheville fertile ground for the resurgent Klan.

Historians identify three distinct phases of the Klan's "Invisible Empire" in the United States. The first, organized after the Civil War by Confederate veterans, had the goal of squelching—through violence and intimidation—the political, economic, and social aspirations of formerly enslaved people. Historian Kenneth T. Jackson characterized the second phase—centered in the 1920s—as a time when the Klan fashioned itself as "the defender of Americanism and the conservator of Christian ideals." A third phase, reborn in mid-20th-century America and continuing as a movement today, is focused on "the maintenance of white superiority." One measure of the Klan's successful appeal during the second phase of activity in the 1920s is reflected in the numbers. At the start of the decade, there were approximately two thousand members of the Klan in the United States; by 1926, the number had swelled to two million. Jackson attributes this growth to new leadership and powerful marketing. Rather than touting the violence that characterized the first phase of the Klan movement, the 1920s version fashioned itself as a fraternal organization upholding American values—"100% Americanism."

In the summer of 1921, Lawrence L. Froneberger, a recruiter for this newly envisioned Klan, arrived in Asheville eager to organize a local chapter of the Invisible Empire. Recruiters, known as kleagles in Klan terminology, were paid—remuneration based on their success in attracting new members who in turn paid a ten-dollar initiation fee to join the organization. Four dollars went to the recruiters while the remainder went to Klan headquarters. Froneberger's coffers must have overflowed when a speaker from the Atlanta Klan headquarters arrived to give a talk in September 1921 at the Asheville City Auditorium, two months before the raid on Masa's office. Nearly eight hundred audience members attended the lecture. Young estimates that "around 450 men joined the Asheville chapter" over the next few weeks.

In 1921, the Klan published the *Constitution and Laws of the Knights of the Ku Klux Klan*—a document thin on principles but chock full of details on regalia, emblems, costumes, rituals, administrative structure, and the official duties and responsibilities of the various roles in the Klan hierarchy with such titles as "Imperial Kladd," "Imperial Klabee," "Imperial Klaliff," "Klazik," "Klexter," and "Klarogo." Compiled and registered with the Library of Congress by William Joseph Simmons—who "resurrected, reconstituted, and remodeled" the Klan in 1915 and served as its imperial wizard until he was ousted by Hiram Wesley Evans in 1922—the document outlines the criteria for membership in Article IV: "An applicant must be white male Gentile person, a native-born citizen of the United States of America, who owes no allegiance of any nature or degree whatsoever to any foreign government, nation, institution, sect, ruler, prince, potentate, people or person." Candidates had to be 18 years or older, of good character and respectable vocation, and "a believer in the tenets of Christian Religion." Although it claimed not to be *against* Roman Catholics or Jews, the Klan explained that the former were excluded because of their allegiance to a foreign power—the Pope—while the later could not become members because they were not Christian.

For much of the month of September 1921, the *New York World* published a series entitled "Secrets of the Ku Klux Klan Exposed by the *World*." The front-page articles ran for 21 consecutive days in the *World* and were syndicated in more than a dozen newspapers around the country reaching more than two million readers. The exposé revealed rituals, oaths, and financial details; unveiled the religious and racial bigotry underpinning the organization; and even listed the official kleagle roster of the salesmen of the organization. Even though Simmons and the *new* Klan claimed to be a non-violent organization, the *World* tabulated a frightening amount of vigilante violence conducted by "cloaked and hooded law-breakers." Their investigation covered "more than forty cities and a score of different states."

Two years after Froneberger's arrival in Asheville, the high-ranking grand dragons of the Ku Klux Klan held their first annual meeting at the Langren Hotel in downtown Asheville. Imperial Wizard Hiram

Wesley Evans [Simmons' successor] urged members to "quit getting your Klan doctrine from the newspapers." He labeled the press "naturally antagonistic" but assured the membership that all the coverage was free advertising for the Klan. No matter where he traveled, Evans gloated, he was hounded by reporters eager to cover the Klan. Historians credit the publicists Elizabeth Tyler and Edward Young Clarke for raising the profile of the Klan and for marketing the organization to be more "palatable" to a larger audience. The papers presented at the Asheville meeting reflected the promotional strategies of Clarke and Tyler. The new Klan did not take the law into its own hands; it partnered with law enforcement. The new Klan supported public education, prohibition, freedom of the press, and freedom of conscience. They believed in separation of church and state, white supremacy, and Protestant Christianity. Members were protectors of the home and the chastity of womanhood. The organization considered itself a movement, a crusade. As the grand dragon of Mississippi declared, "So, in the midst of a sin-racked, despairing world, have come with marching feet and uplifted banners the Knights of the Ku Klux Klan."

If the first generation of the Klan focused on suppressing the social and political engagement of African Americans, Clarke and Tyler broadened the scope of the second wave to include Catholics, Jews, and immigrants. As recorded in the published proceedings of the Asheville conference, one speaker concentrated his remarks on immigration trends. From his perspective, 19th-century immigrants were of good Anglo-Saxon stock, but the new immigrants "from eastern and southern Europe and the Levantine fringe of Asia" are aliens who do not assimilate. "They become American citizens but not Americans." Other speakers decried the new immigrants as paupers or diseased, illiterate in their own language and unable to read or write in English.

The grand dragon of South Carolina declared, "The time has now come when the Knights of the Ku Klux Klan should take the leadership in this great fight to prevent America from becoming the melting pot or dumping ground of the world for the millions of heterogeneous elements who are seeking admission to our shores." Citing the latest census figures, he stated that half of the new immigrants

were Jews, Italians, Armenians, Greeks, Japanese, Chinese, and Finns and claimed that these groups prefer their own—their own churches, languages, customs, and schools. Of particular concern, according to the South Carolina grand dragon, are the Japanese—"a real menace" who control an eighth of the irrigable lands in California and who risk turning that state into a "little Japan."

Although the Asheville conference was held two years after Masa's arrest, we can assume that Froneberger and his associates were motivated by these same sentiments. The grand dragon's remedy—which presages the passage of the National Origins Act the following year—was "an absolute exclusion act of all Japanese who may seek to come here in any capacity for permanent residence." The National Origins Act embedded in the Immigration Act of 1924 significantly reduced immigration from south and eastern Europe and Asian countries while the Asian Exclusion Act effectively barred people from Japan and other Asian countries from becoming naturalized citizens. The 1920s Klan knew how to wield its considerable political power.

Within Asheville, Froneberger partnered in 1921 with a wealthy businessman, Nathaniel Augustus "Gus" Reynolds, and a clergyman, the Reverend Arthur Abernathy. Young writes that the Asheville Klan "launched a widely publicized campaign for 'law and order' in the city" with Froneberger heading the operation, Abernethy as Klan spokesperson, and Reynolds bankrolling the effort.

Since arriving in Asheville, Froneberger had been busy—not only with KKK recruitment efforts but in law-and-order showmanship as well. Two weeks prior to Masa's arrest, Froneberger had made his own headlines in a case involving two white women accused of being "in the company of" two black men. The laws in North Carolina, like those of many states, prohibited interracial marriage and fraternization. Not until 1967, when the United States Supreme Court ruled in *Loving v. Virginia* that anti-miscegenation laws were unconstitutional, did the legal context change.

After being charged, the two women had skipped town, but Froneberger along with a makeshift posse of fellow Klansmen tracked down the women in the mountain town of Saluda near the South

Carolina border. Froneberger's men captured and brought them back to Asheville, then clamored for an even harsher punishment for the accused since they had violated the state's anti-miscegenation laws and forfeited their bail. Young covers this case in *The Violent World of Broadus Miller*, detailing the sentencing and fallout for the four individuals. One woman received a one-year sentence on the chain gang while the other did jail time. One man was sentenced to two years on the chain gang, and the other, a veteran, fled the state "fearing he would get a rope around his neck if he remained."

It was within this "law-and-order" context that Froneberger—who had been appointed a special officer in the police department by the board of commissioners—along with R. H. Luther, chief of city Detectives, and two other members of the police department raided Masa's studio that November night in 1921.

Froneberger might have considered the charges against Masa would hold the same public relations potential as the anti-miscegenation case. Imagine the public outrage directed at a Japanese photographer selling nude photos of high school girls. Eager to prove his case, Froneberger took charge of finding the evidence to implicate the photographer. On the night of the raid, Froneberger read a series of names of high school girls and demanded that Masa produce the corresponding photographs of the students. Masa—likely shocked by the intrusion but eager to comply with the authorities—handed over the portraits. But they were not of scantily clothed or naked women. Most, if not all, of the photos that he pulled from the filing cabinets were of young women, many of whom had appeared in the high school play. All were modestly dressed, some in costume.

The play, which had been performed the previous month, involved a cast of 70 and was described in the *Asheville Citizen* as "ranging from dainty colonial misses to the 1922 models, and from whooping Indians to Oriental girls, with of course a generous sprinkle of colored characters." Prior to World War I, the minstrel show had been an annual fall event at

the high school; the director of the 1921 show had revived the tradition the previous year. Not only had the cast performed the show at the high school, they did an encore performance at the Kenilworth Inn in November 1921. The *Asheville Citizen* provided the details on October 7, 1921: "The show will be a combination blackface and oleo. The first part will be a 'Black and White Review' and the second will include 'The Subway,' an Indian and Oriental dance number, and other interesting sketches and songs. Not the least will be a burlesque on the disarmament conference."

There were many layers of unease and casual prejudice in the description of the minstrel show performed by the students. But it was not the facets of the minstrel show that were of concern in 1921.

Masa was taken down to the station and charged, and a bond was set at five hundred dollars (the equivalent of more than eight thousand in today's dollars). The brief notice in the *Asheville Citizen* on November 17 stated that bond was made and George Pennell retained as Masa's counsel. Pennell's reputation was solid. As an up-and-coming young professional in Asheville, Pennell served as the city corporation counsel where he represented the city in civil claims and defended it when it was sued; he chaired the county board of elections and was engaged in civic, school, and community activities.

For three days, Masa was on trial in police court while much of Asheville was engrossed in the proceedings. Eventually even North Carolina's *Greensboro Daily News*, nearly two hundred miles away, heard the rumors:

> *Unfettered fancies of morbid minded men evolved into idle gossip that went the rounds, until the echoes of statements unsubstantiated by facts in the hearings from day to day, were heard on every street corner.*

Chief of City Detectives Luther offered as evidence two photos and testified that he had "found negatives for the picture in the developing room of Massa's [*sic*]." Masa's attorney moved for a nonsuit and dismissal of charges against his client. Arguing that any nude photographs in Masa's studio were no different than those found in galleries and

museums, Pennell introduced as evidence dozens of magazines with similar portraits. The prosecutor, O. K. Bennett, intimated that he could show more photos and stated that a number of them would be from a *certain* institution. The newspaper's initial discretion in not naming the institution soon evaporated as it became clear to all Ashevillians—and indeed to North Carolinians from Greensboro to Winston-Salem—that Prosecutor Bennett was suggesting girls enrolled in Asheville High School were posing for nude photos in Plateau Studios. Resenting the insinuation, Pennell demanded a bill of particulars listing the names, the sources for those names, and corresponding copies of the photographs that Bennett claimed to have. He also demanded that the instigators be "brought to trial and exposed to the public." One can only imagine Masa's chagrin, his disbelief in the implication that he had taken nude photographs of high school girls.

During the second day of the police court proceedings, Pennell continued to lash out at Bennett, charging that the prosecutor was tarnishing the reputation of his client and sullying the reputation of the high school girls by claiming that Masa had taken pictures of 60 nude high school girls. Pennell emphatically defended his client and the girls:

> *[Masa] absolutely and positively denies the statement, and states through his counsel that he has never taken the picture of any high school girl, except when dressed in a most becoming, modest manner; that said statement is not only untrue, detrimental and damaging to the character of this defendant, but is a direct attack upon the purity and reputation of every girl pupil in the Asheville high school.*

This is the closest we have to a statement from Masa about the charges against him in any known record. Wisely, his attorney kept him from direct contact with the press. It's possible the reporters knew the photographer from his work with the Asheville newspapers. It's evident they understood the witch hunt that was underway and the forces behind it.

Bennett backed down from claiming 60 students, correcting the statement to read "a number of high school girls." When Bennett

called to the stand Frank Hines, an 18-year-old young man who worked at Smith's Drug Store, Hines testified that he'd never seen any nude photos and pointed out that he "visited the studio almost daily in delivering photographic supplies and films for development" to Plateau Studio on the second floor. According to the *Asheville Citizen* on November 21, 1921, Judge R. M. Wells stated that there was insufficient evidence to convict George Masa.

Yet Pennell was not ready to walk away. The reputation of the high school girls was now at stake, and Pennell suspected—and the *Asheville Citizen* seemed to corroborate—that something more sinister was at work in this trial.

On Monday morning, Judge Wells ordered Bennett to produce the "Bill of Particulars." Although Pennell demanded copies of the incriminating photographs, the judge required the prosecutor to supply only the names of those people who provided statements related to the nude photos—not the names or the photographs themselves.

There are two distinct facets to the proceedings: Masa's trial held November 18, 19, and 26 and a subsequent two-day hearing on November 30 and December 1, 1921, on the purported slander of the high school girls. Witnesses divulged more in each of these proceedings, and the newspaper carried many salient details surrounding Masa's arrest and trial.

The extensive coverage provided by the *Asheville Citizen* allows the reader to come away from the accounts of the courtroom drama with a clear sense of villains, cowards, heroes, and victims. In printing the stinging denunciation of the Klan made by defense attorneys during the proceedings or by focusing on some of the nefarious dealings of Froneberger and friends, the *Asheville Citizen* brought home for its local readership some of the same themes covered in the *New York World* series. The dangers were not abstract events happening elsewhere: the Klan was very much a part of the fabric of the Land of the Sky, too.

Testimony revealed that the raid on Masa's studio had been planned for over a week. Special Officer (and Klan Kleagle) Froneberger not only enlisted the help of Masa's current and former assistants but also offered to pay them for their testimony while powerful men,

including one of the prosecuting attorneys, attempted to shift all the blame onto Hines, a naive young man. As Masa's attorney and the judge attempted to trace the source of the information about the purported nude photos, they learned that it was Froneberger who gave the list of names to Detective Luther. Froneberger in turn had gotten the list from a dentist, Dr. Beam, who had received it from a patient, Lillian Callahan, who'd once worked in Plateau Studios. Callahan testified that *she* developed a film "which she alleged was obscene"—one that had been dropped off at Smith's Drug Store. She made three copies of the photo, presumably for the same client, but "it was not established that Massa [*sic*] had ever seen the picture." Callahan subsequently not only told her dentist about the obscene photo that she developed but also offered to compile a list of "six or seven names of girls" whom she suspected might have posed indecently for Masa. Dr. Beam was eager to have her return and repeat her story to Froneberger—a man he'd known and trusted since childhood— one whom he'd even recommended to the commissioners for a post as "special officer." After reiterating the story to Froneberger, Callahan then recounted it to Prosecutor Bennett.

Another Plateau employee, Anne Daves, who'd worked with Masa for nearly a year developing and printing pictures, testified that she had never seen any nude photos of high school girls or any other girls in suggestive poses while working at the studio. When questioned about whether anyone had tried to influence her testimony by offering to pay her, Daves explained that a Mr. Neal (an associate of Froneberger) and Mr. Kyle Parker (Miss Callahan's boyfriend) had invited her to name her price but that she refused. "I have told you the truth and that is all I am going to tell you," she retorted. The judge suggested that perhaps Froneberger's associate was simply trying to reimburse her for missed hours at work while she was in court, but Daves stood firm: "No, I don't make my living that way." "What way?" the judge probed. "By telling lies," she replied.

"Ku Klux Sought to Use Services of Young Citizen" read the *Asheville Citizen* headline on November 23, 1921. The young citizen was Frank Hines, the teenager who worked at Smith's Drug Store.

Froneberger had asked Hines to help him locate nude photos in Masa's studio. As he had with Callahan and Daves, Froneberger invited Hines to his office and offered to pay him for any evidence; that same afternoon, Hines went with Froneberger to city hall where Mayor Gallatin Roberts, Commissioner of Public Safety R. L. Fitzpatrick, Bennett, and Luther talked to him. Hines was eager to do his public duty by helping law enforcement. After all, he was meeting with the mayor, head of public safety, the city solicitor, the chief of detectives, and Special Officer Froneberger. Should Frank find nude photos, the mayor cautioned, he would have to be arrested because he'd have nude photos in his possession—but the mayor assured him he would be exonerated when the true source of the photos came to light. When Frank later confided the plan to his uncle, M. L. Hines—the manager of Smith's Drug Store—the elder Hines forbade it and advised his nephew "to leave the matter to duly constituted authorities." The older Hines added that "he was certain the public would understand an underhand effort had been made to throw blame for an ungrounded accusation against girls of the city on one whom had been picked as a blind."

Another twist to the proceedings came with the revelation that Froneberger was being indicted on federal charges, including "false arrest and imprisonment, kidnapping, and conspiracy to kidnap." Since Froneberger had had no warrant for the arrest of the two women who had violated North Carolina's anti-miscegenation laws, his escapade in Saluda did not go unnoticed by the federal authorities. The *Asheville Citizen* reported that Froneberger would go on trial during the January term of the superior court and that bond had been set at a thousand dollars. In *The Violent World of Broadus Miller*, however, Young reveals that Gus Reynolds, the prominent Asheville businessman who'd been a member of the Buncombe County Board of Commissioners, posted the bond. The charges were also eventually dropped when Froneberger's attorney succeeded in getting the case transferred to a court with what his client described as a "fair one hundred percent American Judge."

Commissioner of Public Safety R. L. Fitzpatrick accused the newspaper of picking on Froneberger and advised "the papers to

let Froneberger alone." He intimated that Froneberger "had been instrumental in unearthing some crime in Asheville" but, when asked to elaborate, replied that he'd "rather not disclose" the specific cases involving the Ku Klux Klan organizer. Fitzpatrick also reported seeing "over a hundred highly respectable citizens" exiting a secret Klan meeting at the Langren Hotel in downtown Asheville, echoing the same propaganda used by KKK marketers: the Klan is 100 percent Americanism; those who attend KKK meetings are law-abiding, patriotic Asheville citizens. The imperial wizard, Hiram Wesley Evans, spoke similar words, according to Jackson:

> *Far from being an un-American hate-mongering institution, the Klan was in reality a benevolent and patriotic society. Emphasis was therefore placed on the positive elements of Klankraft (concepts and relationships): education, temperance, the flag, Protestantism, morality, and charity. . . . Fundamentalism was the central thread of the Klan program . . . 'Declaring that America is Protestant and so it must remain,' the KKK glorified the 'old-time religion', rejected evolution . . . the wearing of short skirts by women and the 'petting' in parked automobiles and dancing in smoke-filled rooms by both sexes. . . . At the root of the problem was 'Demon Rum,' etc. The Invisible Empire unhesitatingly affirmed that it stood foursquare for law enforcement and against bootleggers, moonshiners, and 'wild women.'*

Ironically, on Saturday, November 26, Judge Wells reversed himself, finding Masa "technically guilty" of "having on hand for sale pictures of nude women" and setting bond at two hundred dollars. Although Wells had concluded a few days earlier that there was insufficient evidence to convict Masa, on the last day of the trial, he found Masa culpable. Did Callahan's testimony convince him of Masa's guilt? Had Bennett introduced other incriminating photos? Was Wells weary of the whole police court proceeding? The judge's verdict had to have

shocked Masa. It certainly angered his attorney. Pennell "attacked the new evidence and referred to the testimony of Miss Daves, concerning the alleged offer to buy evidence on which to convict Massa [*sic*]. He then announced that the defense would appeal and intimated that further developments of Solicitor O.K. Bennett and the alleged attempted buying of evidence might be forthcoming."

No sooner had the proceedings ended than "several prominent citizens in the courtroom offered to go security for the bond." It appears that Masa had powerful friends on his side of the courtroom as well.

Following the verdict, a chorus of voices clamored for redress—not for Masa but for the high school girls. Monday's editorial in the *Asheville Citizen* claimed that the judge's ruling—"technically guilty"—left open the possibility that the girls, like the photographer, were culpable. The newspaper recommended a hearing and "an official statement to the people that will authoritatively condemn any further unfounded gossip or insinuation." The Kiwanis club passed a similar resolution advocating an investigation into the alleged slander. In separate petitions, the boys and the girls of the high school demanded that the originators of the slander be identified. The girls demanded a public apology and a second appearance "before the body of the high school." The girls also expressed their appreciation of George Pennell.

Responding to the pressure, the board of commissioners established a special board of inquiry consisting of Mayor Roberts and two commissioners, Fitzpatrick and R. J. Sherrill. The newspaper reported that the "police court was taxed to its utmost capacity," not only by the "battery of fourteen of Asheville's prominent attorneys" representing the high school girls, but by parents, students, reporters, and concerned Asheville citizens.

Attorneys J. J. Britt, J. W. Haynes, A. Hall Johnston, and Kingsland Van Winkle took the lead in representing the girls, Pennell, and Hines, while J. Scroop Styles served as counsel for Froneberger and Dr. Beam. O. K. Bennett—the prosecutor in the Masa police court proceedings—was

represented by Judge Frank Carter on the first day of the hearing and on the second by Styles. Tracking the hearing through the voices of the attorneys and the testimony of the witnesses requires a scorecard.

One of the commissioners, R. J. Sherill, attempted to co-opt the proceedings by introducing a resolution to shut down the hearing. Arguing that Judge Wells had conducted a thorough investigation, Sherill posited that any further inquiry would make the situation for the high school girls "worse by keeping it in the press." Wells had ruled that there was no wrongdoing among the high school girls in "this very scandalous and vulgar matter concerning the conduct of George Massa [*sic*], a Japanese photographer." An attorney representing Pennell asked point-blank whether it was the mayor's intention to end the hearing before it began. Claiming to be just as surprised at Sherill's resolution as the attorneys, Gallatin declared that the hearing would continue.

Some of the testimony related to technical details such as the number of girls implicated and whether Bennett had stated 60 students were involved or only "a number of" girls. Other information clarified key circumstances related to the trial or provided new facts that had come to light. For example, in reviewing the sequence of events in Masa's studio, Detective Luther testified that the girls' photos corresponding to Froneberger's list showed young women who were "particularly modestly dressed as a number of them were taken in costumes in which they played in presenting the high school minstrel."

One could assume that Masa's studio—newly established—must have been considered a trustworthy establishment for the Asheville high school girls and their parents if they were patronizing it for student portraits. Luther confirms that supposition by stating that the names on Froneberger's list were girls "from the most reputable homes." At the same time, one wonders whether Masa or his attorney or the parents saw the irony in students donning blackface while the Ku Klux Klan marched headlong into a city-wide recruitment drive. The "unsettled social conditions" in 1920s Asheville that historian Young describes are laid bare in this trial: Froneberger's zeal in protecting the modesty of high school girls; the Klan's crusade to fan anti-immigrant passions; the rule of law versus vigilante actions; the

casual racism of a high school minstrel show performed in blackface. Although these events in Asheville happened more than a hundred years ago, readers cannot easily dismiss them as *history* given contemporary echoes of racist and anti-immigrant fervor buffeting the country in the third decade of the 21st century.

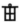

Detective Luther also testified that he'd asked the superintendent of city schools, W. L. Brooker, to review a group of nude photos to determine whether they depicted women of high school age. Brooker's assessment was "they were not of high school girls, but of grown women above the school age—possibly 30 to 40 years old." It is unclear from the press coverage whether these photos were from Masa's studio, whether they were ones printed by Callahan, requested by the druggist, or whether Froneberger had supplied the photos.

One curious detail that is difficult to parse relates to Frank Hines' testimony. Hines reported that Earl Powell, a druggist at Smith's, asked him "to get two pictures like those Hines had on his knife." Did Hines have a silhouette of a naked woman on his knife? Online auction sites showcase an array of vintage knives with risqué images, including pocketknives with carved handles depicting nude women; others have a celluloid image of a naked woman on the handle. Perhaps one of these is the type of knife the druggist is referencing. In any case, Hines had Masa print photos for Powell. Later that same day, Froneberger invited Hines to stop by his office where he urged the young man to locate nude photos, particularly of young women from the list that Froneberger had, in Masa's studio. Froneberger vowed: "These women are going to h--- as fast as they can." As a Klan member whose pledge empowered him as a protector "of the home and the chastity of womanhood," perhaps Froneberger intended to shame the high school girls in order to rescue them from descending into "moral laxity"—another campaign theme of the 1920s Klan.

During his testimony, Hines refuted the allegation that he had tipped off Masa about the potential raid. The defense also called

another former employee, Mrs. R. C. Andrews, who had worked at Plateau in October and November. She, too, denied ever having seen any girls improperly dressed in Masa's studio.

Following two days of testimony, Mayor Roberts declared that there was "no truth in the charges" related to the girls. But the 14 attorneys representing Pennell, Hines, and the parents of the girls as well as the firm representing Bennett, Froneberger, and Beam were not done with the fight.

Froneberger's attorney, J. Scroop Styles, couldn't resist condemning the *Asheville Citizen*. Not only had the newspaper impugned his client's (and friend's) reputation, but he questioned "the motives of the papers and the *Asheville Citizen* in particular in giving the facts publicity."

The rejoinder that J. W. Haynes, chief counsel for the girls, offered countered that claim. Haynes accorded the *Citizen* "high praise for its efforts to get to the bottom of the matter, and determine the responsible parties."

When attacking the press gave him no traction, Styles tried shifting the blame on to Frank Hines and asked the board to "find him guilty of instigating the rumor." That was too much for Hines' attorney, who asked why his client "should be the butt of the whole thing" and why not Froneberger and Dr. Beam as well.

Bennett, who had been the prosecuting attorney in the Masa trial, was now on the defensive in the board hearing. Since he admitted that he had the original list written on pink stationery, which had been given to the dentist by his patient, Linda Callahan, he, too, became party to the proceedings. But Bennett had no regrets, offering that he had "no apology to make for his conduct in the case of Massa [*sic*] or in the hearing." He asserted that all types of pressure had been brought to bear on him in this case and that he had been warned that he would be "dead politically." His parting shot to the press and to his tormentors is acerbic: "I say this now, and I don't want the newspapers to stutter when I say it—so long as I am prosecutor for this city, I'll prosecute any man, woman, or dog in the city of Asheville, and I'm not running for office while prosecuting."

The attorney for the parents of the girls refused to end the proceedings without a final word about the KKK, a movement that Britt, a former congressman, believed was "dangerous to the city of Asheville." In the previous day's testimony, Judge Carter representing Bennett had alluded to a force that was attempting to eliminate "this body of as patriotic men as move in the community." Britt clarified that Carter was referring to an invisible influence trying to stamp out the Ku Klux Klan. Acknowledging that he was not a member of the Klan and confessing he had no sympathy for the organization, he allowed that there might be some good men associated with it. But why, he wondered, would people support an organization whose main purpose is hatred: "What excuse for existing has this Ku Klux Klan? In the words of [Imperial Wizard] Col. Simmons, it is against the Catholics; it is against the Jews; it is against foreigners, and it is against negroes. In the name of Heaven, gentlemen, what is it for?" Like Bennett, he declared he had no regrets for anything he had said and "no intention whatever of retracting any of it."

Mayor Roberts concluded the hearing by stating "that there is no truth in the rumors, and that our high school girls are absolutely vindicated." Although the mayor's resolution might have restored the reputation of the high school girls, one must assume that Masa's standing in the community had been tarnished and his confidence shaken by the experience. It is impossible to gauge Masa's reaction since no reporter seems to have interviewed him and none of his words or reactions made it into any of the copy. Coupled with the suspicions that Seely once harbored in 1916 when he wrote to the Bureau of Investigation, these proceedings had to have discouraged the photographer. Given the anti-immigrant rhetoric and the zeal of the Klan, there was enough unease in the country to make any immigrant cautious and uncomfortable.

J. W. Hayes, chief counsel for the high school girls, made two points in his closing remarks. One of which could be read as direct criticism of Froneberger's vigilante actions since he urged citizens "to leave to our duly constituted authorities and officers the enforcement of the law." The *Asheville Citizen* echoed these remarks in an

opinion piece on December 2 urging the "average man" to restrain his instincts to add "detective work to his regular vocation in life" for invariably it leads to "the wild confusion of rumors and allegations that have lately disturbed the peace of this community."

Hayes' second point addressed Masa's case:

*I don't know what is going on there [Masa's studio]—I had no interest in the defense in the other case. But this Jap—his deeds may be dark, and his deeds may be black, but let us not censure him to such an extent as to lay blame where it is not due.*

Unpacking the Masa case using newspaper accounts is challenging. Masa was charged with "having on hand pictures for sale of nude women." Did Masa have such photos? If so, how many and what type of photos were they? The out-of-town newspapers provided summaries that were more concise and occasionally clarified details. According to the *Charlotte News*, the officers who searched Masa's studio found *two* photos of women (not high school girls) "which could be called improper." Luther also had offered in testimony on Friday, November 18—the first day of the trial—two pictures as evidence.

The summary reported by the *Greensboro Daily News* revealed "the fact that there was probably an improper picture, and duplications of it developed from films sent into the studio by unknown persons and sent out again as other kodak pictures are daily sent out from the depot."

Judge Wells found Masa "technically guilty"—presumably guilty of having a small number, perhaps two, photos of nude women in his possession and selling those photos. There is a cryptic stand-alone statement in the *Asheville Times* in a commentary section of the newspaper that reads: "Technically guilty is not an innocent joke." Sandwiched in between aphorisms and opinions on international affairs, the statement could easily be overlooked. It could also be variously interpreted. It is unlikely that Masa or his friends considered the case against Masa or the verdict an innocent joke. The source of the photos implicating Masa, the motivations behind the

raid, the attempted bribery of witnesses, contradictory testimony, and the suspicious actions (which some might consider entrapment) by Froneberger and friends cast doubt on the verdict. It seems clear that Masa was willing to print the suggestive photos that the druggist Earl Powell requested, but was this simply a favor granted to young Hines and Powell and not a normal segment of his business? Was Masa aware of the Comstock Act and the laws governing the selling and mailing of materials considered obscene?

Important to note is the fact that Masa did not sit alone in that crowded courtroom. Not only was he ably represented by an attorney, George Pennell, but "several prominent citizens in the courtroom offered to go security for [his] bond." Who were these "prominent citizens?" Although we cannot identify these people, we can speculate that they helped Masa weather the storm. It would not be the first nor the last time that friends would come to the rescue of this Japanese photographer.

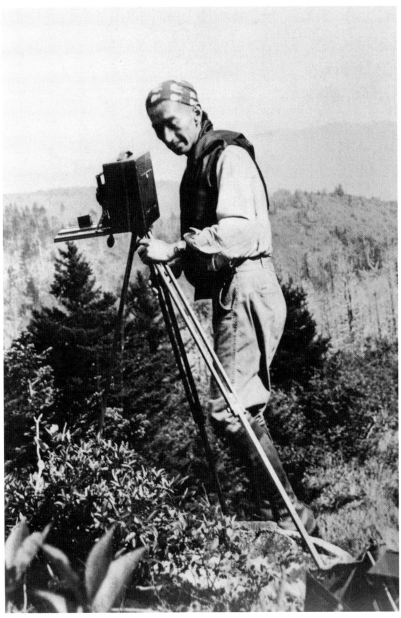

George Masa at Shining Rock in Pisgah National Forest. *Buncombe County Special Collections, Pack Memorial Public Library, Asheville, North Carolina*

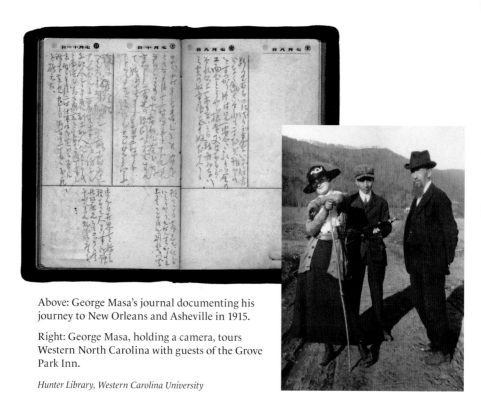

Above: George Masa's journal documenting his journey to New Orleans and Asheville in 1915.

Right: George Masa, holding a camera, tours Western North Carolina with guests of the Grove Park Inn.

*Hunter Library, Western Carolina University*

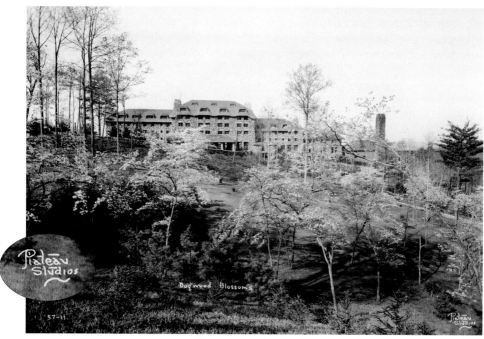

George Masa launched Plateau Studios in 1919, just in time to document the booming 1920s in Asheville and cater to thriving businesses like the Grove Park Inn.

*E. M. Ball Photograph Collection, Special Collections, Ramsey Library, University of North Carolina Asheville*

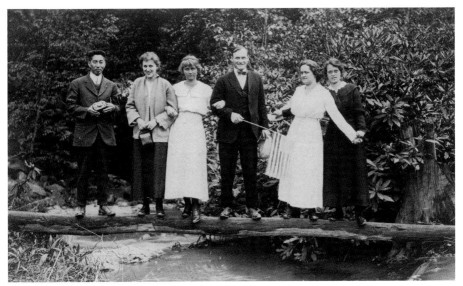

George Masa with a group of Grove Park Inn tourists. *Hunter Library, Western Carolina University*

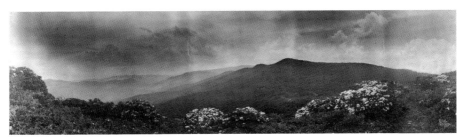

A panoramic photo taken by George Masa at Craggy Gardens, North Carolina, and hand colored by Blanche Creasman. *Creasman family private collection*

Left: George Masa with a canine friend on a Grove Park Inn outing.

Right: George Masa and Blake Creasman, who would go on to work with Masa until 1933.

*Buncombe County Special Collections, Pack Memorial Public Library, Asheville, North Carolina*

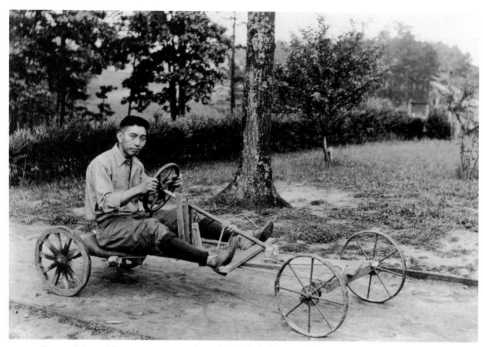

George Masa riding a go-cart—a photo he included in an album for the Creasman family. *Buncombe County Special Collections, Pack Memorial Public Library, Asheville, North Carolina*

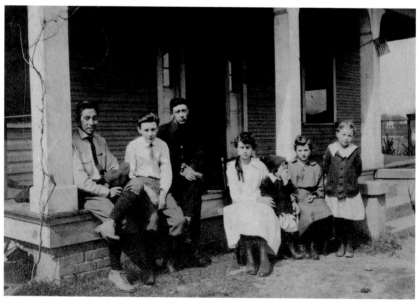

George Masa with the Creasman family at their home on Brookshire Street in Biltmore Village. *Buncombe County Special Collections, Pack Memorial Public Library, Asheville, North Carolina*

A view of Asheville from Town Mountain. Photo by George Masa. *Buncombe County Special Collections, Pack Memorial Public Library, Asheville, North Carolina*

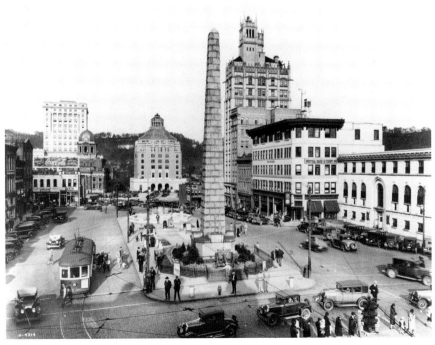

Pack Square in downtown Asheville. Photo by George Masa. *Buncombe County Special Collections, Pack Memorial Public Library, Asheville, North Carolina*

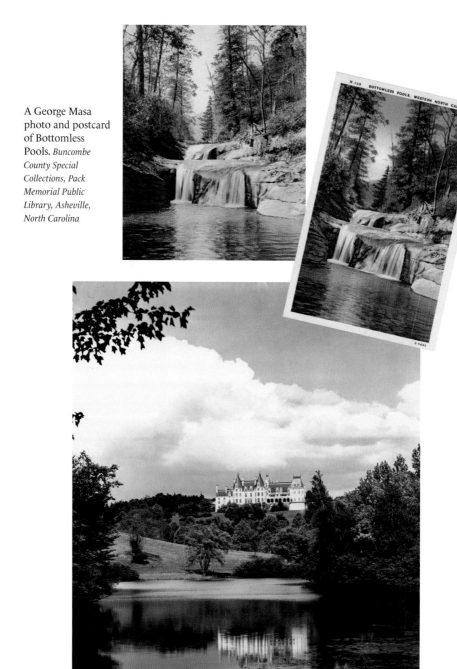

A George Masa photo and postcard of Bottomless Pools. *Buncombe County Special Collections, Pack Memorial Public Library, Asheville, North Carolina*

The Biltmore Estate. Photo by George Masa. *Used with permission from the Biltmore Company, Asheville, North Carolina*

A George Masa photo of Chimney Rock and postcard of Hickory Nut Falls in Chimney Rock State Park. *Buncombe County Special Collections, Pack Memorial Public Library, Asheville, North Carolina*

A George Masa photo and postcard of Lake Lure. *Buncombe County Special Collections, Pack Memorial Public Library, Asheville, North Carolina*

Above: A George Masa photo of a Cherokee family.

Left: A George Masa photo of Cherokee stickball players.

*Kephart Family Collection, Collections Preservation Center*

Below: George Masa (at far right with camera) captures newsreel footage of a Cherokee stickball game. *Museum of the Cherokee People*

Fred L. Seely. *State Archives of North Carolina*    Vera V. Ward. *Courtesy of Heather Duplessis*

A. Bruce Bielaski.
*Library of Congress*

Giovanni E. Elia.
*Wikimedia Commons*

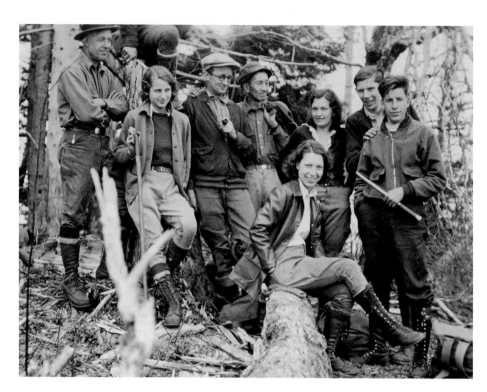

Above: The Carolina Mountain Club on Mount Kephart. George Masa's hand is on the shoulder of his friend Roger Morrow, who would serve as a pallbearer in Masa's funeral. Next to Morrow is Jewell King. *Wilson Special Collections, University of North Carolina at Chapel Hill*

Right: Masa with Barbara Ambler, whose father, Dr. Chase Ambler, was a prominent physician in Asheville and a leader in the early movement for a national park in the South, building Rattlesnake Lodge east of Asheville. Barbara became Barbara A. Thorne after marrying and was one of Masa's closest friends. *Wilson Special Collections, University of North Carolina at Chapel Hill*

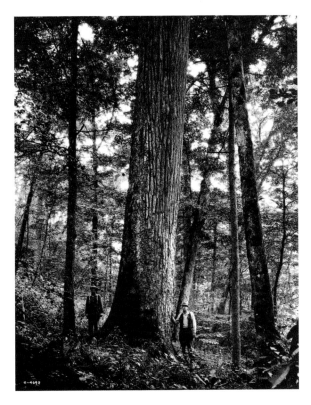

A large poplar tree on Bradley Fork in the Great Smoky Mountains. Photo by George Masa. *Kephart Family Collection, Collections Preservation Center*

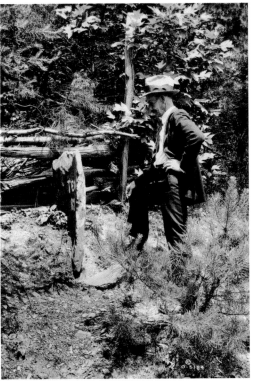

Above: George Masa with Myron Avery, co-founder of the Appalachian Trail. *Appalachian Trail Conservancy Collection, Special Collections Research Center, George Mason University Libraries*

Left: Horace Kephart at the Tennessee–North Carolina state line. Photo by George Masa. *Kephart Family Collection, Collections Preservation Center*

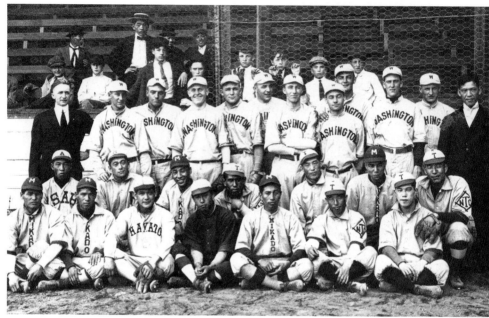

Shoji Endo (seated third from right, bottom row) with teammates on the Mikado and Asahi baseball teams of Seattle, Washington, circa 1913. *University of Washington Libraries, Special Collections*

Shoji Endo (top left) with the Ryodo Baseball Club, Endo's club team while he was in school, circa 1904. *100 Years: History of the Shizuoka Middle and High School Baseball Team*

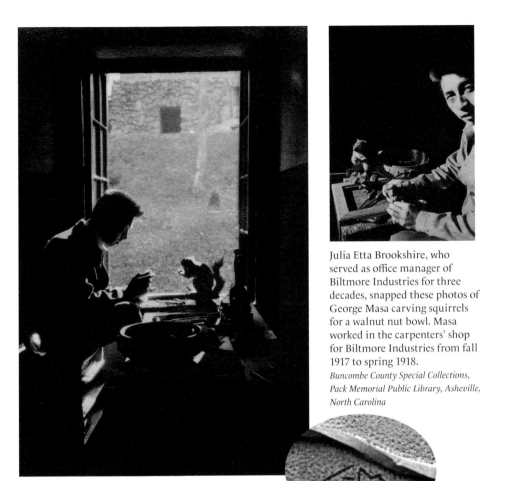

Julia Etta Brookshire, who served as office manager of Biltmore Industries for three decades, snapped these photos of George Masa carving squirrels for a walnut nut bowl. Masa worked in the carpenters' shop for Biltmore Industries from fall 1917 to spring 1918.
*Buncombe County Special Collections, Pack Memorial Public Library, Asheville, North Carolina*

Above: A carving of Masa's initials found by historian Bruce E. Johnson on two Biltmore bowls believed to be made by Masa. The only other Biltmore Industries employee with these initials was Grace McKain.
*Bruce Johnson photo*

Edith Vanderbilt. *Used with permission from the Biltmore Company, Asheville, North Carolina*

Top: A colorized view of Shizuoka City, 1895.
*Kjeld Duits Collection, MeijiShowa*

Middle: Shizuoka Middle School, where Shoji
Endo was a student. The campus was later
destroyed by US bombing in World War II.
*Shizuoka Prefectural Library*

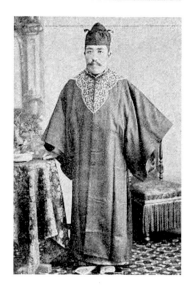

Yasushi Endo, a Shizuoka
lawyer and Shoji Endo's
adoptive father. *1903 Photo
Book of Japanese Lawyers,
National Diet Library*

George M. Stephens. *Buncombe County Special Collections, Pack Memorial Public Library, Asheville, North Carolina*

Paul M. Fink. *GSMNP Archives, Collections Preservation Center*

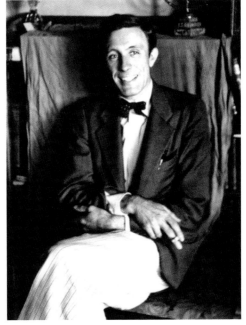

Margaret R. Gooch. *Lexington Historical Society*

Anthony Lord. *Buncombe County Special Collections, Pack Memorial Public Library, Asheville, North Carolina*

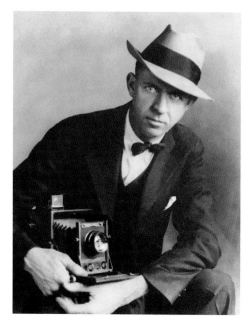

Left: Ewart M. Ball.
*Courtesy Ewart Ball III*

Below left: Herbert Pelton.
*Buncombe County Special Collections, Pack Memorial Public Library, Asheville, North Carolina*

Below right: Elliot Lyman Fisher. *Asheville Citizen, May 23, 1934*

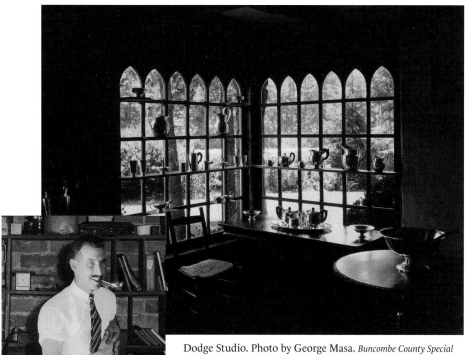

Dodge Studio. Photo by George Masa. *Buncombe County Special Collections, Pack Memorial Public Library, Asheville, North Carolina*

William Waldo Dodge Jr. *Buncombe County Special Collections, Pack Memorial Public Library, Asheville, North Carolina*

Douglas Ellington. *Buncombe County Special Collections, Pack Memorial Public Library, Asheville, North Carolina*

THE ARCHITECTURAL RECORD {127

*Photo Masa, Asheville*
Detail of Roof and Lantern
City Building, Asheville, North Carolina
DOUGLAS D. ELLINGTON, ARCHITECT

A George Masa photo that appeared in the August 1928 issue of the *Architectural Record*. *Page reproduction courtesy of the* Architectural Record

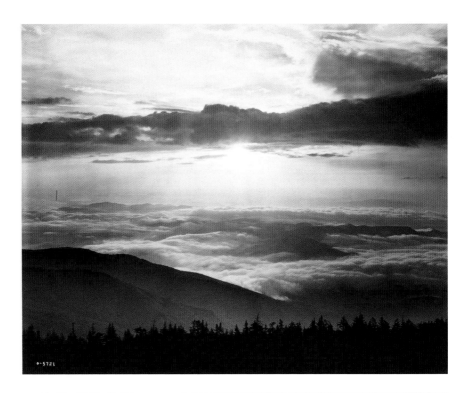

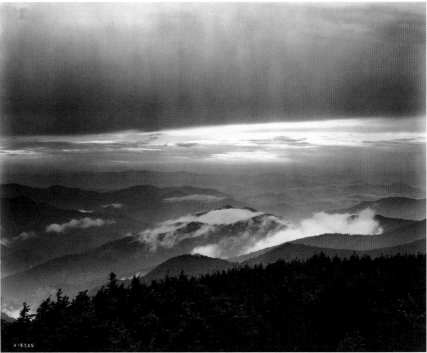

Sunrise (top) and sunset from Mount Mitchell. Photos by George Masa.
*Appalachian Trail Conservancy Collection, Special Collections Research Center, George Mason University Libraries*

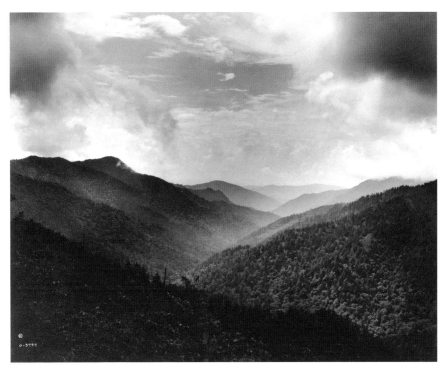

The Black Mountains of North Carolina. Photo by George Masa. *Miller Printing Collection, Daniels Graphics*

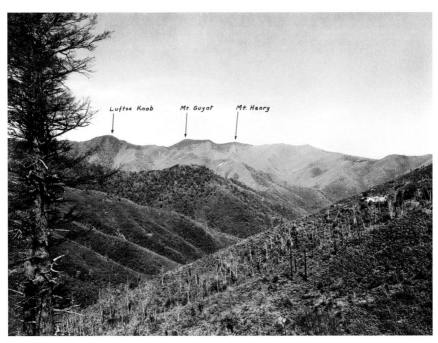

Mount Guyot as viewed from a logging railroad at the head of Swallow Fork. Extensive cutting is visible in the foreground. Photo by George Masa. *Appalachian Trail Conservancy Collection, Special Collections Research Center, George Mason University Libraries*

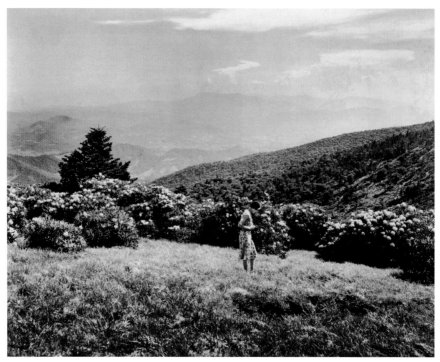

Jewell King at Roan Mountain. Photo by George Masa. *Wilson Special Collections, University of North Carolina at Chapel Hill*

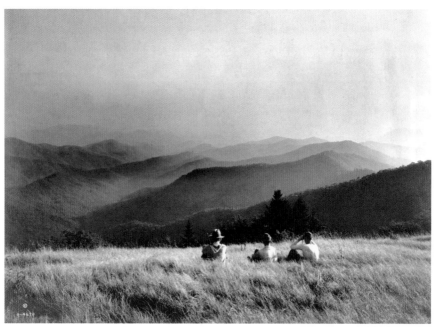

A view from Andrews Bald in the Great Smoky Mountains. Horace Kephart is seated on the left. Photo by George Masa. *Kephart Family Collection, Collections Preservation Center*

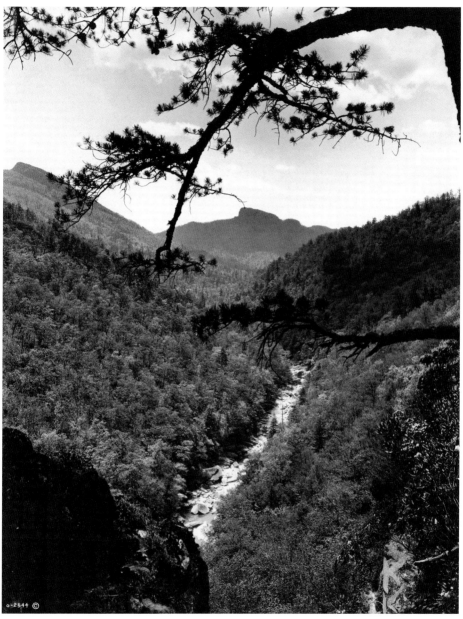

Linville Gorge and river. Photo by George Masa. *Buncombe County Special Collections, Pack Memorial Public Library, Asheville, North Carolina*

Chimney Tops on the Tennessee side of the Great Smoky Mountains. Photo by George Masa. *Kephart Family Collection, Collections Preservation Center*

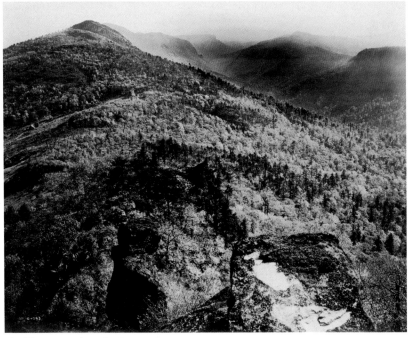

Linville Gorge. Photo by George Masa. *Buncombe County Special Collections, Pack Memorial Public Library, Asheville, North Carolina*

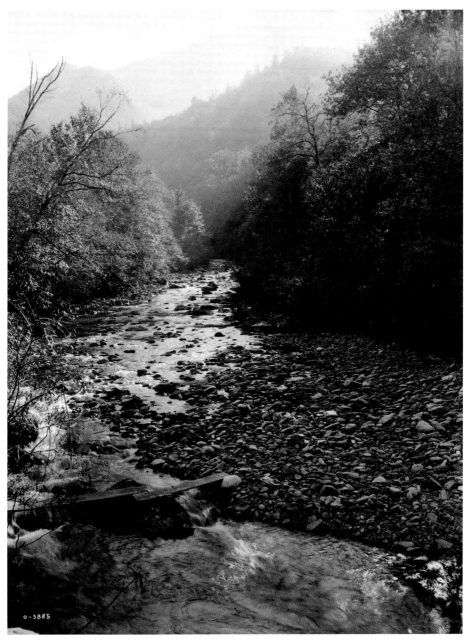

South Toe River below Mount Mitchell. Photo by George Masa. *Miller Printing Collection, Daniels Graphics*

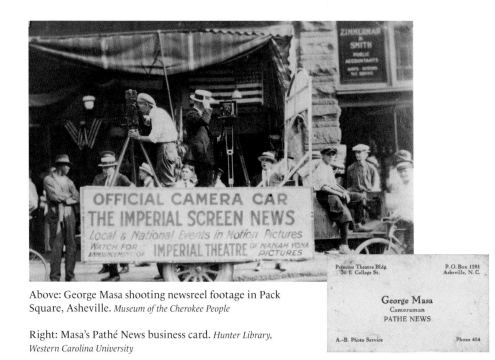

Above: George Masa shooting newsreel footage in Pack Square, Asheville. *Museum of the Cherokee People*

Right: Masa's Pathé News business card. *Hunter Library, Western Carolina University*

Princess Theatre Bldg.
30 E. College St.

P. O. Box 1281
Asheville, N. C.

**George Masa**
Cameraman
PATHE NEWS

A.-B. Photo Service

Phone 404

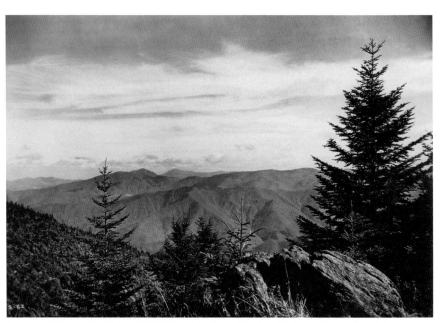

A view of Mount Pisgah and Cold Mountain from Richland Balsam Mountain. Photo by George Masa. *The Hart Masa Collection, Courtesy of Hunter Library, Western Carolina University*

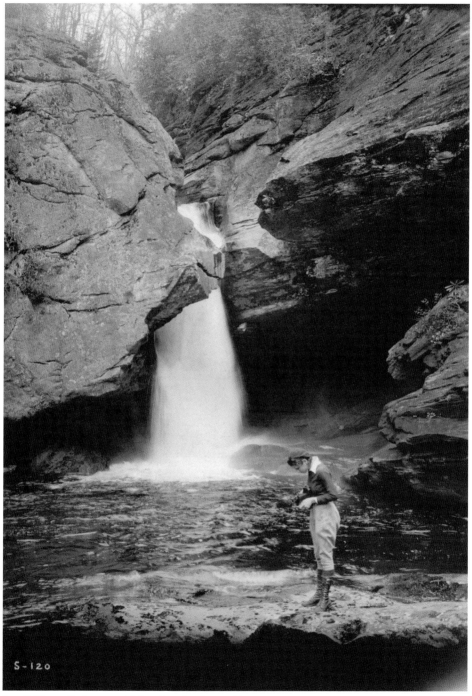

Jewell King at Tuckaseegee Falls. Photo by George Masa. *North Carolina Collection Photographic Archives, The Wilson Library, University of North Carolina at Chapel Hill*

Clouds over Lake Santeetlah, North Carolina. Photo by George Masa. *Appalachian Trail Conservancy Collection, Special Collections Research Center, George Mason University Libraries*

Snowbird Mountain. Photo by George Masa. *Kephart Family Collection, Collections Preservation Center*

Mount Le Conte as viewed from the Tennessee–North Carolina state line some four miles east of Hughes Ridge. Photo by George Masa. *Kephart Family Collection, Collections Preservation Center*

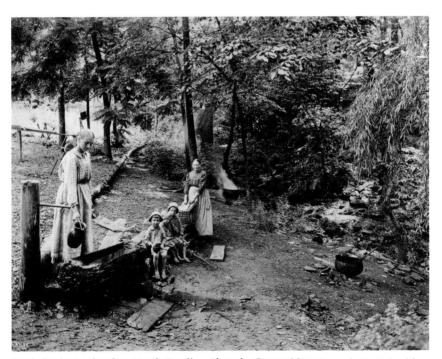

Wash day in Cataloochee, North Carolina. Photo by George Masa. *Buncombe County Special Collections, Pack Memorial Public Library, Asheville, North Carolina*

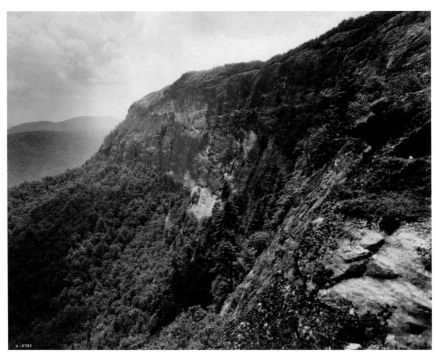

Wildcat Ridge on Whiteside Mountain in Highlands, North Carolina. Photo by George Masa. *Highlands Historical Society Archives*

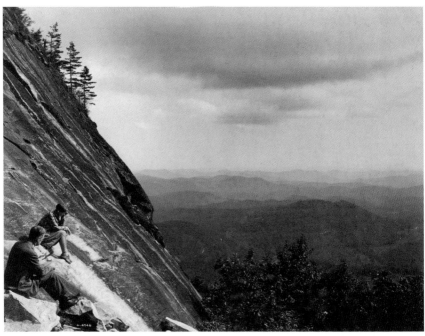

A view from the south side of Satulah Mountain in Highlands, North Carolina. Photo by George Masa. *Highlands Historical Society Archives*

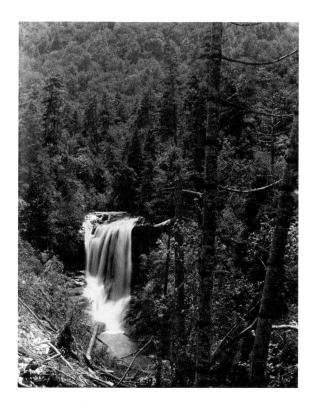

Cullasaja Falls in
Highlands, North
Carolina. Photo
by George Masa.
*Highlands Historical
Society Archives*

Ferns along Big Creek in the Great Smoky Mountains. Photo by George Masa. *North
Carolina Collection Photographic Archives, The Wilson Library, University of North Carolina at Chapel Hill*

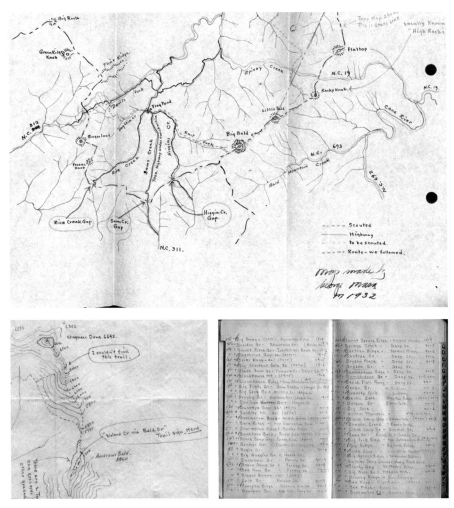

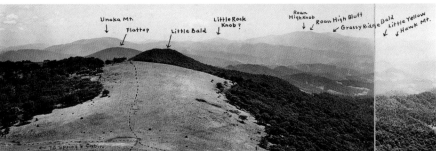

Top: A regional map made by George Masa in 1932. *Appalachian Trail Conservancy Collection, Special Collections Research Center, George Mason University Libraries*
Middle left: George Masa's topographic map of Clingmans Dome. Middle right: George Masa's nomenclature book. *Hunter Library, Western Carolina University*
Bottom: A view from Max Patch, North Carolina, with George Masa's notations. *Appalachian Trail Conservancy Collection, Special Collections Research Center, George Mason University Libraries*

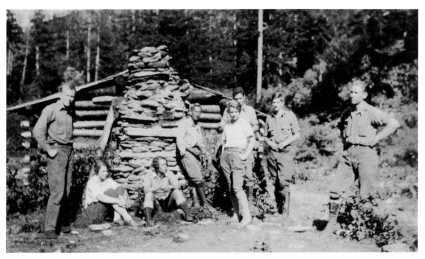

A hunting cabin on Three Forks in the Great Smoky Mountains. Left to Right: Bill Davis, Lucy Hildebrand, Barbara Ambler, George Masa, Bill Shuford, Judy Alexander, Walter McGuire, and Tom Alexander. *Wilson Special Collections, University of North Carolina at Chapel Hill*

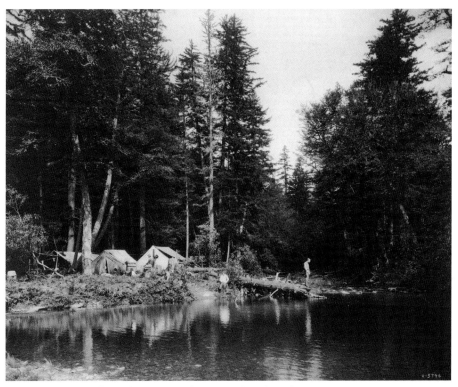

A camp at Three Forks in the Great Smoky Mountains. Photo by George Masa. *Wilson Special Collections, University of North Carolina at Chapel Hill*

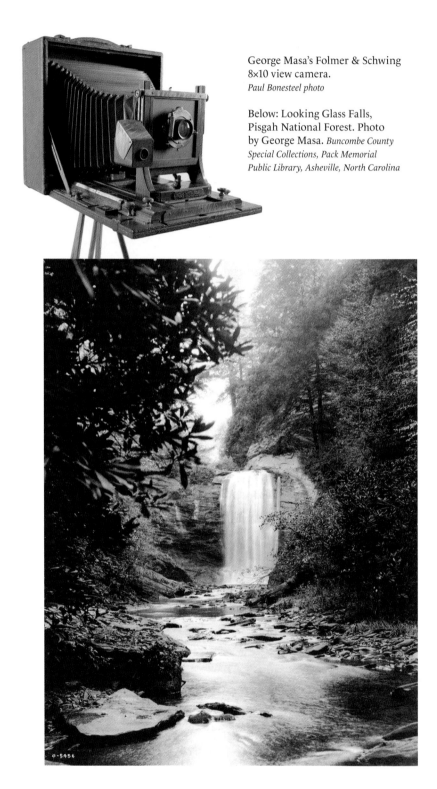

George Masa's Folmer & Schwing 8×10 view camera.
*Paul Bonesteel photo*

Below: Looking Glass Falls, Pisgah National Forest. Photo by George Masa. *Buncombe County Special Collections, Pack Memorial Public Library, Asheville, North Carolina*

# The Middle Years
*1921–1933*

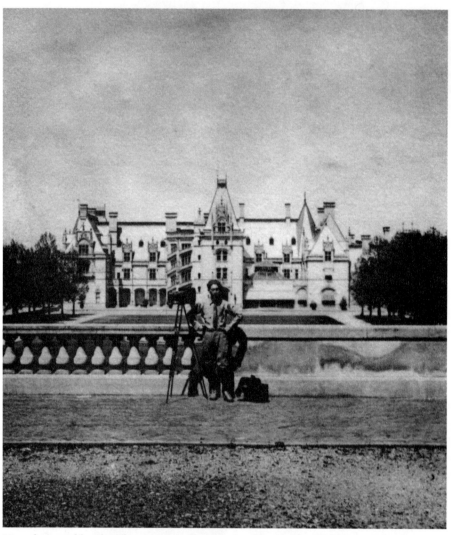

Masa photographing the Biltmore Estate. He jokingly referred to the 178,000-square-foot home with 250 rooms as the "old shuck," by which Masa meant "shack." *Buncombe County Special Collections, Pack Memorial Public Library, Asheville, North Carolina*

## CHAPTER FOUR

### Worked like Hell

*"Indeed I worked like hell, studied like hell
and got good reputation at present."*

~George Masa to Margaret Gooch, June 18, 1931

When George Masa walked into his studio on Monday morning, November 28, 1921, he faced the remnants of the raid. It was easy enough to clean up the mess the police had made of his files and his office; more problematic was determining his future. Had his reputation been irreparably damaged? Should he leave Asheville? Reasonable questions given what he had endured over the past few weeks. He might have been embarrassed and perhaps a little puzzled by the verdict, but he had been defended and championed by some of Asheville's wealthiest and most influential people.

While the efforts of Froneberger and others revealed a rising wave of racial hatred and intimidation sweeping the country, there was a

stronger tide moving into Asheville—a surge of progressive thinking and a booming economic climate fueling the growth of businesses throughout the city, including Masa's nascent photographic services. Perhaps it was his faith in himself as well as the support he felt at the trial that prompted his decision to stay in the burgeoning mountain town. Over the past three years, Masa had "worked like hell and studied like hell" first in his sideline enterprise at the Grove Park Inn, then at Pelton Studios. In making the decision to invest in his profession and his adopted city, he was, no doubt, building that "good reputation."

George Masa's journey as a professional photographer was exceptional. He progressed from using borrowed cameras and developing film in his homemade darkroom at the Grove Park Inn to becoming the most respected photographer in the region. Among his many clients were Edith Vanderbilt of the Biltmore Estate and the architect Douglas Ellington. In his 18-year career in Asheville, Masa made and printed thousands of photographs and countless feet of motion picture film supporting local, regional, and national outlets. Intertwined with his work-for-hire services for individuals, businesses, organizations, and communities, he simultaneously produced an exceptional collection of outstanding images of the Appalachian Mountain region.

Asheville in the 1920s was bursting with boomers and boosters—none more eager or enthused than newcomer George Stephens, co-owner of the *Asheville Citizen*. Having moved to Asheville in 1919 from Charlotte where he'd been a prominent builder and civic booster, Stephens fully intended to invest his time, talent, and money in his newly adopted city. Asheville was flourishing, but the growth was helter-skelter. Lacking a shared vision for development, the city risked diminishing its economic and scenic advantages with a scattershot approach. Without investments in infrastructure, including roads, bridges, and transportation hubs, Asheville would not be able to accommodate the influx of automobiles, visitors, and new residents. Already there were tensions among sectors in the tourist enterprise. How could Asheville reassure healthy visitors (and residents alike) that the city was, as the historian Richard Starnes suggested, "an island of urban civilization amid the scenic wilderness of the 'Land

of the Sky'" when there were 21 sanitariums providing respite for the infirm, often adjacent to luxury hotels serving the wealthy? How could Asheville protect residential areas from industrial or commercial encroachment?

Stephens and other civic leaders recognized the danger of unchecked development as well as the need for a systematic plan to shape Asheville's future. In an open letter to the *Asheville Citizen* in February of 1920, Asheville merchant Herbert C. Allen pleaded with the board of commissioners to hire a professional city planner. Allen decried the "volumes of talk and nothing systematically done," he mocked the narrow roads, the "city hall, and other absurdities and abominations too numerous to mention," and he urged his neighbors to "awake to the practical necessity of working along lines of least resistance by cultivating the tourist and permanent resident." Luckily, Stephens knew just the man who could help shape this discussion and create a worthwhile plan. Stephens had worked with John Nolen on the Charlotte Parks and Tree Commission as well as on a plan for the city of Charlotte, North Carolina. Although Charlotte could not muster the political will to implement Nolen's plan for its city, Stephens hoped that Asheville would have the fortitude to allow Nolen to guide its growth. Nolen, Harvard educated with humble beginnings, was considered the country's foremost city planner. Stephens invited him to make a presentation to the board of commissioners, and the board quickly approved his appointment "to prepare plans and maps and make recommendations for the systematic future development and betterment of this city."

Just as swiftly, Nolen and his team set to work. They studied everything from industry and commerce within the city to the topography and natural resources shaping it. The *Asheville City Plan* published in 1922—just a year after Nolen began his work—reflected the thorough fieldwork and data analysis Nolen and his team had undertaken. It was a blueprint for a generation. Nolen's motto for Asheville's plan—"A better place to live in and a better place to work in"—addressed Herbert Allen's concerns. It would be a model for permanent residents and visitors to the city alike:

*Within a year there has been started a new movement to make Western North Carolina one of the playgrounds of the Nation. The mountains, the climate, and the geographical location of this region produce a combination of conditions that offers unlimited possibilities for development. Because of its central relation to the mountains and other points of interest Asheville can well be the hub of the entire movement.*

The 14 recommendations in the *Asheville City Plan* called for improved infrastructure, including new streets and widened roads; more recreational facilities, such as a municipal golf course, two dozen new parks, playgrounds, and scenic drives; and investments in the city center, including a civic center with a grouping of public buildings and a new auditorium. According to Starnes, "the city embraced Nolen's vision enthusiastically."

Given Asheville's location in the heart of the Western North Carolina mountains, Nolen also touted some of the one-day automobile trips available, including excursions to Mount Mitchell, Chimney Rock, and Black Mountain. Nolen's plan included some zoning recommendations as well, outlining a simple plan for three districts: business, industrial, and residential. Cornell University has an extensive archive of city plans, including Nolen's Asheville files. Among the cache of correspondence between Nolen and Stephens and the extensive photos documenting Asheville features are several bearing Masa's numbering system, including some of the Battery Park Hotel and hilltop. Ironically, one photo in the Nolen collection is a stark reminder of Masa's trial. The photograph labeled "Battery Park Hotel from O'Henry Ave. Asheville, NC" shows a group of hooded Klan members parading down the street, their float decorated in patriotic flags and Klan regalia.

The *Asheville City Plan* offered a scaffold for an enterprising photographer to build his business. Even a glance at Masa's commercial photography from the 1920s reveals a range of projects illustrating

and highlighting the Nolen plan, directly or indirectly—from Masa's photos documenting infrastructure improvements, such as the city's Bee Tree Water Reservoir, to civic center buildings, including the new city hall and the Buncombe County Courthouse, parks and recreation areas, and scenic drive destinations, such as the Mount Mitchell motor road and the trip to Chimney Rock. High-quality photography was needed for the new residential real estate development popping up in many areas of Asheville and being marketed up and down the East Coast, a boom that would continue throughout the 1920s until the Great Depression. Masa was at the right place at the right time. And through this period his studios were virtually everywhere in Asheville.

First, he set up shop in a makeshift photo lab at the Grove Park Inn. Then, he rented space on Pack Square in the heart of downtown Asheville above Smith's Drug Store. This is where the short-lived Photo Craft Shop and then Plateau Studios operated with Masa at the helm until 1924. After leaving Pack Square and Plateau, his studio location and his company name bounced around downtown and Biltmore Village. Later names included the Asheville Biltmore Film Co. and the A-B Photo Service. In 1927, Masa took advice from his friend Don Topping with the Asheville Chamber of Commerce and changed the name of his company from A-B Photo Service to Asheville Photo Service, ensuring that all the photos published by Masa's company in "national and international newspapers and magazines would include the name Asheville in the credit." Topping must have given Masa more than advice, as a few years later, both he and his wife Aileen appear in the 1931 city directory as officers in the company—Don as president/treasurer, Aileen as secretary, and Masa as vice president. Masa's final studio location was in the Grove Arcade building. The details are not well recorded, but the changing names and locations illustrate some inconsistency in his profits, the addition and loss of several investors, and other shifting business variables.

Throughout the 1920s, Masa advertised in Asheville's newspapers, promising "the best results" on Kodak finishing, prints, and enlargements. The photo finishing offerings kept cash flowing, but Masa made higher profits taking original photos. In the various

archives, Plateau photos are marked with the definitive Plateau Studios cursive logo handwritten by Masa. Business was hopping, and Masa needed employees for photo-finishing services and office work. His advertisements in the "help wanted—female" section of the newspapers stressed reliability and experience for a photo-finishing position. One ad read: "Must have experience. No other need apply"; another "Come Monday ready for work if you mean business."

In the early years of Plateau Studios, Masa also held an official position for the *Asheville Times*. On September 11, 1921, the newspaper referred to Masa as their "staff photographer" and highlighted the photos he'd done of the popular writer and Asheville favorite O. Henry (William Sidney Porter). Each Sunday, the newspaper promised, they would feature photos from George Masa, the proprietor of Plateau Studios, showcasing "points of interest, individuals, buildings, etc." Perhaps Masa bartered some of his work with the newspaper since the *Asheville Times* also ran regular advertisements for Plateau Studios' Kodak-processing services.

Masa had positioned himself as the maker of unique images and high-quality work. From 1920 until his death, Masa had strong business relationships with both Asheville newspapers, first the *Times* and then the *Citizen.* Interfacing with two competing newspapers required trust and confidence—the deal signed with a handshake. Masa seemed comfortable with each of those requirements.

Through the backward lens of researching Masa's career, it can appear that things happened more quickly than they actually occurred. The work of hanging a sign on your door, acquiring an array of camera equipment, lens, film, the processing machines, and materials needed to operate a photographic business was not simple or immediate. Masa grew his business slowly, day by day, customer by customer, a process that demanded both the skill for photography itself and a continuity of business practices and personal relationships. There was—much more than exists today—also a bit of magic in the craft of photography. The timing and control of the shutter and exposure on the cameras Masa was using were far more about instinct than mathematics. How the lens caught and refracted the light—be it off an

expansive landscape, the side of a mountain, a waterfall, or an interior room—this was where Masa's touch of magic was revealed.

With professional equipment, his natural talent, and the skills he acquired, Masa was capable of crafting images that were superior to those of other professionals in Asheville. Especially in his first few years, he called himself "a student" and was clearly still learning. With the help of mail-order books and manuals, Masa taught himself skills in depth of field, exposure, processing, and printing. *Picture Taking and Picture Making, The Photography of Colored Objects*, and even *Hints on Photoplay Writing* sat on his shelf as did *The Japan Photographic Annual*. Masa was entrepreneurial and innovative, learning new techniques, such as aerial photography and motion-picture filming. Surely there were stumbles along the way, when images did not 'magically' appear or were under- or over-exposed, but his reputation grew quickly, and his surviving work shows very few technical errors. He had no apprehension for taking to the air to do his work, shooting still and newsreel footage many times from airplanes, flying over sections of the Asheville area and the Great Smokies that had not been photographed previously. In 1928, he took hundreds of photos to create a mosaic aerial map of the property where Enka, a huge new rayon plant, would be built. Four years later, Universal Newsreel hired Masa to shoot four hundred feet of aerial film of the same plant after construction. He timed his flight as hundreds of employees left the building after their shift.

Masa and his Plateau Studios entered a very competitive arena of photographers in the early 1920s. There were a number of well-established businesses, including those owned by Herbert Pelton and L. L. Higgason, firms which provided a range of photographic services. Another competitor, J. J. Robinson, frequently advertised its Kodak printing services. Portrait photography was the bread and butter for several photographers in Asheville, including Ignatius "Nate" Brock and Ray Matthewson. Known for his brilliant painted portraits, Brock had been in Asheville since 1897 and was as successful as he was clever, inventing daylight flashbulbs to use in his portrait studio.

As popular as it was for clients to sit for a formal portrait, there is scant evidence that this type of work was of special interest to

Masa. More likely, he preferred to leave the portrait studio work to others and focus his expertise on commercial and landscape photography. One notable example of Masa's work in portraiture is a photo made of Edith Vanderbilt on the occasion of her daughter's wedding in 1924. While an early ad for Plateau Studios categorized Plateau as "General Photography," soon thereafter he worked to differentiate himself from other photographers, changing the category to "Photographs of Distinction."

William Barnhill was another Asheville photographer who started his photographic explorations in the Western North Carolina mountains a few years before Masa's arrival, finding a fascination in the dramatic scenery but also the unique culture. Between 1914 and 1917, Barnhill made a series of photos documenting "Pioneer Life in Western North Carolina," which were printed in *Life Magazine* in the 1950s and are now archived at the Library of Congress. After serving as a photographer in the US Army during World War I in the 91st Aero Squadron, Barnhill returned to Asheville but moved to Cleveland, Ohio, in the mid-1920s. Years later, in a letter to Fred Seely, he recalled being a photographer in Asheville, remembering Masa's arrival on the scene and his start as a photographer. Barnhill characterized the business of photography as a "very interesting if not awfully profitable profession."

One of the more intriguing names associated with Masa during his first few years in business was another Japanese photographer named G. Maruyama. In both 1920 and 1921, he was listed in the Asheville city directory as a photographer, apparently with an expertise in home and studio portraiture work. In July of 1920, a notice in the newspaper announced that he had "gone to N.Y. Studio for ten days and when he returns will occupy part of Plateau Studios," so, evidently, he and Masa were collaborating in some way. No other records or letters exist to illuminate the nature of their relationship beyond Masa subletting studio space to him. Maruyama had frequent work in both New York City and St. Petersburg, Florida, during the same time period and appeared to cater to an upscale clientele. After 1921, he disappeared from the Asheville scene but continued to advertise studios in New York City and Miami in the 1920s and 1930s.

While there was certainly competition, there seemed to be professional courtesy as well, with regular meetings of an Asheville Photographers Association. One gathering held in 1920 welcomed 12 photographers as members. In 1922, four new studios, Inglis', Sherrill's, Stephenson's, and Ray's, appeared in the newspaper listing of photographers for hire. Later, Masa was elected to various leadership positions in this group and another just for photo finishers. In 1924, the Asheville photographers group hosted some five hundred photographers and association members from across the eastern and southeastern states, with many of the Asheville photographers welcoming guests as well as organizing exhibitions and photo tours.

Specific records of Masa's professional business successes and struggles are not documented in any single source. The best insights into his years producing photos as a professional come from the thousands of scattered surviving photos themselves, his cryptic notebooks recording some of his work, letters to and from clients, and most revealing, the many mentions of Masa and his businesses in the local newspapers. Consistent throughout were the ups and downs of his small businesses. An early indicator of Masa's fluctuating finances—reinforcing Barnhill's point that photography was not "awfully profitable"— was an advertisement he posted in the *Asheville Citizen* in October 1920. Asserting that his Ford automobile was "a real bargain," Masa explained that he had no choice but to sell and "sacrifice at once."

In 1923, Edwin Pepper, a bookkeeper and manager of several Asheville jewelry stores, purchased Plateau Studios and used the name Plateau Engraving Company. His intent was to make it a "modern engraving plant" by incorporating new machinery to allow this type of engraving work to stay in the Asheville area. Masa would remain on board as photographer. It's unclear whether the sale of Plateau was simply a new opportunity for Masa or prompted by a cash-flow problem. This new arrangement did not last, however. Less than a year later, in August 1924, Masa "disassociated himself" from Plateau

and opened Asheville-Biltmore Film Company, with offices in both Biltmore and uptown Asheville "for the convenience of his customers." The company name was soon simplified to A-B Photo Service.

In 1926, Pepper sold Plateau to Ewart M. Ball Sr., who continued to operate a business there under the name Plateau Studios. When Ball died in 1937, his mother, Mrs. Docia Ball, and his son, Ewart M. Ball Jr., continued operating Plateau until World War II, when Ball Jr. was drafted into military service as a photographer for the War Department in Washington, DC. Ownership changed once again when the portrait photographer Ignatius "Nate" Brock purchased Plateau, allowing Ball's mother to retire from the business.

In 1956, Ball Jr. and his brother Ervin Ball opened Ball Photo, a firm that has continued well into the 21st century. The bulk of the Plateau Studios negatives from 1920 through 1941 had been stored for many years in the basement of Ewart Ball Jr.'s house, along with an abundance of other photos. Ervin Ball believed that some might have been recycled for their silver during the war effort and others likely damaged by water and the elements, but in 1979, photographer Ewart Ball III donated more than 11,000 photos and the corresponding notebooks and inventory sheets to the Southern Highlands Research Center to ensure their preservation. Established in 1977 by University of North Carolina history professor Bruce Greenawalt, the relatively new research center accepted the cache of images and later incorporated them as the Ewart M. Ball Photographic Collection, an archive that includes thousands of photos from Masa's years at Plateau Studios. In 1992, it became part of University of North Carolina at Asheville's Special Collections in the D. Hiden Ramsey Library.

For years, the connection and representation of photographs taken by George Masa within the Ball collection had been unclear since the archive had not yet been thoroughly analyzed or documented. Other photographic researchers, including Rob Neufeld, William A. Hart Jr., and Susan Shumaker, recognized that there were many Masa photos in the collection from the Plateau Studios period. In 2023, independent researcher Angelyn Whitmeyer tackled

the problem as part of her effort to develop GeorgeMasaPhotoDatabase.com. Her intent with this project is to locate as many Masa photographs as possible and maintain a public database of his work. The database shows each photograph with a list of its subsequent uses as well as Whitmeyer's own observations. Her painstaking analysis clarified the Ewart M. Ball Photographic Collection, illustrating the enormous volume of work completed by Masa between 1920 and 1924 when the business was sold. Whitmeyer identified nearly 3,400 images on the inventory tallies that represent Masa's work during those four years. Of that number, only 479 images still exist as either a negative in the Ewart M. Ball Photographic Collection or as prints of any kind.

A facet of Masa's business and creativity that has not been as well appreciated is his work with motion-picture cameras. Beginning in 1919 and continuing throughout his career, Masa offered his services creating moving pictures for hire, primarily for newsreel clients such as Pathé, Fox Movietone News, Universal Newsreels, and Paramount News. He also documented local events. Masa was deeply engaged with motion-picture cinematography, and his proficiency and artistic work in the medium was significant. Very few of the motion pictures and newsreels of Masa's or anyone else's from the 1920s and early 1930s have survived. Film historian Frank Thompson, author of *Asheville Movies Volume I: The Silent Era* (2017), explains:

> *The survival rate of silent films is poor enough for the major studios, but the kinds of films which Masa photographed were doomed from the start. He most often worked with itinerant filmmakers who, generally, produced one single print of their movies for one specific engagement. Almost no one felt there was value in them after they were shown. The same went for the newsreel he shot. Most were considered to be as disposable as each day's funny papers.*

*Conquest of Canaan* is the exception to this rule. Filmed in March 1921, it was a major studio production starring a leading actor of the period. Though not filmed by Masa, *Conquest* included many scenes of downtown Asheville shot by Masa with his still camera, putting him smack in the middle of the production of this silent film. In 1988—67 years after its release—a single copy of this movie was found in a Moscow film archive, and a print was made for the City of Asheville. *Conquest* likely inspired Masa to see prospects and profit in filmmaking and motion-picture cinematography.

While the skills are certainly similar in some respects, experience as a still photographer does not immediately make one proficient with moving pictures. Somehow, Masa was able to jump into filmmaking with little known instruction or apprenticing. When Masa was working with Herbert Pelton in the early 1920s, neither Pelton nor any of the other Asheville photographers advertised motion-picture work as a service. Newsreel cameras began passing through the area in the early part of the century, but Masa was ahead of the curve in acquiring a motion-picture camera to have on hand to be used for local and regional filmmaking. Theaters ran multiple showings of dramatic films each day, including national and regional newsreels before each feature. In 1921, the newspaper advertised that Masa had captured motion pictures of the Memorial Day parade and a local theater would show the footage. He was creating business opportunities for himself by shooting local scenes and then having them sponsored when played in local theaters. Masa's entrepreneurial drive is evident in his filming of parades, politicians, and city development projects, gaining him experience with shooting and processing 16mm film, a point he also made in press releases to the newspapers. Masa even floated a potential project to Edith Vanderbilt, proposing that he film Asheville high school football games. The proposal, no doubt gutsy on Masa's part, does not appear to have elicited an enthusiastic response from Mrs. Vanderbilt.

In the summer of 1921, the *Asheville Citizen* reported that several recent graduates of Asheville high school planned to make a motion picture using local talent and settings. The group hired George Masa as

their photographer. There is no evidence that this film was ever made, but given the timing, it's conceivable that the prominence of Masa's name in association with high school students might have prompted the Klan's pursuit of the photographer later that year.

The following year, Masa shot footage of the Mount Mitchell Motor Road, capturing dozens of automobiles making the inaugural drive up the newly opened route to the highest mountain east of the Mississippi. Advertisements proclaimed the road "the greatest scenic trip on the globe," urging readers to experience the drive "in reality, then see it on the screen" at the Imperial Theatre from August 14 to 16, 1922. In November 1922, the *Asheville Citizen* reported that Masa had become "the official photographer for Pathé Exchange for North and South Carolina news reels," celebrating the fact that this would lead to "important advertising for the city." The newspaper highlighted how Masa had captured footage of a large city fire, a boll weevil trap, and a gathering of politicians, each of which would appear on the weekly newsreel shown in theaters around the country. No doubt it was this type of enterprising work that contributed to Masa's growing reputation.

In the summer of 1925, a quirky entrepreneur named J. B. "Slim" Brolund arrived in Asheville and connected with Masa. Now referred to as "itinerant filmmakers," these traveling promoters came into a town, sold stakes in the film as a form of advertising for local businesses, cast local talent (with much fanfare), and generally hyped up the city for a few intense weeks of sales and shooting. Preceded by his own press releases, Brolund aimed to make a romantic comedy film in Asheville starring himself. His strategy was to partner with the city's newspaper to promote the film and connect many of the paper's advertisers to the production, guaranteeing revenue and publicity. Six feet tall and 98 pounds, Brolund appeared in the common costume of the day for a silent cinema comedian—work boots, high-water pants, a derby atop his head, and a silly expression on his face.

Broland was likely a little different from other itinerants who often traveled with their own crew because he engaged a local, Masa, to shoot the film. Drawing on newspaper reports, historian

Thompson describes the plot of *An Asheville Romance* as "a flimsy excuse to show as many Asheville sites and businesses as possible." The Chero-Cola Bottling Plant, Weaver Motor Co., The Man Store, Auto Parts Co., Swann Electric Co., Asheville Baking Co., American National Bank, H. L. Finkelstein, Gulliet's Cafeteria, Dunham's Music House, Wooding's Filling Station, and a host of other Asheville enterprises appeared in the film. The city was bombarded with advertising for the three-night screening spectacle, and it appears everyone, especially the advertisers, left the cinema satisfied. "George Masa, with his cap turned in true 'director fashion,' turned the crank for the scenes yesterday, and at the same time directed the stars in their work," according to the *Asheville Citizen* on June 9, 1925.

Knoxville was next on Brolund's itinerary, and it was reported that the "famous elongated film comedian" had secured the services of North Carolina-based photographer and Pathé News cameraman George Masa. Masa's reputation was further enhanced for publicity of the film by the assertion in a July 1925 edition of the *Knoxville Sentinel* that he was "the only motion picture photographer who has ever been allowed to 'shoot' a set in Biltmore, the estate of Mrs. George K. [*sic*] Vanderbilt." Regardless of Broland's promotional intentions, Masa had clearly become quite accomplished with motion-picture cameras. As with the Asheville production, local businesses and talent were recruited for the Knoxville production directed and filmed by Masa. The raw footage of the movie was sent to Brolund's studios in New York where it would be cut, the subtitles inserted, and the movie printed. Unlike the Asheville production, however, *A Knoxville Romance* was lost in transit and, despite earnest attempts by postal employees, never found. A month later, Brolund and his director, George Masa, returned to Knoxville and began filming in late August 1925. The following month, the newly re-filmed 30-minute *A Knoxville Romance* played for a week in the two Knoxville theaters. A second copy of the film was sent to Asheville, but there is no mention of any screening in the Land of the Sky. Brolund had to have appreciated Masa's skills for he hired him for his *Charlotte Romance,* too. The *Charlotte Observer* reported that "George Masa, famous Japanese camera man, is doing

the photograph work for Mr. Brolund. Mr. Masa has a large studio in Asheville and is a licensed Pathé camera man."

Later in the decade, Masa shot footage for Paramount at the Cherokee Fair, a yearly event open to the public featuring traditional dances and competitions, including archery, blowguns, Cherokee stickball, and arts and crafts exhibits. Another newsreel company, Movietone News, also filmed the fair. The firm captured a rare image of Masa walking around the Cherokee Fairgrounds, well-dressed in Biltmore Industries Homespun wool knickers.

Motion-picture work was more profitable than still photography. It was also a unique service that distinguished Masa from other photographers in Asheville. In 1930, he prepared a bid for a promotional film for the National Park Service, estimating that the project would take 12 days to shoot at a cost of approximately $12,000 in today's dollars. He indicated his day rate as $35 a day for "movie work" equivalent to about $650 a day in 2024. Ever the entrepreneur, Masa asked for a share of the profits if he were able to sell it for broader distribution beyond Pathé. In preparing the estimate, Masa knew that the project would be much more work than a rate card could quantify.

We don't know if Masa secured the contract with the National Park Service since there is no further information from the park superintendent's records, nor is there a completed film in the park archives, the Library of Congress, or the National Archives. There is, however, one solitary roll of 35mm film simply labeled "Great Smokies" that was found in the park archives during the making of the documentary film *The Mystery of George Masa*. Estimating its date from the specific type of Kodak film used in the early 1930s, it is possible this was film shot by Masa as it contains images of locations and framing that are consistent with his travels and his techniques.

Masa was hired to shoot motion pictures for projects with widespread distribution in theaters around the country. Warner Brothers recruited him to film two sites for the syndicated *Ripley's Believe It or Not* series. He shot footage of Blowing Rock in the Blue Ridge Mountains and Eve's Monument in Fountain Inn, South Carolina. A year after Masa submitted his film to Warner Brothers, his friend

Margaret R. Gooch watched the Ripley's episode in a movie theater near her home in Lexington, North Carolina. Masa's footage of these two curiosities can still be viewed in the reissued *Believe It or Not: The Complete Vitaphone Shorts Collection.*

Masa's client list was a who's who of prominent Asheville residents. William Waldo Dodge Jr. was one such customer. An MIT-trained architect and a skilled craftsman, Dodge first came to the Asheville area in 1919 for treatment of injuries sustained while in France during World War I. His shrapnel wound had healed, but his lungs needed more treatment from chlorine-gas exposure. During his recuperation at a military hospital in Oteen, outside of Asheville, Dodge learned the basics of metalwork from his occupational therapist, Margaret Robinson, who would later become his wife. In 1924, the couple returned to Asheville where Dodge opened his first shop, Asheville Silvercraft. Dodge embraced the Arts and Crafts movement, and his influential legacy was especially well-represented in his silver work. A savvy promotor of his craft, Dodge hired Masa in 1928 to photograph his studio, his products, his employees, and many of the houses he had designed. Masa's sharpness of detail and perfect exposures capture the essence of Dodge's skills and artistry. These photos make it clear that Masa had become a master of his tools. By utilizing his large-format equipment and the best lenses he could afford, he was able to provide superior images to his clients.

Also exemplifying the quality of Masa's work-for-hire photography were the images he crafted for the architect Douglas Ellington, another notable visionary whose modern art deco style defined late 1920s Asheville. Ellington was born in Clayton, North Carolina, educated in Pennsylvania, and awarded a scholarship to study at the École des Beaux Arts in Paris. He enlisted in the US Navy during World War I and applied his artistic skills to designing camouflage. Following the war, he established himself as an architect in Pittsburgh. In the 1920s, Ellington moved his office to Asheville, where he'd been hired for a

number of prominent projects. One hundred years later, his iconic buildings remain largely in their original condition.

Masa photographed Ellington's Asheville City Hall, Asheville High School, First Baptist Church, and the S&W Cafeteria. Ellington's works represented the modern and progressive ideas flourishing in Asheville in the 1920s, and his civic buildings exemplified the type of architecture Nolen, Asheville's urban planner, envisioned for the city center. Ellington blended neoclassical building design with art deco aesthetic, incorporating geometric patterns and colorful ornamentation reflecting the landscape surrounding Asheville. *Architectural Record* published an extensive profile of Ellington in 1929 featuring 19 beautifully composed photographs by Masa. While capturing landscapes and mountain vistas is difficult, the framing and exposures needed for architectural photography pose a different kind of challenge. Masa's use of light and lens express the artistry of the photographer in a manner on par with the architect.

Artists and architects were not the only clients securing Masa's services. He was hired by horticulturalists to illustrate plant specimens for nursery catalogs, managers to showcase golf courses, and developers to promote their properties. In 1929, innkeeper Frank Cook recruited Masa to highlight the small town of Highlands, North Carolina, and the surrounding area. About 80 miles west of Asheville, Highlands began in 1875 as "a health and summer resort on the highest crest of the Western North Carolina plateau in the Southern Appalachian Mountains" according to historian Randolph Shaffner. The community became a "cultural center for artists, musicians, actors, authors, photographers, scholars, and scientists who have thrived in its natural setting."

Perched on the edge of the Blue Ridge escarpment at four thousand feet in elevation, the Highlands constitute a unique biological area. The Cherokee and other Native peoples understood this well before Spanish conquistador Hernando de Soto passed through around 1540. In the 1770s, naturalist William Bartram likely explored the Highlands area during his expeditions collecting plants and keeping a journal that would later inform *Bartram's Travels*. The Highlands area soon became a sought-after hunting place for collectors of

botanical specimens. Between 1785 and 1796, French naturalist and explorer André Michaux traveled throughout the United States and Canada, including the Highlands area, in search of botanical and agricultural treasures for King Louis XVI. Following in the boot prints of these early explorers, in 1927, a group of botanists, naturalists, and community members organized the Highlands Museum and Biological Laboratory, Inc. Masa photographed some of the early meetings at this small research lab and museum, which would grow into today's Highlands Biological Station of Western Carolina University. Its executive director, Dr. James Costa, wrote, "Field stations are founded in environmentally interesting places, and when it comes to temperate-zone biodiversity our region is deeply interesting indeed."

As proprietor of the Highlands Inn, Frank Cook's goal was to secure images that promoted the beauty of the area and the lifestyle of the Highlands. Centered around the forests and dramatic rock formations, the community featured charming homes built for seasonal residents escaping the summer heat and outbreaks of disease in cities scattered across the Piedmont and the coastal Southeast. Masa's reputation among his clients with interests similar to Cook's, along with his passion for the high country, made the hire a logical one.

Over a two-week period in the summer of 1929, Masa captured close to a hundred photographs for Cook. His images showcased the dramatic and imposing natural world of waterfalls and gorges, the rustic charm of the area, the Highlands Estates Country Club, and several impressive homes. Thanks to the Cook family's preservation efforts, this collection of 97 images—now archived at the Highlands Historical Association—is one of the most cohesive examples of Masa's work-for-hire photography. Oral history interviews with Cook family members mention that Masa kept extending his stay at the inn in order to wait for clear weather or ideal lighting to create a quintessential image. His 13 different views of Whiteside Mountain—each photo from a different angle at a different time of day—illustrate Masa's perpetual desire to find a unique perspective. These 97 photographs of Highlands blend Masa's passion for the natural world with Cook's interests in promoting the area's potential.

Masa's images captured both the natural and man-made world of Highlands at an important moment in time. In *George Masa's Wild Vision* (2022), Brent Martin tries to imagine Masa's reaction to contemporary Highlands: "What would Masa think now with skies trashed by all-night vapor lights, adelgid-infested hemlocks, four more golf courses in Highlands and eighteen more within twenty miles, the landscape loaded with starter mansions and multi-million-dollar homes?" Martin asks important questions: Is it possible to balance stewardship of the natural world with human development? Can we understand the world we live in well enough to have the vision and discipline to shape our future? Masa may not have imagined how out of balance the area would be a hundred years later, but as a photographer who was determined to make both a solid living in his craft and play a role in what we now consider "conservation," he likely grappled with some of these questions. They may even have catalyzed his commitment to the protection of the Smokies.

Over the Labor Day weekend in 1927, Asheville hosted an international motorcade embarking on a 2,500-mile journey from New Orleans, Louisiana, to Quebec, Canada. The ten-day excursion—sponsored by newspapers, chambers of commerce, civic clubs, and hotels along the way—highlighted the newly constructed roads, including the Appalachian Scenic Highway, and the connections among some of the East Coast's most popular tourist routes. Publicity for North Carolina's scenic and expanding motor roads was front and center for the visitors. The entourage of celebrities and notables was treated to a gala dinner at Asheville's Kenilworth Inn sponsored by the publisher of the newspaper and other prominent locals. A number of Asheville citizens joined the adventure, including Masa who was described as the official photographer by the *Asheville Times*. As the good-roads fans made their way north, more vehicles and more celebrities joined the motorcade, adding excitement and publicity to the campaign as the

procession stopped in cities all the way up into Canada. Participants interviewed 40 years after the event remembered having "a whale of a time" as they were "royally feted" with entertainment and lavish meals at each stop and greeted by motorcycle escorts as they drove through towns on their way north. They remembered the popular professional golfer Bobby Jones offering golfing demonstrations in towns along the way. The April 17, 1967, *Asheville Times* described a lasting impression:

> *One poignant incident stands out in Mrs. Holleman's memory of the trip. An Asheville photographer, George Masa, whose real name was Marabara Kizukar, was the official photographer for the motorcade. Masa . . . operated a photography studio in Asheville where he was widely known for beautiful photographs of the Smokies. He also was a very popular man with Ashevillians, she recalls, and all of them shared his disappointment when he was not allowed to cross into Canada because he had forgotten to bring his citizenship papers.*

Likely no one knew that their official photographer had no citizenship papers, nor was he eligible to become a US citizen.

In 1930, George Masa moved his Asheville Photo Service company into his final studio location, the recently completed Grove Arcade, a grand shopping mall and office building financed by the same man whose hotel, the Grove Park Inn, hosted Masa's first photo-finishing business. Masa had photographed the Grove Arcade before, during, and after its construction. The final flourish for the ornate and highly decorated arcade building was to be a prominent tower rising 14 stories above the lower five floors of shops and offices, but with Grove's death in 1927, the tower was never completed. Even without the tower, the Grove Arcade was already one of the most impressive buildings in Asheville, and Masa the city's most accomplished photographer.

Masa's files and a detailed list created for his estate allow us a glimpse into the broad sweep of his business. They catalog both the subject of his prints and negatives and the names of his clients, a virtual directory of Asheville notables from Colburn to Seely, from Vanderbilt to Waddell. Each item or name in the inventory indexes a folder containing tens or hundreds of images. A dozen different summer camps are itemized along with more than one hundred corporations, manufacturers, retail shops, and many kinds of organizations and institutions: The Farmers Federation, Champion Fiber Co., Hollywood Production Co., Radiolite Battery Co., Brown Hardware, and the list goes on and on. There are file folders for developers, country clubs, schools, and events; large collections including over five hundred 8×10 prints of the Great Smoky Mountains; numerous negatives for the Chimney Rock, Linville Gorge, Mount Mitchell, the US Veterans Hospital, and Biltmore House; and five different folders simply labeled "Baseball."

All told, the inventory of Masa's contacts speaks volumes about the complex nature of his work and the diligence it required for him to stay in business for 13 years. The craft and practice of photography and motion-picture making are one thing, but the operation of a successful business for any length of time is something remarkably different. He certainly made mistakes—took on partners who faded away, tried to innovate, sometimes unsuccessfully—but he continued to corral his talent and his gumption into making a profit. Some might have speculated that he was not interested in making money and that he only worked to allow himself time for hiking in the mountains. This romantic notion made for heroic copy, but there was much more to George Masa's professional commitment. He had worked like hell, studied, too, and now that he had that good reputation, Masa was appreciated for his knowledge, competence, ingenuity, and passion.

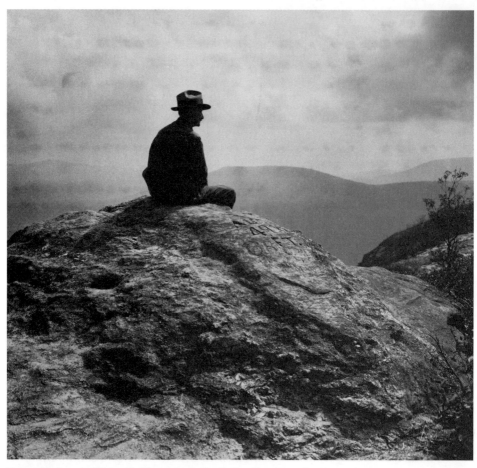

Horace Kephart on Whiteside Mountain in North Carolina. Photo by George Masa.
*Kephart Family Collection, Collections Preservation Center*

## CHAPTER FIVE

*Painted by Nature's Brush*

*"When we were at Andrews Bald we saw wonderful colors*
*painted by nature's brush. There is no words to express it . . .*
*we all just set down, look and looked, it was wonderful."*

~George Masa to Margaret Gooch, October 14, 1930

*Asheville—the Land of the Sky,* a film by the Floridian Dudley Reed, had its New York City premiere on October 7, 1926. Targeted to tourists and politicians, Reed's film contained "some of the most beautiful photography of Western North Carolina that has ever been carried to the world." But it was the resident photographer—not the out-of-state filmmaker—whom the *Asheville Citizen* credited for the artistry. "Many of the scenes of Western North Carolina were photographed by George Masa, well-known local photographer. Altogether the film is regarded as one of the most eloquent tributes to the beauty of this section of the South that has ever been prepared."

Reed, official cameraman of the Tampa Board of Trade, had been hired by Asheville boosters to showcase the region. A daredevil photographer who captured hair-raising stunts from the air and speedboat races from the water, Reed also knew how to market his talents. With a showman's flair, he executed a dawn-to-dusk December flight from Florida to deliver fresh strawberries to the mayor of the Big Apple as a Christmas gift, delighting the press, touting the state's produce, and burnishing his own reputation.

Reed envisaged his Western North Carolina production as one of a series of "Outdoor America" reels, believing the region's dramatic landscape a superb backdrop for "scenic films and sport pictorials." Boosters saw his movie as a perfect promotional vehicle. The film was a complement to the launch of the Asheville Good Will Tour of the North, a train trip starting in Atlanta, then heading north through Pennsylvania, Maine, and the province of Quebec.

Newspaper coverage described the film as showcasing "the beauties encountered upon the trip from Asheville to Chimney Rock and the 'Lure country.'" It was familiar territory for George Masa. Reed could rely on Masa's camera skills as well as his local knowledge and contacts. The film also awed conventioneers gathering in Atlanta for the Appalachian Scenic Motorcade conference. One of the audience members for this showing was the writer Horace Kephart who declared *Asheville—the Land of the Sky* "a beautiful picture." The fact that the film contained "several hundred feet" devoted to Bryson City and the Cherokees had to have pleased the area's most famous resident.

Was filming *Asheville—the Land of the Sky* the catalyst that sparked a partnership between the talented photographer and the celebrated author? The *Ruralite,* a local newspaper in the neighboring town of Sylva, North Carolina, noted on June 29, 1926, that Masa, official photographer of the Asheville Chamber of Commerce, was en route to Bryson City where he would be "joined by Mr. Horace Kephart of that place, going for a trip in the Great Smoky Mountains." According to the news report, Masa's photos had been commissioned "by a larger number of periodicals of the country, which will be used in advertising the Great Smoky Mountain [*sic*] National Park. They will be

used in booklets and folders." The newspaper reported that Masa was well-equipped "for making all kinds of views." Although there are no extant copies of the film, it's possible that some of Masa's views from this trip could have been included in Dudley's film as well.

Kephart likely was familiar with Masa's photos, which appeared regularly in the Asheville papers, and perhaps even aware of Masa's book, *Mount Mitchell and Views along Mt. Mitchell Motor Road*, issued in 1924.

Whatever the catalyst for their meeting, by the late 1920s, Kephart and Masa had merged their respective talents to focus on a mighty campaign of promoting and protecting the Smokies environment. Their teamwork, dedication, and perseverance had a profound impact not only on Great Smoky Mountains National Park but on the nomenclature of the park, the revitalization of the region's hiking clubs, and the routing of the Appalachian Trail.

On February 16, 2011, then president Barack Obama recognized George Masa and Horace Kephart during an address on the America's Great Outdoors initiative. He said that their story was one of "ordinary Americans who devoted their lives to protecting the land that they loved. That's what Horace Kephart and George Masa did.... Two men, they met in the Great Smoky Mountains of North Carolina— each had moved there to start a new life."

Horace Kephart's new life began in 1904 when he arrived in Western North Carolina. His old one, centered around his family and his career, had collapsed the previous year. He had burned too many bridges to go back into librarianship and was seemingly overwhelmed by the responsibilities of parenthood. With his family safely back in his wife's hometown of Ithaca, New York, Kephart had freed himself—at least temporarily. He could begin anew.

Until the turn of the 20th century, Kephart had followed a conventional course. Born in Pennsylvania on September 8, 1862, he spent much of his childhood on the frontier after his father, Isaiah,

moved the family to Iowa. Kephart's father and uncles were prominent educators and ministers in the United Brethren Church, and much of Kephart's education was spent in UBC schools. Following his graduation from Lebanon Valley College in Pennsylvania in 1879, he took a year of special studies at Boston University before enrolling as a graduate student in history and political science at Cornell University in upstate New York. He also began working in the university library. Following several years at Cornell and a year abroad, Kephart was hired for his first professional position at the Yale University Library.

Now with a permanent job, a reasonable salary, and some hope for advancement, Kephart proposed to his sweetheart, Laura White Mack. He and Laura spent three years in New Haven, Connecticut, where the first of their six children was born. With his strong background in languages, literature, and history, practical work experience, and a list of prominent librarians attesting to his talents, the rising young star was ready to move on from Yale. In 1890, Kephart was hired as director of the St. Louis Mercantile Library, considered the finest library west of the Mississippi. Over the next 13 years, he modernized the library, hired trained staff, introduced new services, and developed the collections. Kephart left the library "in vastly better shape than he found it," according to Frank Crunden, Kephart's counterpart at the neighboring St. Louis Public Library.

Midway through his tenure at St. Louis Mercantile Library, however, Kephart's interests began to shift. His commitment to his profession waned, while his passion for the wilderness intensified. He began spending more time in his secluded campsites, less time in the library, and fewer hours at home with Laura and the six children. His writing shifted as well. Now there was a steady stream of articles about rifles, camping, and woodcraft published in outdoor magazines with Camp Nessmuk as the locale and Kephart the author. In the fall of 1903, the library board asked him to resign. They had been "patient and lenient" with Kephart's extended absences from the library, Crunden insisted, but eventually they'd had enough.

Several months after his forced resignation, on March 24, 1904, Kephart left a letter with a bartender at Marre's Saloon. The note,

published in full on the front pages of the St. Louis newspaper, revealed Kephart's desperation. Believing that he had "been driven insane," Kephart intended to end his life. He explained that powerful demons had "taken a man who never did any one intentional harm. They have deliberately and by slow torture driven him mad. I am at this writing mad." He described his message as "the last and desperate effort of one driven by devilish torments quite outside of any human failing to tell those he loves that he did his best. In spite of worse than hell, I died with my boots on."

Kephart's letter and the newspaper coverage that followed are painful reading. Kephart headed to the Eads Bridge, intending to jump from the St. Louis landmark, but was stopped by a police officer and taken by ambulance to the hospital. That was no refuge. A reporter from the *St. Louis Republic* made his way into Kephart's hospital room and, seemingly without qualms, interviewed the very ill man. Kephart's psychotic delusions and tangled hallucinations were soon public fodder for readers of the *St Louis Republic* on March 26, 1904.

Kephart's parents took their son back to Dayton, Ohio, where he recovered from his breakdown. In his short autobiographical sketch "Horace Kephart by Himself," published in 1922, he crystalizes these events simply: "My health broke down." Although it is impossible to provide a posthumous diagnosis of a person's mental state, the details published in the newspapers give a vivid sense of the seriousness of his collapse. What is awe-inspiring, though, is his will to climb out of this dark abyss. After a few months recuperating with his parents in the Midwest, Kephart headed to the Smokies.

Home for Kephart became Western North Carolina. His first fixed camp was on Dicks Creek, a tributary of the Tuckasegee River 50 miles southwest of Asheville and not far from the small town of Dillsboro. For three months, he made his elaborate tent camp his home, but with winter approaching, he moved into an abandoned cabin on the Little Fork of Sugar Fork of Hazel Creek in Swain County. Kephart published his first title, *The Book of Camping and Woodcraft*, in 1906, two years after his arrival in Western North Carolina. He wrote dozens of articles and several more books, earning celebrity status in

Bryson City, the county seat where he settled in 1910. He emerged as a national figure through his writing and in the 1920s for his advocacy for a national park in the Smokies. Both his award-winning books—*Our Southern Highlanders* (1913) and the revised edition of *Camping and Woodcraft* (1916–1917)—were national bestsellers. They remain in print more than one hundred years after publication.

Kephart came to the Smokies a broken man. It was the recuperative power of nature that pulled him back from the edge. "I owe my life to these mountains," he often acknowledged. Kephart translated this debt into prose, capturing in his books and articles the allure of the mountains and the people who inhabited them. He also rendered his debt into passionate pleas embedded in letters, speeches, articles, and pamphlets in the hopes of rallying his fellow citizens and politicians to fight for the protection of the Smokies.

For years, Kephart, an amateur photographer himself, had searched for good illustrations for his texts. In Masa, he found an artist whose talents were unrivaled. Kephart described Masa's technique and the uniqueness of his photographs in a September 22, 1930, article for the *Asheville Times*:

> *By judicious use of various ray filters and an uncanny skill in timing exposures, he has overcome the difficulties of haze and cloudy weather which often balk an amateur photographer in the Smokies. The result is a series of about fifty views of wild mountains and gorges, deep forests and naked crags, trout streams and waterfalls, camp scenes, 'close-ups' of blooming shrubs and wilderness flowers, the like of which is not to be found elsewhere than in Masa's collection.*

For much of the country, the Smokies were *terra incognita,* an unknown and unexplored world. Masa offered viewers a glimpse into what he was experiencing. Words would help explain the majesty and mystery of the mountains, but Masa moved the audience in a different way. Masa photos were an invitation to "see" what he was experiencing, to walk into the landscape with him and be mesmerized in the process.

Although the details of the story may be apocryphal, it does not seem improbable that Stephen Mather would complain to Secretary of the Interior Franklin Lane about conditions in the country's national parks in 1914. A hiker, camper, mountain climber, and Sierra Club member, Mather knew the western parks well. During his trip to Yosemite and Sequoia national parks, Mather had been dismayed to find poorly maintained trails, encroachments by poachers, loggers, and cattle, and little or no professional oversight. There was no National Park Service in 1914; no overall management structure for the 11 national parks, 2 reservations, and 18 national monuments that existed; and few resources to maintain, develop, or staff the 4,544,552 acres in these holdings. It's not hard to imagine the secretary of the interior throwing down the gauntlet and challenging Mather: "If you don't like the way our national parks are being run, come on down to Washington and run them yourself."

Mather was a man of action—a former reporter, Chicago industrialist, marketing manager who coined the phrase "20 Mule Team Borax," millionaire, and committed conservationist. The historian Charles Snell, who wrote *Formation of the National Park Service: 1913– 1929* (1963), described Mather as "a man of prodigious and explosive energy, a tireless worker, and a high-pressure super-promoter, organizer, and salesman." Mather's biographer, Robert Shankland, describes his subject as "a striking alloy of drive and amiability." Mather would utilize all of his considerable skills—and donate a significant portion of his income—in building the National Park Service.

In January 1915, Mather accepted Lane's offer to become assistant to the secretary of the interior on the condition that Horace Albright, "the young, able, self-effacing, hardworking lawyer" who served as confidential clerk in Lane's office, would stay on to become his right-hand man and keep him out of trouble. Albright had had other plans—to return to California, marry his sweetheart, and open his own law firm—but Mather was persuasive. And, as Albright admitted, "I instantly felt a strong kinship with him. He was old enough to

be my father, a bit taller than my six feet, with prematurely white hair, piercing blue eyes, and a smile that radiated friendliness, gentleness, and kindness." The two men agreed to stay for a year and focus on the goal of creating an independent park service bureau. It was "a crucial partnership; neither could have achieved the outcome without the other," suggests National Park Service historian Robert M. Utley.

Mather wooed well-known writer and editor Robert Sterling Yard for the parks' publicity arm, recognizing that neither politicians nor the public would support national parks if they were unknown and invisible. In July 1915, Mather organized a trip to the Sierra Nevada to showcase the potential of national parks and the issues facing them. He included in his select invitation list politicians, such as the ranking Republican on the House Appropriations Committee, and editors from *National Geographic Magazine* and the *Saturday Evening Post*. He convinced the vice president of a railroad and the president of the American Museum of Natural History to join the excursion and selected a well-regarded chef to be camp cook. Mather covered the expenses for the 19 guests and the associated staff handling the provisions and animals. "Not wanting to subject his guests to privations, which might sour rather than sweeten them, he put out some four thousand dollars for equipment and food, including such refinements as air mattresses and a lavish supply of fresh fruits and vegetables," writes Shankland. According to Douglas Hillman Strong in *Dreamers and Defenders: American Conservationists* (1988), Mather's strategy worked. Congress allocated funds—"the first authorization of this kind for any park"—to purchase a prized section of Sequoia National Park that was still in private hands. "Mather realized that Congress was not going to authorize adequate funding until the American people demanded it and that the people would not do much demanding until they had been introduced to the parks. Thus, the first task was to publicize the parks and promote American tourism." According to Snell, Mather wasted no time:

> *By the end of his first year, Mather had vastly intensified park-consciousness both in the Federal Government and throughout the country generally. The greatest number of people to date,*

*334,799, had visited national parks in 1915 and newspapers all over the country were writing about them. For the first time national parks had become big news, and he and Yard had lined up newspapers all over the country. Traveling more than 30,000 miles, Mather had also visited most of the parks and had observed what they needed in the way of hotels, camps, roads, trails, and other services to the park.*

Mather's publicity campaign was beginning to work its magic. Two years after Mather arrived in DC, Congress passed, and President Wilson signed, the National Park Service Organic Act. Mather became its first director and Albright its assistant director.

By 1920, the number of national parks had grown to 19, but other than Lafayette (later renamed Acadia) in Maine, there were no national parks in the East. Mather intended to fill that gap. In his annual report for 1923, Mather wrote that he "should like to see additional national parks established east of the Mississippi." The next year, Mather's new boss, Secretary of the Interior Hubert Work, established the Southern Appalachian National Park Committee (SANPC) to examine the region and determine whether there were suitable areas for a national park. Mather, like Yard, believed that national parks should possess "scenery of supreme and distinctive quality or some natural features so extraordinary or unique as to be of national interest and importance," as the act establishing the National Park Service stipulated. He resisted approving—in spite of politicking and political pressure—inferior areas for new parks in the West and was determined to apply the same strategies for parks in the East. The SANPC established six guidelines to anchor their discussions and recommendations. These included: 1) mountain scenery with inspiring perspectives; 2) an extensive area with the potential to accommodate millions of visitors; 3) substantial portions of forested land, with rich flora and fauna, mountain streams, and waterfalls; 4) sufficient streams and springs to support camping and fishing; 5) opportunities to protect and enhance the wildlife and preserve outstanding features; and 6) accessibility by rail and road. Bombarded with hundreds

of submissions, the committee spent eight months inspecting dozens of sites in Georgia, Kentucky, West Virginia, Alabama, North Carolina, and Tennessee.

Historian Daniel Pierce chronicles the establishment of Great Smoky Mountains National Park in his comprehensive study *The Great Smokies: From Natural Habitat to National Park* (2000). With a particular emphasis on human interactions with the environment, Pierce begins his study with the earliest inhabitants of the land before covering the series of movements aimed at protecting the Smokies. These efforts, begun in the late 19th century, culminated in the dedication of Great Smoky Mountains National Park on September 2, 1940. There had been earlier earnest attempts in the late 19th and early 20th centuries but no alignment of political will, infrastructure, financing, and public enthusiasm to convert these attempts into a successful plan for a national preserve. Pierce believes the synergy developed with the establishment of the National Park Service in 1916 with Mather at the helm. His leadership—along with heightened public awareness of the destructive impact of large-scale logging on the wilderness and an increased understanding of the economic benefits of tourism—turned the tide. Pierce also credits the men and women who "had come of age during the Progressive Era and possessed both a strong sense of civic duty and an intense optimism that they could change their world." These progressive boosters transformed both Asheville and Knoxville, where businesses boomed and cultural institutions flourished. New construction reshaped the skyline while real estate deals and new housing developments extended the city centers. In a chapter entitled "God-fearing, Hustling, Two-Fisted Regular Guys," Pierce highlights the conservation efforts of Horace Kephart in North Carolina and Paul M. Fink in Tennessee. George Masa would become a pivotal partner to each of these men as well as a collaborator with his counterpart in Tennessee, photographer Jim Thompson. Documenting the boom times in Asheville and Knoxville throughout the 1920s was the bread and butter for these two photographers, but capturing the charm of the Smokies—Masa primarily focused in North Carolina and Thompson in Tennessee—became their obsession.

Deciding upon a location for a park was problematic for North Carolinians. Some favored the summer resort region of the Highlands and the Whiteside Mountain area near Brevard. Several prominent politicians lobbied for the scenic Linville Gorge and Grandfather Mountain area (now part of the Linville Gorge Wilderness) northeast of Asheville, whose ruggedness had prevented widespread clear-cutting. Selecting one of these other areas appealed to the lumbering interests, too, since it would allow them to continue the more lucrative operations in the Smokies. Squabbles over a national forest versus a national park also plagued the early park movement. Pierce reports that the "Western North Carolina Lumber and Timber Association passed a resolution declaring that 'the National Park System is not adapted to the needs of North Carolina.'" This assertion fed into the debate between utilitarians, who believed that natural areas could be scientifically managed for activities such as logging or grazing, and scenic preservationists urging protection of unique areas for the enjoyment of future generations. These disputes also fanned competition between the utilitarian approach of the Forest Service and the philosophy of the National Park Service. Contention over sites and competition over control were only part of the problem in North Carolina. Indifference also seemed endemic. Frustrated by North Carolinians who seemed "strangely apathetic" about the park idea, Kephart redoubled his efforts.

In Tennessee, the location was never an issue. "The park movement in Knoxville began almost immediately after the publication of Stephen Mather's annual report declaring his desire to see national parks in the East," writes Pierce. Knoxville boosters and husband-and-wife team Willis P. and Ann Davis dedicated considerable energy to the endeavor, as did the businessman Colonel David C. Chapman. In promoting the park movement, they saw not only the opportunity to protect a beautiful region but also the potential for economic development through tourism and new roads. Chapman and the Davises used their personal, professional, and political connections to promote the idea of a national park in the Smokies. The Tennessee boosters met Kephart and the Bryson City advocates during a

five-day inspection tour of the Smokies. One of the results of this early collaboration was a *New York Times* editorial on July 27, 1924, in support of the establishment of the national park in the Smokies with quotes from both Kephart and W. P. Davis. Asserting that the Smokies would be "despoiled unless Congress intervenes to save them for a national park," the editorial argued that there was no "people's recreation ground" in the East other than a tiny one in Maine. They contrasted Lafayette Park, "a national park only in miniature," with the Smokies: "For exploring, camping, hunting, fishing and botanizing, for all the delights of the wilderness under the sun and stars, the region of the Great Smokies alone in the East has the resources required for a national playground."

Following eight months of research and inspections, SANPC members met in December 1924 to assess their findings and submit a recommendation to Secretary Work. Their report acknowledged that the Smokies "easily stand first because of the height of the mountains, depth of the valleys, ruggedness of the area, and the unexampled variety of trees, shrubs, and plants," but the group shocked the community by recommending not the Smokies but the Blue Ridge in Virginia. Although not as grand as the Smokies, SANPC members felt that the Blue Ridge not only met the guidelines but its scale would make road building easier. In addition to its "delightful details," the area's proximity to population centers and the richness of its Civil and Revolutionary war historic sites made it the most logical selection for the new eastern park.

Incredulity and anger erupted over this decision. How could the Smokies meet all the criteria and not be selected? Both the Tennessee and North Carolina park commissions set to work; Horace Kephart did as well. On Christmas Eve, Kephart responded to a request for the facts from Congressman Zebulon Weaver. Kephart penned an eight-page letter extolling the beauty of the Smokies and the uniqueness of its environment. His letter, read on the House floor and printed in the *Congressional Record*, addressed each of the qualities outlined by the SANPC guidelines. In a second letter to Congressman Weaver, Kephart addressed concerns raised by the lumber interests, questions

posed about the impact on waterpower, and worries related to taxes. Kephart argued that the economic benefits of tourism would outweigh any short-term losses, asserting that revenues would "soon be dwindling to nothing" while tourism dollars would be a perpetual benefit.

Kephart gave talks to businessmen, hosted dinners for diplomats, and wrote passionate prose for magazines with national readership. In a November 14, 1926, article for the *Asheville Citizen*, Ann Bryson wrote that Kephart "has become our most powerful ally in giving out information about the Great Smokies." Because there were competing interests in North Carolina for the proposed park site, Kephart highlighted the uniqueness of the Smokies, arguing that there were no comparable areas in the Southern Appalachians. While there were ranges, such as Craggy and Black, that had soaring mountains, these areas were smaller, he argued, "only eighty-five square miles, whereas the Smokies cover more than seven hundred square miles with their giant ridges and profound gulfs." The Smokies "are the mountain climax of Eastern America, the master chain of the Appalachian Mountain system." What was even more remarkable, Kephart proclaimed, was the ecosystem within: "The most luring feature of the Smoky Mountains is their extraordinary variety of trees and plants . . . the richest collecting ground in the United States."

As he highlighted each of the features outlined in the SANPC guidelines, Kephart was adopting the same logic of intensifying awareness that Mather had used in generating enthusiasm for the nation's parks. One of the SANPC members, William Gregg, urged Kephart not to shy away from suggesting that the boundaries of the national park could be tilted in favor of Tennessee if North Carolinians didn't get behind the Smokies:

> But the facts are—at present our Commission does not see how the park can include the Champion and Parsons area against their will and against an indifferent North Carolina. We do see how a Park can be laid out two thirds in Tennessee and one third in North Carolina leaving out those two properties. As you well say, they will not be fit to take in after they are devastated.

That threat of a lopsided park favoring Tennessee was enough to rile North Carolinians. The competing factions in North Carolina soon rallied around the Smokies as a preferred site while both the Asheville Chamber of Commerce and the *Asheville Citizen* became vocal proponents of a national park in the Smokies.

Early in 1925, Congress passed and President Coolidge signed "an Act to provide for the securing of lands in the southern Appalachian Mountains and in the Mammoth Cave regions of Kentucky for perpetual preservation as national parks." The quick turnaround was the result of congressional pressure, public outrage, and political reality. By including four southern states—Virginia, North Carolina, Tennessee, and Kentucky—in the proposal for eastern national parks, the framers of the bill ensured a swift passage of the legislation. Yet the law was only a first step. Boundaries needed to be drawn, lands acquired, and funds raised, and large-scale logging of proposed park lands had to be stopped. Pierce covers the extensive arguments, negotiations, and legal wrangling associated with timber interests as well as the wavering support of local politicians over the issuance of state bonds to support the purchase of lands.

The campaign to protect the Smokies required funding—$10 million—money that would need to come from state coffers, wealthy philanthropists, and generous citizens. The federal government would not begin administering a national park in the Smokies until substantial acreage had been acquired, nor could any federal funds be used for purchasing lands for the park. The report *A Gift for All Time* is subtitled "Great Smoky Mountains National Park Administrative History," but its author, Theodore Catton, actually provides a more extensive history of the park than the subtitle suggests. Catton delves into the complex interactions of politics and people as well as the unique character of the park:

> *It was the first big national park to be made from private lands. Unlike most western national parks, which were carved from vacant public domain or national forest lands, this national park had to be purchased entirely from private landowners. It*

*required a complicated and lengthy process to bring this park into existence. Three congressional acts formed the outlines of the process: an authoring act in 1926, an establishing act in 1934, and a supplemental act to facilitate land acquisition in 1938.*

Catton also points out that logging companies owned 85 percent of the areas to be included in the park, and this reality, along with ongoing cutting, "profoundly shaped" the movement to protect the park.

Without the federal government's financial support, private funds were needed. A capital campaign was launched on October 1, 1925, with a goal of raising $5 million at the national level; Tennessee and North Carolina would each raise $500,000. Asheville initiated its statewide campaign by creating the Great Smoky Mountains, Inc., with the dual goals of promoting the park and raising funds for land purchases. F. Roger Miller, head of the Asheville Chamber of Commerce, served as executive secretary, and Horace Kephart as field secretary for the statewide campaign. A similar initiative began in Tennessee, centered in Knoxville, just as the 19th-century movement to protect the Smokies had been. The powerhouse Davis couple alongside businessman David Chapman took the lead in Tennessee under the auspices of the Great Smoky Mountains Conservation Association, an organization closely aligned with the East Tennessee Automobile Club and the Knoxville Chamber. Both states were helped by a professional fundraising firm. In four months, each state had met its goal of $500,000.

Kephart's writings were a key feature of these fundraising campaigns. William Gregg, a member of the SANPC, encouraged Kephart to combine the best of two newspaper articles he had authored and publish them in pamphlet form, offering to support the printing costs with $500 from his own funds. Kephart's 20-page essay "The Smoky Mountain National Park," distributed in pamphlet form, and "The Last of the Eastern Wilderness," a substantial article published in the prominent journal *World's Work*, were two of his most significant pieces. Kephart invited the reader on a prose journey through the mountains as he described the majesty, variety, and enchantment of the Smokies; photos from the Thompson Brothers

studio in Knoxville illuminated the texts. In "The Last of the Eastern Wilderness," one photo showcased the cloud forest, another a sparkling waterfall. Thompson included soaring mountain peaks as well as striking images showing "mountain laurel in bloom along a mountain brook." That Knoxville photographer Jim Thompson was selected to illustrate Kephart's article reflects both his photographic skill and his Tennessee credentials. Because Great Smoky Mountains National Park would straddle North Carolina and Tennessee, words from the Bryson City author paired with the Knoxville photographer's pictures symbolized the combined efforts of both states.

Pamphlets are ephemeral objects, intended for contemporary readers, often not preserved in archives. Content may get updated or republished in a new version. In the case of Kephart's pamphlets, there are various surviving iterations. One undated pamphlet, entitled *The Great Smokies* and produced by the North Carolina National Park Commission, included photos from both Masa and Thompson. Since Masa was the official photographer of the Asheville Chamber of Commerce, it is not surprising that this version, compiled by its publicity bureau, included some of his work.

The photographer, curator, and critic John Szarkowski writes that "the photographer-as-explorer was a new kind of picture maker: part scientist, part reporter, and part artist. He was challenged by a wild and incredible landscape, inaccessible to the anthropocentric tradition of landscape painting and by a difficult and refractory craft." Szarkowski was writing about photographers such as William Henry Jackson whose images helped support the case for the protection of the Yellowstone area in the 1870s. Given the inaccessibility of the Great Smoky Mountains, it would be no exaggeration to refer to Thompson in Tennessee and Masa in North Carolina as photographers-as-explorers. These two men—friends as well as colleagues—were part scientists, part reporters, and fully artists working in a challenging terrain with cumbersome equipment and unpredictable weather.

In the case of Thompson, we have a rich and varied collection— Thompson himself donated 35,000 images to Knoxville's McClung Historical Collections chronicling his career and showcasing his

artistry. Not so for George Masa. Much of his photographic legacy has been lost—sold after his death, vanished during transfers of ownership. What we do have, though, are outstanding examples of Masa's landscape photography collected in archives often from prints made for clients or occasionally found in various publications. In 1926, *National Geographic Magazine* published a 50-page photo essay by the writer Melville Chater chronicling a three-month, two-thousand-mile trip across North Carolina. Chater started his excursion at the shellfish beds on the Atlantic coast, then trekked across the state, highlighting the historic, scenic, and industrial sites along the way. Although most of the photos in the article were by Chater or staff photographer Clifton Adams, two of the most striking nature photos were done by George Masa, one of Upper Creek Falls, near Cold Spring in the Pisgah National Forest, and the other of Chimney Rock taken from the vantage point of Table Mountain.

Masa's early nature photos seem to center on the area around Asheville—some in the Pisgah Forest, views from Mount Mitchell or nature scenes in gardens or resort areas. We cannot verify that Masa took photos of the Smokies until the mid-1920s. But it may have been during these years that they were most needed.

Kephart ended his essay "The Last of the Eastern Wilderness" with a choice and a challenge: "Here to-day is the last stand of primeval American forest at its best. If saved—and if saved at all it must be done at once—it will be a joy and a wonder to our people for all time. The nation is summoned by a solemn duty to preserve it."

Kephart's charge to the nation—the "solemn duty"—was not simply a moral imperative but a financial down payment. According to the final park legislation (P.L. 268, 69th Congress), the National Park Service could not administer nor protect the park until North Carolina and Tennessee donated 150,000 suitable acres—through purchase or gift—to the federal government; nor would National Park Service initiate development of the park until the states had turned

over the major portion of the 704,000 acres outlined in the park boundary. Although the two states had met their fundraising goals, it would take a great deal more capital to purchase the thousands of acres owned by lumber companies, homeowners, and businesses. Raising $5 million would require *national* leadership.

Unlike the successful state-wide campaigns, the national effort was a shambles. The chair of the national campaign, Major W. A. Welch, resigned in January 1928 having failed to raise funds or secure any pledges from major donors. Had Arno Cammerer, the assistant director of the National Park Service, not stepped in, this debacle could have resulted in disaster. Characterizing it as "an emergency situation," Cammerer warned that the "inroads being made by operating lumber and pulp companies in the heart of the wonderful primitive forest stands" jeopardized the entire Smokies project. In a last-ditch effort to rescue the national fundraising campaign, Cammerer took a leave of absence from his National Park Service duties to focus in an unofficial capacity as the de facto chief fundraiser. Cammerer stuffed his "briefcase with all the photographs of the Big Smokies" he had collected and headed for a meeting with John D. Rockefeller Jr. in August 1927. Rockefeller was a willing audience. Friends with National Park Service Director Stephen Mather, Rockefeller had also forged a close relationship with Horace Albright through their collaborative work on projects in Yellowstone, the Grand Tetons, and Acadia (formerly Lafayette) national parks. It did not take Rockefeller long to develop a strong rapport with the earnest and hardworking Arno Cammerer.

On January 23, 1928, Cammerer received a letter from Rockefeller marked private and confidential. Rockefeller wrote that it was his intent to honor his mother by making a gift "to the Big Smoky Mountain Park"—in the range of $4.5 to $5 million dollars—from the Laura Spelman Rockefeller Memorial Foundation. When news of the gift was announced, celebrations erupted. "It's the greatest single thing that has happened for Knoxville, Tennessee, and this entire southeast country," proclaimed Governor Henry Horton in the March 7, 1928, *Knoxville Journal*. During his lifetime, Rockefeller would give $40 million for state and national parks and $56 million for the restoration

of Colonial Williamsburg—this in addition to millions for schools, colleges, religious institutions, and medical and relief organizations.

Rockefeller could not have found a better partner than Cammerer. Described by Albright as "hard-working, amiable, and even tempered, with a great sense of humor, and an optimistic, business-like devotion to duty," Cammerer stepped in just in time to rescue the Smokies. As he confided to Rockefeller, "My heart is wrapped up in this eastern park proposition, and particularly the Great Smoky Park, because of the great possibilities of doing something worth while for humanity that is involved." If Rockefeller's commitment resolved the financial crisis facing the Smokies project, it was Cammerer's determination to protect against deforestation that helped seal the deal. Frustrated by the inroads lumber companies continued to make in the proposed park area, Cammerer set off in miserable weather to establish a firm boundary line for the park:

> *It was thought by the lumber people that I would not be able to mark this line until May or June, but I went into the mountains the next two days in snow and rain, and climbing several peaks over 5,000 feet in height to get my bearings, and established the line then and there.*

Masa as that "photographer-as-explorer" set off on comparable explorations—not to mark property lines but to showcase the beauty within the park. Lola M. Love, a reporter for the *Asheville Citizen*, profiled Masa in the article "Japanese Photographer Is Artist with Camera." In her visit to his studio in 1929, Love shares with us a glimpse of Masa's expeditionary record:

> *In his office there is a large wall-map, showing the whole Smoky Mountain area in detail. Every mountain and hill is carefully marked. On this map, Massa [sic] has marked peaks which he has visited or which he hopes to visit soon. The marking is done by means of pins with colored heads, and the amount of them is truly remarkable, even considering the number of trips which the*

*owner of the map has made each year since coming to Asheville. This map is his text book and the visual expression of the plans and dreams which he has made for his work. The map brings to his mind the beauties of the journeys which are past and unfolds before his eyes some of the wonders which he may expect on trips to come. If everything else were taken from him, he says, there would still be contemplation and beauty enough—set free by study of that map, to fill all the days, and to console him for whatever other losses there might have been.*

Masa was helped no doubt in his expeditions by his deepening friendship with the writer-explorer Horace Kephart. In July 1928, Masa requested payment for work done at Biltmore Industries. This time it wasn't photography equipment he needed but gear for an extended camping trip. As he explained to Miss Jackson, who handled the accounts at Biltmore Industries, the intent of the trip was to explore "in the heart of wildness spot of Smokies one week or ten days, so you see I need money buy tent etc." In September, Kephart mentioned a trip that the two men had done in the Blue Ridge during which Masa had made "a wonderful series of pictures in the wild ranges where few but hunters and timber cruisers and naturalists have been." We also know Kephart sent some of Masa's photos to Cammerer in July 1929 since the National Park Service assistant director thanked the photographer for the "unusually fine photographs" of the Smokies. Cammerer promised to drop by Masa's studio to see his "enlargements and color work in addition to the other pictures you have taken of the Smokies."

Masa's photos were eliciting praise from all quarters. One Smokies enthusiast on the Tennessee side, Paul Fink, wrote that he had heard from several sources about Masa's photos but, after seeing them, realized "that their glowing descriptions have rather under than over described them." Similarly, Myron Avery—a maritime lawyer in his day job and a driving force behind the Appalachian Trail in all his spare time—asserted that he had "never seen anything to equal your Smoky pictures." In a follow-up note, Avery, who

also led the Potomac Appalachian Trail Club, encouraged Masa to document the Blue Ridge: "We believe that you can procure better pictures than are now available. Your Smokey [*sic*] pictures clearly demonstrate this." The writer and illustrator Robert Lindsay Mason urged Masa to send photos of "mountains, wild life, Indians, plants, trees, or even animals of the Vanderbilt estate" for an article in a special "Carolina" issue of *Nature Magazine:* "I would like to have you represented in grand style in your own number of Nature. I like your photographs and would like to see them published in such a high-class publication. They have a rate of purchase which I am sure will be satisfactory to you in every way." "Old Smokey," Mason's richly illustrated article in the May 1931 *Nature Magazine* features photos from Thompson's studio as well as Masa's, including Asheville Photo and A-B Photo. So, too, does another article, "Heritage of Trees," by the North Carolina state forester J. S. Holmes.

Masa was not shy about sending his photographs to politicians and philanthropists. The governors of North Carolina and Tennessee received Masa's photos, as did First Lady Grace Coolidge in spring 1928. Masa mailed Rockefeller some photos, as well as an invitation: "Come back, stay a little longer, and see some of the unspoiled beauty of western NC." Masa was an emissary inviting governors, philanthropists, first ladies, and the readers of magazines and newspapers to come see the "unspoiled beauty" that is Western North Carolina.

Love explained Masa's approach:

*Taking only the necessary supplies and equipment for picture-making, he will start out on a slow thorough trip through some special section of the mountains. Circling out from a base-camp, he will explore peak after peak, and valley after valley. Sometimes he is gone for days and sometimes for weeks, but always he returns with a very intimate and correct knowledge of the territory which he has covered. As many as twenty times in one year, Massa has left the city behind and has gone out to the virgin mountain country, and every time he takes many pictures—pictures of every beautiful thing which comes to his*

*attention. We would think that in all that number of pictures he*
*would surely find one which seems to him to express the essence*
*of nature's spirit—to be, in short, the picture for which he con-*
*tinuously strives. But he says that not even yet is he satisfied with*
*the result which he has obtained.*

Love believed Masa was "an artist at heart, and—like the true artist—wants to express by means of his art, something of this feeling of worship which contemplation of Nature has inspired in him." Although the medium and the tools are different, Love posits that Masa's talents with a camera equal those of his Japanese "artist-ancestors" who utilized brushes and paint, who featured the silhouette "in all its grace and force." Rather than a camera limiting his ability, Masa has "mastered the tools which he employs, patiently taking picture after picture until cloud and sunlight, mountain and leaf of tree have been transferred to the plate as he wishes them to be transferred." Although multitudes utilize cameras to try to capture a scene in nature, Masa's work is different. His ability to "express distance and space in his pictures," immerses the viewer in the layers upon layers of the landscape.

In some of the Smokies images known to be taken by Masa, it is clear his intention was to inspire the viewer—he was striving to make art. Others are less dramatic, representing Masa as a documentarian, capturing scenes that would be used to help identify and name or re-name features for the proposed national park. In a modern evaluation, photographer and historian Gil Leebrick sees much of Masa's work perhaps influenced by some training in composition but more likely a natural, instinctual talent:

*Masa had a love for nature and a tenacity to be out in nature*
*and to wait for a certain moment to make the type of photograph*
*he wanted. He had, certainly, a very good eye for framing and a*
*natural sense for composition. . . . Frequently we'll see an image*
*that doesn't focus on anything, and everything is of equal impor-*
*tance, and that's very much an Asian ideal where nothing has a*
*visual hierarchy within the image.*

But other photos show his eye was certainly on a specific object. That could be an entire mountain or waterfall, but it's clear that Masa was intent on capturing a context for the natural scenes. Many of Masa's photos of the Great Smokies express the drama and wildness of the region but also express an accessibility, a visual invitation for the viewer to explore these places.

Nature for George Masa as for Horace Kephart was also restorative. Writing to a friend in 1931 following a series of economic setbacks, Masa explained nature's tonic: "When I make trip these things don't bother me I just leave office and go into woods get fresh balsam air then come back start strong fight, no use to worry, that's way I do, may I am wrong, but it good to me all time." Kephart felt the same way. In the opening lines of *Camping and Woodcraft*, he urged his readers to set off on a wilderness vacation for a corrective elixir: "To many a city man there comes a time when the great town wearies him. He hates its sights and smells and clangor. Every duty is a task and every caller is a bore. There come visions of green fields and far-rolling hills, of tall forests and cool, swift-flowing streams." Nature was also a prescription that Stephen Mather used to stave off his depressions.

Perhaps it was their own personal experiences that inspired Mather, Kephart, and Masa to protect these areas of pristine beauty. Each found in nature a refuge, a curative for the stress in their life; each expressed his gratitude with a level of commitment that inspired others—Kephart with his pen, Masa with his camera, and Mather through public service. Each devoted time, energy, and passion into protecting lands that we continue to enjoy today. Kephart wrote that all of Masa's work—his exploring, mapping, and photography—were done without compensation but "out of sheer loyalty to the park idea and a fine sense of scenic values."

In October 1930, Horace Albright, by then the director of the National Park Service, and Assistant Director Arno Cammerer, along with a group of state and local dignitaries, set off on an inspection tour of the Smokies. A snippet of a silent film preserved by the National Park Service shows a smiling George Masa crossing a creek on horseback while waving at the camera. It had been a momentous journey

for Masa. Fifteen years earlier, he had labored in the laundry room of the Grove Park Inn. Through grit, determination, talent, and passion, he was now accompanying National Park Service personnel on their official trip to the new Great Smoky Mountains National Park.

Masa chronicled the trip for his friend Margaret Gooch:

> *National Park officials had great reception Monday night at Battery Park Hotel and next morning inspection trip started to Cataloochee then go up Balsam Mountains where we see Clingmans Dome to Mt. Guyot, entirely sweep of main divide, then drove to Bryson City. We went Cherokee Fair on Wednesday and Thursday made trip to Deep Creek. Then Friday we went up Andrew's Bald and Saturday visited Smokemont, come back to Asheville, our jaunt end.*

> *When we were on Andrews Bald we saw wonderful colors painted by nature's brush. There is no words to express it, I wish you could, we all just set down, look and looked, it was wonderful.*

Three months later, Horace Albright thanked Masa for the photos he'd sent and explained to the photographer that "I am having them put in a scrapbook where I can easily refer to them." Although Albright retained much of his correspondence and records, we've not been able to locate this scrapbook in any of Albright's archives. Nor can we locate the scrapbook that Masa prepared for Mrs. Coolidge or the one Kephart sent to the industrialist Julius Stone after his trip to the Smokies. Although there were "no words" to describe the beauty that Masa saw on his trips into the Smokies, one suspects that, in these lost scrapbooks, Masa would have given the viewer a glimpse of the beauty he had found, painted by nature's brush but captured by the photographer's camera.

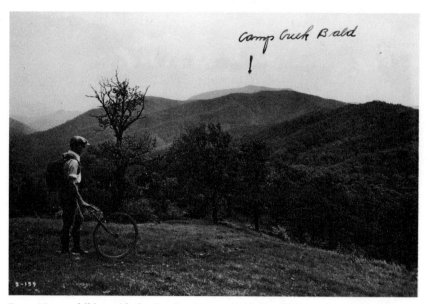

Roger Morrow hiking with the Carolina Mountain Club trail-measuring wheel on a scouting trip along the Appalachian Trail. Photo by George Masa. *Appalachian Trail Conservancy Collection, Special Collections Research Center, George Mason University Libraries*

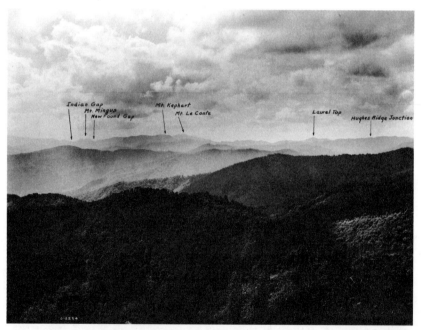

A George Masa photo of the proposed Great Smoky Mountains National Park labeled "View from Indian Ridge" and taken while scouting the Appalachian Trail. *Appalachian Trail Conservancy Collection, Special Collections Research Center, George Mason University Libraries*

## CHAPTER SIX

### Best Mountaineer on the North Carolina Side

*"In my opinion, you are the best mountaineer on the North Carolina side, because you do make it a point to go into the park every chance you get."*

~Arno Cammerer to George Masa, February 16, 1933

The writer Barry Lopez saw geography as a shaping force, not simply a subject to be studied. Lopez believed his imagination was sculpted by the sensations and forms of the Southern California landscape of his childhood.

Masa shared little about his background with his Asheville friends and revealed nothing of the sights and sounds from the Japanese archipelago that might have shaped his imagination. Yet we do know that Masa was intrigued by mountainous landscapes. On page 41 of his diary written in 1915 and now archived at Western Carolina University's Hunter Library, Masa compiled a list of prominent peaks from Alaska to Wyoming. We also believe that, soon after his arrival

in Asheville in 1915, Masa began a conversation with the mountains of Western North Carolina.

The forests in eastern North America might have reminded Masa of home. As Masa explored his Western North Carolina landscape, did he experience a sense of déjà vu? Similar trees—oaks, beeches, hemlocks, and maples—and familiar understory plants—trilliums, violets, and anemones—are found in the Smokies and in East Asia.

Ecologist Robert Askins had a comparable epiphany while hiking in the mountains north of Kyoto. Askins, who'd studied the forests of eastern North America, was struck not only by the similarity but also by the strangeness—the same types of plants but so many more species in East Asia than in the Appalachians. "It was as if I were visiting a North American forest 8 million years ago, before the Pleistocene extinctions," he writes in *Saving the World's Deciduous Forests* (2014).

Askins was not the first to make these observations. The Asian connection, documented as early as the 18th century, was described in 1846 by the botanist Asa Gray in "Analogy between the Flora of Japan and That of the United States." These early natural history observations highlighting the similarities in genera (the next highest biological grouping above species) between these two landmasses were formalized later by fossil analysis and more recently by molecular phylogenetics to reveal the deep connections between East Asia and eastern North America. With each new piece of evidence, ecologists, paleobotanists, and biogeographers unravel the mystery of how two widely separated landmasses could share such a unique collection of species with common ancestors.

Masa may not have pondered the supercontinent Laurasia, which once connected Asia, Europe, and North America, nor the fragmentation, intermittent land bridges, climate changes, and extensive glaciation that continually altered the landscape over millions of years. But scientists now posit that plant types once widely distributed across the formerly connected high-latitude zone were forced to migrate south by profound climatic changes, thinning their ranks as they ran up against mountain ranges in Europe and western North America. Remnants of these plant types—or disjuncts as they are called—persisted in

East Asia and the forests of eastern North America. It is these disjunctions that might have made the Smokies feel more like home for Masa than any other place in the continental United States.

In the essay "A Literature of Place," Lopez offers his thoughts on developing an intimacy with a place. His first suggestion is to be silent, to listen. Next, he urges us to use our other senses to understand the multitextured essence of the space and to develop an understanding of the stories and history of an area. Lastly, Lopez argues for living "in some sort of ethical unity with a place—as a fundamental human defense against loneliness." He concludes, "The key, I think, is to become vulnerable to a place. If you open yourself up, you can build intimacy. Out of such intimacy may come a sense of belonging, a sense of not being isolated in the universe."

One way Masa expressed his "ethical unity with a place" was through his dedication to the establishment of Great Smoky Mountains National Park. He also signified his connection to the environment on a more granular level through his nomenclature work and a commitment to the establishment of a vibrant hiking group in Asheville, an initiative that complemented his wholehearted efforts with the Appalachian Trail Conference. Through his work on each of these projects, Masa strengthened his connections to the community. His close friendship with Kephart, the professional respect accorded his photography, and the warmth of companionship experienced in the hiking community each ensured that Masa was not isolated in the universe. He had given himself up to the landscape of Western North Carolina, and it rewarded him with a sense of belonging.

Geographic nomenclature—the art and science of applying and clarifying names upon the landscape—is an important step in defining an area. Assigning a name to a place or a plant or a body part gives that entity a context within a larger whole; in the case of geographic nomenclature, designating official names is foundational for developing authenticated maps and trail guides. In the Smokies, there were

large swaths of unmapped lands, duplicative names aplenty through-out the region, and mountains with one name on the Tennessee side and another in North Carolina. Nomenclature committees established in each state wrestled with these issues and made recommendations to the federal agency in charge of nomenclature, the United States Board on Geographic Names.

Toponyms—the names we use for mountains, streams, and towns—evolve over time (e.g., Nieuw Amsterdam to New York). They can and do become embroiled in politics—as was the situation with the naming of Mount Kephart in the 1920s—and they continue to stir passions as Deirdre Mask reveals in her fascinating study *The Address Book: What Street Addresses Reveal about Identity, Race, Wealth, and Power* (2020). Names can and do "tell a grander narrative of how power has shifted and stretched over the centuries," Mask theorizes. Assigning names also can require strenuous physical exertion when dealing with uncharted territory or baffling terrain. Although nomenclature may seem like an esoteric academic subject, the placement of names upon the landscape reflects not only the cultural history of places but the tenacity, research skills, and staggering effort required to do so.

Arnold Guyot—born in Switzerland with a PhD from Germany and academic interests in glaciers, meteorology, physical geography, and cartography—came to the United States in 1848. The following year, he began his study of the Appalachian Mountains, and a decade later, he wrote "On the Appalachian Mountain System," published in the *American Journal of Science and Arts* (1861). Guyot begins his article with an observation: "The remark has been made with justice that the Appalachian or Alleghany system of mountains, although situated in the midst of a civilized nation, is still one of the chains concerning which we have the least amount of positive knowledge." Measurements had been done for canals and railroads, Guyot points out, but most of these surveys focused on the practicalities of locating the lowest points for transportation crossings. His goal was different, and his project enormous.

Guyot embarked on his fieldwork in 1849, devoting his sum-mers to "a study of the physical configuration of the Appalachian

system, and to the barometric measurement of those points which were most important in the establishment of the laws of its relief." Beginning with four excursions in the White, Green, and Adirondack mountains in the North, Guyot then headed south for three summer investigations in the central and southern mountains. The Southern Appalachians, he learned through his observations, were "the culminating region of the whole Appalachian system" stretching from Quebec to Alabama, "a chain of thirteen hundred miles in length."

More mapping had been done in New England and New York of the Green, White, and Adirondack mountains, and some in Pennsylvania and Virginia, but the Smokies presented a stark contrast as Guyot explains:

> *It is a mistake to suppose that names have been given to even the most prominent points in the mountains of the Appalachian system. Just in the wildest and most elevated regions, such as western North Carolina, for instance, the great majority of them have yet to be named. In a country without a regular chart, and in the midst of forests rarely visited, far from any human habitations . . . [it is] not surprising that this should be the case. . . . The observer who measures the height of definite points must do more. In order to make his labors useful, he ought to designate them individually, and determine their position so that they can always be identified, or afterwards traced upon a chart. It is, therefore, almost a matter of necessity for him to sketch such a map while proceeding, and to name, either ill or well, the points determined by his observations. A good geographic nomenclature, however, is not an easy thing; the chart of the United States proves this.*

Guyot outlines the three most common categories of toponyms: Indigenous names (e.g., Mount Katahdin); descriptive monikers (e.g., White, Green, Balsam); and the most numerous, names of men (e.g., Mount Mitchell, Mount Oglethorpe). He developed principles for nomenclature, ones that he shared with his protégés and his readers. Guyot believed in the importance of giving preference to names

in local usage and preserving Indigenous names, but he lamented the multiplication of the same name throughout the Appalachian chain because this caused "intolerable confusion." Characterizing duplicated names as "a serious evil," one wonders whether he would be chagrined or amused at the irony of three Mount Guyots—one in the Smokies, another in the White Mountains, and a third in the Rockies.

Seventy years after Guyot enumerated the challenges and articulated his principles for toponyms, the nomenclature teams in North Carolina and Tennessee wrestled with many of the same issues. Guyot bemoaned the thickets of rhododendron, the difficulty in establishing sight lines, and the fickle weather. As his experience taught him,

> *The explorer must be ready to march without any trusty guide, and to sleep in the open air, exposed to the inclement temperature of the elevated regions, and obliged to depend for nourishment on the food which he can carry with him. In these circumstances the danger of perishing from exhaustion is by no means imaginary.*

Guyot published a decade worth of research with "On the Appalachian Mountain System" in 1861 at the start of the Civil War; his detailed "Notes on the Geography of the Mountain District of Western North Carolina" was submitted to the United States Coast and Geodetic Survey two years later. Given the turmoil of the Civil War years and perhaps the strategic importance of his concluding section, "Military Importance of That Southern Mountain Region," Guyot's manuscript, "Notes on the Geography," was never published. Not until 1929 did a researcher rediscover this report and its accompanying map.

The pre-Civil War nomenclature recorded by Guyot on his maps and in his notes provided a base layer of information. And, by the 1930s, there were additional instruments in the cartographic toolbox and new techniques, such as aerial surveys, to capture bird's-eye views. Yet even with these supplementary sources and tools, the Smokies still provided major challenges for geographic explorers. As E. I. Ireland, a

topographer in the Geological Survey unit of the Department of the Interior, explained to Masa by way of apology for the lack of a reliable map of the Smokies,

> *Some day we will be able to present you a map, correct in its position thanks to the most excellent work of our own control men; a map true to form and accuracy in detail, thanks to the painstaking labor of our topographic force; a map correctly described with names, thanks to you, to Mr. Fink, Mr. Kephart, and many others who are so splendidly assisting us in this matter.*

In order to succeed with the lofty goal of producing a trustworthy map, the effort would require an improvised team of trained governmental professionals and dedicated volunteers with Masa, Fink, Kephart, and Thompson serving in the latter role.

Paul Fink, chair of the Tennessee group, consulted with representatives of the National Park Service and the Geological Survey to lay out principles and general guidelines for two state nomenclature committees to follow. Their advice to "preserve the picturesque native names" echoed Guyot's 19th-century principle. Fink's partner on the Tennessee side was the photographer Jim Thompson, while Verne Rhoades, a forester and executive secretary of the North Carolina National Park Commission, chaired the North Carolina contingent working with newspaper editor Hiden Ramsay, Kephart, and Masa. Although Masa was not named as an official member of the North Carolina committee, his contributions were nonetheless critical to its accomplishment. The writer Robert Lindsay Mason and naturalist Brockway Crouch in Tennessee also contributed to the effort.

In a March 2, 1930, article for the *Asheville Times*, Kephart takes his readers on a tour of the Smokies through its vivid nomenclature: "On the way up Shooting Creek to the Chunky Gal, one goes parallel with Drowning Creek and passes Licklog Branch, Jack Rabbit Mountain, Fleaback Mountain, Hothouse Branch, Pounding Creek, Burnt Cabin and Thumping Creek, all in the course of ten miles." His litany of names compiled along the Oconaluftee River or around Hazel

Creek provides a glimpse of the whimsical, satirical, and descriptive nomenclature given by Native peoples, early European settlers, and backcountry adventurers; his explanations often provide the historical or linguistic origins of the names. Although there were names aplenty in local usage for the dozens of creeks, branches, and gaps in the Smokies, the majority of these names were not transcribed on any official map. That goal was taken up by Masa and Kephart. Masa reduced the large official map used by the North Carolina National Park Commission to a scale of one inch to the mile and then "added the local names of nearly all mountains, streams, gaps and other natural features, so far as possible." Kephart explained that they "got those names mostly from old residents on the respective watersheds, when we did not know them or find them on any map." Along the way, the two men also corrected some errors on the map based on their knowledge of the area and their extensive trail explorations.

Not surprisingly, through their analysis the men also uncovered the same "serious evil" that had plagued Guyot's nomenclature work, noting "so many duplications and reduplications of local names in the Smoky Mountains National Park that changes should be made to prevent confusion." These included "five Big Creeks on the North Carolina side, five Big Branches, four Indian Creeks, four Long Branches, three Bear Creeks, three Nettle Creeks, three Stillhouse Branches." Kephart told Fink that he was happy to take on the "sweet job of drawing up a list of suggested new names to take the place of local ones duplicated and reduplicated on our side of the Park area." A similar exercise would need to be done on the Tennessee side, followed by a reconciliation along the state line.

Different explanations could be made for Masa's absence on the roster of the nomenclature committees. Kephart might have recruited him as an informal partner; perhaps there were limitations on the number of committee members. Prejudice over Masa's ancestry or rules relating to his "alien" status might also have disqualified him from these official committees. Whatever the cause, it is clear from Kephart, Fink, Avery, and Ireland's correspondence that Masa was a key player and an equal partner in this nomenclature initiative.

*George and I put in a lot of work on the nomenclature of our side of the Park area—George especially; for, while I only interviewed old residents throughout the territory and studied old records and selected Indian names, he, the persevering little divvle, labored long and earnestly on his maps. It is astonishing that a Jap (not even naturalized, so far as I know) should have done all this exploring and photographing and mapping on his own hook, without compensation but at much expense to himself, out of sheer loyalty to the Park idea and a fine sense of scenic values. He deserves a monument.*

Fink, too, was impressed by Masa's talents. He told Verne Rhoades that "George Masa is an excellent man to work with your committee, for he knows the Smoky country excellently well." Fink credited Masa for the "wonderful piece of work" in "running names down and in the actual map drawing." Regretting that his group did not have someone of Masa's caliber helping with the effort, Fink worried that Tennessee's report would compare "unfavorably with what the Carolina people have to offer." Edward Tufte, an expert in information visualization, wrote that "maps resemble miniature pictorial representations of the physical world." It was Masa's goal to create this representation. With official maps still on the horizon, Masa utilized those that were available, enlarged or reduced others to make it easier to annotate, and added detail and nomenclature to create a "miniature pictorial representation" of the Smokies park area. Until Ireland's cartographic teams completed their work, Masa's maps were the standard—and in demand. One eager mountain enthusiast who requested copies of Masa's latest map for himself and his hiking companions at the University of Tennessee declared that Masa's map was "in our opinion, the best published." Raymond H. Ewell, in charge of Scoutcraft at Asheville's Camp Sequoyah, "a real camp for real boys," wrote a similar inquiry. Not only did Ewell intend to buy prints of Masa's panoramas and maps, but he hoped to have a gabfest with Masa on existing trails in the Smokies.

The Sunday edition of the *Asheville Citizen-Times* on April 10, 1932, featured George Masa's map of the hiking trails in the Great Smokies.

Stretching over seven columns of text, his map depicts highways, dirt roads, and trails on both the North Carolina and Tennessee sides of the park, including the in-progress route of the Appalachian Trail. The lengthy article accompanying his map provides short descriptions of the North Carolina trails, background on Masa's nomenclature work, the efforts of the Carolina Mountain Club, and the ongoing work on the Appalachian Trail. The article also acknowledges Masa's map of the North Carolina trails—likely the one Ewell and others were anxious to purchase—noting that "Mr. Masa has traveled over a majority of the trails designated on the map and while doing so, measured distances and took notes." With regard to the AT,

> *Mr. Masa, in his work in connection with the Carolina Mountain Club, has measured the distances between certain points on the Appalachian Trail inside the park area. The work of measuring between points along the Appalachian Trail in the Great Smokies is expected to be completed by Mr. Masa before May. The distances are being measured by wheel along the State line.*

Masa was a serious and sophisticated researcher whose skills are evident in his correspondence, particularly with Paul Fink and Myron Avery, both of whom were preparing articles on Guyot's explorations and his nomenclature. While Masa spent five weeks recuperating from the flu in fall 1930, he used his convalescence to study "history, geography etc. of Great Smoky and Western N.C." In a lengthy letter to Avery, Masa theorized on the direction of Guyot's explorations of the Smokies. Not only are Masa's precision and accuracy on display in his February 23, 1931, letter to Avery, but equally evident is his ability to integrate into a coherent argument the clues gleaned from an extensive array of historical documents and contemporary sources, which he then verified with his own measurements and photographs. In his reply, Avery acknowledged Masa's work, thanked him for his contributions, incorporated all of Masa's comments, and rewrote the related text. Avery also hoped to use three of Masa's "superb" photos as illustrations for his article.

Masa's talents also impressed Verne Rhoades, whose knowledge of the area was extensive—gleaned not only from his work as a forester but even more importantly through his experience on the North Carolina National Park Commission, where he was responsible for the acquisition of land for the park, supervising surveys, and developing valuations for land and timber purchases. Rhoades wrote that he "called on George Masa, who is a man of fine imagination, to give some suggestions for the names of these peaks, as I am a dry well on these things." In his reply to Rhoades, Fink seconded that estimation, characterizing Masa "an excellent man."

Masa and Kephart's nomenclature work complemented another passion for the two men—the Appalachian Trail.

The Appalachian Trail—conceived by the visionary Benton MacKaye, orchestrated by the talented and driven Myron Avery, and built through the energies of trail club members throughout its more than two thousand miles—took root in the American imagination in the 1920s with the publication of MacKaye's article "An Appalachian Trail: A Project in Regional Planning." The Appalachian Trail in MacKaye's mind was much more than a long-distance walking trail; it was the opportunity for a social and economic experiment. Envisioning intentional communities springing up near the trail, MacKaye imagined places where "cooperation replaces antagonism, trust replaces suspicion, emulation replaces competition." His project reflected his training as a forester, his socialist-leaning beliefs, and his utopian dreams. The AT was an enabling thoroughfare, a welcome relief "for the toilers in the bee-hive cities along the Atlantic seaboard and elsewhere." MacKaye's distress at the hardships of the laboring classes—"The great body of working people—the industrial workers, the farmers, and the housewives—have no allotted spare time or 'vacations'"—echoed a similar concern expressed by Kephart, who began his seminal work *Camping and Woodcraft* by acknowledging the frustrations of a man weary of the sounds, smells, and sights of the

city, one who yearns for the tall forests. Kephart asks, "Seriously, is it good for men and women and children to swarm together in cities and stay there, keep staying there, till their instincts are so far perverted that they lose all taste for their natural element, the wide world out of doors?" Getting into the woods was a prescription for recovery and rejuvenation for both MacKaye and Kephart.

MacKaye outlined these opportunities in his proposal. First, the mountain air of the Appalachian Trail would provide "health-giving possibilities," potentially saving thousands of lives and relieving "the sufferers from tuberculosis, anemia, and insanity." The communities that would coalesce along the trail would provide employment opportunities, too, allowing for the redistribution of the population from urban centers to rural areas and helping ameliorate post-war inflationary prices. Included in the proposal were shelter camps, community camps, and food and farm camps. MacKaye saw the camp community as "a sanctuary and a refuge from the scramble of everyday worldly commercial life," "a retreat from profit," an "experiment in getting 'back to the land.'"

Thomas R. Johnson, historian of the AT, writes that "within a year into the article's appearance, MacKaye's idea for a trail had caught the attention of a very influential group, people who could make it happen." MacKaye acknowledged the efforts of the Appalachian Mountain Club in the White Mountains and the Green Mountain Club in Vermont that had already built 210 miles of the Long Trail through the Green Mountains. MacKaye extended this model throughout the Appalachian Trail, proposing that the path be subdivided into sections with local groups developing the route and maintaining the trail with a general organization linking the sections. MacKaye was a conceptual artist, avoiding the details by stating at regular intervals "no suggestions regarding this form are made in this article."

It would fall to another northerner, the builder Myron Avery, to translate the first portion of MacKaye's vision—the Appalachian Trail—into reality. Born and raised in Maine where he attended college, worked summers in the state's forests, and became fascinated with Maine's highest peak, Mount Katahdin, Avery left for Harvard

Law School and, in 1923, moved to Washington, DC, for a position as admiralty attorney for the United States Shipping Board (later the US Maritime Commission), the agency responsible for the US shipping industry. Four years later, rumors about the AT reached Avery's ears. Eager to learn more, he wrote to Arthur Perkins, chairman of the board for the Appalachian Trail Conference—the federated organization that oversaw the management and conservation of the AT—and offered to help. Perkins suggested he start a local group, and within months, Avery and a group of friends formed the Potomac Appalachian Trail Club and set to work. "What Perkins needed was some progress from Harpers Ferry to Georgia," according to Johnson, and Avery was the man. Perkins headed south after the 1929 meeting of the Appalachian Trail Conference, stopping in Jonesborough, Tennessee, where Fink lived; Bryson City, North Carolina, Kephart's residence; Asheville, North Carolina, Masa's hometown and the location of the Carolina Mountain Club; and Knoxville, Tennessee, home of Harvey Broome and the Smoky Mountains Hiking Club. When ill health forced Perkins to step down as the head of the Appalachian Trail Conference, he asked Avery to assume leadership. Perkins died in 1932, but it was he, Avery believed, who had kept MacKaye's vision alive.

For the next 22 years, though, it was Avery who became "the unchallenged leader of the Appalachian Trail effort." Often charming, sometimes acerbic, Avery could inspire or irritate, but no one questioned his commitment to completing the AT. It was not only his own zeal and organizational talents that made him that "unchallenged leader" but his prodigious energy, legendary hiking skills, and intimate knowledge of each section of the sprawling and ever-fluid route of the Appalachian Trail that inspired others to push beyond their own limitations. Avery also relied on the experts in the field, with Masa being a key informant for the South:

*A letter from Masa shows me that I have overlooked a very real bet between the Unakas and Smoky. He sent me a Pisgah Forest map to call my attention to that portion of Pisgah which comes in from Big Butte (south of the Nolechucky) [sic] to the French*

*Broad. Masa writes that he expects an organization in Asheville will develop shortly and I presume that they would be interested in the territory between Unaka and the Big Pigeon. Undoubtedly there are trails in Pisgah, which form the larger portion of this gap. I know that we can find markers for such trails in the Forest as can be used. I am writing Masa to ask him if he will get from the Supervisor a detailed account of what trails we can use there. George says that he understands that the Smoky Club wishes the trail to come up Sharp Top from Waterville rather than follow up Big Creek as Roy did. This seems a minor change and puts the trail on the crest line sooner.*

MacKaye, Perkins, and Avery each acknowledged that the northern section of the Appalachian Trail was further along, the southern section sketchier. For MacKaye, Mount Mitchell had been the logical southern terminus, a boundary embedded in the constitution of the Appalachian Trail Conference. But Harlan Kelsey—former president of the Appalachian Mountain Club, a landscape architect, and a member of the Southern Appalachian National Park Commission—attempted to persuade him otherwise. As MacKaye wryly noted in a tribute to his friend, Kelsey urged a course correction: "Hell, don't take your trail to Mount Mitchell—take it through the Smokies—that's where the scenery is."

Johnson covers all the details and nuances of the trail deliberations in his exhaustive study, *From Dream to Reality: History of the Appalachian Trail* (2021). Kelsey was right, but it took some persuading, some politicking, and a prodigious amount of energy to route the southern portion of the trail not only through the Smokies but into Georgia. Throughout these debates, the most influential voices were those of Kephart, Masa, Fink, the trail enthusiasts Harvey Broome and Roy Ozmer, and Georgia's assistant state forester Everett B. "Eddie" Stone. Each of these men were well-informed, familiar with the territory, and persuasive in their arguments and discussions with both the ATC leadership and their own club's membership. Both Georgians, Ozmer and Stone, strongly favored Mount Oglethorpe (formerly

known as Grassy Knob) over Cohutta as the southern terminus, as did the two North Carolinian representatives who had driven to Mount Oglethorpe to verify their instincts. As Kephart explained to Perkins,

> *The scenic attractions of Oglethorpe and its surroundings are superior, its accessibility from everywhere in Georgia is all that could be desired, and both the State authorities and the local people heartily support the AT project, whereas, if there is any corresponding sentiment in Cohutta I have not heard of it.*

In addition, Kephart explained, "George 'shot' the country around Mt. Oglethorpe and we drove and tramped over a truly beautiful land." A meeting at Fink's home in Jonesborough, Tennessee, sealed the Mount Oglethorpe decision for the men. At the 1930 ATC meeting that Masa attended in Kephart's stead, Ozmer presented the proposal, using Masa's photos to illustrate the southern route through Georgia and North Carolina. The final formality was a revision to the ATC constitution to reflect Mount Oglethorpe as the new southern terminus—a vote that went off without a hitch, according to Ozmer.

Trails not only needed to be determined but required marking, measuring, and describing. In both Avery's mind and MacKaye's, those jobs were best accomplished by local hiking groups. As early as 1920, Kephart, who had hiked the White Mountains as a young man, was touting to Paul Fink the efforts of northern clubs whose members had "mapped the country, made trails, built huts and camps, and publishe[d] *Appalachia*." The Carolina Mountain Club traces its origin to an early outdoor hiking group, the Southern Chapter of the Appalachian Mountain Club established in 1920. However, the chapter withdrew from that association following a dues dispute. (The AMC was absorbing 70 percent of the southern chapter's membership fees and using them mainly for constructing trails in the Northeast.) The collective restarted as the Carolina Mountain Club (CMC) in 1923, but by the late 1920s, it was described as "moribund" by the local hiking community.

According to William A. Hart Jr., it was George Masa who became "the moving spirit" in organizing what was initially a separate

hiking club in Western North Carolina that would ultimately help revitalize the Carolina Mountain Club. Following his analysis of correspondence related to the creation of what was initially known as the Carolina Appalachian Trail Club (CATC), Hart concluded that Masa, like Avery, was "selflessly dedicated to the cause and unwavering and unrelenting" in his efforts. In January 1929, Avery sent Masa a summary of the AT project, urging him to use the plan to kindle interest in the Asheville hiking community. Later that year, Masa confided his goal of forming a club to his friend Paul Fink, who encouraged him to do so. Perkins, too, added to the chorus: "I hope you will be able to get the Asheville Hiking Club organized before long and get in touch with the Knoxville Club." When it seemed likely that Masa had succeeded, the chairman of the Appalachian Trail Conference was relieved: "I'm glad to know there is a prospect of getting a hiking club in Asheville started for the more of this sort of thing that we can do, the better I like it." Masa drew up a constitution and bylaws for the club, modeling them on the Potomac Appalachian Trail Club documents. He also designed the club's logo. Knowing that the name "Horace Kephart" would be a draw, Masa insisted that his friend preside over the initial assembly. In early January 1931, the newly created Carolina Appalachian Trail Club garnered a crowd. Kephart boasted to Fink that they had "about 50–60 members" at the first meeting and predicted that they'd "have 100 before long."

In a letter to Fink, Kephart included Masa's description of an early club hike. Masa's vivid account depicts an organization that continues to thrive in the 21st century by offering three-to-five hikes each week and supporting miles of trail maintenance with membership far exceeding Masa and Kephart's projections. Given their level of activity, one suspects that the 350 active members in today's manifestation of the club are no different than the "sure enough hikers all right" Masa described in his 1931 trail report to Kephart:

> When I got up this morning about 7 a.m. it was cloudy not fit to hike anywhere, but I went to Federal Bldg. where supposed to meet, about 8 a.m. start snowing, just before starting time here

*comes Miss Ambler, Mr. Buell and members I declare it should be*
*postpone to next Sunday because we cant see anywhere from top*
*of mountain, but they say 'snow or rain we better try as sched-*
*uled' O.K. Lets go, we left here 9 a.m. arrived Piedmont Hotel*
*(out skirts of Waynesville) 10:30 then start hike in <u>snow storm</u>*
*to Eagle's Nest, got there 12:15 3 ½ miles in distance, we cant*
*stay top of ridge where used to be Hotel stood, so came down to*
*hollow, near spring house made fire ate lunch, a few moment we*
*saw <u>sun</u> but most of time snowing. There were 23 hikers, believe*
*it or not over ½ of them were <u>ladies</u>. Craziest people I ever saw,*
*sure enough hiker all right, I should say they are.*

Two weeks later, the recipient of Masa's hiking chronicle—
Horace Kephart—was dead, killed along with fellow writer Fiswoode
Tarleton in a fatal automobile accident on April 2, 1931. Tarleton was
47 years old, Kephart 68. The tragic news stunned family and friends
who gathered in Bryson City for the funerals for the two men; trib-
utes poured in from around the country. The eulogy given by Dr.
James T. Gillespie, and quoted in the *Asheville Citizen* on April 6, 1931,
acknowledged the significant role that Kephart had played: "He left
a monument for all mankind in his movement for preservation of
the mountains in a great national park. The whole nation pays him
honor." Indeed, the *New York Times* reported that all the seats in the
auditorium of the school were filled while hundreds stood outside at
Kephart's funeral. One Bryson City resident, Dodette Westfeldt Grin-
nell, recalled that "some people came from Tennessee and Georgia.
Many were from the Smoky Mountains and walked in." The broad
swath of Kephart's friendship group was reflected in the pallbearers
selected for his funeral:

*Two stalwart mountaineers, a Japanese photographer, a college*
*professor, a man high in the political affairs of the state, and*
*men from other walks of life were selected to perform this duty.*
*He was at home in the most rude mountain cabin or as a guest*
*of the rich.*

The Japanese photographer—George Masa—was bereft. Just a week earlier, he and Kephart had explored a cave in Nantahala Gorge, and the two were in the midst of planning several summer trips in the Smokies. Masa told his friend Margaret Gooch that he had received a letter from Kephart—mailed the day before he died—reporting that he was feeling good and was hoping to see Masa on the weekend. Masa drove up to Bryson City after learning of Kephart's death, ironically noting, "Yes, I saw him today but he couldn't see me."

Masa was determined to protect Kephart's legacy. For the next two years, he devoted himself to finishing the projects with which he and his friend had been engaged: nomenclature for the park, developing the southern route of the AT, and strengthening the Asheville hiking club. In completing these memorials, Masa chose to highlight his friend's contributions rather than his own.

Masa told Gooch he was so busy that he failed to send Christmas cards or New Year's greetings. He'd made two trips to Knoxville in December as well as several scouting trips related to the AT:

> Sure we needed oldman Kep last December when I went Knoxville for Nomenclature, I am not in this committee but I assisted Kep all the time and Kep counted on me, so after he gone I still stick to it and finished his part, providing that best I can. I tell you it was <u>some job</u>. While in conference at Knoxville there were five members of Tenn. Nomenclature Com and N.C. presented only one by me, but I put it over what we wanted.

That same determination motivated Masa's work with the hiking club. According to an organizational history of the Carolina Mountain Club, the Carolina Appalachian Trail Club

> was extremely active in getting unfinished segments of the Appalachian Trail (AT) routed, marked, measured, and maintained in North Carolina. During the club's first year of existence, CATC had scouted, measured, and marked 29.2 miles of the Appalachian Trail from Devils [Fork] Gap on the Tennessee border to Hot Springs [North

*Carolina], the 31.6 miles from Hot Springs to Waterville, and 43.5*
*miles from Nantahala Station to Rich Knob on the Georgia border.*

That phenomenal accomplishment was acknowledged by Avery
in his 1931 article "Progress of the Appalachian Trail," explaining that
the CATC concentrated on marking the route on either side of Great
Smoky Mountains National Park since park trails would be scouted,
graded, and marked by park service staff. Avery pointed out that "the
route through the northern sections of this Club's territory has been
located by George Masa, Chairman of its Trail Committee. It follows,
for the most part, the circuitous course of the State line and leads over
an interesting series of lofty 'balds.'"

In the fall of 1931, the two clubs, CATC and CMC, began dis-
cussing a possible merger, and by the end of the year, it was decided:
"The enlarged club adopted all the by-laws of the CATC and almost
all of the officers and Council of the CATC became the first govern-
ing body." George M. Stephens was elected the first president of the
combined clubs; George Masa was appointed to the council. "Except
for the name of the club [Carolina Mountain Club], the old CMC
appeared to have been completely taken over with the goals and the
philosophy of the CATC," according to the club's history.

Avery elaborated on Masa's efforts in a six-page letter sent to
the leadership of the southern clubs. First, he acknowledged the phe-
nomenal efforts of the trailblazers in the three clubs, then he offered
guidance in the creation of a trail guide for the southern portion of
the AT. But the main point of his letter was to break an impasse over
the connection between the Smokies and Nantahala. Avery argued
that the AT is a "through trunk line" and that options some south-
ern club members were championing would entail a circuitous route,
add 150 meandering miles to the route, and require years of labor to
complete. Avery proposed feeder trails and side trails to incorporate
additional points of interest or to capture more of the grandeur of
the Southern Appalachians. Ever the pragmatist, focused on complet-
ing the AT, and perhaps weary of the year-long dispute, Avery sug-
gested two official routes: the first being the more complex Smokies to

Tapoco and back to Nantahala route; the second, a trail that could be completed in three days. To prove his point, his boots-on-the-ground ambassador had shown that it could be done:

> *George Masa has done an extraordinary piece of work in going over the route to demonstrate the existence of trail all the way. He has even measured it and prepared trail data. I am asking him to exhibit the maps (Smoky Advance Sheets 20, 28, Nantahala Quadrangle) showing this route and his photos, particularly from Cheoah Bald. From Bushnell to High Rocks, it is 9.25 m; from Bushnell to Weser 17 m.*

Avery urged the three clubs—the Smoky Mountains Hiking Club, the Carolina Mountain Club, and the Georgia Appalachian Trail Club—to adopt this pragmatic solution; otherwise, he warned, "We must frankly admit the impasse will continue for years."

What was it like to hike with George Masa? We're fortunate to have interviews with two CMC members who shared their recollections. Historian, archivist, author, and lifelong hiker Leonard Rapport had attended the organizational meeting of the CATC with a friend in January of 1931 when he was 17. No doubt intimidated to be a teenager among the older lawyers, dentists, foresters, and other well-educated men and women and outdoor enthusiasts—not to mention a former captain of the Swedish cavalry—Rapport opined that "it was very interesting and challenging to us because you had people like Horace Kephart who'd come over and started it." Kephart, one of Rapport's heroes, "presided over the meeting until we had an election of officers, and then he took a seat in the audience." George Masa was there as well, and Rapport reminisced about his hikes with the photographer:

> *He was minimal in his requirements and very generous about helping anybody if you were there and you weren't very good at making a fire or you needed wood. George became kind of a handy man for the whole group. He never served himself; he just was always helping everybody there.*

Rapport, in his late 80s when he was interviewed by Paul Bonesteel on July 10, 2001, spoke warmly of Masa's character and commitment:

> *A lot of people do things for money; they expect something out of it tangible. I don't think George ever expected anything except satisfaction. I don't think he [would have] profited if he had lived on and on. I think he would have continued to go up there and help build the shelters, mark the trails, clear the trails. I think he was just a dedicated person like I said, like Johnny Appleseed.*

Barbara Ambler Thorne, also a charter member of the CATC, was interviewed in 1996 by Hart. Daughter of Chase Ambler—physician, conservationist, and early advocate for the protection of the wilderness—Ambler credited her father for her love of the outdoors. She was 92 years old when she spoke with Hart, but she still had vivid memories of her hikes from backpacking with her friend Jewell King to the many excursions she took with Masa and the club—sometimes in the Smokies but throughout the Western North Carolina mountains as well. Thorne chuckled as she remembered how easy it was to persuade Masa to drop everything and join them for a hike: "I'd go up to his office and say I had a bright idea. He'd say, 'When do you want to go?'" Barbara believed that George "knew every place we wanted to go" and "loved every foot of it."

Ambler described Masa as "a very smart man, a very talented man" with a good sense of humor. "We could kid him, and he'd kid us sometimes," she added. Although Masa packed light for his own comfort—Thorne remembers his tiny can of caviar for sustenance—club members helped him carry his heavy photographic gear. Not trusting herself to carry his camera, she often volunteered to tote his tripod. "The man was an artist, he truly was," she said, noting that "nobody would have the patience that he had to wait for a cloud."

Masa was also a private man, and neither Thorne, Rapport, nor other club members could puncture his reserve—in spite of their best efforts. Barbara remembered asking, "George, what did your mama call

you?" In reply, Masa just sighed, "Oh Barbara." No one knew how old
he was, nor details about his schooling or family life in Japan, or even
specifics about his arrival in the States. He just didn't want to talk about
it: "It was his business, he didn't have to tell us, so we just quit [asking]."
If anyone gleaned any knowledge about Masa's background, it might
have been the president of the club, who was easy to talk to, mused
Thorne. George M. Stephens was the only person Masa might have
confided in, Thorne guessed, and "George Stephens would not tell us."

In a June 1930 article, "Trail of the Great Smokies," written for
*Appalachia*, Paul Fink describes hiking in the Smokies as only he and
a few others might understand it:

> *The first step in preparation for the prospective visitor to the Great
> Smoky Mountains of North Carolina and Tennessee, where a great
> new National Park is in the making, is a mental one. He must dis-
> abuse his mind of any idea that tramping among these high hills
> is the same sport, with the same technique, that he has enjoyed
> among the White Mountains, the Rockies, the Sierras, or any other
> well-known range . . . Smoky is still a primitive region, its trail
> systems and its accommodations are as yet undeveloped, and
> tramping over its ridges and through its valleys can bring some
> of those thrills that come only to the explorer of an unknown land.*

Recording distances with his makeshift measuring wheel,
documenting the terrain in his field notes, and annotating his pho-
tographs with the nomenclature of the mountains, Masa secured
the details that allowed him to create "miniature pictorial repre-
sentations" of his natural environment. The facts he logged had a
pragmatic purpose, of course, given his work with the AT and CATC,
but the specifics captivated his imagination as well. In her 1929 inter-
view with Masa, Lola Love, the *Asheville Citizen* reporter, averred that
Masa's photography also inspires the viewer "to think and dream":

*When you look at the pictures which Massa [sic] has made, you will find yourself thinking about the mountains, about their greatness and majesty—about the power which brought them into being, and about the littleness of many of our human endeavors when compared to those which shaped the hills and caused the trees to have their being.*

For Love, Masa was an artist who used his camera to catch "nature's moods with uncanny skill." For Avery, Masa's photographs were "superb" illustrations for his articles on the Appalachian Trail. North Carolina State Forester J. S. Holmes considered the photographer a treasure:

*Only the other day we were speaking of photographers and I referred to the enterprise, energy and public spirit which you have always shown in your public work. Your great success in western North Carolina is due I consider in large part to your willingness to take an endless amount of trouble without definite guarantees as to where the profit is coming from. I consider you are one of the finest assets western North Carolina has.*

His admirers recognized his talents and his determination. Whether wrangling his measuring wheel over rugged terrain, balancing his tripod on an overhang, urging CATC hikers with his mantra "off your seats and on your feets," doggedly pursuing the location of Porters Gap—"that dam Porter Gap that not gap," which was positioned improbably on a ridge—or devising a pragmatic solution to a thorny section of the AT, Masa was in his element. Arno Cammerer, associate director and later director of the National Park Service who played a pivotal role in the establishment of Great Smoky Mountains National Park, wrote of his high regard for the photographer. Signing his letter with the familiar "Cam," he asserted that Masa was "the best mountaineer on the North Carolina side, because you do make it a point to go into the park every chance you get." The colored pins on Masa's wall map were simply the evidence.

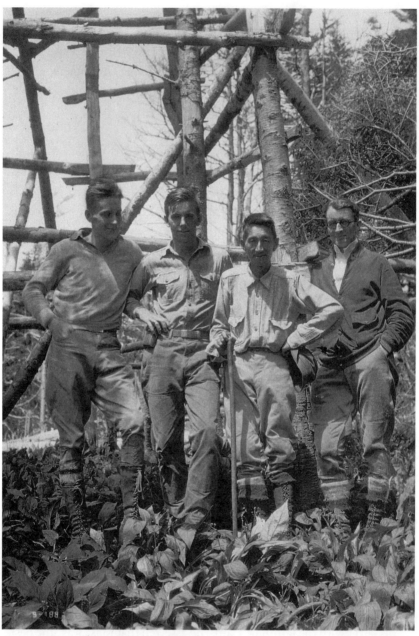

George Masa on Mount Guyot with (left to right) Billy Shuford, Walter McGuire, and Roger Morrow. *Buncombe County Special Collections, Pack Memorial Public Library, Asheville, North Carolina*

# CHAPTER SEVEN

*Never Surrender*

*"I lost every cents I had in American National Bank, so that's that,*
*but believe me always my head is up, never surrender."*

~George Masa to Margaret Gooch, March 2, 1931

Business was hopping for Masa in the spring of 1930. He set off on the morning of May 14 for the Biltmore House, one of two local contracts for the Asheville-based photographer. The second was a job at the Asheville Art Association's new museum on Beaucatcher Mountain overlooking the city. Although the forecast predicted clouds and a spring rain, both jobs entailed interiors as well as exterior views, so prospects for the shoots were good.

The previous day he'd been halfway across the state in Greensboro, North Carolina, documenting a golf tournament at the Sedgefield Country Club. He had rushed back, eager to begin the Biltmore gig. Biltmore—"this old shuck [*sic*] and ground" as he

jokingly characterized the estate—was a plum job. Photographing the luxurious home and gardens, owned by one of the most prominent families in the world, would be complex and time consuming, but Masa knew he was fortunate to have the work.

Masa had been courting business from the Vanderbilts as far back as 1920 when he had photographed the installation of a bronze marker honoring George Washington Vanderbilt at the entrance to Pisgah National Forest. Your "pictures are superb" was the response he received from the Biltmore Estate and "Mrs. Vanderbilt will gladly avail herself of your professional services whenever she has the opportunity to do so." Biltmore regularly availed itself of Masa's talents throughout the decade, most recently in December 1929. Chauncey Beadle, the Vanderbilt's estate manager, had hired Masa to photograph the cartoons painted by Mrs. Cornelia Vanderbilt Cecil, daughter of George and Edith Vanderbilt. Cecil's paintings had been part of the fundraising festivities for *Watch Y'r Step*, a benefit cabaret for the Biltmore Hospital's building campaign.

Biltmore, the "old shuck," by which Masa meant "shack," was a 175,000-square-foot home with 250 rooms, including 35 bedrooms and 43 baths. Designed by the eminent architect Richard Morris Hunt, it was the largest house in America. Just as impressive were the grounds. Frederick Law Olmsted, father of landscape architecture, planned the estate—from the winding approach road with its naturalistic plantings to the formal gardens on the terrace—while the woods were managed by Carl Alwin Schenck, founder of the Biltmore Forest School, the first forestry institution in the United States. Construction of the French Renaissance château that is Biltmore began in 1889, and for the next six years, a cadre of craftsmen performed magic to turn it into a showcase. In 1895, George Washington Vanderbilt invited friends and family to Biltmore—still a work in progress—for the Christmas holidays. For the next 35 years, the Biltmore home remained primarily a retreat for family and friends, but on March 15, 1930, Cornelia Vanderbilt Cecil and her husband John opened Biltmore to the public.

Managing the finances of the massive estate had been challenging for Edith after her husband's death in 1914. She sold a large

portion of the estate to the government for the Pisgah National Forest in 1914, sold Biltmore Industries to Fred Seely a few years later, and sold Biltmore Village to businessman George Stephens in 1920. In the midst of Asheville's housing boom, she and a group of investors began offering lots in what would become the exclusive residential development Biltmore Forest. In 1925, Edith remarried and moved with her new husband, Senator Peter Goelet Gerry, to Washington, DC; that same year, her daughter Cornelia turned 25 and inherited the Vanderbilt trust fund and various properties, including the Biltmore Estate and the enormous financial challenges that came with it. The previous year, Cornelia had married the English diplomat John F. A. Cecil at All Souls Church in Biltmore Village, a wedding attended by family and friends, dignitaries, and estate employees. "Chauffeurs and servants stood alongside lords and sirs, farmers and dairy workers mingling with the governor of North Carolina," wrote Denise Kiernan in *The Last Castle* (2017). John Cecil had resigned his diplomatic post at the British embassy in Washington, DC, to move to Biltmore with his bride and take an active role in managing the estate. Opening the opulent home to the public in 1930 was yet another way the Cecils hoped to cover some of the costs associated with the "old shuck and grounds." Kiernan posits that their decision benefited both the city and the estate. Tourists would boost the local economy, and the $2 entrance fee to Biltmore would provide "income to help defray the costs of managing the estate—taxes alone were $50,000 per year."

The same year that Cornelia and John Cecil welcomed the public to Biltmore, another prominent Ashevillian, Philip S. Henry—an Australian by birth who'd made his fortune in copper and coffee—opened the Asheville Art Association Museum on the grounds of his own estate. Henry had moved to Asheville from New York City in 1904 with his two daughters following the death of his wife. Like George Vanderbilt, he was an avid collector, amassing one of the largest private art collections in the South. For many years he had welcomed the public to his home, Zealandia, but his long-term goal had been constructing a separate museum for his burgeoning collection. On May 15, Henry inaugurated the new museum, a three-story Tudor-style granite

building "commanding a superb panorama" of the city. Built with local labor using stone quarried from the property, the new museum was filled with cabinets of curiosities, lined with paintings and drawings from European masters, and packed to the rafters with Chinese, Japanese, and Etruscan ceramics, rare editions, illuminated manuscripts and cuneiform tablets. Asheville's Sunday newspaper, the *Citizen,* showcased the museum in a front-page article on May 18, 1930, illustrated with a collage of images. Although the photo illustrations are unattributed, they may be the work of George Masa given his contract for the shoot.

There was no shortage of wealth in Asheville. George and Edith Vanderbilt set the stage as did E. W. Grove and his Grove Park Inn. But others who called Asheville home included the railroad tycoon and inventor William Greene Raoul, who built the fashionable Albemarle Park—which joined Montford, Kenilworth, Grovemont, Lakeview park—and the exclusive Biltmore Forest to ensure plenty of housing stock for the strivers and the wealthy. The few examples we have of Masa's work photographing homes and neighborhoods in these developments show that they, too, provided some income for Masa during the boom years.

Also in the spring of 1930, Masa supplied motion-picture footage for Champion Fiber along with some aerial work. His friendly relationship with the publicity managers at Sedgefield County Club and the adjoining elegant campus of the Pilot Life Insurance Company in Greensboro, North Carolina, regularly took him halfway across the state. That summer, Masa photographed various boys and girls camps around Brevard, Blowing Rock, Linville Gorge, and Banner Elk.

Masa was fully immersed in the national park initiative and equally engaged in AT activities. Whether capturing scenes "painted by nature's brush" or authenticating trail details for Myron Avery or Arthur Perkins, Masa was a busy documentarian in 1930.

But elegance, country clubs, sublime scenery, and summer camps were not the only things on Masa's docket. In the fall of 1930, it was "cattle, cows and hogs all day long, climbing hills—very steep, carrying regular 8×10 camera outfit about 6 miles walk under that darn hot sun." The next day would feature sheep—all in the service

of a sale to a "big packing house." The 1930s correspondence reflects Masa's wide range of work and belies the notion that his professional work had taken a back seat to his volunteer efforts. The letters depict instead the reality of a creative professional intent on making ends meet. Even in the best of times, photography was "a very interesting if not awfully profitable profession" as had been asserted by William Barnhill, the photographer, friend, and contemporary of Masa.

In October 1930, Masa had made the inspection tour of the Smokies with Horace Albright, Arno Cammerer, and a party of federal and state officials. A week later, the man was laid low. Masa was "attacked by Flu and sore throat spent one week in hospital and 4 weeks in bed." It could not have happened at a worse time. As he told his friend Margaret Gooch, not being able "to make color plates this Fall as I laid up when most beautiful time in the year" was his biggest regret. The holiday rush forced him to get back on his feet, but that, too, took its toll: "I am nearly worn out but I got back my strength already feeling fine at these days." The start of the decade had been filled with so many highs—the inspection tour with park service officials, photographing the Biltmore house and grounds, filming Blowing Rock for Warner Brothers—but while the bout of flu, his hospitalization, and the loss of income nearly wore him out, it was the death of Horace Kephart in 1931 that "shocked [him] to pieces." Masa's resilient and optimistic spirit seemed to remain strong, however. He urged his friend Margaret Gooch to visit. Masa promised to "take you on my back," if need be, to inaccessible places so that she could "write as many [articles] as you can, because we need more publication about this section." Not only were there human-interest stories she could cover but "splendid scenery along the crest." And no matter what photos she needed, Masa vowed, "Whatever you say I will go and get it."

In *The Great Crash: 1929*, a book first published in 1955, John Kenneth Galbraith analyzes the collapse of the financial system. His research—based on contemporary coverage of the financial market in the *New York Times*, the *Financial Times*, and *Barrons* as well as theories and

statements by academic and financial prognosticators—provides a vivid rendering of the volatility in the market. Like a threatening storm, Galbraith's day-by-day analysis in September and October of 1929 reveals the structural weaknesses in the financial system: "The singular feature of the great crash of 1929 was that the worse continued to worsen. What looked one day like the end proved on the next day to have been only the beginning."

There are dozens of books and hundreds of articles analyzing the stock market failure and the ensuing depression. Economist and former chair of the Federal Reserve Ben Bernanke argues that this period is worth discussing not only because "it was a (very) big event, and it affected most of the world's countries," but also to learn the lessons in our "supercharged, information-age economy of the twenty-first century."

Galbraith targets "a great speculative orgy [that] occurred in 1928 and 1929," but he also pinpoints five weaknesses, some of which align with Bernanke's concerns for the 21st-century economy. Galbraith classifies problems with economic intelligence, balance of trade issues, and an inadequate banking structure, exacerbated by the domino effect with one failure leading to the next. Compounding these problems were unequal income distribution—"in 1929 the rich were indubitably rich"—and "bad corporate structure"—"American enterprise in the twenties had opened its hospitable arms to an exceptional number of promoters, grafters, swindlers, imposters, and frauds." Asheville in the 1920s had its share of these issues.

One hundred and twenty banks in Tennessee, Arkansas, Kentucky, and North Carolina failed in November and December 1930. Masa saw the problems first hand: "Banks closed their door. I never see such excited people in my life." The panic-induced bank closures in Asheville reflected the structural defects in the banking system as well as the domino effect that Galbraith identified.

Caldwell and Company was the largest chain of banks in the South. When it closed, "more than fifteen banks in western North Carolina failed, the largest of which was the Central Bank and Trust of Asheville." Although not part of the Caldwell chain, Central's finances

and business associates were closely entwined. Economist Elmus Wicker explains the cozy association and the questionable practices in "A Reconsideration of the Causes of the Banking Panic of 1930":

*Through a close business associate of Roger Caldwell, the Bank of Tennessee had agreed to a sale of bonds by repurchase agreement to Central Trust and to the purchase amount of Revenue Antici-pation Notes of the City of Asheville. Depositor knowledge of the relationship between Central Trust and Colonel Luke Lea, Rogers Caldwell's business associate, explains the run on the bank and its closing one week after the Caldwell closing. Fourteen other banks in and around Asheville suspended within three days.*

The closure of Masa's bank wiped him out: "I lost every cents I had in American National Bank, so that's that, but believe me always my head is up, never surrender." Masa's situation played out across the city as families lost their savings, mortgages went unpaid, salaries were slashed, and unemployment soared. Local Asheville historian Lou Harshaw captures the cascading collapse of the city's economy: "The day Asheville's banks closed was remembered and talked about for years to come. Family money and commercial finances were gone. Small businesses lost their entire working capital. Businesses declared bankruptcy. Hundreds of people lost their jobs, and many also lost their homes as businesses closed down."

Masa's livelihood was intimately tied to the health and wealth of his adopted city. The growth of the city in the 1920s had fueled his commercial work while his landscapes, landmarks, and scenic per-spectives fed the tourist trade. David L. Knowles analyzed Asheville's economic situation during the years 1929 to 1933, a critical period in George Masa's life. In Knowles' thesis, "Days When Futures Passed," he argues that, by mid-1931, "the economic situation in Asheville had deteriorated from the unthinkable to the unbelievable":

*Over two hundred stores and eighteen hundred homes were vacant. Downtown, almost surreal conditions prevailed, with*

*less than 15 percent of the office space occupied. The usually dependable stream of tourist had dwindled to a trickle, construction nearly dried up altogether, and several factories closed. In 1931 the Central Labor Union found 90 percent of all building trades workers unemployed in Asheville, along with 30 percent of all railway employees, retail clerks, and printers, and 95 percent of all musicians.*

Masa had certainly not gotten rich nor built his "castle of success" as a photographer, but any financial stability he had achieved during Asheville's boom years was wiped out by the Great Depression.

Masa still had a few projects in early 1931, but business was drying up for the photographer. One of his jobs related to the national park; the other, the tourist trade. The North Carolina National Park Commission had reached an agreement to purchase 33,000 acres from the Suncrest Lumber Company for the national park, but the property valuation the lumber company proposed differed considerably from the North Carolina National Park Commission estimate. Masa's photos likely helped clarify the value of the property for the various legal proceedings that ensued. The second job was more straightforward—photographing the sumptuous Magnolia Gardens near Charleston, South Carolina, a three-hundred-mile drive each way.

In the spring of 1931, Masa confided a new plan he was hatching—a notion to open up a souvenir shop in Bryson City. Here, in the hometown of his friend Horace Kephart, he figured he could gain some experience before launching a bigger initiative near or in the park "selling photos, mountain craft, rugs, etc." with photography as a sideline. But, to do it, he'd need "dough . . . \$250. More and do business by myself or burst." Writing to his friend Margaret Gooch in June, Masa explained the challenge he faced and his reluctance to solicit financial support from his patrons:

*Local people thinks I am and have plenty money because my customers all rich people or social persons, indeed I worked like hell, studied like hell and got good reputation at present, and I never*

*told any one business 'rotten' whenever they asked I say 'Business fine' and I smile thru, so you see people doesn't know. I don't want send my S.O.S. to my customer that's hurt my business. I will try best I can but in case I need help, I might call on you, if you can that's great, if you can't well thats O.K and it doesn't effect our friendship at all.*

This was his public face, but as his troubles multiplied, Masa had no choice but to reach out to those rich friends and ask for help.

Masa's Asheville Photo Company, like dozens of other businesses in Asheville, "bursted," collapsing while Masa attended the Appalachian Trail Conference meeting in Gatlinburg, Tennessee, in June 1931. He and Don Topping had formed a corporation the previous year with Topping serving as president and treasurer of the business. When Topping walked out, the mortgage company moved in to take over the business. Not willing to lose his negatives, Masa made an arrangement with the mortgage company to assume ownership of the business. To keep his business afloat and pay off debts required capital.

Masa wrote to Arno Cammerer, the associate director of the National Park Service, hoping that Cam and some of the "rich folks" he knew might be able to invest $1,000 to help Masa make the capital purchases he needed to stay in business. He even approached Julius Stone, a wealthy industrialist from Columbus, Ohio. Kephart had organized a visit to the Smokies for Stone and his son in 1929. Following their trip, Kephart had sent the businessman an album of Masa's photos. It was a stretch for Masa to ask Stone for a loan of $250. since it's unclear that the two men even knew each other, though the two did share a connection forged by their late mutual friend. "Through Kep, I feel as though I were intimately acquainted with you," Stone wrote, but the Ohioan was unable to help.

Masa even made a business proposition to Fred Seely, his benefactor in previous situations. Using park service statistics, Masa noted that 151,000 visitors traveled to Great Smoky Mountains National Park in 1931; he assumed another 755,000 tourists vacationed in resorts. If he could sell one postcard to every three tourists, he calculated he'd

be in good shape. He explained to Seely that he had the views, having pre-selected 75 shots of Western North Carolina and the Smokies, and even bought some of the equipment: "One of printing machine cost $350 and now must have $250 to complete my plan but I am stuck." Masa acknowledged the challenging business climate but hoped that Seely could "spare me $250. It save whole my business and I am sure I can repay you in the middle of season with 10% interest":

> *I have been studing [sic] past several years about Post Card busi-*
> *ness and found out that most every tourist want them badly, they*
> *don't buy 50 or 75 cents photograph any more, they don't want*
> *pay more than 25 cent, they don't like cheap penny post card*
> *still want better grade some postcard so I can furnish them FIVE*
> *CENTS post card, that's what exactly they want.*

Seely was frank in his reply: "I have received your kind letter and am very sorry to hear of the trouble you have had, but I believe I have as much trouble as you have, and I don't see any possible way I could help you. Money is very scarce and difficult to get."

Even without Seely's funding, Masa persevered with his plan, testing out his new postcard-printing machine with a Biltmore scene. Previously, the estate had ordered high-quality postcards from a Swiss company using Masa's images. As an alternative or perhaps to supplement their supply, Masa offered to furnish a thousand post-cards of one subject for $30. Masa hoped that printing the images locally would give him a new source of income and maybe even cut out the Swiss middleman. But Biltmore wasn't interested: "I am not impressed with it," scribbled Judge Junius Adams, the Vanderbilt's advisor, in a penciled note to Chauncey Beadle, "and think we have a large enough selection as it is."

Seely and the Vanderbilts were not the only local people Masa approached. Dozens of letters written in 1931 and 1932 reveal the desperate state of Masa's finances. He appealed to locals, such as Frank Cook and Burnham Colburn, with whom he had done busi-ness. Cook's reply on March 8, 1932, echoed Seely's: "Now, about this

$500—I am not acquainted with anyone who has that much money, but will keep on the look-out."

When "some son of a pig stole" and wrecked his car in February 1932, Masa was furious. He relied on his car as much for work as he did for mapping, nomenclature, and trail activities. Without an automobile, jobs at Magnolia Gardens in South Carolina or golf tournaments at Sedgefield Country Club would be impossible. How could he carry out his responsibilities as the area representative for American Newsreel? Or support his work for the park or the Appalachian Trail? Although Masa had insurance on the car, the reimbursement covered only a small portion of the $200 repair bill. The only immediate option was to give up the car. He'd have to hustle to solve his transportation issue later. Masa still hadn't surrendered, but the reality he depicted for Gooch was grim: "Not much business, no money circulating, what we can! hard luck hits me quite often, but still I am holding."

He wrote to Seely again in the summer of 1932, requesting a smaller amount to cover the basics: "I need your help this time that I have to have $194. To meet payments (my board bill behind over two months) in this month, otherwise I don't know what will be." He tried to assure Seely by telling him that there was a good prospect of doing a film for South Carolina to be screened at the 1933 Chicago World's Fair. Promising to repay the loan with 10 percent interest if he got the South Carolina job, Masa ended his note with a plea: "Please lend me the amount above mentioned and pull me out from this deep hole, then I might get in my foot again."

To a friend in Waynesville, North Carolina, H. C. Wilburn—a cartographer and historian—Masa returned a borrowed topographical map and tucked a request for financial help into his letter. Wilburn's kind reply, explaining his own shaky situation, was similar to others Masa had received from friends and colleagues: "George I am sorry to have to say to you in regard to your proposition about the $200.00 in money that I am not in a position to accommodate you, much as I would like to do so."

Later that month Masa, tried another tack. If he couldn't secure a loan, perhaps someone would be willing to go into business with

him. He approached Rudolph F. Ingerle, a landscape artist known as the "Painter of the Smokies." Ingerle had visited Asheville and, presumably, Masa's studio. In return for a $1,000 investment, Masa offered Ingerle a deal:

> *I will give him 50% profit, this means the business whatever I attend, not only photographic, its include others, for instance I am preparing to issue Guide book of Great Smoky Mountains National Park, etc. . . . but I haven't any working capital, this bother me all time and haven't any business past year not only me, all over the States as you know. So I don't want partner or similar one this time, but I will make agreement protect one who back me up.*

Masa made a similar appeal to R. H. Kress two days later. Kress, whose brother founded the S. H. Kress chain of five-and-dime variety stores, was an executive with the New York City firm but maintained a residence in Asheville. One of Masa's regular customers, Kress also had the resources to buy half interest in Masa's business.

Reading Masa's appeals to colleagues and customers, one does not sense desperation but determination. He kept up appearances, requesting a hand-me-down suit from Seely: "You know the suit cloth you gave me in Spring 1930 getting very thin so I wish and pray to have other one, if you can give me, I am tickle to death." Masa only had his professional livelihood to keep him afloat. There was no family support, no safety net of public assistance or medical insurance, but he was determined to find a way out of this quagmire.

In November 1932, he confided to Gooch that he was feeling somewhat better after another bout of illness. He also told her that he decided to have the rest of his teeth pulled: "I took all my upper teeth some time ago, they bother me most of time and I should take them out before but on account of HIKE I kept them, because when we hitting trails, we like to eat plenty and it stay. So I am living with soup and soft food til I get plates." In 1932, Masa was living on Mount Clare Avenue with Mrs. Sallie May, mother of his dentist, Dr. Hugh

May. Masa never got his false teeth, but both the accumulating dental bills and the mounting debt for room and board hung over him.

Keeping his business afloat was a priority, but his other ventures loomed just as large. As he explained to Gooch, he was "quite busy attending so many things beside my own business." Following Kephart's death in April 1931, Masa had felt an even greater duty to complete his nomenclature, mapping, and hiking club activities—projects "which Kep left to me alone." Fulfilling these responsibilities was one way Masa could truly honor his friend.

Masa was deeply offended, however, by the methods employed by the Horace Kephart Memorial Association. To settle Kephart's debts and establish a museum, the association had sent out a public appeal, a tactic Masa believed was an affront to his memory. Telling the world how much Kephart owed was neither Masa's way nor Kephart's. Imagining his friend's reaction, Masa asserted, "'Hells bells! Cut that out, nobody's business but me,' what Kep will say." He tried to dissuade the association from broadcasting Kephart's indebtedness and probed to determine whether Kephart's family had approved of their approach. Frustrated, Masa left the association meeting "sick and tired." He told Gooch, "If I can secure the amount what I can pay Kep's debts that they called, including funeral expenses, I pay out all of them." It was a quixotic declaration by a man struggling with his own shaky finances, but it revealed, nonetheless, the depth of Masa's friendship and his sense of loyalty. As Masa confided to Kelly Bennett, a close friend of Kephart's, he was disappointed in the way Jack Coburn was handling affairs: "I am doubt he really interest our movement to build Kep's library or not, I may not close friend to Kep than he was, but I am sure I know Kep better than he does."

Masa may not have had the resources to settle Kephart's debts, but he did have other ways to honor his memory. On April 2, 1933, the second anniversary of Kephart's death, the Carolina Mountain Club organized a hike to Mount Kephart. Masa had sent out invitations to officials, friends, and fellow hikers, asking Paul Fink, civic leader Kelly Bennett, and *Asheville Citizen* editor Walter Adams to give two-minute remarks. An article in the *Asheville Citizen-Times* and the Knoxville

papers provided the details. Members from the Carolina Mountain Club in Asheville and Knoxville's Smoky Mountains Hiking Club would meet in Newfound Gap and hike the three miles to Mount Kephart. The Horace Kephart troop of Boy Scouts would leave from Bryson City, and another group, which had left the previous day from Almond, near Bryson City, North Carolina, would spend the night on the mountain. Friends such as Paul Fink and Harvey Broome from Tennessee would be there as would colleagues from the Appalachian Trail Conference, members of the Horace Kephart Memorial Association, and various admirers from near and far. Sleet and a brief snow squall interrupted the mountaintop speeches, but it was a fitting tribute to the dean of American campers.

Although Great Smoky Mountains National Park was not chartered until 1934, when Congress passed legislation establishing the park, and not dedicated until 1940, the National Park Service appointed J. Ross Eakin as the first superintendent in January 1931 to manage the transition from private lands to national park. Eakin wrote Masa to thank him for the invitation and express his regrets at not being able to attend the ceremony, which he had heard had been "quite a success."

Six days after the hike, Masa wrote to Horace Albright, then director of the National Park Service. It's a newsy letter, recounting the memorial hike to Mount Kephart, mentioning some of the friends in attendance—Fink, Broome, Thompson—and explaining the trip to Gatlinburg for a nomenclature meeting. His main purpose, though, was to ask a favor. Would Albright write an introductory essay for a new guidebook? Masa explained that he was "nearly ready to publish pocket size guide book to the Great Smoky Mountains National Park," a project that he had been working on with George McCoy, a staff writer for the *Asheville Citizen*. "And I hearty desire to have your article in this book, I might say 'Welcome to the Great Smoky Mountains National Park,'" similar to the statement Albright had done for the Smoky Mountains Hiking Club. Masa mentioned that their guidebook was patterned on the *Haynes Guide Handbook of Yellowstone Park*. Having been superintendent of Yellowstone at the start of his career, Albright was very familiar with the style and format of Jack

Haynes' tourist guide. Albright lost no time in responding to Masa's appeal. Having spent time with him on the 1930 inspection tour, he had experienced firsthand Masa's knowledge of the Smokies. He was also a great admirer of Masa's photography. A week after the request came in, Albright sent a warm introductory welcome.

Albright's message extolled the beauty of the Smokies, stressing that the park "now is, and always will be, primarily a trail region." Who better than George Masa to co-author the guidebook? Albright's second in command, Arno Cammerer, asserted that Masa was "the Great Smoky Mountains patriot" and "the best mountaineer on the North Carolina side," because Masa took every opportunity to explore the park. Albright reinforced that faith in the guide's welcome message: "George Masa, its co-author, knows and loves the region well. Those fortunate enough to have gone into the woods with him know that any guide-book he may issue will be invaluable. I have spent many days in the Smokies with Mr. Masa and speak from experience."

Albright ends his message with another acknowledgement—this time to the "the unselfish, wholehearted work done by a group of men and women in North Carolina and Tennessee who have labored for many years to make the Great Smoky Mountains National Park a reality. To them I extend the thanks of a grateful Nation."

The *Guide to the Great Smoky Mountains National Park* was similar in scope to Haynes' with comparable chapters on wildlife, traveling in the park, and rules and regulations. Haynes illustrated his Yellowstone guide with photos, maps, and charts; so, too, did McCoy and Masa. Haynes was the official photographer of Yellowstone; he opened shops there where visitors could get film developed and buy books, photos, and camera supplies. Known as "Mr. Yellowstone," Haynes was a successful concessionaire. Masa had had similar dreams for himself. He had applied to be the official photographer for the North Carolina Park Commission in 1928 and sketched his plans for his friend Margaret Gooch, imagining "a rustic place for a souvenir shop" with a complementary photography operation once the park was established.

Dozens of photos illustrate the Smokies guidebook, a compilation that historian William A. Hart Jr. believes is the most extensive

published collection of Masa's work. There are scenic vistas through-out the guidebook—from Chimney Tops to Nantahala Gorge—along with action shots of hikers and stickball competitors, group portraits of prominent figures in the founding of the park, and a tribute photo of Horace Kephart. Charts list the principal elevations of the dom-inant peaks; maps illustrate various scenic tours. Descriptions of hiking trails to scenic areas and a history on the formation of the park are two of the most extensive sections in the guidebook. Short essays expand on plants of the Smokies, the unique natural features such as grassy and heath balds, and the communities living in the Smokies, including the Cherokee and the Highlanders. The guide ends with listings of accommodations, museums, and gift shops, including Jim Thompson's photography studio in Knoxville and Masa's Asheville photo shop. Throughout the book there are references to botanists, geologists, historians, and ethnologists along with a smattering of quotes from Horace Kephart.

The language is polished, the text well-researched. McCoy, a native of Dillsboro who would later be promoted from staff writer to editor at the *Asheville Citizen,* was married to Lola M. Love, the writer who had profiled Masa in 1929. It is unclear how much of the text was written by George Masa, although one suspects that the trail and tour information relied heavily on his experience as did the technical compilations, such as the various mountain elevations. Masa's carto-graphic skills and knowledge of nomenclature were highlighted in an Asheville newspaper article on June 22, 1933:

> *In addition to being an expert photographer, Mr. Masa also was adept at map making. He drew, to scale and from actual first hand information, many maps of places in the park and else-where in Western North Carolina for use in published articles. Without hesitation, when asked he could give correct information as to the altitudes, distances, location, general topography and other characteristics of virtually every part of the Smokies, the Black mountains, and other southern highlands. Writers of arti-cles on this section for many years found a veritable gold mine*

*in Mr. Masa as an information source. He not only could supply*
*excellent pictures from his large collection but he could identify*
*them all as to location, names and so on: could draw a map on*
*short notice, if desired, and then give very comprehensive facts*
*regarding the subject.*

One contemporary reviewer classified McCoy and Masa's 50-cent, 146-page guidebook as "a useful little inexpensive guide, approved by the National Park Services" and designed for the ever-increasing number of visitors traveling to the new national park.

The review in *Appalachia* was less flattering: "Despite its many admirable features, the tramper seeking to plan an outing in the Great Smoky Mountains National Park will find this guide a disappointment." The reviewer complains that there is no attempt to explain how to get to the Smokies and little detail on where to stay. Although the map is "adequate in plan, it is so badly printed that it is hard to find localities and impossible to distinguish the various types of roads and trails." The most positive comments relate to the motor trips, "meticulously detailed as to route and conditions," and the descriptive chapters on wildlife and history, which depict the park "as an alluring spot." The review ends as it begins on a negative note: "The pamphlet suffers from being partly guide and partly publicity."

The guide was clearly a labor of love by McCoy and Masa, one that might have provided another trickle of income. In the preface, the authors write that the goal was to focus on current conditions—not speculate on what plans the NPS might have—creating a guidebook that would "give information on what is in the park today." McCoy and Masa hoped that this approach would help "the visitor in acquiring a background for a deep appreciation of the beauties and the wonders of this wilderness area."

Masa shared with the reader his appreciation of the Smokies in the photographs. The *Guide to the Great Smoky Mountains National Park* reflects his detailed knowledge of the terrain, trails, and attractive motor routes while his photographs capture his perspective of the grandeur and wonder of the mountains.

Masa identified himself as "a photographer and booster of Western N.C." The guide proves his point as does another venture: *Touring the Great Smoky Mountains National Park and the Southland.* A companion to the guide, *Touring* was offered in a magazine format and geared more to the automobile tourist. George Masa is listed as an associate editor, as is Tom Alexander, Masa's friend and proprietor of Cataloochee Ranch and the Three Forks trout camp. The masthead summarized Masa's qualifications as "photographer and authority on hiking and topography in the Great Smoky Mountains National Park and North Carolina." One suspects that he—when some "son of a pig" hadn't stolen his automobile—was also one of the representatives who were driven to "travel over every mile of the main highways in the region which we cover, and report every necessary detail from personal observations." The magazine promised information on scenic routes, maps, and points of interest. Masa's photographs illustrate many of the articles with more than a dozen in the first issue; subsequent issues throughout the 1930s continued to incorporate his images. The Grove Park Inn included a copy of *Touring* with their guest services directory, along with a letter urging guests to explore the scenery and attractions of the area. It's ironic that 18 years earlier, while serving as valet in the Grove Park Inn in 1917, Masa might have delivered the guest services directory to rooms at the inn. Now he was a tour guide for these privileged guests, enticing them to leave the comfort of the inn's grounds and explore the Land of the Sky, a country Masa knew so well.

Had these initiatives—*Touring* and the *Guide to the Great Smoky Mountains National Park*—not collided with the economic depression of the 1930s, Masa might have been able to crawl out from under his financial burdens. He might have been able to open his souvenir shop. Subsequent editions of McCoy and Masa's guide might have become as well-known as Haynes'.

Other scattered correspondence from January to April 1933 shows Masa clarifying creek names with Smokies assistant chief ranger John Needham, verifying elevations with US Geological Survey engineers for the final nomenclature report, and confirming decisions with fellow photographer Jim Thompson. The nomenclature committees

of both states were wrapping up their work. Although they may seem like arcane debates, decisions on the placement of names such as Derrick Knob, Mad Creek, and Defeat Branch were important decisions for cartographers and park officials. The series of letters from Masa to Needham and Masa to Thompson in spring 1933 illustrate how complex and collaborative the process was—and how engaged Masa was in the endeavor.

But the toll all this painstaking work took on his body is evident. In one undated photo with the hiking club, likely taken in the early 1930s, Masa looks healthy and robust; two years later in another photo, he is skin and bones, his loose trousers cinched tight around his narrow waist and his cheeks sunken from the tooth extraction.

All of Masa's work came to an abrupt halt in May 1933. The Asheville newspaper reported on Tuesday, May 16, that the "well-known photographer and outdoorsman" had been ill for several weeks. Friends said that he had rested well on Sunday, "but his condition became worse yesterday." The newspaper provided an update the following week reporting in the May 24 issue that he was improving. One imagines a steady stream of friends from the Carolina Mountain Club checking in on the photographer, particularly his co-author George McCoy and his close friend George M. Stephens. The "improvement" was temporary, however. When it became clear that Masa was critically ill and no longer able to care for himself, he was admitted to the Buncombe County Home and Sanitarium on the outskirts of Asheville.

Margaret Gooch, who lived more than two hours away in Lexington, North Carolina, rushed to the sanitarium to be with Masa on June 13 after receiving a telegram informing her of the seriousness of his illness. Stunned, having no idea that "conditions were so bad with him," Gooch stayed for two days but saw little improvement in her friend, who was so ill he could barely talk. Gooch professed that had she "known anytime in the past few months that he was ill or in need I would so gladly have done anything I could to help relieve the situation."

The following week on June 20, Barbara Ambler, a close friend from the Carolina Mountain Club, received a phone call from one of the nurses at the sanitarium explaining that Mr. Masa wanted to speak to her. Since Ambler lived miles from the sanitarium and it was late in the day, she thought it best to visit the following morning. When Ambler called to check on Masa's condition the next day, she learned that he had died. She was devastated, disappointed in herself for not venturing out to see him the previous night. In an interview conducted with William A. Hart Jr. in 1996, the 92-year-old woman talked about the night George Masa died: "One thing that broke my heart which I did which was wrong" was not going to the sanitarium when the nurse called to say, "Mr. Masa would like to see you." Sixty-three years later, it was a decision she still deeply regretted.

The death certificate states that George Masa died at 11 a.m. on June 21, 1933. Dr. Sumner, the attending physician, indicated pulmonary tuberculosis as the primary cause of his death. Barbara Ambler did her best to provide the basic details of Masa's life for the official records: that Masa was a photographer, single, born January 20, 1881, in Tokyo, Japan; that his parents were unknown. According to the certificate, George Masa, "Masabara Izuka," was 52 years, 5 months, and 1 day old when he died. They were guesses. As Barbara explained in later interviews, Masa just didn't want to talk about his past. "It was his business, not mine," she said, so she didn't press.

The *Asheville Citizen* newspaper published two tributes to George Masa the day after he died. The shorter tribute on the fourth page of the June 22 issue summarized his contributions:

> *Next to Horace Kephart, it is probable that George Masa knew the Great Smoky mountains better than any one else. His services in the development of the park have been invaluable. For years he has given his time and talent to this great project and although his resources were limited he was always ready to put any call that had to do with the park ahead of his own interests. As an outdoors photographer Mr. Masa's extraordinary talent has long been acclaimed. . . . Mr. Masa spared himself no exertions or*

*hardships or even dangers if the prize was to be a new view of*
*surpassing loveliness. . . . He has identified himself with the life*
*of this region. He has left his stamp upon it. His part in the map-*
*ping of the park and in the establishment of its nomenclature*
*was a very important one. The photographs which he took have*
*been enjoyed by thousands and tens of thousands in every part*
*of the land. The death of this adopted son of the Western North*
*Carolina mountains is a great loss. It brings sorrow to those who*
*had come to know him and admire him.*

The longer article on the third page of the *Asheville Citizen* was perhaps the best contemporaneous account of Masa's career and his community contributions. The article details Masa's Appalachian Trail and Carolina Mountain Club activities, praises his cartographic skills and nomenclature work, and even chronicles the locations of Masa's various studios. Making reference to the recently published *Guide to the Great Smoky Mountains National Park,* "profusely illustrated with Mr. Masa's photographs," the article asserts it is "the first authentic and complete work of its kind."

Masa "was buried in the city he loved and by the friends who knew and loved him best." One hundred mourners gathered under a large pine tree in the Riverside Cemetery for the brief service on June 23, 1933. It was a Christian burial conducted by Dr. W. A. Lambeth, pastor of the Central Methodist Church in Asheville. Shortly before his death, the article reported, Masa had confided to a friend that he had adopted the Christian faith while a student in Tokyo.

"A sea of black umbrellas" was what Jeanne Creasman Lance remembered 68 years later. A frightened little eight-year-old attending her first funeral, Jeanne watched from her vantage point up on the road as the torrential rain pelted the mourners massed below. Trying to stay dry, she might have focused on her older brother, Blake, who helped carry the casket. She was only a baby when Masa had boarded with the Creasmans, but she visited his studio regularly as a little girl. Blake worked as Masa's assistant, and her older sister Blanche "did a lot of the hand-tinting of photographs." The family was fond of

Masa—"He was just a member of the family," she recalled. The photo album that Masa had created for her family reflected that affection—Masa grinning broadly as he sat in the handmade go-cart, posing with the children in the Biltmore fountain, capturing Blanche and her mother's beauty in the reflection of the mirror. Jeanne inherited the photo album when her parents died, later donating it to Special Collections in the Buncombe County Public Library.

Dr. Hugh M. May, Masa's dentist and the owner of the house where Masa lived at the end of his life, was another pallbearer—the Creasmans and the Mays, bookends symbolizing the Asheville families who had befriended and supported Masa. It has only recently come to light that the May family had even deeper connections to Masa: George Pennell, the attorney who defended Masa in court in 1921, was Dr. May's brother-in-law.

The Carolina Mountain Club and a few other close friends made the arrangements and covered the costs for Masa's casket, funeral, and burial. Four club members served as pallbearers including George M. Stephens, one of Masa's closest friends and the first president of the combined Carolina Appalachian Trail Club and Carolina Mountain Club where Masa had been elected a councilor. The architect Anthony (Tony) Lord, who paid the interment fee at Riverside, joined two other Carolina Mountain Club members, Roger Morrow and L. D. Rogers, as pallbearers.

One has a sense that all of Asheville was grieving the loss of a favorite son. With no photographs or memorial books listing the mourners at his funeral, we can only assume a mix of friends, colleagues, clients, and hiking companions huddled under that sea of black umbrellas. The steady stream of notices in the newspapers had alerted the community to the seriousness of Masa's illness. The articles appearing between June 21 and 23 were not structured as traditional obituaries but rather eulogies celebrating the man who had "given his time and his talent" to the city and the country he called home. Even in the midst of the Great Depression, George Masa's sacrifices were celebrated.

# The Legacy

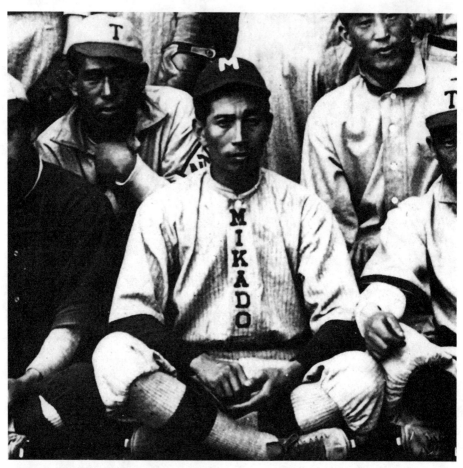

Shoji Endo with Mikado and Asahi baseball teammates in Seattle, Washington, circa 1913.
*University of Washington Libraries, Special Collections, UW41666*

## CHAPTER EIGHT

### *Two Thousand Miles Away Southward*

*Here I am, two thousand miles away southward.*
*Looking back at the way I have passed,*
*I see rough weaves and vortexes*

~Translated poetry excerpt from Shoji Endo's writings

Six days after Masa's death, his friend Glen Naves at the *Asheville Citizen-Times* wrote to the Japanese ambassador asking for help in locating Masa's relatives. The matter, Naves stressed, was of "utmost importance":

*I send in this letter clippings from our morning and evening editions on the death and burial of my very dear and valued friend, George Masa, a native of your country. His Japanese name, as nearly correct as I can ascertain, is included in these newspaper accounts, which also have all the information we are*

169

*able to obtain regarding Mr. Masa's past career and his birth and residence in Japan.*

*May I assure you that he was one of the finest and most noble characters I have ever known. The account of his burial in Riverside cemetery here describes to full extent the characteristics for which he was noted and loved by hundreds of men and women—many of them leading citizens—in this mountain section of our state of North Carolina. . . .*

*The purpose of this letter is to interest some member of the legation in an effort to locate if possible, the relatives or relative, if any, that survive Mr. Masa. It is my opinion that if he left any relatives, they reside in Japan. . . . He was indeed a genius.*

Naves' plea for help in locating Masa's family set in motion a search by the Tokyo police. On October 4, 1933, the superintendent general of the Tokyo Metropolitan Police Department, Shohei Fujinuma, reported that "the above-mentioned person is not registered under our jurisdiction, nor is there anyone at Meiji University, and therefore the whereabouts of his family is unknown."

Naves' mission in 1933 was "to learn more of the family, position and early life of Mr. Masa." Decades later, Masa's biographers are still pursuing the answers to that query.

When a man dies, he leaves behind in his office the tools of his trade—equipment, bulging file drawers, scattered correspondence—in his home, perhaps the keepsakes·and clothes, the glimpses of a personal life. A life unfinished.

Buncombe County appointed H. Kenneth Lee as administrator of Masa's estate. Lee's formal report to the court summarized Masa's possessions and his indebtedness: "There is property, consisting of photographic equipment and supplies, office furniture and various

books and papers, as shown by inventory heretofore filed in this cause. There is a file of negatives of mountain scenes, which from an artistic standpoint are very beautiful."

The inventory done by Miss Billie Daves chronicles Masa's professional life. There are photographs made for the Vanderbilts, the Cecils, and Fred Seely. Masa's copy of *Who's Who in America* must have guided him through the corridors of wealthy Asheville. Negatives of Camp Sequoyah and Mount Mitchell Motor Road are interspersed with scenes from the Cherokee Fair, the *Asheville Times* expedition to the Smokies in 1929, and the 1930 inspection trip with national park officials. Sequenced in with shots of flood scenes and aerial photographs were six folders of photos documenting golf, polo, football, and baseball games. A hunting bag, frying pan, and fishing pole hint at dozens of camping trips with Horace Kephart. Among the few personal items in the office inventory were Masa's Christmas card sent to friends and customers, an English–Japanese dictionary, and three effervescent bromides.

Lee, the estate administrator, calculated Masa's indebtedness as $1,633.96 with more than half that amount owed to the May family. Dr. Hugh M. May, who had served as one of Masa's pallbearers, was also his dentist; his mother, Mrs. Sallie May, provided lodging for the photographer at her home on Mount Clare Avenue, in a neighborhood north of downtown. With the hefty room and board bill of $886.95, which had accumulated over months as well as an overdue dentist bill, one can only assume that the May family had been generous and understanding of Masa's reduced circumstances. The administrator also itemized Myron Avery's $200 loan to Masa. Having no idea of the worth of Masa's equipment and photographic negatives, Lee consulted with others who estimated the value between $250 and $500. The photographic equipment listed in the inventory included a suite of lenses, filters, tripods, cases, and cameras along with rolls of 16mm motion-picture film and hundreds of "pictures" listed by name or subject matter, including over "240 8×10 prints of the Great Smokies."

In 1935, Arthur Stupka, a naturalist with Great Smoky Mountains National Park, examined Masa's extensive collection of more than 6,000 images, judging 300 to 400 park scenes to be "exceptionally

fine" and ordering 75 to be made into lantern slides. In 2023, Michael Aday, librarian and archivist at Great Smoky Mountains National Park, examined the Stupka lantern slides in the collection. Almost all of the slides are credited—e.g., Jim Thompson, Willis King, H. M. Jennison—but none are attributable to Masa or one of his studios. The fate of Masa's "exceptionally fine" lantern slides "will remain a mystery, I'm afraid," lamented Aday.

Another Asheville photographer, Elliott Lyman Fisher, arrived in Asheville in 1934, having relocated from Alaska where he'd been a successful professional operating Fisher Studio for the past decade. Fisher bought Masa's negatives, a purchase enabling him to quickly establish himself as a scenic and business photographer in Western North Carolina. Initially, Elliot attributed the purchased inventory to Masa but eventually sold the images under his own name. For the next two decades, Fisher practiced commercial and illustrative photography in Asheville. Before his move to Florida in 1958, Fisher offered his long-standing clients an option to purchase negatives related to their account. He wrote that "in my business there is little to sell except negatives and reputation," and he found it "hopeless to connect with anyone responsible who will take over." It's possible that some of Masa's negatives were sold; others could have gone to Florida along with Fisher's four decades of work. Given Fisher's frustration at finding a reputable buyer for his business, it may be that much of his Western North Carolina photographic legacy along with Masa's inventory was destroyed. Fisher died in 1969 in Port Charlotte, Florida. Despite significant research, none of the Masa images purchased by Fisher have ever been located.

Masa's correspondence, maps, and archives fared better. I. K. Stearns, good friend to both Kephart and Masa, purchased and protected Masa's paper documents, just as he had Kephart's. This collection included 125 maps, notebooks filled with nomenclature and trail data, scrapbooks, pamphlets and a few photos, "none of special value." Stearns' hope was that the park would construct a museum to house Kephart's camping kit, his archive of correspondence, and his library along with the Masa material. Although a park museum concept for

this material never materialized, Stearns' wish that it would be preserved was honored. Masa and Kephart's correspondence, maps, and some photos are archived now at Great Smoky Mountains National Park, Western Carolina University's Hunter Library, Buncombe County Public Library, and several regional museums and libraries.

Inevitably there are bits and scraps that don't make it into the estate sale but flesh out a story. Pulitzer Prize-winning author Louis Menand wrote that "the historian should never rule anything out. Everything, from the ownership of the means of production to the color that people painted their toenails, is potentially relevant to our ability to make sense of the past." One of Masa's notebooks, which we refer to as "the diary," gives hints at a life before Asheville—addresses in New Orleans, accounting notations recording ten-cent tickets for baseball games and five-cent sodas, the schedule for baseball training camps. Do the check marks beside the Pittsburgh Pirates and the Boston Red Sox suggest that Masa intended to visit their training camps in Hot Springs, Arkansas? Can we assume that Masa enjoyed watching baseball? Playing it? The jottings become possible clues—or perhaps red herrings.

After his death, the May family found a cache of letters written in Japanese in Masa's room. Although no one in the family read Japanese, they saved the letters because they liked the beauty of the *kanji* characters on the paper. Following the 2002 release of Paul Bonesteel's documentary *The Mystery of George Masa*, May descendants alerted Bonesteel to the existence of these letters and provided him with a photocopied set. Bonesteel commissioned a translation in 2007, but some sections of the photocopies were difficult to read and translate. A fragmented storyline and numerous names made the content difficult to understand and contextualize. It was clear, however, that the letters recounted someone's painful childhood, chronicled an immigrant's journey, and attempted to explain a shameful episode.

In spite of a subsequent search by the descendants of the May family in 2022, the family could not find the original copies of the

letters. Using software to enhance the legibility of the letters photo-copied in 2007, the authors then commissioned a modern transcription of the letters and a second translation. We came away with a litany of questions. Were the letters written by Masa? Sent to him? Are the sto-ries recounted in the letters fact or fiction? Can we verify any details? Identify the people? The biographer James Atlas wrote that "letters are the foundation of biography.... Uncensored and unsculpted, they often reveal a great deal about their author that the author may not have wanted known—or didn't know he was revealing."

We believe that these letters reveal a great deal about our sub-ject. Working with a specialist in Japanese genealogy, Linda Harms Okazaki, and a research team in Japan, we verified the existence of people mentioned in these letters—e.g., a lawyer named Fukaura and a Dr. Inoue—as well as elements of the stories mentioned in the let-ters. As we pieced together the fragments, we began to believe that the early history of George Masa was embedded in this correspondence, embodied in a person named Shoji Endo.

The letters—one addressed to a Mr. Matsui, a community leader in Portland, Oregon, in the early 20th century, and the other to a Mr. Miya-saka, a man who lived in the same West Coast boardinghouse as Shoji Endo—recount snippets of Endo's life in sequential paragraphs. They are written in the third person, the letter writer narrating the details of Shoji Endo's life. The correspondence reveals intimate biographical details about Shoji Endo. Like a ballad wherein each stanza discloses another aspect of the story, the author of these undated letters, whom we assume to be Masa, struggles with explaining and refining the complex narrative of Shoji Endo's life. These letters appear to be written in Masa's hand; one includes his signature and Asheville address. We assume these letters are drafts since the writer excised phrases and inserted revisions, but we don't know if polished versions of the correspondence were ever sent. If the letter writer were Masa, how would he know the thoughts and personal feelings of Shoji Endo's life in such detail?

The letters reveal that Endo's biological mother died of compli-cations resulting from childbirth and that the four-month-old baby was sent to live with an aunt. When the child was three years old, he

was adopted by another relative who lived in Shizuoka, a prefecture located along the Pacific coast of Japan midway between Tokyo and Osaka. With five main islands and thousands of smaller islands, the Japanese archipelago was in a period of rapid modernization when Endo was born in 1885. Dramatic changes in the political, economic, and social fabric during the Meiji era (1868–1912) transformed the island nation as it moved from a closed feudal society to a modern, industrialized nation. Japan opened to the world with trade, travel, and rapid economic development. Rigid class distinctions began to soften with the establishment of compulsory education and the dissolution of the samurai social class and its hereditary privileges.

Reared by his adoptive parents, Shoji Endo grew up in a household that was comfortably well-off and respectable, but as the letter writer explained, he "never really experienced warm love." His adoptive father, Yasushi Endo, a member of the former samurai class, was a lawyer; his adoptive mother was "an uneducated country woman" who treated Endo "coldly as just a stepson." In 1891, Endo's adoptive father purchased property located in a residential area of Shizuoka City from a famous photographer, Mizuno Hanbei. Views of Mount Fuji dominated the cityscape.

When Endo was a teenager, his adoptive parents added a second child to the family—a daughter, the youngest of three children whose mother (a relative of Endo's adoptive mother) had died. The adoptive mother doted on the young girl, whom the letter writer described as "a spoilt child, who wouldn't listen to her parents." A litany of challenges faced the young Endo, sibling rivalry perhaps being the most recent, but his loneliness was palpable. He was, in essence, orphaned a second time. His birth mother had died; his biological father was a man the child had been instructed to refer to as "Uncle." His adoptive parents were cold and removed. In a culture where patrilineal primogeniture was the norm, Shoji Endo would not inherit property or family wealth as his biological father's second son. As it was common in Japan for second and subsequent sons to be adopted by families without a male heir, Endo grasped that "a second son was just like a cat tail and had no place at home."

Shoji Endo attended the prestigious Shizuoka Middle School (now the Shizuoka Prefectural Shizuoka High School). Avoiding home and his adoptive family became the norm for the teenager: "After school, he would stay away from them until evening." His record showed that he excelled at sports but was a mediocre student in most academic subjects. The school's curriculum included traditional Japanese language, literature, and history classes, along with a variety of math and science courses. Endo's English courses ranged from dictation and grammar to reading, speaking, and writing.

Sometime after graduating from middle school, Endo moved to Tokyo. If he had time and money, he traveled and enjoyed mountain climbing. At 19, deciding his life in Japan was untenable, Endo applied for a passport. With his adoptive father's financial support, he boarded the SS *Doric* on December 28, 1904, headed for the United States.

The scholar Yuji Ichioka wrote about the wave of young Japanese people who came to the United States in his pioneering 1990 study *The Issei: The World of First Generation Japanese Immigrants, 1885–1924*. Lured by opportunity and intrigued by popular guidebooks, student workers came to the States to learn English, develop a skill, and find a career:

> *Their ultimate goal was to achieve success in Japan by applying what they learned and acquired in the United States. Prepared to endure hardships, many of these students had high ambitions, drawing inspiration from the Meiji creed of risshim shusse. This embodied the belief that anyone could realize lofty goals with dedication, diligence, thrift, and perseverance.*

Endo asserted that his motivation was different from the typical student worker. His was "to escape from the situation of being a stepchild."

Endo was foiled in his first attempt to liberate himself. The SS *Doric* arrived in San Francisco on January 13, 1905, but Endo, along with seven other passengers from Japan and one from China, were denied entry because of various medical ailments. Passengers were

screened for syphilis, trachoma, and hookworm. Given the conditions on board, it is not surprising that some passengers were sick. First-class passengers might have enjoyed luxurious accommodations, but "Asiatic steerage" was bleak. One young traveler described "a virulent stench, the wettish sweet smell of the steerage," which was

> a large room filled with bunk beds—often three or four tiers high. . . . There was no separate living space, so leisure time and meals were spent in the same room. . . . The reek of cooked food, body stench, and (if the seas were rough) vomit filled the enclosed space. Vermin and disease could spread easily.

One of the letters to Matsui explained that Endo had been denied entry to the United States and "was expatriated under the suspicion of a contagious eye infection." Our first clue that the letters to Matsui and Miyasaka revealed real events about a real person named Shoji Endo was a relevant record from the Board of Special Inquiry for the Port of San Francisco. In these reports, the medical officer diagnosed a passenger named Shoji Endo with trachoma. The board met to hear the case, affirmed the medical officer's decision, and deported the 19-year-old on February 2, 1905. This confirmation gave us confidence that information in the letters had some grounding in reality.

According to the translated letters, Endo's adoptive mother was no more welcoming to the returning young man than she had been when he was a child. "From now on, you had better take care of yourself. We are not going to help you with your school expense," she scolded. To support himself, Endo found a job in a publishing company; he also enrolled as a college student, possibly in order to avoid the draft. The letters describe Endo's hectic life that year: "He would leave his college cap at a coffee shop, attend a class for an hour or so, and then sneak out from the back gate, rush to the office to work as a journalist." Juggling the two roles was unsustainable, so Endo began planning his second escape. A friend and neighbor, Dr. Toyosaku Inoue, whose office was across the street from the Shizuoka Middle School, offered to help. Seeing promise in the young man, he

agreed to finance Endo's return trip to the States. On April 11, 1906, the 21-year-old was issued a new passport. He was ready to try again.

A request to Meiji University in 2022 to search the student records for the name "Shoji Endo" as well as variations of the name "Masaharu Iizuka" confirmed that there were no records or transcripts filed under any of George Masa's Japanese names but that a student named Shoji Endo had enrolled in preparatory classes at Meiji University in March 1905. Not surprisingly, Endo's academic career was short-lived. His attempt to juggle a job as a journalist with the responsibilities of a full-time student was ultimately untenable, and he soon withdrew from Meiji University. Shoji Endo's new passport, valid for a period of six months, listed Seattle, Washington, as his intended destination.

We know little of Endo's first four years in North America, but the 1910 US census shows that the 25-year-old Shoji Endo was living in a boardinghouse with a group of Japanese men, having arrived in 1907, according to the census enumerator. Whether the 1907 date relates to an error by the enumerator, relays incorrect information provided by another boarder in the household, or refers to Endo's arrival in the United States from Canada, we do know that, from 1910 to 1915, Shoji Endo lived in various cities on the West Coast. Among his fellow lodgers at the Seattle boardinghouse was a man named Motomi Miyasaka. It is Mr. Miyasaka, along with Mr. Matsui, to whom the Japanese letters found in the May house are addressed.

Motomi "Frank" Miyasaka was captain of Seattle's Nippon baseball team, "the oldest Issei team in the Northwest," according to Robert Fitts, baseball historian and author of *Issei Baseball: The Story of the First Japanese American Ballplayers* (2020). Fitts credits the arrival of baseball in Japan to the docking of the USS *Colorado* in 1871. In late October, nine sailors from the *Colorado* played against a group of American civilians living locally "on the cricket field known as the Swamp Ground for a game of baseball." The game soon caught on, fueled by middle school and university teams in Japan, athletic clubs, and international competition. By the mid-20th century, it had become the national sport in Japan. It did not take long for baseball to

establish itself in Japanese communities throughout the Pacific Northwest. As Fitts notes, "Between 1912–1914 Japanese ball clubs sprang up throughout the West Coast. Nearly every Japanese community soon boasted at least one amateur team. Most teams played pick-up games with nearby Japanese nines and local white amateur teams, but a few wanted to play in more competitive, organized leagues."

Star second baseman and later coach Tokichi "Frank" Fukuda believed that baseball "brought immigrants together physically and provided a shared interest to help strengthen community ties. They also acted as a bridge between the city's Japanese and non-Japanese population." Hoping that the common bond the baseball players shared would "undermine the anti-Japanese bigotry in the city," Fukuda also established youth baseball teams to further strengthen those ties. Often referred to as the father of baseball in the Pacific Northwest, Fukuda died in 1941, before having to endure the forced incarceration of Japanese Americans during the Second World War.

In 1911, the Seattle Mikado won the Northwest baseball team trophy. That same year, Endo and Matsui "reestablished the Portland Japanese Baseball Team," according to the Seattle-based *Taihoku Nippo* newspaper (the *Great Northern Daily News*). As captain of the Portland team, Endo also had a special training regimen: "Mountain climber Endo's Mikado style of training has given the team a great advantage, and all the Japanese in the city have joined the cheering squad." Team trainings focused on running and potential plays; in one timed competition among players from various West Coast teams, Endo was ranked "the fastest to start."

Manager Miyasaka wanted his team to be the first Japanese American baseball team to tour Japan and play ball with some of its best teams. He recruited talented players, hired as manager and coach an experienced minor league pitcher, George Engel, and planned a series of challenging games with professional teams in the Northwest League in the spring of 1914—all in preparation for the Japanese tour.

In spring 1914, Shoji Endo played ball for the Portland Mikado team; previously, he had been affiliated with the Seattle Mikado team. A visiting team from Montana, the Helena Union Association,

practiced in Portland's Vaughn Street Baseball Park. On March 30, the visitors and the Mikado met for a match. The game was a romp, according to the headline in the Portland *Oregon Daily Journal*—an embarrassing 20–0 shutout for the Mikado club team. Although the headline for the article was offensive—"Jap Tossers Let Helenans Grab 20 Big Fat Runs: Brown Men Can't Throw Ball Very Far"—Endo, the splendid center fielder, impressed the reporter:

> *The Japanese, though they lacked knowledge of the fine points of the game, played good ball, and with a season or two of practice they will be able to play a better brand. One of the weaknesses of the Japanese player is the inability to throw the ball very far. Endo, the Mikado center fielder, is a good player. He is a splendid fielder, and made the most sensational catch of the game, when he grabbed a drive from Stepp's bat in the fifth inning with one hand after a long run. Nogy and Ishi also played fair ball.*

The day before the game, the *Oregon Daily Journal* printed a photo of the team with Endo in center field. The resemblance between the "splendid fielder" and George Masa is startling. Other photos of the Mikado team members show a remarkable resemblance to images of the young George Masa in Asheville.

Members of the research team delved into the collection at the Baseball Hall of Fame and Museum in Tokyo while stateside we consulted with various baseball historians and scoured newspapers—both Japanese language and English editions—for photos and coverage of the teams. Tina LaFreniere, founder and CEO of Related Faces, used Rekognition software to analyze data points related to facial measurements on the photos—from the ears to the hairline, the chin to nose. For control, she ran known early photographs of George Masa against other known photos, then evaluated known images against the photographs of Mikado team players. We were excited when the facial-recognition software confirmed with a high degree of confidence—98.38 to 99.41 percent certainty—that the Mikado player and Asheville's George Masa were a match.

The software confirmed our hunch but turned our narrative topsy-turvy. No longer was the life of Shoji Endo a tangential backstory. Instead, it was the key to understanding George Masa's early life. We were finally beginning "to learn more of the family, position and early life of Mr. Masa." Shoji Endo and George Masa were indeed the same person.

George Masa was born on April 6, 1885, the second son of Mr. Takahashi, a Tokyo landowner. As the Japanese letters recount, his birth mother, whose name is not known, died when he was an infant, and he was adopted by Yasushi Endo, a prominent lawyer who lived in Shizuoka. Masa's loneliness as a second son, then as an adopted but unloved child, is reflected in the Japanese letters. He graduated from Shizuoka Middle School and then briefly attended Meiji University before leaving for the United States.

It is likely that Masa wrote at least some of his Japanese chronicles on a cold day in early January 1921. "It is getting late and snow is piling up. The heater in the room is not enough to cut off the draft. I long hesitated to bother you. But today I just had to write to you," he tells Yorisada Matsui, the trusted West Coast community leader, who was also an interpreter, language teacher, and journalist.

In early 1921, Masa was probably living with the Creasman family since the 1920 census lists him ("George Iizuka") as a boarder at their home on 626 Brookshire Street. Photos from the time reflect a lively household with Blanche (18 years old in 1920), Blake (15), Rachel (11), Doris (5), and a niece, Leila Pressley (15), who lived with the Creasmans. On that cold day when he drafted these notes to Matsui, Masa was overwhelmed with loneliness, burdened by his secrets and his responsibilities. It was the New Year, the most important holiday season in Japanese culture. Family and friends gather for special meals and celebratory traditions in Japanese communities. One can imagine the sharp contrast between the warmth of the Christmas holiday festivities of the Creasman family and Masa's sense of isolation.

Alone in his cold room, Masa might have turned to poetry to reflect on his solitary condition. Along with the correspondence to Matsui and Miyasaka, the May family found poems written in Japanese for the first days of the New Year. We do not know when they were written, but the last line of one poem, referencing "two thousand miles away southward," suggests they were written after he left the West Coast for the South. As the English translations reveal, many of the references in the poems are despairing: "Solitary life is hard and keeps me sleepless," "This is a world of dreariness, sadness, grudge and wail," "Tired of wandering around the dreamlike road and foggy bridge."

> *Looking back at the way I have passed,*
> *I see rough weaves and vortexes, . . .*
> *This is January, the fragrance of New Year sake is gone.*
> *The heavy head and tired body, rough breathing,*
> *Here I am, two thousand miles away southward.*

The story of how and why Masa arrived "two thousand miles away southward" is complex.

Most, if not all, baseball players in the amateur leagues held down day jobs while playing ball in the evenings and on weekends. Although the 1910 census showed Shoji Endo residing in Seattle, no occupation was listed for the 25-year-old. The Shizuoka Middle School alumni directory of 1911, however, reported that Endo had moved to Portland, Oregon, and was working as a newspaper reporter in 1910. The 1912 yearbook of the *North American Times*, a directory listing various Japanese community businesses and people, also identified Endo as a Portland resident.

While playing ball, Endo juggled various jobs, including as a bathhouse operator, according to the *North American Times*. Popular in Japan, public bathhouses, or *sento*, also dotted the streets of Japanese neighborhoods on the West Coast, side by side with barbershops, laundries, grocery stores, restaurants, and other basic services. *Sento*

were also social spaces, serving as gathering places for the community as well as offering the bather the opportunity to relax and recharge. It's likely Endo also operated a grill (perhaps a bar), since the *Morning Oregonian* reported on December 13, 1913, that his grill license had not been renewed.

Endo was handsome, popular, and . . . a baseball star. In one letter, he admitted he was a bit mystified that "he was so popular . . . [and found it] simply strange that people talked about him so much." In the Japanese letters, he portrayed himself as "a rustic boy," with no interest in the theater or pop music. Perhaps, he conceded, he was "outspoken," maybe still sported some of that "schoolboy attitude," but he didn't consider himself "such a playboy around the West coast."

The Japanese-language newspapers did, however. A tidbit in a gossip column in the *Taihoku Nippo* on March 12, 1913, characterized "Yama" Endo as a "longtime baseball contributor and lady-killer of the Portland Youth." Shoji Endo's nickname "Yama" or "Yam" appeared regularly in newspaper accounts and in the Japanese letters found at the May home. The word "yama," when spoken in Japanese, can mean mountain. The newspaper, published in Seattle, also reported that Endo had married his sweetheart, Hajime of Tokyo and Portland. Hajime, which is typically a man's name, was "a common professional name used by barmaids in that period," according to the historian Kazuhiro Oharazeki. Hajime's actual name was Tsuru Iizuka. Endo, who traveled regularly between Seattle and Portland, most likely for baseball as well as business, apparently had been smitten with Hajime for a while—"since her days at the Uraume," a restaurant with locations in Seattle and Portland, according to the newspaper.

Oharazeki discusses the important social role bar-restaurants played in Japanese culture:

> *For all classes of Japanese men, these bar-restaurants were important places to meet their friends and relax. . . .*

> *The barmaid's primary job was to entertain customers: serving food and alcohol, talking to them over drinks and dancing*

*and playing the samisen (a three-stringed Japanese musical instrument). Some literate women exchanged tanka, traditional Japanese poems, with their customers. Japanese barmaids were similar to geisha in that they not only sold sexual favors but also entertained customers with artistic skills. The precise number of women who turned to prostitution while working as barmaids is subject to debate. Typically, barmaids were married women who entered the trade due to financial and family problems that developed after they arrived in North America.*

We have few details about Tsuru Iizuka, but we know she was "a pretty well-dressed woman," according to one newspaper account. She'd been married to Ben Shizuno Kono (or Kohno) for five years but filed for divorce after he'd abandoned her to work as a fisherman in Alaska. She had not heard from him since he left in spring 1912, nor had he provided her any financial support, forcing her to work in a hotel to support herself. The *Sunday Oregonian* reported that the court proceedings were unusual—"one of the few Japanese divorces ever granted in Portland"—not because divorce was uncommon in Japanese society (normally they were documented in the *koseki,* the family registry), but few had been processed through the American court system. The newspaper suggested that "all the American customs necessary to the occasion were observed." Mrs. Kono, wearing "fashionable, well-fitting American clothes," had an interpreter and a corroborating witness to her husband's desertion. Yorisada Matsui, recipient of Endo's letter, served as her official interpreter for the proceedings. The judge granted the divorce and agreed to her request to revert to her maiden name, Iizuka.

The *Oregon Daily Journal* reported that Endo and Iizuka were issued a marriage license on October 9, 1914, another of the "American customs" the handsome couple followed. In Japan, they would have registered the marriage and divorce in the family *koseki*; perhaps this is what occurred the previous year when the *Taihoku Nippo* announced in a gossip column the marriage of Endo and Iizuka on March 12, 1913. But, here in the States, Iizuka secured her divorce

through the courts while the modern couple applied for a marriage license through the state to ensure the legality of their union.

As far back as 1905, when Waseda University arrived for its first match against Stanford University, Japanese baseball teams had been touring the United States while American university varsity teams traveled to Japan. In August 1914, the Seattle Nippons left for an eight-game series against Japanese universities. Endo's friend Miyasaka, who played first base and served as team manager, was on that trip. But, Shoji Endo, the "the splendid fielder" on the Oregon team, was not. He had served as manager of the Seattle Mikado team the previous year, but he was not on the roster for the trip to Japan. Was he injured? Perhaps the almost 30-year-old did not make the cut for the all-star team.

What happened next is as mysterious as it is puzzling.

Both the Japanese letters and the news articles in the *Rafu Shimpo* newspaper refer to a financial impropriety involving $1,500, money earmarked for the players' travel back to the States. Endo seems to have played a role as money manager for the team. The news item in *Rafu Shimpo* (January 29, 1915) accused Endo of "pretending" to send the money to the team members; the chief secretary of Seattle's Japan Association demanded an explanation as well as the return of the funds. The baseball players, stranded in Japan and forced to find enough money to cover their own passage back to the States, were furious, blaming Endo as well as team manager Miyasaka for entrusting Endo with the funds.

Ashamed, unable to return the funds, Endo must have felt he had no choice but to flee. According to the newspaper report, he left a suicide note and headed to Los Angeles. *Rafu Shimpo* reported that his next step would be the Sierra Nevada mountains where he intended to end his life.

The letters to Matsui and Miyasaka provide some additional background from Endo's perspective. As a letter explains, it was Endo's goal "to bring success to you all [presumably the team but

possibly the community] but his good intention failed." He declared that he "died once to apologize for his sin and intended to live again to fulfill his responsibilities."

According to the letters written to Matsui and Miyasaka, Endo believed that he had been deceived, tricked by "the cunning conspiracy" of Masajiro Furuya and Ototaka Yamaoka. Prominent businessmen in the Northwest in the early 20th century, Furuya and Yamaoka were wealthy and powerful figures in the Japanese community and in the larger commercial world. Endo's adoptive father, Yasushi Endo, knew Yamaoka, having served as one of his attorneys when he lived in Shizuoka.

The M. Furuya Company was an important exporting and importing business in Seattle with branches in Vancouver, Portland, and Tacoma. Yamaoka established the Oriental Trading Company, a major labor contractor in the Pacific Northwest, and owned a prominent newspaper, *Shin Nippon*. Yamaoka became Furuya's right-hand man when he joined the Furuya company in 1914. Although achieving great professional success in the Pacific Northwest, each had a shady past. The foundation of Furuya's thriving enterprises had been built on the financial earnings of prostitutes. According to the historian Oharazeki, Furuya served as a kind of "private banker" to workers in the sex trade. Early in his career, when Furuya had accumulated enough capital, he opened a grocery store in Seattle—the first of his many enterprises, which ran the gamut from banking to department stores. Yamaoka made counterfeit passports to supply the railroad and agricultural industries on the West Coast; in Japan, he had been arrested and jailed for an assassination plot before fleeing to the United States.

*Rafu Shimpo* followed up with a second article about Endo on March 7, 1915. Now, the headline (in translation) read "Shameless Certain Mr. Endo." The newspaper reported that Endo had sent "fake last notes to many people in order to avoid payment." The source of this revelation was a rumor that Endo had mailed a subsequent letter to his wife requesting that she send him $100 "after the problem was solved." Now the rumors flew. Endo had not died in the Sierra

Nevadas. He was alive "in the East" and in need of cash. The *Rafu Shimpo* column ended with a public rebuke: "It is extremely shameless of him if this is true."

Among the Japanese correspondence found by the May family was a letter written by team manager Miyasaka to Hajime Endo, the professional name of Endo's wife, Tsuru Iizuka. In this letter, probably composed in February 1915, Miyasaka pleaded with Hajime Endo to help him pay back the debt. The $1,500 belonged to the group—not to Miyasaka, not to Endo. As team manager, Miyasaka had had "to advance about two hundred yen of my personal money to the group in Japan" and another hundred dollars once the group was back in the States in order to cover expenses. Miyasaka wrote that he was stressed and "constantly worried." Endo and Miyasaka had been close, like brothers, but while Miyasaka was sympathetic, he could not assume responsibility for Endo's debt.

Miyasaka also had to explain the situation to the players. Although the team recognized that Miyasaka was not to blame, the players were angry. He recounted to Hajime:

> *They persisted in such absurd logic that I was wrong in trusting Endo and handing the money over to him. They shouted that if Miyasaka does not pay them back, they will throw me into jail. I felt so miserable. I never touched one cent of the group money myself. . . . I finally was pardoned on the condition that I return three hundred and fifty dollars, one third of the one thousand three hundred dollars [sic] the members lost.*

Miyasaka was able to borrow $350 from Mr. Furuya, the banker, businessman, and, according to Endo, the man who tricked him into losing the $1,500. Furuya insisted on 12 percent interest and a $20-per-month repayment plan. This payment schedule would take him "15 months or so of hard work in order to raise the amount I owe," groaned Miyasaka. He begged Hajime Endo to "pay back what little amount you can afford on a monthly basis. . . . Indeed, I feel like the debt of three hundred and fifty dollars is squeezing the blood out of my body."

Miyasaka alludes to previous correspondence so we can assume that this letter to Hajime was from a series of letters written around the same time between Miyasaka and Endo's wife—although no other letters were found. Miyasaka wrote that he shared her correspondence with the players, along with Endo's last note, presumably the suicide note. Since the May family found the correspondence between Miyasaka and Hajime Endo in Masa's room, our assumption is that Hajime forwarded Miyasaka's letter to her husband. Perhaps there were other letters that were not kept.

In spite of significant effort, we've not been able to untangle the reasons Endo might have taken $1,500 belonging to the team. Did it have something to do with his new wife, Tsuru Iizuka? Did she need the money? Other than a handful of scattered references in Japanese language newspapers, we know few details about Tsuru Iizuka. According to *Rafu Shimpo*, she worked as a barmaid in another Japanese restaurant, Kikutei, in Los Angeles in 1915, still using her professional name, Hajime.

Was Endo being blackmailed? Had Furuya and Yamaoka convinced him to invest in an enterprise that was shaky? That failed? How had he been tricked? And, what were the circumstances? In one letter fragment, Masa wrote that "Yama could not admit his having been deceived by 'furu tanuki' [old farts/badgers]."

In attempting to understand a life, we often have only snippets of information. We cannot interview Masa or Miyasaka, nor do we have Furuya or Yamaoka's account of the financial transaction involving the $1,500, not a trivial sum, equivalent to almost $47,000 in 2024. Instead, we can only follow the clues and then try to interpret an incident within a lifetime of other events.

Soon after the events recorded in the letter from Miyasaka to Hajime, Shoji Endo was on a train headed east. Escaping the men whom he believed had tricked him, escaping the shame, Endo determined to start a new life. He left the security of the Japanese communities, left his friendships, left his wife. A new man with a new name arrived in New Orleans on January 24 and Asheville, on July 11, 1915. In his diary, G. M. Iizuka practiced his signature on a blank

page, his repeated cursive signature cementing his new identity. Using his wife's last name, George Masaharu Iizuka "intended to live again to fulfill [Endo's] responsibilities."

One wonders whether it was this story that George Masa sought to reveal on his deathbed. Was this why he had asked his friend Barbara Ambler to come to the Buncombe County Home and Sanitarium on June 20, 1933? Had he hoped to explain his background, divulge his original name, ask her to notify a family member? Another letter found in the May home was written by a person named Shigeko. Dated simply February 21, Shigeko's letter refers to previous correspondence from Masa, written "on a snowy day in mid-January." This suggests that Masa—at least initially—stayed in touch with some family members or close friends in Japan. Shigeko makes reference to family news and urges Masa to continue writing. Consider me your elder sister, she writes, "I am very much looking forward to remembering shared memories and hearing about Yama." Shigeko ends her letter wistfully:

> Seas, mountains, rivers may divide us afar.
> But in my dreams I meet you always.

James Atlas asserted that the biographer's purpose is to show what other factors—besides genius—contribute to the making of a creative person's life. We understand that we can never capture the whole story—cannot interview the principals, recreate the context—but we can try to imagine and understand the situation. We can also speculate on how these newly discovered details provide insights into the man who has been called the Ansel Adams of the Smokies.

We can imagine the challenges Shoji Endo faced in leaving the Pacific Northwest. Since his arrival in North America in 1906, he had lived in cities with large populations of Japanese residents, sharing a common language and culture. He'd roomed with friends, enjoyed

the close camaraderie of ballplayers. All that changed in the winter of 1915. Now his teammates saw him as a thief; the community viewed him as a coward. Unable to pay back the money, he felt he had no choice but to flee, landing first in New Orleans, a stranger in a southern city. With no promising job opportunities in Louisiana, he soon headed to Asheville. Only two Japanese persons are listed in the entire state of North Carolina in the 1910 census and only 50 in the South Atlantic region from Delaware to Florida.

George Masa went on to forge a new identity for himself. He fashioned a new profession and found a sense of family with the Creasmans, and a feeling of community with the Carolina Mountain Club. He built a deep friendship with Horace Kephart—a man, like Masa, who had come to the mountains to begin again. Unlike Kephart, we have little of Masa's writing, mostly business correspondence or detailed notes on trails and nomenclature. These Japanese letters are different. They are Masa's attempt at autobiography.

One wintry night in 1921, Masa took stock of his life. Six years had passed since he had left the West Coast. Perhaps he was trying to make sense of himself, no doubt hoping to explain himself to his friends, Miyasaka and Matsui, the intended recipients of the draft letters. To a certain extent, he is also confiding in us, explaining the "rough weaves and vortexes" of his life. Masa had retained these letters for years—packing them up as he moved from the Creasman household to rental apartments and eventually to the May household. They were links to his past, connections to friends and family, a haunting reminder of the pivotal events that led him to Asheville.

Quoting Shakespeare, "Frailty, thy name is woman," Masa inquired after his wife in one of these translated letters. Was she still a barmaid, he asked Matsui? "I feel sorry for her. She was tossed in waves of hardship in this world and must have had a hard time after Yama's death." Tsuru (or Hajime) had been abandoned by her first husband and now her second. "Indeed this world is too hard for frail women," Masa wrote.

The financial scandal also ended Miyasaka's baseball career. "Miyasaka Leaves Baseball Club" read the *Taihoku Nippo* headline on

February 23, 1915. Cutting all ties with the team he once had nurtured, the former manager cited "personal reasons" for his decision. Given the acrimony expressed at the team meeting with Miyasaka, following the team's return from Japan, it's not surprising that Miyasaka would be forced to resign. It was a better option than being thrown in jail, as the players had threatened. A few years later, Miyasaka opened his own tailoring shop.

Masa regretted the trouble he had caused his friends. "I believe it was a heart-breaking business for you and Miyasaka and Takano to take care of the aftermath," he wrote to Matsui. But he wanted his friends to know that the newspaper articles about a certain "shameful Endo" were not the whole story. From his perspective, he had been tricked by the "greedy money lender." Had he the talent of a writer, he asserted, he "would write a novel based on a true story that is extremely tragic and more dramatic than real life."

A novel could certainly flesh out his story, but even without these details, the pathos and drama of Masa's life experiences are intense. The Japanese letters revealed his unhappy childhood, the money scandal, and some of the "other factors" referred to by Atlas that influence a person's life. Research uncovered his baseball career, his short-lived marriage, the anti-Asian sentiment brewing on the West Coast. His Asheville life added more drama and new challenges: government case files documented Seely's suspicions, then scrutiny by the Bureau of Investigation. Newspaper reports disclosed his targeting by the Ku Klux Klan. Masa's attempts to borrow funds hint at his desperation in the midst of the 1930s economic depression. This is a real life. This is a "true story that is extremely tragic and more dramatic" than most. Yet, it is Masa's strength, his ability to persevere, that is remarkable. Some might have crumbled.

Masa confided in one of the Japanese letters that it had been his intent all along to bring success—not shame—to the community. Did this intent drive his ambition, particularly after he left the West Coast? Was his selfless dedication to the establishment of Great Smoky Mountains National Park and the Appalachian Trail driven—at least in part—by his quest to bring success to the community?

The Smokies were "a project and an area dear to the heart of this little genius from Japan," Masa's friend Glen Naves explained in his 1933 letter to the ambassador. The lure of the mountains had been a constant throughout Masa's life. When he had time and money as a young man in Japan, he went mountain climbing; in his abbreviated sojourn to Colorado, he scaled Cameron Cone. The wall map in his Church Street office in downtown Asheville depicted the hundreds of trips he'd made to the Smokies in order to capture nature's spirit, the terrain, or the potential of a trail. The reporter Lola Love wrote,

> *The map brings to his mind the beauties of the journeys which are past and unfolds before his eyes some of the wonders which he may expect on trips to come. If everything else were taken from him, he says, there would still be contemplation and beauty enough—set free by study of that map, to fill all the days and to console him for whatever other losses there might have been.*

The losses were significant—a homeland, a family, a wife, a culture, Pacific coast friends. He started over in Asheville, but the past, as recorded in the Japanese letters and poetry, stayed present. Perhaps the past haunted him. It may also have inspired him to bring success to his community.

Masa's photography, cartographic efforts, and his trail work were done in support of his adopted homeland—"out of sheer loyalty to the park idea," Kephart asserted. The photographer showcased a landscape to a nation whose residents needed to imagine its beauty. Only in seeing its grandeur—in person or captured in a photograph—were politicians, citizens, philanthropists, and school children inspired to act. Masa tunneled through thickets of rhododendron to verify placenames and scout routes for the Appalachian Trail. These, too, were gifts to the community. "Time flies," he wrote in 1921—but he hoped, as he confided to Miyasaka, "to show big success to you as soon as possible." It would take more than another decade to achieve that goal, but it would come with the establishment of Great Smoky Mountains National Park and the completion of the Appalachian Trail. ·

Masa's dedication inspired his contemporaries; it continues to inspire us today. As Naves explained to the Japanese ambassador, Masa was no ordinary person:

> *May I assure you that he was one of the finest and most noble characters I have ever known. The account of his burial in Riverside cemetery here describes to full extent the characteristics for which he was noted and loved by hundreds of men and women— many of them leading citizens—in this mountain section of our state of North Carolina. His death has saddened me and has left a vacancy in Asheville that cannot be filled.*

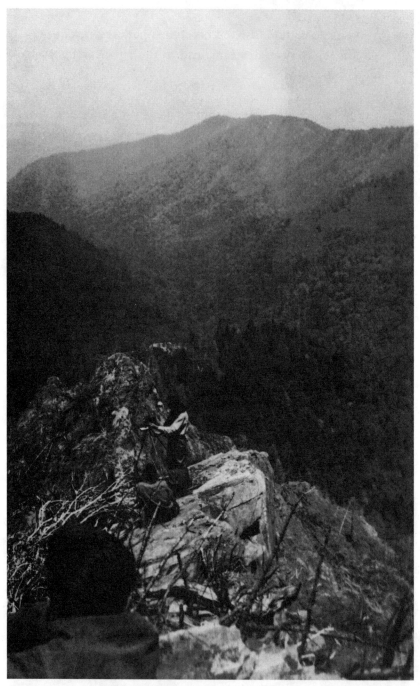

George Masa photographing Mount Le Conte on one of the knife-edge ridges near the intersection of Boulevard Trail and the main Smoky divide. *Jewell King scrapbook, Wilson Special Collections, University of North Carolina/Chapel Hill*

## CHAPTER NINE

### *Something of a Legend*

*"And Masa, mystery man of the mountains,*
*is already becoming something of a legend."*

~*Detroit News*, October 14, 1934

There are 920 species of lichen in the Great Smoky Mountains National Park making it "the most lichenologically diverse National Park in the United States," according to Erin Tripp and James Lendemer in their book, *Field Guide to the Lichens of Great Smoky Mountains National Park* (2020). Lichens, miniature ecosystems composed of a fungus and an alga and/or cyanobacteria, are complex and ubiquitous organisms.

"Lichens grow on anything that sits still long enough, including you, when your time expires," assert Tripp and Lendemer. Although we see them everywhere—on the trunks of trees, on bare rocks, fenceposts, and rooftops—we seldom stop to admire or even notice them. They are food for flying squirrels, nest-building material for

hummingbirds, and air quality bio-monitors for humans. Although they are "fundamental contributors to ecological processes," we are still learning much about these tiny alchemists.

The taxonomic name for one of these newly discovered lichens in the Smokies is *Lecanora masana*. Growing on the bark and branches of fir trees and hardwoods in the high elevations, *Lecanora masana* has circular yellow-orangish fruiting bodies, a feature inspiring its common name, Masa's Dots. Many of the other whimsically named species in the genus *Leconora*—Dumpy Discs, Elizabeth's Eyeshadow, Alabama Sunset, Doll's Eyes, Lost My Margins, Exposed Henry, and even Rhubarb Pie Lichen—have a much broader range, some found as far away as British Columbia; others are common along the East Coast. But, like Kephart's lichen, *Kephartia crystalligea* (Horace's Ramble), Masa's Dots is endemic to the Smokies: "You won't ever see it in any other ecosystem, that is, anything lower in altitude in the southern Appalachian Mountains." *Lecanora masana*, the authors write, is one of the "numerous secrets of the Smokies that puzzles us as much as anyone."

Tripp and Lendemer marvel at the diversity of lichens in the Smokies: "How are there so many species endemic to this small area? How is it that this species [*Lecanora masana*] went unrecognized for so many decades?" Botanists, ichthyologists, ornithologists, herpetologists, entomologists, ecologists, and biologists of all stripes have asked similar questions, awed by the variety of plant and animal life in the Smokies. Its uniqueness was key to Kephart's rationale for creating the national park. Writing to his congressman in 1924, he argued that the Smokies are "the most varied forest in the world" and "one of the richest collecting grounds for botanists in the United States." Kephart was channeling Asa Gray when he wrote that the botanist identified "a greater variety of forest trees than could be found in crossing Europe from England to Turkey or going across our continent from Boston to the Rocky Mountain plateau" during his 31-mile hike in Western North Carolina in 1840. Almost 170 years later, George Ellison created a two-volume anthology of nature writing published between 1674 and 2009. Each of the authors represented in *High Vistas: An Anthology of Nature Writing* extolled the diversity and splendor of the

Smokies and Western North Carolina. No doubt Ellison could have amassed a third volume covering the next decade.

The Smokies are a biodiversity hotspot, designated an International Biosphere in 1976 and a World Heritage Site in 1983. In 1998, the Smokies All Taxa Biodiversity Inventory (ATBI) was launched to catalog all species of living organisms found in the national park. Focused on four research fronts, the Smokies ATBI is identifying the species in the Smokies and their geographical distributions, abundance, and ecological relationships to other species. Scientists estimate that there are 60,000 to 80,000 species in the Smokies, but 65 to 75 percent are still unknown. Yet it's not the megafauna—the bear or the elk—nor the heritage trees or showy wildflowers that make up the mass of the Smokies biodiversity. It's the little guys—the insects, spiders, snails, lichen, and fungi—that comprise 84 percent of the total Smokies biodiversity, a feature critical to the ecosystems of the region. "If we want to be good stewards of our environment and keep the world around us healthy and vibrant, we need to understand the web of biodiversity," said Todd Witcher, executive director of Discover Life in America (DLiA), the organization that manages the Smokies All Taxa Biodiversity Inventory focused on this goal. It's an all-hands-on-deck kind of project. Scientists such as Tripp and Lendemer are key components of this initiative, but DLiA also recruits students, interns, and citizen scientists to help.

That this biodiversity hotspot was saved from destruction, protected from logging or development, is attributable to the men and women who fought for its establishment as a national park. Masa was a significant figure in this conservation effort and is considered one of the founders by the National Park Service. His photographs documented a hidden landscape where few outsiders had ventured. Chambers of commerce selected Masa's images; his photos were sent to governors and a First Lady. Even after Masa's death, his photographs were included in a gold-embossed leather album presented to President Franklin Delano Roosevelt. Unfortunately, none of these albums has been found in any archive or library despite the diligent efforts of curators.

Ansel Adams, considered America's greatest landscape photographer for his iconic images of Yosemite and the Sierra Nevada, came to the Smokies in 1948. Unfamiliar with the dense forests, haze, and unpredictable weather, Adams lamented, "The Smokys [*sic*] are OK in their way, but they are going to be devilish hard to photograph." In *Pictures for a Park: How Photographers Helped Save the Great Smoky Mountains* (2016), Rose Houk reports that Adams visited the Smokies in October for about a week, making 47 images, but only four were ever published. Masa captured thousands, sold hundreds, and published dozens of his images. Edward J. Beck, a writer for the *Detroit News* who spent his vacation weeks in the Smokies, described the exertion required to capture a photo in these devilishly difficult mountains:

> *Masa only weighed about 115 pounds yet he had the fortitude to lug 60 pounds of camera equipment to heights too steep for ordinary, unencumbered persons to climb. An 8 by 10 view-camera with a complete set of filters reposed in one carrying case. Another case held plate-holders with a tripod strapped to the side. When a photographer drags equipment half his own weight to a mountain top, he shows a fairly serious interest in his art.*

It was not the herculean effort that most impressed Beck. It was instead Masa's photographic skills that were legendary. The Smokies "have scenery to knock your eye out," he wrote, but he knew of only one photographer who could truly capture its essence:

> *Camera clicks are as numerous as cricket chirps in the Land of the Sky but the pictures might as well be of the Ohio River bluffs or the bantam Kentucky mountains. . . . But the photographs—even the best of them—do not make the prospects gasp 'oh' and 'ah' as they are supposed to do if and when they finally arrive. . . . As press time approaches, the planners of the booster books always have one 'out.' They can fall back on the negatives made by the late George Masa, who died a year ago. This frail Japanese*

*expatriate established such a psychological rapport with the*
*mountains, that he might almost be described as the little brother*
*of the Smokies and the Blue Ridge. This intimate familiarity, he,*
*more than anyone else, succeeded in putting on film.*

Lola Love, columnist with the *Asheville Citizen*, echoed Adams' and Beck's remarks on the challenge of capturing mountain scenery but she also compared Masa's artistry to traditional Japanese painters, particularly in the photographer's ability to evoke distance and depth and his skillful use of the silhouette. Love believed that Masa's photos "set the mind to think and dream."

But why, as Beck asserts, was Masa already becoming something of a legend in 1934? And, secondly, what drove him—a man not naturalized, a man who endured scrutiny from the Bureau of Investigation, harassment from the Ku Klux Klan in the 1920s, and the collapse of the economy, his business, and his health in the early 1930s—to dedicate himself to national initiatives, such as the establishment of the national park in the Smokies and the routing of southern portion of the Appalachian Trail?

For the Carolina Mountain Club, it was the essence of the man— his kindness, his generosity, his dedication, his knowledge, his talent, and his contributions—that were legendary.

In the midst of the economic depression affecting all of Asheville, his friends in the Carolina Mountain Club contributed the funds to pay for his funeral, casket, and interment. In 1947, following the explosion of the Second World War, Carolina Mountain Club minutes record that a simple 1×2-foot marker for George Masa was installed. Today, Masa's gravesite is a stop on the historic tour of Riverside Cemetery, along with the gravesites of senators, governors, generals, artists, writers including Thomas Wolfe and O. Henry (William Sydney Porter), and even some of Masa's clients such as Biltmore Estate Superintendent Chauncey Beadle. Admirers leave lucky stones, photos, aperture settings, and trinkets on Masa's grave marker.

Bryson City friends petitioned to reinter Kephart's remains on the top of Mount Kephart; Masa's Carolina Mountain Club friends

launched a similar initiative in Asheville. Both drives to reunite the "congenial companions" in adjacent plots failed when neither scheme gained support from the National Park Service. To honor Masa's wish to be buried next to Kephart and a similar hope expressed by Kephart's wife, Laura, Libby Kephart Hargrave, great granddaughter of Horace Kephart, led an effort to install companion markers in the Bryson City Cemetery in 2023.

Kephart had once declared that Masa deserved a monument for his efforts on behalf of the Smokies, particularly his work on mapping, nomenclature, and trails. In 1937, five years after Masa's death, members of the North Carolina nomenclature committee for Great Smoky Mountains National Park proposed "that recognition be given the work of George Masa by naming some landmark in his memory." The group proposed that False Gap be renamed Masa's Point in honor of Masa's dogged determination and erstwhile efforts to untangle a decades-long nomenclature misnomer.

Nothing concrete emerged from this 1937 proposal. Earlier initiatives mentioned in both the Asheville and Knoxville newspapers also fizzled out. Twenty-five years later, it was Samuel Robinson, an Asheville optometrist and active member of the Carolina Mountain Club, who succeeded in honoring Masa with his own bit of nomenclature. The club's resolution, passed on May 11, 1960, called for designating a peak "Masa's Pinnacle," "in commemoration of the stranger who stirred us to such depths of love for our wilderness." For the next four months, as chair of the club's George Masa Memorial Committee, Robinson went to work, writing dozens of letters to park officials, hiking groups, and elected representatives. A steady stream of articles and notices in the Asheville newspapers kept the public informed, the initiative visible, and bureaucrats on their toes.

The club proposed a peak adjacent to Charlies Bunion, but the idea collided with the perspective of Tennessee's Great Smoky Mountains Conservation Association. The association's report sent to Fred J. Overly, then superintendent of Great Smoky Mountains National Park, laid out the objections. First, Charlies Bunion was too small an area to divvy up into two. "To give one of those tiny points a separate

and unrelated name would be . . . ridiculous," the report stated. The two adjacent peaks were both Charlies Bunion, they asserted. The association's second gripe was more subjective:

> *It is the conviction of the Committee that, although George Masa was a likeable man, an artistic photographer, and a man who was keenly interested in the Mountains around Asheville and in the Great Smokies, his contribution to the Park movement, in comparison with the work of many others, was negligible. Many North Carolinians and an equal number of Tennesseans who did far more for the Park movement have not been honored in any such manner. It is, therefore, the recommendation of the Committee that naming any point along the state line, or main crest, of the Great Smokies for Mr. Masa would not be justified.*

The report ends with a suggestion that it would be more appropriate "to find a spot on the North Carolina side, either inside or outside the Park."

Characterizing Masa's contribution as "negligible" had to have rankled the members of Carolina Mountain Club. Robinson ignored the roadblocks outlined in the Great Smoky Mountains Conservation Association's report, interpreting them as yet another instance of interstate rivalry. Undeterred and politically savvy, he enlisted the support of North Carolina's two senators. He followed up with letters to officials at the National Park Service and secured the support of his congressional representative, Hon. Roy A. Taylor, who offered to meet with Superintendent Overly "so that we can lay out our case before him."

North Carolina's state senator William Medford—chair of the North Carolina National Park, Parkway, and Forests Development Commission—attended a meeting with Overly, who explained his objection to the bifurcation of Charlies Bunion. Medford advised the club to switch tactics and locate a different peak in the Smokies to honor Masa. The Club met on August 1, amending their proposal. As an alternative, they proposed

*an unnamed peak situated over half a mile west of Dry Sluice Gap and beyond the Charlies Bunion Group . . . a heavily wooded knob rising to an elevation of 5600 [feet]. . . . The Appalachian Trail skirts around the north side of the peak ascending from the Charlies Bunion group and descending beyond the peak to the state line at the lead to Mount Kephart. The peak shows up prominently when viewed from Richland Mountain on the North Carolina side of the Park. We would like to have this spruce-clad peak—at present without a name—designated as Masa Knob.*

Robinson was indefatigable. He sent the revisions, the justifications, and Masa's biographical sketch—along with a new article about Masa that had been published in the magazine *The State*—to Conrad Wirth, then director of the National Park Service, with copies filtered on down through the chain of command.

Robinson hammered home his point in a letter to J. O. Kilmartin, chair of the Board on Geographic Names:

*The Great Smoky Mountains National Park does not belong to North Carolina. Neither does it belong to Tennessee. It belongs to the people of the United States. We have to rise above state rivalries in memorializing people who have stimulated us in the appreciation of the scenic grandeur of these mountains. The late Horace Kephart, an Ohion [sic] who was also a member of the Carolina Mountain Club was memorialized by having a peak which is mostly in Tennessee named Mount Kephart. George Masa who was neither North Carolinian nor a Tennessean—not even an American—well deserves to have his name commemorated. Both of these men happened to start their expeditions from the North Carolina side of the mountains. What more fitting memorial can there be than the naming of this small peak described as nestling against the North Carolina Face of Mount Kephart.*

Robinson also sent the packet of materials to Carlos Campbell, a member of the Great Smoky Mountains Conservation Association

in Tennessee. It was Campbell who had penned the association's objection to the original Carolina Mountain Club proposal, he who characterized Masa's contributions as "negligible." In responding to Robinson, Campbell assured him that the association's objection was not prompted by "interstate rivalry," protesting that "the Great Smoky Mountains Conservation Association, although composed entirely of Tennesseans, is and always has been concerned with the Park as a whole, not as two competing halves." To reinforce his point, he copied his response to all the interested parties in the National Park Service and the Board on Geographic Names.

Robinson then arranged a meeting—a meeting that would include Congressman Taylor—with Superintendent Overly on September 22 at the Oconaluftee Ranger Station. Ten days later, the *Asheville Citizen-Times* headline read that there would be a "hearing on naming of a peak for Masa," at which several members of the Carolina Mountain Club would present their case to Superintendent Overly. The article stated that, although Congressman Taylor would not be able to attend, he was sending his resident secretary, Thomas L. Mallonee, in his stead. The press's announcement of a public hearing took Overly by surprise. The superintendent averred that it could not be a public hearing because the opposition had not been invited, but Robinson's ploy revealed his public relations strategy. He was keeping the issue in the public eye, holding public officials accountable. Robinson would not let the issue wither in a bureaucratic morass.

Overly made no commitment on the proposal but suggested a decision be delayed until after the October meeting of the North Carolina National Park, Parkway, and Forests Development Commission. When that group failed to meet, lacking a quorum, Robinson swung into action again. Finally, in January 1961, Robinson's campaign to honor Masa succeeded. "The way was paved Tuesday for naming a peak in the Great Smoky Mountains National Park as a memorial to the late George Masa," wrote John Parris in the *Asheville Citizen*. The North Carolina National Park, Parkway, and Forests Development Commission approved the proposal jointly submitted by the Carolina Mountain Club and the Western North Carolina Associated Communities.

Overly had no choice but to submit the official request to the Interior Department's Board on Geographic Names. Parris reported that Overly "saw no reason why the board would not take favorable action." Overly requested a short biography of George Masa and "seven prints of a photograph of the mountain in question." It was that latter request—made in January—that proved problematic. Given the "present depth of snow along the summit of the Smoky range," the club announced that it would be "possibly several weeks before we can get all the information required by the Bureau." The club planned "to measure and pinpoint the location" on Sunday, March 5. Two days later, Robinson summarized the club's findings in a letter to Overly, including a few photos taken in late February. Robinson's correspondence—always polite, courteous, and peppered with occasional anecdotes—finally succeeded in moving the initiative forward.

Parris wrote a follow-up piece, acknowledging that "they're getting around at last to perpetuating the name of an unforgettable little man from the Land of the Rising Sun who first captured the mood and magic of the Great Smokies with a camera." Parris ends his article with the club's rationale for this effort:

> As so often happens, most folks soon forget when a man dies how he walked upon the earth unless he cast a long shadow that caught the eye. George Masa walked quietly upon the earth, doing things that were neither spectacular nor unusual. But all who knew him remember him as a great little guy. . . . George Masa roamed the Great Smokies for nearly 20 years. He was the first to measure many of the trails and chart the fastnesses of the Great Smokies. The Great Smokes were his love. They were his temple and his life.

On April 25, 1961, the *Asheville Citizen* announced that it was official. The US Board on Geographic Names approved "Masa Knob" in honor of George Masa. After nearly a year of intense work and unceasing commitment, reams of correspondence, and the coordinated effort of the press, club members, a network of business and personal

relationships, the initiative had succeeded. We have no record of Robinson's reaction but can imagine a standing ovation from the members of the Carolina Mountain Club. Nearly three decades after Masa's death, club members were willing to fight for what they believed was a long-overdue recognition for their friend. Thirty years later, Parris was still writing about Masa and Kephart's contributions: "Few Men Have Ever Known Smokies as Well as Photographer Masa," read the headline on June 14, 1996. The "congenial comrades," Kephart and Masa "roamed the vastness of the Great Smokies together—one writing about their wonders, the other photographing their magnificence."

Sixty years after Robinson's effort to memorialize Masa's contributions, another generation caught sight of Masa's shadow. While reading about Masa's contributions to the Smokies, the Appalachian Trail, and North Carolina nomenclature, William E. King of Durham, North Carolina, a historian and retired Duke University archivist, echoed Kephart's remark that Masa deserved a monument. "George Masa deserves a North Carolina historical marker," King asserted and soon set about making that happen. He enlisted two other Masa enthusiasts, William A. Hart Jr. and filmmaker Paul Bonesteel, to work with him and Ansley Herring Wegner, administrator for the North Carolina Highway Historical Marker Program. King knew Western North Carolina intimately, having "spent part of every summer for eighty-three years at Lake Junaluska" and having "visited the national park constantly and as a teenager hiked thirty miles of the Appalachian Trail." With a PhD in history from Duke along with experience teaching American history, King was also familiar with the history and culture of Western North Carolina. But it was also Masa's Japanese background that King felt was significant. "What a unique individual and singular historical contribution to a land and people far from his native country," King wrote. "As humble as he was, he definitely contributed to the life and well-being of those following him."

Similar motivations inspired William A. Hart Jr., whose groundbreaking work on George Masa was published in 1997. Like King, Hart believed that Masa's contributions to the park and the Appalachian Trail were significant, as were the photographer's portrayal

of Asheville and Western North Carolina to the world. "Masa was an unassuming man who worked tirelessly for causes to which he dedicated himself, even putting them before his personal welfare, never seeking acclaim for his contribution. George Masa's story of selfless dedication and accomplishment is a narrative that warrants being continually shared," Hart emphasized. In 2018, Hart had helped ensure at least part of that legacy would be remembered when he delivered a moving tribute to Masa on the occasion of the photographer's induction into the Appalachian Trail Hall of Fame. Working with King, Bonesteel, and Wegner on the historic marker was yet another way he could ensure Masa's story would be shared. On April 8, 2022, Asheville's mayor, Esther Mannheimer, welcomed representatives from state agencies, park officials, trail clubs, and Masa fans to the unveiling of the highway marker honoring George Masa. Situated on Patton Avenue, just west of Pack Square and close to two of Masa's former studios, the prominent marker celebrates Masa's contributions to Great Smoky Mountains National Park and the Appalachian Trail. Bonesteel, in his closing remarks, reflected on the ways Masa's story influences and inspires us today: "To truly honor George Masa is to hike gently into and upon the mountains he loved deeply."

Each of these initiatives to highlight Masa's story—from the tiny lichen *Lecanora masana* named in Masa's honor in 2017 to a 5,600-foot peak in the Smokies designated in 1961 as Masa Knob, from the installation of the tombstone in Riverside Cemetery in 1947 to the dedication of the North Carolina historic marker in Asheville's Pack Square—is the result of a homegrown movement. Groups of individuals inspired by Masa's story believed that his life, his commitment, and his substantial contributions should be celebrated. We are each the recipient of Masa's reimagined life, appreciating his photography, his protection of the Smokies, and his selfless dedication.

Many of the features of Masa's life story resonate with narrative and mythic conceptions of the hero's journey. His past was mysterious.

According to the Japanese letters, Masa, or Shoji Endo, saw himself as an orphan—a superfluous second son, an unloved adopted one. Parris wrote that Masa moved from "the Land of the Rising Sun," leaving behind his culture, friends, and family. In mythic narratives, the solitary hero is forced to confront and overcome a series of obstacles. We did not make it easy for George Masa. In the 18 years that he spent in Asheville, the social, economic, and legal roadblocks were significant. Seely's dog whistle to the Bureau of Investigation prompted an inquiry in 1916; the Grove Park Inn manager goaded the bureau to pursue Masa, Vera Valentine Ward, and Giovanni Emanuele Elia of the Royal Italian Navy all the way to the North Carolina coast in 1918. Masa visited the capital of a nation that did not allow a Japanese man to become a citizen, a visit that coincided with the outbreak of the 1918 Influenza Pandemic, where he contracted the flu and was hospitalized for a week.

Laws and court decisions in the United States made it obvious that he did not belong. The US passed a flurry of restrictive laws in the late 19th and early 20th centuries, including the Chinese Exclusion Act and the restrictive 1917 Immigration Act. The US Supreme Court weighed in when a Japanese man, Takao Ozawa, after living in the United States for 20 years, educated in California and working in Hawaii, applied for citizenship. In a case argued before the Supreme Court in 1922, *Ozawa v. United States* (200 U.S. 178), the court found that Japanese were not "free white persons" for purposes of naturalization. On the heels of this decision, Congress passed the National Origins Act of 1924 banning all immigrants from East Asia. Kephart—impressed by Masa's efforts on behalf of nomenclature, trail work, and mapping—was awed "that a Jap (not even naturalized so far as I know)" should have done all this work without compensation. Kephart did not mention—might not even have realized—that the legal constraints made it *impossible* for someone like George Masa to become a United States citizen.

But what drove George Masa to persevere?

Despite the avalanche of social, physical, legal, and economic obstacles, Masa never succumbed to despair. His mantra, "never

surrender," inspired him and continues to inspire us. Masa's strength came not only from his grit but from the rejuvenating power of the natural world. Nature, for him, as for Kephart, was restorative—a place to find solace and comfort: "When I make [hiking] trip these things don't bother me. I just leave office and go into woods get fresh balsam air then come back start strong fight, no use to worry, that's way I do, may I am wrong, but it good to me all time."

Like Thoreau, Muir, Lopez, and a host of other literary writers who believed in the regenerative power of nature, a congress of contemporary biologists are documenting the benefits of spending time in green spaces. Although the evolutionary biologist Edward O. Wilson did not coin the term "biophilia," he defined and popularized the concept in his 1984 book of the same name. His hypothesis centers around the idea that human beings have an affinity for nature, that we are attracted to other forms of life, that this connection is embedded in our biology and rooted in our evolutionary history. Thirty years after Wilson's book, Florence Williams delved into the science and the research studies related to nature's impact on the brain and a person's well-being in *The Nature Fix* (2017). Williams begins her quest in Japan with an exploration of forest bathing, *shinrin yoku*, a practice of intentional immersion in nature and experiencing the environment through one's senses. She moves on to South Korean healing forests, the science of forest smells, and nature initiatives in Scottish hills and Singaporean cities. She embeds herself in research projects, wears a portable EEG headset for one study, and joins a nature challenge in another. Her conversations with scientists who are studying nature's impact on creativity and mood, or investigating the phenomena of awe, reveal how seriously the scientific community is wrestling with the biophilia hypothesis.

There was also a spiritual dimension to Masa's reverence for nature, some of which Lola Love captured in her 1929 profile:

> *George Massa [sic], of Asheville, has always felt the inherent*
> *beauty of Nature—her strength, which seems to be an almost*
> *visible expression of some Good Power who lovingly rules the*

*universe. Nature is her own living temple to this power—a temple which knows no man-made limitations but which suggests greater wisdom and greater majesty even as we contemplate its wonders.*

One of the few pieces of evidence we have of this spiritual side of Masa in his own voice is a poem, written in Japanese, found after his death. Dated January 10, the poem, perhaps composed in 1915 during Masa's travels or on a cold January day in 1921, is part of a series of verses written for the new year. The translated poem echoes Love's remarks and expresses Masa's belief in the benevolence of the universe:

> *Deep into the mountain path,*
> *Where there is Being of Help,*
> *The Spiritual Friend is found there,*
> *Birds are singing, flowers are blooming.*
> *Be alert, my friends,*
> *God will not fail nature's children.*
> *The light of Silver Mountain, the Other World,*
> *Will be ours, I trust.*

Daniel McKee, a specialist in Japanese art and literature in Cornell University's Department of Asian Studies wrote:

> *Very little of this [Masa's poem] relates to traditional New Year poetry. . . . The vaguer, non-concrete phrases, such as "being of help," "spiritual friend," "God," "The other world," and even "silver mountain" all ring more of his American experiences than his influences from Japanese poetry. That said . . . what a great poem to discuss the place of nature in his life and his faith in it. Everything rings of it. Go deep into the mountains and you will find help and aid for your spirit. God created this beautiful world and it's a sign that He won't let us down. It's a fantastic piece to show what the natural world meant to him.*

Mountains were a constant throughout Masa's life. Mount Fuji soars on the northern horizon of Shizuoka Prefecture where he grew up, while the foothills of the mountainous area known as the Minami Alps (designated a UNESCO Eco Park in 2014) are a two-hour drive from Shizuoka city. As a young man living in Tokyo, when he had the time and some money, he quit the city to go mountain climbing. During his baseball years on the West Coast, the Japanese-language newspapers referred to him as a mountain climber; in Colorado, it was the mountains outside of Colorado Springs that enticed him. And, when Masa settled in Asheville, the colorful pins in his office wall map documented his frequent trips to the Smokies. He sought the mountains for his own rejuvenation as well as the accomplishment of his goals on behalf of the Appalachian Trail, nomenclature work for the park, or for that perfect photograph to illustrate an article. Geography seems to have been a shaping force for Masa, just as it was for Barry Lopez.

The mountains were "a paradise for contemplation and for study," according to Love. She contrasts Masa's dedication to the attitude of the typical worker: "In this day when work is so often done for the sake of the immediate returns it will bring, it is refreshing to find a man who devotes all of his time and his thought to work because it means to him the fulfilling of an ideal."

Masa's ideal was to capture the perfect photo, to invoke the awe-inspiring scene he was experiencing. From all reports, Masa did not take shortcuts. No doubt driven as an artist, Masa also understood that his photos, when used by chambers of commerce or government officials, served a broader persuasive purpose, eliciting "oohs" and "ahs" from the viewer. Neither did he take shortcuts in his nomenclature documentation nor his trail work.

In one of the Japanese letters, Masa wrote that his original intent was to bring success to the community. Perhaps, this, too, was a motivating force for Masa. We can never know all that happened on the West Coast, what went wrong with his brief marriage, or the details of the ill-fated financial transaction that launched Masa on his cross-country odyssey. But we do know that Masa moved to

Asheville to begin again, that in his 18 years of living in Western North Carolina, he had a profound impact on his friends and his community. Writing in support of Masa Knob, George M. Stephens, an Asheville civic and business leader, asserted that the tribute would inspire others:

> *Because recognition when clearly deserved spurs others to high public service, I join those who appear before you in supporting honor for George Masa. The good it can do will reach people around the world. It can say that all men are brothers when they work to preserve the beauty of Nature.*

Our lives are all journeys of sorts. Some longer and complex, others shorter or a bit more straightforward. And we are all, at times, the hero in our own story. How can it be any other way? We grow up knowing only a certain reality and then face decisions and junctures that lead to new directions, choices, and redirections. The boy who sought in vain for the affection of his adopted family and would run through the village streets in the shadow of Mount Fuji chose to go to Tokyo. The college student who was a part-time newspaper writer chose to jump on a ship and head to the United States, not once but twice, hoping for a new life of fortune, or fun, or simply his own life. The self-assured playboy who had just settled down made a choice that he thought was a good one, but it was not. He then symbolically ended his life and "launched out on" another adventure. He pushed forward into every opportunity he could find in this new life, only looking back a few times (that we are aware of). Paraphrasing a well-known proverb, Masa wrote, "Opportunity's head hair grows only front, so when it toward you, can grab it easy but when he passed can't catch him because back of head is bare." Masa embraced the opportunities in his new life, never surrendering nor taking short-cuts. He grasped what was important to him, found new ways to use his talents, vision, personality, intellect, and his leadership.

In their tribute to Masa, published in the Carolina Mountain Club bulletin shortly after his death, club members celebrated both

the gifts Masa had shared with his friends and the solace he found in his "beloved Smokies":

> *In the deep, peaceful silence of the eternal our leader is breaking trails and exploring new worlds. We miss him keenly, we shall continue to miss him, his kindness, his gentleness, his reliable wisdom as a guide, his knowledge and appreciation of beauty and wonder to be found in our mountains. To breathe the fragrance of spruce on the heights was new life to George, and his beloved Smokies often found him among the spruce and balsam seeking new energy and inspiration.*

> *To those who had spent hours on the trail with George, climbing into the less accessible places of the Smokies, discovering or making new trails into territory seldom visited by others, there is left the memory of a genius whose love of beauty was so intense that a hard hike of ten or twenty miles was not too great a price to pay for a photograph capturing some of the beauty to be found at the end of the trail.*

> *His service to the Park authorities and to many other organizations and individuals throughout the United States in supplying photographs and valuable information on the nomenclature, topography, and mineralogy of this section has established his name in the minds of many, all of whom mourn his going.*

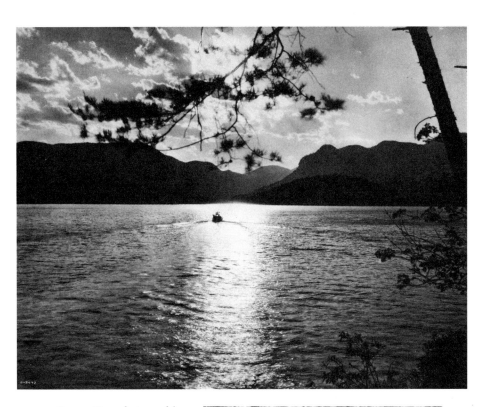

George Masa photographing
Mount Le Conte on one of
the knife-edge ridges near
the intersection of Boulevard
Trail and the main Smoky
divide. *Jewell King scrapbook,*
*Wilson Special Collections,*
*University of North Carolina/*
*Chapel Hill*

# CHAPTER NOTES

### PROLOGUE

1    **"well-known photographer"**: *Asheville Citizen,* May 16, 1933.

1    **Buncombe County Home and Sanitarium:** "Nestled just over the brow of the hill to the rear of the County Home," the sanitarium was a well-run operation according to Asheville's *Sunday Citizen,* June 8, 1930. A social service delegation recently declared the county home system "a shameful blot on the history of North Carolina," but the separate white frame building housing the sanitarium was run by trained staff who stressed "abundant rest, fresh air and sunlight, and expert dieting" for the patients.

2    **"a splendid fielder"**: *Oregon Daily Journal,* March 30, 1914.

3    **"Mr. Masa would like to see you"; "One thing that broke my heart"**: Interviews with Barbara Ambler Thorne conducted by William A. Hart Jr. on June 3, 1996, and November 9, 1996.

3    **"The purpose of this letter"**: Naves to Head of the Japanese Legation, June 27, 1933. MOFA.

4    **"The above-mentioned person"**: Superintendent General Fujinuma's Report, Oct. 4, 1933, Tokyo Police Dept. MOFA.

4    **"other factors—beside genius"**: Atlas, *The Shadow in the Garden,* 260.

4    **"a great future, a castle of success"**: Masa to L. Scott, Nov. 3, 1916. BCSC.

4    **"worked like hell"**: Masa to Gooch, June 18, 1931. UTN.

5    **"Quiet and retiring"; "and friendly"; Masterpieces of camera"**: Naves to Head of Japanese Legation, June 27, 1933. MOFA.

5    **"his kindness, his gentleness"**: *Carolina Mountain Club Bulletin* 3, no. 7 (July 1933).

5    **"all this exploring"**: Kephart to Fink, March 13, 1931. UTN.

5    **"Never surrender"**: Masa to Gooch, March 2, 1931. UTN.

6    **"Because recognition"**: Stephens to Medford, Jan. 23, 1931. UNCA.

### I – LAUNCHED OUT ON AN ADVENTURE TODAY

9    **The 29-year-old man:** The school record at Meiji University lists Masa's birth date as April 6, 1885.

9    **"Launched out"**: Masa's diary entry for January 16, 1915. The archives at Hunter Library's Special and Digital Collections at Western Carolina University contain eight pocket notebooks used by Masa throughout his lifetime. Most of them are written in English and relate to hiking excursions. One of the notebooks records events in 1915 with notations chiefly in Japanese. Throughout the biography, we have used the English translations of these entries and refer to this notebook as Masa's diary (MSS 80-29.6, Folder 7).

10   **"finally received a substantial amount"**: Masa's diary, Jan. 18, 1915.

10   **"a church covered"; "Didn't feel like"; "covered in snow": "extremely cold"**: Masa's diary, Jan. 21–24, 1915.

11   **"thousands of unsheltered"**: Bezou, "Memories of a Quarter-Century," June 1980, Ozanam Inn, ozanaminn.org/history.html.

11   **"Japanese student wants position"**: *New Orleans Times-Picayune,* Feb. 12, 1915. By 1908, US immigration law restricted the immigration of Japanese laborers. As Linda Harms Okazaki explained, "A 'student' status did not necessarily imply he was going to study, just that he was not a laborer."

In *George Masa's Wild Vision,* Brent Martin cites a "work wanted" advertisement for a "Japanese first class butler" published in the *San Francisco Call* (Dec. 15, 1907). The name associated with the ad is "George Masa." The authors have no evidence that Masa was living in San Francisco in 1907 or that he used this name prior to coming to Asheville. In the 1910 census, the man we know as George Masa was living in Seattle, having arrived in 1907 according to the US census enumerator. The only George Masa found in the 1910 federal census was George W. Masa, a White male born about 1881 in Vermont.

12–13 **Early in February 1915:** Bissell to Iizuka, Feb. 16, March 22, and May 7, 1915. BCSC.

15 **"I visited Grove Park Inn":** Masa's diary, July 11, 1915. After Masa's death, there were mentions in some newspaper stories that suggested he arrived with a group of European tourists. No evidence for this exists, and his journal clearly presents a man traveling solo. It's possible that the basis of this idea was his early interaction with guests at the Grove Park Inn and his appearance in photographs with others who appear to be European.

15 **Fred Loring Seely:** Unless otherwise noted, background on the Grove Park Inn, Seely, and Grove is taken from *Built for the Ages* by Bruce Johnson.

15 **only one of around a hundred employees:** Personal correspondence, Johnson to McCue, March 29, 2017.

15 **"to know the character of the people":** *Proceedings of the American Pharmaceutical Manufacturers' Association,* 20th Annual Meeting (1933): 190.

16 **"Grove Park Inn is Fred Seely":** Hubbard, "A Hotel with a Soul," *Roycroft* 1, no. 4 (Dec. 1917): 109.

18 **"an Inn worthy of the mountains":** Invitation to GPI opening as quoted in Johnson, 39.

18 **"not built for a few":** William Jennings Bryan's address on the official opening of the GPI as quoted in Johnson, 39.

18 **"As this is a mountainous":** Masa's diary, July 12, 1915.

19 **"Colorado already shows":** *Asheville Weekly Citizen,* July 14, 1915.

19 **"decorously short new skirt":** *Asheville Times,* July 12, 1915.

19 **"while he learned":** Seely to Bielaski, Nov. 3, 1916. UNCA.

19–20 **"an elderly lady"; "just right for me"; "quite interesting"; "using an iron all alone":** Masa's diary, July 12–13, 1915.

20 **"adamant in his belief":** Johnson, 49.

20 **"old-fashioned businessmen":** Johnson, 48

21 **"a two- or three-story dormitory":** Personal correspondence, Johnson to Bonesteel, Dec. 11, 2021.

21 **"photographic purpose":** Iizuka to Seely, March 20, 1917. BCSC.

21 **"developed into or was a most expert":** Seely to Bielaski, Nov. 3, 1916. BCSC.

22 **"excellent place to live":** Masa's diary, July 12, 1915.

22 **"bewildered by the scenic grandeur":** *Asheville Citizen,* July 11, 1915.

22 **"A man never grows too old to build castles":** Grove's remarks as quoted in Johnson, 39.

## II – SO FAR AWAY FROM MY PURPOSE

25 **"As you know":** Masa to Scott, May 4, 1917. BCSC.

26 **"not suit to me"; "work by the order"; "no system"; "I will tell you why"; "I will get job easy":** Masa to Scott, Nov. 3, 1916. BCSC.

26 **"purge the country"**: Jensen, *The Price of Vigilance*, 10.

27 **Seely's political connections:** For background on this aspect of Seely, see Johnson, *Built for the Ages*. Barbara Kraft's *The Peace Ship* details Henry Ford's mission, and Gerald Herman provides a well-researched chronology in *The Pivotal Conflict*.

27 **"as a Don Quixote"**: Kraft, *Peace Ship*, 2.

27 **"Somebody in Europe"**: *Asheville Citizen*, Jan. 16, 1916.

27–28 **"very persistent about coming here"; "He has become very proficient"; "most of his spare time"; quite a collection of records"; "is well-educated"**: Seely to Bielaski, Nov. 3, 1916. BCSC.

28 **"officers' quarters"**: Johnson suspects Seely is referring to "Sunset Hall," "a two- or three-story dormitory Seely built for hotel staff who could not travel home each night." Personal correspondence, Johnson to Bonesteel, Dec. 11, 2021.

28 **"local officer, located near Asheville"**: Bielaski to Seely, Dec. 1, 1916. BCSC.

28 **"let the matter drop"**: Seely to Bielaski, Dec. 5, 1916. BCSC.

28 **"carefully guarded"; "leading men"**: Extract from 1917 *Annual Report of the Attorney General* as it appears in *American Protective League* (1918), 8.

29 **"As you know, am a student"; "If God favor me"**: Masa to Scott, May 4, 1917. BCSC.

31 **"modern artistic"; "rob the Industries"; "I promise that same degree"**: *Asheville Citizen*, April 14, 1917.

32 **"I hope you will soon"**: Seely to Masa, undated reply to Masa's letter to Seely on May 27, 1917. BCSC.

33 **draft registration:** "U.S. World War I Draft Registration Cards, 1917–1918," entry for George Masa Iizuka, Colorado Springs, Colorado, digital image, Ancestry, ancestry.com/imageviewer/collections/6482/images/005241928_04705.

33 **"a couple months wages"**: Masa to Seely, June 10, 1917. BCSC.

33 **"had a good time seeing"**: Masa to Seely, June 10, 1917. BCSC.

34 **"I had fine time for 'hiking'"**: Masa to Seely, July 4, 1917. BCSC.

34 **Seely was offering enticements:** Seely to Masa, July 9, 1917. BCSC.

34 **Masa asked Seely to cover:** Masa to Seely, Aug. 4, 1917. BCSC.

35 **"by the week without room"; "when you find his feeling"**: Masa to Scott, Feb. 14, 1918. BCSC.

35 **"I found nothing of a suspicious"**: Frederick Handy's report dated March 16, 1918, in Bureau of Investigation Case #103402, Investigative Records related to German Aliens ("Old German Files"), 1915–1920. NA.

36 **"foreign style"; "seemingly a native"; "Distinctly German"**: Seely to Bielaski, May 14, 1918. OGF.

36 **Giovanni Emanuele Elia:** Elia made quite the entrance in 1918. The Old German Files (OGF) of the Bureau of Investigation Case #103402 provide dozens of reports filed by agents, some describing his camp, along with interviews with hotel managers, including Seely, and reports from the US Navy.

36 **"electrical and ice making plant"**: Seely to Bielaski, May 14, 1918. OGF.

37 **"several of our guests"**: Tufts to Bailey, Dec. 8, 1917. OGF.

37 **"accounts in regard to himself"**: Agent Norman Gifford filed a report on Jan. 2, 1918, related to a telephone call from Dr. Edwin Reynolds (on behalf of other guests at the Carolina Hotel) who urged the bureau to investigate the suspicious behavior of Elia. OGF.

37 **"pronounced German physiognomy"**; **"utterly unlike any breed"**: Gallagher to Department of Justice, Jan. 22, 1918. OGF.

37 **"he lived more luxuriously"**: Agent William S. Jackson recorded Mrs. E. P. Spencer's (Matron of the Cliff House and formerly a matron and chaperone of the riding school) remarks in his Aug. 26, 1918, report. OGF.

38 **"supplying a base for this submarine"**: Jackson, report, Aug. 26, 1918. OGF.

38 **"to be trusted"**; **"eccentric ways"**; **"not doing anything"**; **"just an eccentric man"**: Report from Agent Dorsey Phillips dated Dec. 31, 1917. OGF.

38–39 **"twelve miles of water front"**; **"very courteous"**; **"high-power dynamo"**; **"nothing to do"**; **"general air of mystery"**;**"Tokio—Geo. Iizuka"**: Report from Agent J. E. B. Holladay dated July 6, 1918. OGF.

39–40 **"He came here about three"**; **"There is not the slightest"**; **"any lack of respect"**: Seely to Bielaski, Aug. 8, 1918. OGF.

40–41 **"Am very fine"**; **"swimming, fishing, riding, canoeing"**; **"I think, may be"**: Iizuka to Mrs. G. Brown, Aug. n.d., 1918. OGF.

41 **"In the event a raid is made"**: Seely to Bielaski, Aug. 16, 1918. OGF.

42 **"absolutely harmless"**: Welles to Bielaski, Sept. 20, 1918. OGF.

43 **"The lowest estimate"**: Barry, *The Great Influenza*, 4.

43 **"two thirds of the deaths"**: Barry, 5.

43 **"caught 'Flu' got in hospital"**: Masa to Seely, Feb. 25, 1919. BCSC.

43 **"On Saturday"**: Barry, *The Great Influenza*, 311.

45 **"I having"**: Masa to Seely, Feb. 25, 1919. BCSC.

45 **"There could have been some technique"**: Interview with Ben Porter conducted by Bonesteel, November 23, 2001.

45–46 **"And let me have loan"**: Masa to Seely, Feb. 14, 1918. BCSC.

46 **"just put me in your shop"**; **"all small lettering"**: Masa to Seely, Feb. 25, 1919. BCSC.

46–47 **"I believe you don't"**; **"anything photographic work"**: Masa to Seely, Dec. 13, 1919. BCSC.

47 **"one of the principal"**: *Asheville Citizen-Times*. March 15, 1942.

48 **"artistic painter"**; **"photographer"**: "Application, Pt. 1, Phoenix Mutual Life Insurance Company of Hartford, Connecticut," May family files, WCU.

48 **"Honma"**: In addition to using the word "Honma" on the insurance application, there are several other instances of Masa appending "Honma" to his name, including in the Japanese letters found in his room after his death. Our research team considered various possibilities. We could find no evidence that it was a family name. The word can mean truth or reality, so perhaps Masa was affirming his signature as being truthful.

### III – BLAME WHERE IT IS NOT DUE

51 **"But this Jap"**: The *Asheville Citizen* provided extensive coverage of Masa's trial and the subsequent hearing beginning Nov. 17 when he was charged and continuing through the close of the hearing on Dec. 1, 1921. See *Asheville Citizen,* Nov. 17, 1921, Nov. 19–22, Nov. 24, Nov. 26, and Nov. 29–Dec. 2. Other North Carolina newspapers gave periodic reports (e.g., *The Twin Dispatch*, Winston-Salem on Nov. 22, 1921; *Western North Carolina*, Nov. 25, 1921, and *Greensboro Daily News*, Nov. 28, 1921).

52 **"making or keeping on hand"**: *Sunday Citizen*, Nov. 20, 1921.

53      **unsettled social conditions:** Young discusses the Asheville Klan and the local conditions in *The Violent World of Broadus Miller*, 82–85.

53      **"the defender of Americanism":** Jackson, *The Ku Klux Klan in the City*, 1915–1930, xi–xii.

53      **"the maintenance of white superiority":** Jackson, xi–xii.

53      **summer of 1921, Lawrence L. Froneberger:** Young, 82.

53      **"around 450 men joined":** Young, 82.

54      **"Imperial Kladd," "Imperial Klabee":** Linda Gordon provides a glossary of some Klan titles in Appendix I of *The Second Coming of the KKK*.

54      **"resurrected, reconstituted, and remodeled":** Frost, *The Challenge of the Klan*, 299.

54      **"An applicant must be white":** *Constitution and Laws of the Knights of the Ku Klux Klan*, 17.

54      **syndicated in more than a dozen newspapers . . . two million readers:** Streitmatter, *Mightier than the Sword*, 93.

54      **"cloaked and hooded law-breakers"; "more than forty cities":** Between October 1920 and September 1921, the *New World* tabulated throughout the country 4 murders, 41 floggings, 27 people tarred and feathered, 5 kidnappings, a branding with acid, and an "irreparable mutilation"—all of which the newspaper attributed to "cloaked and hooded law-breakers." As if to confirm these assertions, the *Asheville Citizen* on Dec. 2, 1921, reported on the front page, "White Men Flog Texas Blacks," explaining how three Black men, including a 75-year-old man, were beaten by members of the Denison (TX) Klan, who warned them "not to mingle with the whites."

55      **"quit getting your Klan doctrine"; "naturally antagonistic":** Evans, "Where Do We Go from Here?" in *Papers Read at the Meeting of Grand Dragons*, 8.

55      **Historians credit the publicists:** See Jackson, 9–10 on Clark and Tyler; also see Young, Gordon, Pegram, and others for background on the resurgence of the Klan in the 1920s.

55      **"So, in the midst of a sin-racked":** Grand Dragon of Mississippi, "A Spiritual Interpretation of Klankraft" in *Papers Read at the Meeting of Grand Dragons*, 52.

55      **"from eastern and southern Europe":** Great Titan of the Realm of Georgia, "Endorsement of Policies" in *Papers*, 17.

55      **"The time has now come":** Grand Dragon of South Carolina, "The Regulation of Immigration" in *Papers*, 74.

56      **"a real menace"; "an absolute exclusion act":** Grand Dragon of South Carolina, "The Regulation of Immigration" in *Papers*, 72.

56      **"launched a highly publicized":** Young, 82.

57      **Young covers this case:** Young, 83.

57      **"ranging from dainty colonial misses":** *Asheville Citizen*, Oct. 23, 1921.

58      **"The show will be a combination of blackface":** *Asheville Citizen*, Oct. 7, 1921. The phrase "blackface and oleo" refers to the two parts of the minstrel show—the first being the "Black and White Review" with some characters working in blackface and the second part being the oleo portion. Oleo or olio can mean one of two things: the oleo curtain or painted backdrop or a set of acts and jokes, including in this case the burlesque.

58      **"Unfettered fancies of morbid":** *Greensboro Daily News* (NC), Nov. 28, 1921.

58    **"found negatives for the picture"**: *Asheville Citizen*, Nov. 19, 1921.
59    **"brought to trial"**; **"absolutely and positively denies"**: *Sunday Citizen*, Nov. 20, 1921.
59    **"a number of high school"**: *Sunday Citizen*, Nov. 20, 1921.
60    **"visited the studio almost daily"**: *Sunday Citizen*, Nov. 20, 1921.
61    **"which she alleged was obscene"**; **"not established that Massa"**; **"six or seven names of girls"**: *Asheville Citizen*, Nov. 27, 1921.
61    **"I have told you the truth"**; **"No, I don't make my living"**: *Asheville Citizen*, Nov. 30, 1921.
62    **"to leave the matter"**; **"he was certain the public"**: *Asheville Citizen*, Nov. 23, 1921.
62    **"false arrest and imprisonment"**: *Asheville Citizen*, Nov. 30, 1921.
62    **"fair one hundred percent"**: Young quotes Froneberger's words on 83.
62–63  **"the papers to let Froneberger alone"**; **"had been instrumental"**; **"rather not disclose"**; **"over a hundred highly"**: *Asheville Citizen*, Nov. 23, 1921.
63    **"Far from being an un-American"**: Jackson, *The Ku Klux Klan in the City*, 18.
63–64  **"technically guilty"**; **"having on hand"**; **"attacked the new evidence"**; **"several prominent"**: *Asheville Citizen*, Nov. 27, 1921.
64    **"an official statement"**; **"before the body of the high school"**: *Asheville Citizen*, Nov. 28, 1921.
64    **"police court was taxed"**; **"battery of fourteen"**: *Asheville Citizen*, Nov. 30, 1921.
65    **"worse by keeping it in the press"**: *Asheville Citizen*, Nov. 30, 1921.
65    **"this very scandalous"**: *Asheville Citizen*, Nov. 30, 1921.
65    **"particularly modestly dressed"**; **"from the most reputable homes"**: *Asheville Citizen*, Nov. 20, 1921.
66    **"they were not of high school girls"**: *Asheville Times*, Nov. 30, 1921.
66    **"to get two pictures like those"**: *Asheville Citizen*, Nov. 30, 1921.
66    **"These women are going to"**: *Asheville Citizen*, Nov. 30, 1921.
67    **"no truth in the charges"** *Asheville Citizen-Times*, Dec. 1, 1921.
67    **"the motives of the papers"**: *Asheville Citizen-Times*, Dec. 1, 1921.
67    **"high praise for its efforts"**: *Asheville Citizen-Times*, Dec. 1, 1921.
67    **"find him guilty"**; **"should be the butt"**: *Asheville Citizen-Times*, Dec. 1, 1921.
67    **"no apology to make"**; **"I say this now"**: *Asheville Citizen-Times*, Dec. 1, 1921.
68    **"dangerous to the city of Asheville"**: *Asheville Citizen-Times*, Dec. 1, 1921.
68    **"this body of as patriotic men"**; **"What excuse for existing"**; **"no intention whatever"**: *Asheville Citizen-Times*, Dec. 1, 1921.
68    **"that there is no truth in the rumors"**: *Asheville Citizen-Times*, Dec. 1, 1921.
68–69  **"to leave to our duly constituted"**; **"average man"**; **"detective work to his regular vocation"**; **"I don't know what is going on"**: *Asheville Citizen-Times*, Dec. 1, 1921.
69    **"which could be called improper"**: *Charlotte News*, Nov. 22, 1921.
69    **"the fact that there was probably"**: *Greensboro Daily News*, Nov. 28, 1921.
69    **"Technically guilty is not an innocent joke"**: *Asheville Times*, Dec. 2, 1921.

**IV – WORKED LIKE HELL**

73    **"Indeed I worked like hell"**: Masa to Gooch, June 18, 1931. UTN.

74–5  **"an island of urban civilization"**: Starnes, *Creating the Land of the Sky*, 65.

75    **"volumes of talk"; "city hall"; "awake to the practical"**: *Asheville Citizen*, Feb. 29, 1920.

75    **"to prepare plans"**: *Board of Commissioners Minutes* 17, no. 1–2 (1921), 154–55, as quoted by Kevan Frazier in "Outsiders in the Land of the Sky," *Journal of Appalachian Studies* 4, no. 2 (Feb.1998): 306.

76    **"Within a year"**: Nolen, *Asheville City Plan*. CU. Also available online: hdl.handle.net/2027/coo1.ark:/13960/t86h5478k.

76    **"the city embraced"**: Starnes, 89.

77    **"national and international newspapers"**: *Asheville Times*, Dec. 18, 1927.

78    **"Must have experience"**: *Asheville Citizen*, June 16, 1920.

78    **"Come Monday"**: *Asheville Citizen*, June 13, 1920.

80    **"very interesting if not"**: Barnhill to Seely, May 18, 1938. BCSC.

80    **"gone to N.Y. Studio"**: *Asheville Citizen*, June 16, 1920.

81    **"a real bargain"; "sacrifice at once"**: *Asheville Citizen*, Oct. 31, 1920.

81    **"modern engraving plant"**: *Asheville Citizen*, Nov. 28, 1923.

81    **"disassociated himself"**: *Asheville Citizen*, Aug. 17, 1924.

82    **"for the convenience"**: *Asheville Citizen*, Aug. 17, 1924.

83    **"The survival rate of silent"**: Personal correspondence, Thompson to Bonesteel, Oct. 8, 2023. See Thompson, *Asheville Movies Volume I: The Silent Era*. Thompson also discusses Masa's involvement in other silent films, including *The Baseball Sheik* (1926).

84–5  **The group hired George**: *Asheville Citizen*, July 11, 1921.

85    **"the greatest scenic trip"; "in reality"**: *Asheville Times*, July 6, 1922.

85    **"the official photographer"; "important advertising"**: *Asheville Citizen*, Nov. 5, 1922.

86    **"a flimsy excuse"**: Thompson, Facebook post, July 7, 2019.

86    **"George Masa, with his cap"**: *Asheville Citizen*, June 9, 1925.

86    **"famous elongated"; "the only motion picture"**: Reeves and Trott, "Itinerant Filmmaking in Knoxville in the 1920s," *The Moving Image* 10, no. 1 (2010): 126–43.

86–7  **"George Masa, famous Japanese"**: *Charlotte Observer*, Sept. 10, 1925. See also Reeves and Trott.

87    **"movie work"**: Hiram Wilburn Collection, GRSM 13406, box 4, folder 13. CPC.

87    **35mm film simply labeled "Great Smokies"**: When the film footage was uncovered in the GSMNP archive in 2001, its contents were unknown. It was sent to a National Archives film lab in Washington, DC, to be transferred to videotape for review and use by the filmmaker. CPC.

88    **Blowing Rock ... Eve's Monument**: *Ripley's Believe It or Not: The Complete Vitaphone Shorts Collection* 8, 1172.

88    **Gooch watched**: Gooch to Masa, June 3, 1931. UTN.

88    **William Waldo Dodge**: For general background on Dodge and his work, see, "Architect as a Craftsman" in *The American Architect* 134, no. 11 (1928): 595–601, as well as *North Carolina Architects and Builders: A Biographical Dictionary,* ncarchitects.lib.ncsu.edu/people/P000464.

88    **Douglas Ellington**: For general background on Ellington and his work, see: *Architectural Record* 64, no. 2 (August 1928): 89–93; the Asheville

Museum of History online exhibit: ashevillehistory.org/douglas-ellington; and *North Carolina Architects and Builders: A Biographical Dictionary,* ncarchitects.lib.ncsu.edu/people/P000010.

90   **"Field stations are founded"**: Costa, "Highlands Biological Station: Our Continuous Project," written on the occasion of the 2013 Master Site Plan, highlandsbiological.org/wp-content/uploads/2021/01/Our-Continuous-Project.HBS-History.2013.Costa_.pdf.

91   **"What would Masa think now"**: Martin, *Masa's Wild Vision,* 37.

91–2   **"a whale of a time"; "royally feted"; "One poignant incident"**: *Asheville Times,* April 17, 1967.

### V – PAINTED BY NATURE'S BRUSH

95   **"When we were at Andrews"**: Masa to Gooch, Oct. 14, 1930.

95   **"some of the most beautiful photography"; "Many of the scenes"**: *Asheville Citizen,* Oct. 1, 1926.

96   **Asheville Good Will Tour**: Asheville boosters had organized two previous tours by train to various other cities including Houston and Little Rock. The 130 people on the *Land of the Sky* special traveled 7,000 miles on the 14-day trip and distributed 15,000 booklets featuring information about Western North Carolina. Twelve of the cities showed Dudley Reed's film. The Western North Carolina visitors brought gifts that included Biltmore homespun and jewelry made with Western North Carolina stones. *Asheville Times,* Oct 10, 1926.

96   **"the beauties encountered"**: *Asheville Citizen,* July 8, 1926.

96   **"a beautiful picture"; "several hundred feet"**: Kephart was one of several Bryson City residents who traveled in the motorcade to Atlanta in October 1926 and gave this report. *Asheville Citizen,* Nov. 18, 1926.

96–7   **"joined by Mr. Horace Kephart"; "by a large number of periodicals"; "for making all kinds"**: *Ruralite,* June 29, 1926.

97   **"ordinary Americans"**: "Remarks by the President on America's Great Outdoors Initiative," February 16, 2011, obamawhitehouse.archives.gov/photos-and-video/video/2011/02/16/president-obama-americas-great-outdoors-initiative#transcript.

97   **Horace Kephart's new life**: For biographical background on Kephart, see Ellison and McCue, *Back of Beyond.*

98   **"in vastly better shape"; "patient and lenient"**: Crunden to Koopman, March 31, 1904. BU.

99   **"been driven insane"; "taken a man"; "the last and desperate"**: *St. Louis Globe-Democrat,* March 25, 1904.

99   **"My health broke down"**: "Horace Kephart by Himself," in *North Carolina Library Bulletin* 5 (1922): 49–52.

100   **"I owe my life to these mountains"**: "Authors Die Instantly in Wreck near Bryson City," *Asheville Citizen,* April 3, 1931. There are slight variations ("by Gad, I owe my life") on this quote. See Livingstone, *Asheville Citizen-Times,* April 12, 1931.

100   **"By judicious use"**: *Asheville Times,* Sept. 22, 1930.

101   **"If you don't like the way"**: Albright explains the origins of the story in *Creating the National Park Service: The Missing Years,* 32–35.

101   **"a man of prodigious"**: Snell, *Formation of the National Park Service,* 3.

101   **"a striking alloy**: Shankland, *Steve Mather of the National Parks,* 8

101   **"the young, able, self-effacing"**: Robert Utley, chief historian of the National Park Service, describes Albright in the foreword to Albright's

book, *Creating the National Park Service*, xiii.

101 **"I instantly felt a strong kinship"**: Albright, *Creating*, 36.

102 **"It was a crucial partnership"**: Albright, *Creating*, foreword by Utley, xiii.

102 **"Not wanting to subject"**: Shankland, *Steve Mather*, 68.

102 **"the first authorization"**: Strong, *Dreamers and Defenders*, 115.

102 **"Mather realized that Congress"**: Strong, 114.

102–3 **"By the end of his first year, Mather"**: Snell, 12.

103 **"should like to see additional parks"**: Mather, *Report of the Director of the National Park Service . . . Travel Season 1923*, 14.

103 **"scenery of supreme and distinctive quality"**: Lane to Mather, May 13, 1918, as published in Mather, *Report of the Director of the National Park Service . . . Travel Season 1918*, 273–76.

103 **The SANPC established six guidelines**: United States Department of the Interior, *Final Report of the Southern Appalachian National Park Commission*, 7.

104 **"had come of age during"**: Pierce, *The Great Smokies*, 56.

105 **"Western North Carolina Lumber"**: Pierce, 83.

105 **"strangely apathetic"**: Kephart to Fink, Aug. 24, 1924. MHC.

105 **"The park movement in Knoxville"**: Pierce, 61.

106 **"despoiled unless Congress"; "people's recreation ground"; "a national park only in miniature"; "for exploring"**: *New York Times*, July 27, 1924.

106 **"easily stand first"**: *Final Report*, 7.

106 **Kephart penned an eight-page**: Kephart to Weaver, Dec. 24, 1924. WCU.

107 **"soon be dwindling to nothing"**: Kephart to Weaver, Jan. 13, 1925. WCU.

107 **"has become our most powerful ally"**: *Asheville Citizen*, Nov. 14, 1926.

107 **"only eighty-five square miles"; "are the mountain climax"**: Kephart, "The Last of the Eastern Wilderness," *World's Work* 51, no. 6 (April 1, 1926): 621.

107 **"The most luring feature"**: Kephart, 624.

107 **"But the facts are"**: Gregg to Kephart, July 29, 1925. WCU.

108 **"an Act to provide"**: The Southern Appalachian National Park Committee submitted their final report on Dec. 12, 1924, recommending a national park in the Blue Ridge area of Virginia. Although acknowledging the Smokies "stand first," the SANP Committee reported the area had "some handicaps." On Feb. 21, 1925, Congress passed a bill, signed by the president, directing the secretary of the interior "to determine the boundaries" for three parks—one in the Blue Ridge, another in the Smoky Mountains, and a third in the Mammoth Cave area. Secretary Work appointed each of the members from the SANP Committee to a new commission (with the same acronym). When the SANP Commission submitted their report to Secretary Work, he referred it to Congress, which passed the bill "to provide for the establishment of Shenandoah National Park . . . and the Great Smoky Mountains National Park." President Coolidge signed the legislation into law on May 22, 1926. A second bill establishing Mammoth Cave National Park was introduced, passed, and approved by the president on May 25, 1926. The *Final Report of the Southern Appalachian National Park Commission* provides a short legislative summary, but both Catton and Pierce delve into the details and complications.

108–9 **"It was the first big national park"**: Catton, *A Gift for All Time*, 1–2.

109 **"profoundly shaped"**: Catton, 18.

109 **A capital campaign**: The fundraising goal of $10 million was an initial best guess estimate for the cost of securing the acreage (427,000) needed for the park. The cost of land, continued logging, the inability of individuals to make good on their pledges due to the economic depression, and other factors complicated the fundraising. Both Catton and Pierce detail the struggle and the complexity involved in securing the funds required for the establishment of the national park.

110 **That Knoxville photographer Jim Thompson**: Paul James profiles Thompson's 50-year career as a photographer and the influential role his photos played in the park movement. See knoxvillehistoryproject.org/the-photographic-conservationist for an appreciation of Thompson's work. See Rose Houk's *Pictures for a Park* and Ren and Helen Davis' forthcoming book from the University of Georgia Press, *Land of Everlasting Hills: George Masa, Jim Thompson and the Photographs That Helped Save the Great Smoky Mountains and Complete the Appalachian Trail*.

110 **"the photographer-as-explorer"**: Szarkowski, *The Photographer as Explorer*, 3.

111 **Not so for George Masa**: In 2023, Angelyn Whitmeyer created and continues to curate a comprehensive database of Masa images. Because of her dedication and diligent work, we can see in one site the range of Masa's work stored in various archives and scattered across a range of publications. See georgemasaphotodatabase.com.

111 **"Here to-day is the last stand"**: Kephart, "The Last," 632.

112 **"emergency situation"; "inroads being made"**: Cammerer to Rockefeller, Aug. 12, 1927. RA.

112 **"briefcase with all the photographs"**: Pierce, 124. We believe that Cammerer became familiar with Masa's work through Kephart. Based on a letter from Cammerer to Masa on July 22, 1929, we don't think that Cammerer packed in his briefcase any of Masa's photographs on his visit to Rockefeller in 1927. The Rockefeller archive does not contain any Masa photos; more likely, Cammerer shared some of Thompson's photos with Rockefeller.

112 **"to the Big Smoky Mountain Park"**: Rockefeller to Cammerer, Jan. 23, 1928. RA.

112 **"It's the greatest single thing"**: *Knoxville Journal*, March 7, 1928.

113 **"hard-working, amiable"**: Albright, *Creating*, 355.

113 **"My heart is wrapped up"**: Cammerer to Rockefeller, Aug. 12, 1927. RA.

113 **"It was thought by the lumber people"**: Cammerer to Chorley, April 4, 1929. NA.

113 **"In his office there is a large wall-map"**: Love, *Asheville Citizen*, August 25, 1929.

114 **"in the heart of wildness"**: Masa to Jackson, July 7, 1928. BA.

114 **"a wonderful series of pictures"**: Kephart to Pauline Maisch Kephart, Sept. 12, 1928. WCU.

114 **"unusually fine photographs"; "enlargements and color"**: Cammerer to Masa, July 22, 1929. BCSC.

114 **"that their glowing descriptions"**: Fink to Masa, Nov. 13, 1929. BCSC.

114 **"never seen anything"**: Avery to Masa, Nov. 26, 1929. BCSC.

115 **"We believe that you can"**: Avery to Masa, Dec. 23, 1929. BCSC.

115 **"mountains, wild life, Indians"**: Mason to Masa, Jan. 28, 1931. BCSC.

115 **The governors … as did First Lady**: A letter dated April 6, 1928, from Mary Randolph secretary to Mrs. Coolidge confirms the arrival of the scrapbook. BCSC.

115 **"Come back, stay"**: Masa to Rockefeller, Nov. 26, 1928. RA.

115 **"Taking only the necessary"**: Love, *Asheville Citizen*, Aug. 25, 1929.

116 **"an artist at heart"; "artist-ancestors"; "in all its grace"; "mastered the tools"; "express distance"**: Love, *Asheville Citizen*, Aug. 25, 1929.

116 **"Masa had a love"**: Paul Bonesteel conducted an interview with the photographer and art professor Gil Leebrick on July 16, 2001.

117 **"When I make trip"**: Masa to Gooch, Sept. 11, 1931. UTN.

117 **"To many a city man"**: Kephart, *Camping*, 11.

117 **"out of sheer loyalty"**: Kephart to Fink, March 13, 1931. MHC.

117 **snippet of silent film**: National Archives and Records Administration (NARA) #NWDNM (m)-79.10. NA.

118 **"National Park officials"**: Masa to Gooch, Oct. 14, 1930. UTN.

118 **"I am having them put"**: Albright to Masa, Feb. 13, 1931. BCSC.

### VI – BEST MOUNTAINEER ON THE NORTH CAROLINA SIDE

121 **"In my opinion"**: Cammerer to Masa, Feb. 16, 1933. BCSC.

121 **Lopez saw geography as a shaping force**: Lopez, "A Literature of Place" in *Portland Magazine* (Summer 1997), 23–25.

121 **Masa compiled a list of prominent peaks**: Masa's diary, 41. WCU.

122 **"It was as if I were visiting"**: Askins, *Saving the World's Deciduous Forests*, 1, and the chapter "Parallel Worlds," 1–7.

122 **Asian connection**: Gray, "Analogy between the Flora of Japan and that of the United States," *American Journal of Science and Arts* 2, no. 2 (Nov. 1846): 135.

123 **"in some sort of ethical"; "The key, I think, is to become"**: Lopez, 25.

124 **"tell a grander narrative"**: Mask, *The Address Book*, 14.

124 **"The remark has been made"**: Guyot, "On the Appalachian Mountain System" in *American Journal of Science and Arts* 3, no. 92 (March 1861): 157.

123–4 **"a study of the physical configuration"**: Guyot, 157–187.

125 **"the culminating region"**: Guyot, 175.

125 **"It is a mistake to suppose"**: Guyot, 178.

126 **"intolerable confusion"; "a serious evil"**: Guyot, 179.

126 **"The explorer must be ready to march"**: Guyot, 158.

126 **Not until 1929 did a researcher**: Guyot's notes and his nephew's map were discovered in 1929 at the Coast and Geodetic Survey's Library. Myron Avery and Kenneth S. Boardman published the *Notes* in the *North Carolina Historic Review* 15, no. 1 (July 1938): 251–318. See Bridges, Clement, and Wise in *Terra Incognita* 41–42 for additional background.

127 **"Some day we will be able to present"**: Ireland to Masa, March 27, 1930. BCSC.

127 **"preserve the picturesque"**: Fink to Kephart, April 16, 1930. MHC.

127 **"On the way up Shooting Creek"**: *Asheville Times*, March 2, 1930.

128 **"added the local names"; "got those names mostly from old residents"; "so many duplications"; "five Big Creeks"**: *Asheville Times*, March 2, 1930.

128 **"sweet job of drawing up a list"**: Kephart to Fink, Jan. 17, 1930. MHC.

129 **"George and I put in a lot"**: Kephart to Fink, March 13, 1931. MHC.

129 **"George Masa is an excellent"**: Fink to Rhoades, Sept. 21, 1931. MHC.

129    **"wonderful piece of work"; "running names down"; "unfavorably with what the Carolina people"**: Fink to Masa, March 15, 1931. BCSC.

129    **"maps resemble miniature"**: Tufte, *Visual Explanations*, 14.

129    **"in our opinion, the best published"**: Brewer to Masa, Sept. 12, 1931. BCSC.

129    **"a real camp for real boys"**: Motto on letterhead for Camp Sequoyah, Ewell to Masa, Aug. 6, 1931. BCSC.

130    **"Mr. Masa has traveled"; "Mr. Masa, in his work"**: *Asheville Citizen-Times*, April 10, 1932.

130    **"history, geography etc."**: Masa to Gooch, March 2, 1931. UTN.

131    **"called on George Masa"**: Rhoades to Fink, Sept. 9, 1931. MHC.

131    **"an excellent man"**: Fink to Rhoades, Sept. 21, 1931. MHC.

131    **Appalachian Trail**: Benton MacKaye's article on the AT was published in *Journal of the American Institute of Architects* 9, no. 10 (Oct. 1921): 325–30.

131    **"cooperation replaces antagonism"**: MacKaye, 329.

131    **"for the toilers in the bee-hive"**: MacKaye, 326.

131    **"The great body of working people"**: MacKaye, 325.

132    **"Seriously, is it good for men"**: Kephart, *Camping and Woodcraft*, 13.

132    **"health-giving possibilities"; "the sufferers from tuberculosis"**: MacKaye, 326.

132    **"a sanctuary and a refuge"; "a retreat from profit"**: MacKaye, 329.

132    **"experiment in getting 'back'"**: MacKaye, 328.

132    **"within a year"**: Johnson, *From Dream to Reality*, 56.

132    **"no suggestions regarding"**: MacKaye, 328.

133    **"What Perkins needed"**: Johnson, 81.

133    **Perkins died in 1932 ... kept MacKaye's vision alive**: *Potomac Appalachian Trail Club Bulletin*, July 1932, 53.

133    **"unchallenged leader of the Appalachian"**: Johnson, 93.

133    **"A letter from Masa"**: Avery to Fink, Dec. 3, 1930. GMU.

134    **"Hell, don't take your trail"**: MacKay, *Cosmos Club Bulletin* 12, no. 5 (June 1959): 2.

135    **"The scenic attractions:"** Kephart to Perkins, Feb. 21, 1930. GMU.

135    **"George 'shot' the country"**: Kephart to Fink, Jan. 2, 1929. MHC. The letter is dated 1929, but it is likely a mistake. Context suggests it should be dated 1930.

135    **"mapped the country"**: Kephart to Fink, Jan. 28, 1920. MHC.

135    **"moribund"**: Kephart quotes Rhoades and Adams' description of the club in his letter to Fink, Jan. 29, 1929. MHC.

135–6  **"moving spirit"; "selflessly dedicated"**: Hart, "Pushing to the Front: A Sample of Correspondence between Myron Avery, George Masa and Friends," unpublished manuscript, donated in 2024 to WCU.

136    **"I hope you will be able"**: Perkins to Masa, Jan. 21, 1930. BCSC.

136    **"I'm glad to know there is a prospect"**: Perkins to Masa, Feb. 28, 1930. BCSC.

136    **Masa drew up a constitution; designed the club's logo**: The CMC summarized Masa's activities in minutes from various meetings from 1931 to 1933.

136    **"about 50–60 members"; "have 100 before long"**: Kephart to Fink, March 13, 1931. MHC.

136–7  **"When I got up this morning"**: Masa excerpt as quoted in letter from Kephart to Fink, March 13, 1931. WCU.

137    **"He left a monument"**: Gillespie as quoted in *Asheville Citizen*, April 6, 1931.

137    **all the seats:** *New York Times*, April 6, 1931.

137    **"some people came from Tennessee":** Grinnell's reminiscence is available at BCSC and WCU.

137    **"Two stalwart mountaineers":** *Bryson City Times*, April 10, 1931.

138    **"Yes, I saw him today":** Masa to Gooch, April 3, 1931. UTN.

138    **"Sure we needed oldman Kep":** Masa to Gooch, March 16, 1932. UTN.

138    **"was extremely active":** Steurer, *History of the Carolina Mountain Club*, 3.

138    **"the route through the northern":** Avery, "Progress of the Appalachian Trail," *Mountain Magazine* 9, no. 2 (June 1931): 8–9.

139    **"The enlarged club adopted":** Steurer, *History*, 3.

139    **"Except for the name of the club":** Steurer, 3.

140    **"George Masa has done"; "We must frankly admit:** Avery to various hiking clubs—SMHK, CMC, GATC—May 17, 1932. GMU.

140–1   **"it was very interesting"; "presided over the meeting"; "He was minimal"; "A lot of people":** Interview conducted on July 10, 2001, by Paul Bonesteel.

141    **"I'd go up to his office":** Interview conducted on June 3, 1996, and Nov. 9, 1996, by William A. Hart Jr.

141–2   **"knew every place"; "a very smart man"; "We could kid him"; "The man was an artist"; "George, what did"; "It was his business;" "George Stephens would not":** Interview conducted on June 3, 1996, and Nov. 9, 1996, by William A. Hart Jr.

142    **"The first step":** Fink, "Trail of the Great Smokies," in *Appalachia*, 63.

142–3   **"to think and dream"; "When you look at the pictures"; "nature's moods":** Love, *Asheville Citizen*, Aug. 25, 1929.

143    **"Only the other day":** Holmes to Masa, May 7, 1931. BCSC.

143    **"off your seats":** Steurer, 5.

143    **"that dam Porter gap":** As quoted by Kephart in letter to Fink, March 13, 1931. MHC.

143    **"the best mountaineer":** Cammerer to Masa, Feb. 16, 1933. BCSC.

## VII – NEVER SURRENDER

145    **"I lost every cents":** Masa to Gooch, March 2, 1931. UTN.

145    **Business was hopping:** Correspondence with Fink and Gooch provide evidence of the range of Masa's work.

145    **"this old shuck and ground":** Masa to Fink, May 14, 1930. MHC.

146    **"pictures are superb"; "Mrs. Vanderbilt":** Biltmore Estate to Masa, Dec. 14, 1920. BA.

146    **Cecil's paintings . . . for *Watch Y'r Step*:** Beadle to Cornelia Vanderbilt Cecil, Dec. 12, 1929. BA.

147    **"Chauffeurs and servants stood alongside lords and sirs":** Kiernan, *The Last Castle*, 258.

147    **"income to help defray the costs":** Kiernan, 269.

148    **"commanding a superb panorama":** *Asheville Citizen*, May 18, 1930.

148    **"cattle, cows and hogs all day long":** Masa to Gooch, Sept. 1930, UTN; other details on photography jobs in summer camps, Masa to Gooch, Aug. 24, 1930, UTN; golf tournament, art museum, and Biltmore, Masa to Fink, May 14, 1930, UTN; Warner Bros. jobs, Masa to Gooch, Dec. 28, 1930, UTN.

149    **"a very interesting if not awfully profitable profession":** Barnhill to Seely, May 18, 1938. BCSC.

149    **"attacked by Flu and sore throat"; "to make color"; "I am nearly":** Masa to Gooch, Dec. 28, 1930. UTN.

149 "shocked [him] to pieces": Masa to Fink, April 19, 1931. MHC.

149 "take you on my back"; "write as many"; "splendid scenery"; "Whatever you say": Masa to Gooch, Dec. 28, 1930. UTN.

150 "The singular feature of the great crash of 1929": Galbraith, *The Great Crash 1929*, 113.

150 "it was a (very) big event": Bernanke, *Essays on the Great Depression*, vii.

150 "great speculative orgy"; "in 1929 the rich"; "bad corporate structure"; "American enterprise": Galbraith, 174, 182–91.

150 "Banks closed their door": Masa to Gooch, Dec. 28, 1930. UTN.

150 "more than fifteen banks": Wicker, "A Reconsideration of the Causes of the Banking Panic of 1930," *Journal of Economic History* 40, no. 3 (Sept. 1980): 579.

151 "Through a close business associate of Roger Caldwell": Wicker, "A Reconsideration," 579.

151 "I lost every cents I had": Masa to Gooch, March 2, 1931. UTN.

151 "The day Asheville's banks closed": Harshaw, *Asheville*, 214.

151 "the economic situation in Asheville had deteriorated": Knowles, *"Days When Futures Passed,"* 45.

151–2 "Over two hundred stores": Knowles, 45.

152 Suncrest Lumber Co & Magnolia gardens photo shoot, Masa to Gooch, April 16, 1931. UTN.

152–3 "selling photos, mountain craft, rugs, etc."; "Local people thinks I am": Masa to Gooch, June 18, 1931. UTN.

153 "rich folks": Masa to Cammerer, July 20, 1931. BCSC.

153 "Through Kep, I feel as though": Stone to Masa, Oct. 31, 1931. BCSC.

154 "One of printing machine cost $350"; "I have been studing": Masa to Seely, March 15, 1932. BCSC.

154 "I have received your kind letter": Seely to Masa, March 18, 1932. BCSC.

154 "I am not impressed with it": Masa to Adams, March 1, 1932, with penciled annotation from Judge Junius Adams to Chauncey Beadle. BA.

154–5 "Now, about this $500": Cook to Masa, March 8, 1932. BCSC.

155 "some son of a pig stole": Masa to Gooch, March 16, 1932, UTN; *Asheville Citizen*, Feb. 5, 1932.

155 "Not much business, no money circulating": Masa to Gooch, March 16, 1932. UTN.

155 "I need your help this time"; "Please lend me": Masa to Seely, July 26, 1932. BCSC.

155 "George I am sorry to have to say to you": Wilburn to Masa, Nov. 4, 1932. BCSC.

156 "I will give him 50% profit": Masa to Ingerle, Nov. 14, 1932. BCSC.

156 Masa made a similar appeal: Masa to Kress, Nov. 16, 1932. BCSC.

156 "You know the suit cloth": Masa to Seely, March 15, 1932. BCSC.

156 "I took all my upper teeth some time ago": Masa to Gooch, Nov. 15, 1932. UTN.

157 "quite busy attending so many things": Masa to Gooch, Oct. 20, 1931. UTN.

157 "Hells bells"; "sick and tired"; "If I can secure": Masa to Gooch, Oct. 20, 1931. UTN.

157 "I am doubt he really interest our movement": Masa to Bennett, Jan. 23, 1932. BCSC.

157–8 hike to Mount Kephart: *Asheville Citizen*, April 16, 1932, and April 18,

1932; *Knoxville News-Sentinel*, April 13, 1932. See also, Masa to Bennett, March 17, 1933. BCSC.

158  **"quite a success"**: Eakin to Masa, April 3, 1933. BCSC.

158  **"nearly ready to publish pocket size guide book"**: Masa to Albright, April 8, 1933. Albright's reply to Masa dated April 15, 1933. BCSC.

159  **"Great Smoky Mountains patriot"**: Cammerer to Masa, April 20, 1932.

159  **"the best mountaineer on the North Carolina side"**: Cammerer to Masa, Feb. 16, 1933.

159  **"now is, and always"**; **"George Masa, its co-author"**; **"the unselfish, wholehearted"**: Horace Albright's welcome in McCoy and Masa, *Guide to the Great Smoky Mountains National Park*.

160  **"In addition to being an expert photographer"**: *Asheville Citizen*, June 22, 1933.

161  **"a useful little inexpensive guide"**: Platt, "Portrait of America: Guidebooks and Related Works," *Geographical Review* 29, no. 4 (Oct. 1939): 659–64.

161  **"Despite its many admirable features,"** Marjorie Hurd [M. H.], *Appalachia* 19, no. 4 (Dec. 1933): 633.

162  **"a photographer and booster of Western N.C."**: Masa to Henson, Feb. 3, 1933. BCSC.

162  *Touring*: Five years after his death, the magazine still relied on Masa's photos for illustrations. For example, Chimney Rock, Lake Lure, and a striking panorama of the view from Table Rock highlighting the high peaks on the horizon—from Andrews Bald (5,900') to Mount Sterling (5,600') with gaps and summits neatly noted in Masa's handwriting—are scattered throughout various 1930s issues.

163  **"well-known photographer"**; **"but his condition"**: *Asheville Citizen*, May 16, 1933.

163  **he was improving**: *Asheville Citizen*, May 24, 1933.

163  **"known anytime in the past few months"**: Gooch to Creasman, June 23, 1933. UTN.

164  **"One thing that broke my heart"**: Interview with Barbara Ambler Thorne conducted by William A. Hart Jr. on June 3, 1996.

164  **"It was his business"**: Hart interviewed Thorne on June 3, 1996, and Nov. 9, 1996.

164–5 **"Next to Horace Kephart"**: *Asheville Citizen*, June 22, 1933. The *Asheville Times* ran a stirring front-page tribute along with a photo of the photographer on June 21, 1933.

165  **"profusely illustrated"**; **"the first authentic"**: *Asheville Citizen*, June 22, 1933.

165  **"was buried in the city he loved"**: *Asheville Times*, June 23, 1933.

165–6 **"A sea of black umbrellas"**; **"did a lot"**; **"He was just a member"**: Interview with Jeanne Creasman Lance conducted by Paul Bonesteel, Feb. 28, 2001.

## VIII – TWO THOUSAND MILES AWAY SOUTHWARD

169  **"Here I am"**: Translation of poem found by the May family in George Masa's room after his death.

169  **"utmost importance"**; **"I send in this letter"**: Naves to Japanese legation, June 27, 1933. Included with the Naves letter is a second letter addressed to the Japanese ambassador from Col. D. W. Adams, president of the Daniel Boone National Forest Park Association. Adams enclosed

newspaper clippings about his friend Masa and requested that the clippings be passed along to Masa's family. We know very little about the relationship between Naves, a member of the news department of the *Asheville Citizen*, and Masa and assume that their work overlapped through the newspaper and community affairs. Given the tenor of the letter, Naves had great respect and admiration for Masa as did Col. Adams. The *Shin Sekai Nichi* newspaper on June 28, 1933, noted that a group of Masa's supporters sent a letter to the Japanese ambassador asking for help in locating Masa's family. The article also summarized the Tokyo police findings. MOFA.

170 **"the above-mentioned person"**: *Superintendent General Fujinuma's Report*, Oct. 4, 1933, Tokyo Police Department. MOFA.

170 **"to learn more of the family"**: Naves to Japanese legation, June 27, 1933. MOFA.

170 **"There is property"**: Buncombe County [North Carolina] Wills and Probate Records, 1665–1998, v. 13, available through Ancestry.com.

171 **Miss Billie Daves**: Although we were unable to verify, she is likely the same "Miss Daves" who worked in Masa's studio and testified at his 1921 trial. Offered a bribe to testify against Masa, she refused, asserting, "No, I don't make my living that way. . . . by telling lies."

171 **Myron Avery's $200 loan**: Correspondence between Avery and Lee documents the loan that Arthur Perkins (former chair of the ATC) made to Masa for his business. "Perkins had the note made payable to me [Avery] with the understanding that I should use any proceeds for work to be done on the Appalachian Trail in Maine." Avery to Lee, July 12, 1933. GMU.

171–2 **"exceptionally fine"**: *Park Naturalist Narrative Reports, 1935–36* (Jan. 1936). CPC.

172 **"will remain a mystery I'm afraid"**: Personal correspondence, Aday to McCue, Jan. 31, 1923.

172 **Fisher bought Masa's negatives**: Lathrop, "The Little Jap," *The State*, Sept. 5, 1953. Elliot Lyman Fisher and his wife moved to Florida in 1958, and it may be that they brought Masa's negatives, along with Fisher's own prints and negatives from his more than 40 years in business. Fisher remained somewhat active professionally with several Florida newspapers featuring his photographs. He and his wife returned to Asheville occasionally according to his 1968 obituary. But research, which included phone calls to Port Charlotte museums, photography shops, and antique stores from 2001 to the present have yet to turn up any leads on the Fisher collection of images—his own or Masa's. A few images of Fisher's turn up on eBay or other auction sites, but they are usually printed copies that he was marketing in the 1950s. Fisher's wife, Ella Hicks Fell Fisher, died a year after Fisher in 1969, still in Port Charlotte, but it appears they both are buried in Sudbury, Massachusetts. Fisher's stepdaughter died in 1939 in Asheville, and no children who might have collected or maintained the photos survived them. It is unknown if any other family members survived and managed the estate after Ella Fisher's passing. Sadly, even with the extensive research put into this effort by many, it can still be said with certainly that none of the negative images that Fisher possessed of Masa's work have been found.

172 **I. K. Stearns**: To gain an appreciation of the work that Stearns did in protecting Kephart and Masa's legacy and the specifics of its dispersal, see Ellison and McCue, *Back of Beyond*, 373–79.

172 **"none of special value"**: Wilburn to Stearns, Sept. 23, 1935. BCSC.

173 **"the historian should never rule"**: Menand, "The People Who Decide What Becomes History," *New Yorker*, April 11, 2022.

173 **letters written in Japanese**: Following the release of Bonesteel's film, various members of the May family contacted Bonesteel, including Henry P. May, a grandson of Mrs. Sallie May. While visiting his grandmother when he was a boy, Henry P. May met Masa, a boarder at his grandmother's house. May shared with Bonesteel the names of various May descendants who might have additional information, including Nancy May Leppert, who gave Bonesteel copies of the Japanese letters found in the May home after Masa's death. No one in the family knew where the originals were in 2002, nor have subsequent searches by various May descendants led to the original letters.

174 **"letters are the foundation of biography"**: Atlas, *Shadow*, 37–39.

174 **The letters . . . to a Mr. Matsui [and] . . . a Mr. Miyasaka**: The letters we refer to throughout this chapter are written in *kanji*; on occasion, there is a word written in *katakana* or *hiragana*. Since these letters are drafts and undated, there is no way to differentiate each of them within the text of this chapter. Even the salutations varied—e.g., the first draft of the letter might be addressed to Matsui, but his name was lined out and replaced by Miyasaka. Fusako Kudo Krummel was the first person to translate the George Masa diaries held at Western Carolina University in 2001. After the recovery of the Masa letters and letter drafts in 2007, she translated photocopies of what we then called the "Yama letters" and consulted Bonesteel extensively about her thoughts on them, including the various ways they could be interpreted. She was the first to theorize that these were actually George Masa writing autobiographically in some way to the (then) unknown people whose friend and family member was known as Shoji Endo, with the nickname "Yama." Krummel was born in Tokyo in 1933 and was a graduate of Meiji Gakuin University with a PhD in English literature. She died on July 4, 2017, and was as fascinated as anyone about George Masa's life.

Enhanced versions of the photocopied letters were reviewed by members of our research team who are native speakers of Japanese. Using software to enhance the photocopies to try and clarify words that were illegible on the copies reviewed by Krummel, team members then did a modern transcription of the letters. Bonesteel expects to donate these photocopied letters and the translations to WCU following the publication of this biography and the release of his new film.

176 **"Their ultimate goal"**: Ichioka, *The Issei*, 8.

176–7 **Passengers were screened**: Ito, *Issei*, 12.

177 **"a virulent stench"; "a large room"**: Fitts, *Issei Baseball*, 5–6. For first-hand descriptions of the conditions on board, see also Ito, 26–34.

177 **medical officer diagnosed a passenger named Shoji Endo**: San Francisco, CA, US Immigration Office Minutes, 1899–1910.

177 **in order to avoid the draft**: Perhaps to avoid conscription in the Russo-Japanese War of 1904–1905.

178 **the 21-year-old was issued a new passport**: A local Shizuoka newspaper, *Shizuoka Minyu Shimbun*, reported on Sept. 11, 1904, that Endo had applied for a passport to travel to the US to study. The newspaper also reported on Oct. 4, 1904, that the passport had been issued. Unable to stay in the US because of his eye infection, Endo returned his passport

on April 29, 1905. The following year, he was reissued a new passport on April 11, 1906.

178    **A request to Meiji University**: Shoji Endo graduated from Shizuoka Middle School on March 20, 1903, according to school alumni records. In a letter summarizing enrollment status, Meiji University confirmed a student named Shoji Endo enrolled in March 1905. The school year typically runs from April to March. We do not know precisely when he stopped taking classes, but Meiji University confirmed that his status was "withdrawn" in September 1906.

178    **Shoji Endo's new passport**: Passports were valid for six months from the date of issuance. According to Canadian Incoming Passenger Lists, 1865–1935, available through Ancestry.com, a passenger named S. Endo left Yokohama on May 17, 1906, and arrived in Victoria, British Columbia, on May 31, 1906. It is possible that this passenger was Shoji Endo.

178    **"the oldest Issei team in the Northwest"**: Fitts, 208.

178    **"on the cricket field"**: Fitts, 11–12.

179    **"Between 1912–1914 Japanese ball clubs"**: Fitts, 207.

179    **"brought immigrants together"**; **"undermine the anti-Japanese bigotry in the city"**: Fitts, 208.

179    **In 1911, the Seattle Mikado**: There were several city teams with the Mikado name (e.g., Denver Mikado, Portland Mikado).

179    **"reestablished the Portland Japanese Baseball"**: *Taihoku Nippo*, March 6, 1911. Endo's interest in baseball stretched back to his youth. In a visit to the Shizuoka Library, the research team found a photo of Shoji Endo with his teammates on the Ryodo baseball club in a *History of the Shizuoka Middle and High School Baseball Team* [translated title]. Most members of the school team also played on club teams, such as Ryodo, which sponsored training camps and practices. Photo credit is dated 1904.

179    **"Mountain climber Endo's"**; **"the fastest to start"**: *Taihoku Nippo*, March 6, 1911.

180    **"Jap Tossers Let Helenans"**; **"The Japanese, though they lacked knowledge"**: *Oregon Daily Journal*, March 30, 1914, oregonnews.uoregon.edu/lccn/sn85042444/1914-03-30/ed-1/seq-8/#words=Endo.

181    **"to learn more of the family, position"**: Naves to Japanese legation, June 27, 1933. MOFA.

181    **Shoji Endo and George Masa were indeed the same person**: As Linda Harms Okazaki wrote in her research report in February 2024, "The evolution of George Masa's name can easily be explained. Shoji Endo was a second son who married Tsuru Iizuka in 1914. As was customary with second sons, it is likely that Shoji took the surname of his wife, Iizuka, to become Shoji Iizuka. The name Shoji in Japanese can also be read as Masaharu, meaning that his name was possibly Masaharu Iizuka. Many first-generation Japanese living in the US adopted western names, such as George, Ben, Thomas, Frank. George was probably adopted as a western name, and Shoji became George Masaharu Iizuka, initially shortened to Geo. M. Iizuka and eventually to George Masa."

181    **George Masa was born on April 6, 1885**: A letter from Meiji University documented Shoji Endo's birth date. Okazaki explains why Western documents often have conflicting birth dates or ages. Before 1902, Japan practiced a traditional method of age reckoning whereby infants were considered to be one year of age on the day of birth. Traditionally, a person's age in Japan (and many other East Asian countries) was

incremented on New Year's Day, not on the birth date. Japan adopted the modern birth age system in 1902. Shoji Endo's first passport records his age as 19 years, 6 months, suggesting his birth date was March or April (1885 or 1886 depending on the method of calculation). A Shizuoka Middle School transcript from March 1903 recorded his age as 18 years and one month, which would imply a birth month of January or February.

Without access to the koseki, we cannot ascertain Masa's birthplace. Both the life insurance application Masa completed in 1919 and his death certificate list "Tokio" as his birthplace. After his death and well into the 21st century, it was reported that Masa was born in Osaka. There is no confirmation regarding Osaka as his birthplace. Instead, this supposition might be attributable to a newspaper article that appeared in the *Osaka Asahi* on Nov. 25, 1933. As we know, Glen Naves sent a letter to the Japanese legation requesting help in finding Masa's family. Naves or possibly other friends also alerted Japanese newspapers. The *Osaka Asahi* reported that "Mr. Keene, a friend of Japan" received a letter from North Carolina, recounting the story of George Masa. The newspaper article highlighted Masa's advocacy on behalf of the Smokies, his spirit as an artist, and his death. It mentions his "real name was Masahara Iizuka." In the archives of the Carolina Mountain Club at UNCA's Ramsey Library, there is also a fragment of a letter referencing the newspaper articles in the Japanese press. In this fragment, the letter writer (presumed to be Keene) who lives in Japan mentions that he had received a letter from a man in Osaka who read the newspaper accounts and thought "George was his long-lost brother whom they have not heard of in twenty-five years." The author of the letter explains that he is "having Tachibana answer the letter." It may be that these early mentions of Osaka resulted in the later statements attributing Masa's birthplace as Osaka.

Similarly, no further additional information is available regarding Masa's siblings. Masa lists a brother and a sister* on the life insurance application. We know that Masa was the second son, but we do not know his elder brother's name. It may be that Shigeko, who encourages Masa to consider her his "eldest sister," may be his sister-in-law and the wife of his elder brother. We also know from the Japanese letters that he had a younger adopted sister whose name is unknown. According to a Sept. 3, 1933, article in the *Asheville Citizen-Times*, "In 1923 the newspaper reported that George Masa 'Has grave fears' for the fate of his brother and sister following a massive earthquake in Tokyo."

182     **The 1912 yearbook . . . identified Endo:** *The North American Times Yearbook, no.* 3 (1912), NDL Digital Collections, dl.ndl.go.jp/pid/767438/1/1.

183     **likely Endo also operated:** "Nine Licenses Withheld," *Morning Oregonian,* Dec. 13, 1913, oregonnews.uoregon.edu/lccn/sn83025138/1913-12-13/ed-1/seq-16/#words=Endo.

183     **"longtime baseball contributor":** *Taihoku Nippo,* March 12, 1913. Endo was often referred to by his nickname, Yama, which can mean "mountain."

183     **"a common professional name used by barmaids":** Personal correspondence, Oharazeki to McCue, Jan. 21, 2023. Hajime is usually a man's name and would be written in *kanji* to refer to a man. In the Japanese letters found at the May home, Hajime was written in katakana (a syllabary used for foreign words and loan words), which suggests it was a woman's pseudonym.

183     **"since her days at the Uraume"**: *Taihoku Nippo*, March 12, 1913.

183     **"For all classes of Japanese men"**: Oharazeki, *Japanese Prostitutes in the North American West, 1887–1920*, 106–8.

184     **"pretty well-dressed woman"; "fashionable, well-fitting"**: *Oregon Sunday Journal*, October 26, 1913, oregonnews.uoregon.edu/lccn/sn85042444/1913-10-26/ed-1/seq-11/#words=Matsui (The *Oregon Sunday Journal* was the Sunday edition of *Oregon Daily Journal*).

184     **"one of the few Japanese"; "all the American customs"**: *Sunday Oregonian*, October 26, 1913, oregonnews.uoregon.edu/lccn/sn83045782/1913-10-26/ed-1/seq-15/#words=Iizuka (The *Sunday Oregonian* was related to the *Morning Oregonian* newspaper).

184     **Endo and Iizuka were issued**: *Oregon Daily Journal*, Oct. 21, 1914, posted the notice of a marriage license between Shoji Endo and Tsuru Iizuka. The sequence of marital and divorce dates reported in the newspapers may be confusing. On March 12, 1913, the *Taihoku Nippo* (*Great Northern Daily News*) reported the wedding of Endo and Hajime in a brief gossip column. As Mizuho Takagi, one of the researchers on our team, noted, Endo and Hajime were pop stars of their time, the handsome baseball player and the talented and popular barmaid, and their activities were followed closely by gossip columnists. Tsuru's divorce from her husband, Ben Kono, was finalized on Oct. 26, 1913. The *Oregon Daily Journal* reported that Endo and Iizuka were issued a marriage license on October 9, 1914, and their marriage was recorded on Oct. 19, 1914. It seems likely that the 1913 marriage was a traditional Japanese marriage, while the later divorce proceedings and 1914 marriage license and registration were to ensure that both events were legal in the US. See: Multnomah County [Oregon] Marriage Records, 1914, entry for Shoji Endo and Tsuru Iizuka, register no. 29348, available through Ancestry, ancestry.com/discovery-ui-content/view/120297591:61677.

185     **In August 1914**: On Sunday, August 23, 1914, the day before the Seattle Nippon baseball team left for Japan, the team played send-off games between the Allied Team and Asahi, and Endo was a member of the Allied Team. He did not go to Japan, perhaps because he was a member of the Portland Mikado and not of the Seattle Nippon team, which had been formed by the merger of Seattle Mikado and Tacoma. In August 1913, Endo appeared in the magazine *Yakyukai* (*The Baseball World*), and Endo was identified as the manager of the Mikado team in Seattle. The photo of Endo strongly resembles Masa.

185     **"pretending"**: Two articles in *Rafu Shimpo* (Jan. 29, 1915, and March 7, 1915) report on the travel money problem. In the January 29, 1915, article, the newspaper reports that Endo tried to end his life in the Sierra Nevada mountains and had been "pretending to try to send money" to the team in Japan. The second article reported that Endo had sent suicide notes to friends but that he had instead left for Los Angeles. The article then posits among other theories that Endo might be hiding, might have tired of his wife, or perhaps he and his wife are co-conspirators.

185–6     **"to bring success to you all"**: The letters discuss the travel money but through the lens of Endo and sometimes in a more oblique way, e.g., "die once to apologize for his sin" referring to the symbolic death of Endo. As Okazaki suggests, "suicide (*seppuku*) had traditionally been viewed in Japanese culture as a manner of restoring honor, particularly for the *samurai class*."

186     **"the cunning conspiracy"**: Endo refers to "the cunning conspiracy" in one of the Japanese letters. For additional background on Masajiro Furuya and Ototaka Yamaoka, see Ito, 85, 136, 699–724, and 735; Ichioka, 58, 61–64; and Oharazeki, 120.

186–7  **"Shameless Certain Mr. Endo"; "fake last notes"; "after the problem solved"; "It is extremely shamelesss"**: *Rafu Shimpo*, March 7, 1915.

187     **"to advance about two hundred yen"; "They persisted"; "15 months or so"; "pay back what little amount"**: Miyasaka to Hajime Endo, n.d. This letter provides more detail about the situation surrrounding the $1,500 and allows us to understand it from Miyasaka's perspective and feel his desperation. In his haste, he may have written the wrong total.

189     **"on a snowy day"; "I am very much looking forward"; "Seas, mountains, rivers"**: Shigeko to Yama, Feb. 21 (n.d.). This correspondence was found in Masa's room after his death like the other Japanese letters. Shigeko wrote it in response to a letter she had received from him. We do not know the precise relationship to Masa nor her family name, but she writes, "Consider me your elder sister since I am older than you." It is possible Shigeko is Masa's sister-in-law. She also updates Masa on her husband who might be Masa's older biological brother. The only other connection to Endo's family or friends in Japan is a newspaper advertisement. On March 18, 1918, a man named Shinjiro Iwasaki posted an ad in a San Francisco Christian newspaper, *Shin-Sekai* (*New World*) seeking Shoji Endo. We do not know whether Masa knew about this inquiry, nor do we know the motivation for the posting. Was there a crisis in his biological family or his foster family? *Shin-Sekai*, March 18, 1918.

189     **what other factors**: Atlas, *Shadow*, 260.

190     **"Miyasaka Leaves"**: *Taihoku Nippo*, Feb. 23, 1915.

191     **A few years later, Miyasaka**: *Taihoku Nippo*, March 28, 1918.

192     **"a project and an area"**: Naves to Japanese legation, June 27, 1933. MOFA.

192     **"The map brings"**: Love, Aug. 25, 1929.

192     **"out of sheer loyalty"**: Kephart to Fink, March 3, 1931. UTN.

193     **"May I assure you"**: Naves to Japanese legation, June 27, 1933. MOFA.

## IX – SOMETHING OF A LEGEND

195     **"And Masa, mystery man"**: Beck, *Detroit News*, Oct. 14, 1934.

195     **"the most lichenologically diverse"; "Lichens grow on everything"**: Tripp and Lendemer, *Field Guide to the Lichens of Great Smoky Mountains National Park*, 50 and 6.

196     **"fundamental contributors"; "You won't ever see"; "numerous secrets"; "How are there so many"**: Tripp and Lendemer, 4 and 236.

196     **"one of the richest"**: Kephart to Weaver, Dec. 24, 1924. WCU.

196     **"a greater variety of forest"**: Kephart to Weaver, Dec. 24, 1924. WCU.

197     **"If we want to be good"**: Personal correspondence, Todd Witcher to Frances Figart, May 28, 2024.

197     **Masa was a significant figure**: "Founding the National Park," Great Smoky Mountains National Park, updated April 14, 2015, nps.gov/grsm/learn/historyculture/biographies.htm.

198     **"the Smokys are OK"**: Adams to Beaumont Newhall, Oct. 9, 1948. CCP.

198     **"Masa only weighed"; "have scenery to knock"; "Camera clicks"**: Beck, *Detroit News*, Oct. 14, 1934.

199     **"set the mind to think"**: Love, *Asheville Citizen*, Aug. 25, 1929.

199    **a simple 1×2-foot marker:** Carolina Mountain Club (CMC), minutes, March 11, 1947. See also a summary of mentions of Masa in the CMC minutes dated Oct. 20, 1959, compiled by Wilma J. Dykeman. UNCA.

199    **reinter Kephart's remains:** Cammerer to Fink, May 1, 1940. UTN. See also memorandum on interments in the park issued Jan. 3, 1940.

200    **companion markers in the Bryson City Cemetery:** Griffin, "Kephart Reunited with Wife, Best Friend," *Smoky Mountain Times*, May 24, 2023, thesmokymountaintimes.com/feature/kephart-reunited-wife-best-friend.

200    **"that recognition be given the work":** North Carolina Place-Name Committee, minutes, Sept. 23, 1937. CPC.

200    **"in commemoration of the stranger":** CMC Resolution, May 11, 1960. UNCA.

200–1    **"To give one of those tiny points"; "It is the conviction":** Campbell to Overly, July 6, 1960, and attached Place Names Committee, GSMCA recommendations, dated July 6, 1960. UNCA.

201    **"so that we can lay out our case":** Robinson to Taylor, July 25, 1960. UNCA.

202    **"an unnamed peak":** Robinson to Wirth, Aug. 4, 1960. UNCA.

202    **"The Great Smoky Mountains":** Robinson to Kilmartin, Aug. 30, 1960. UNCA.

203    **"the Great Smoky Mountains Conservation":** Campbell to Robinson, Sept. 1, 1960. UNCA.

203    **"hearing on naming":** *Asheville Citizen-Times*, Sept. 18, 1960.

203–4    **"The way was paved Tuesday"; "saw no reason":** *Asheville Citizen*, Jan. 25, 1961.

204    **"present depth of snow":** Allen to Acting Superintendent to the Regional Director, Feb. 2, 1961. UNCA.

204    **"to measure and pinpoint":** *Asheville Citizen*, Feb. 7, 1961.

204    **Robinson summarized the club's:** Robinson to Overly, March 7, 1961. UNCA.

204    **"As so often happens":** *Asheville Citizen*, Jan. 26, 1961.

205    **"roamed the vastness":** *Asheville Citizen-Times*, June 14, 1996.

205    **"George Masa deserves"; "spent part of every summer"; "What a unique individual"; "As humble":** Personal correspondence, King to McCue, July 20, 2022.

206    **"Masa was an unassuming man":** Personal correspondence, Hart to McCue, Feb. 16, 2024.

206    **"To truly honor George":** "Masa Historical Marker," Bonesteel Films, vimeo.com/ondemand/georgemasa/794118420.

208    **"When I make [hiking]":** Masa to Gooch, Sept. 11, 1931. UTN.

208–9    **"George Massa of Asheville":** Love, *Asheville Citizen*, Aug. 25, 1929.

209    **"Deep into the mountain path":** Translation of poem found among Masa's papers at the May family residence after his death.

209    **"Very little of this":** Personal correspondence, McKee to McCue, April 14, 2023, and May 22, 2023.

210    **"a paradise for contemplation"; "In this day":** Love, *Asheville Citizen*, Aug. 25, 1929.

211    **"Because recognition":** Stephens to Medford, Jan. 23, 1961. UNCA.

211    **"Opportunity's head hair":** Masa to Kress, Nov. 16, 1932. BCSC.

212    **"In the deep":** *Carolina Mountain Club Bulletin* 3, no. 7 (July 1933).

# ARCHIVAL RESOURCES

To write this biography, the co-authors and members of our research team visited archives from Tokyo to Tennessee. Dozens of online repositories, including the Hoji Shinbun Digital Collection at Stanford's Hoover Institution Library and Archives, provided valuable newspaper and magazine articles; microfilm reels from the US Bureau of Investigation or the Ministry of Foreign Affairs in Tokyo revealed essential government documents. Popular databases such as Ancestry, Family Search, and Newspapers.com supplied other sources. Academic institutions provided letters, photos, or articles helping us weave together the story of George Masa. The repositories listed below archive correspondence, government documents, and photographs that are cited or referred to in *George Masa: A Life Reimagined*.

**BA**    Biltmore Estate Archive (Biltmore Museum Services). Correspondence between various administrators (e.g., Chauncey Beadle, Junius Adams) with or about George Masa and his photographic services are available, as are some photographs with Plateau Studio markings. Also see correspondence related to the Landscape Architecture exhibit at the San Francisco Museum of Art, which featured some of Masa's photos. A significant number of photographs made by Masa for the estate and the Vanderbilt and Cecil families are in the Biltmore Estate Archive including the negatives for many of the photos.

**BCSC**    Buncombe County Special Collections, Pack Memorial Library, Asheville, North Carolina. BCSC contain a vast collection of photographs by George Masa and of Masa through decades of donations of images from many sources, including the scrapbook from the Creasman family. This collection and the ongoing presentation and interpretation of this material has made Pack Library a vital partner in the preservation of Masa's legacy. Because of the stewardship of I. K. Stearns, BCSC hold a rich collection of Masa correspondence. See Horace Kephart and George Masa Correspondence (MS025) files. BCSC also host a significant collection of Masa photos and postcards that have been digitized: 7039.sydneyplus.com/archive/final/portal.aspx.

**BU**    Brown University, Manuscript Collections, John Hay Library. See the Harry Lyman Koopman Collection for correspondence between Horace Kephart and his friend Koopman.

**CCP**    Center for Creative Photography Archives, University of Arizona. The letter from Ansel Adams to Beaumont discussing Ansel's reaction to the Smokies is available: 1947–53, Box 2, Beaumont and Nancy Newhall Collection, AG 48, aspace.ccp.arizona.edu/repositories/2/archival_objects/26293.

**CPC**    Collections Preservation Center, National Park Service. This center in Townsend, Tennessee, houses the Great Smoky Mountains National Park archives. Collection 108632, Park Naturalist Narrative Reports 1935–36, Box 14, Folder 27, was useful in ascertaining whether Masa's photos made it into lantern slides. The Kephart family collection is a valuable source for photos.

**CU**    Cornell University Library, Rare and Manuscript Collections. Cornell has almost three hundred collections related to city and regional planning. The John Nolen Papers, 1890–1938, Collection 2903, which includes correspondence, photos, and plans, was the primary collection used for this book.

**GMU**    George Mason University Libraries, Special Collections Research Center (SCRC). In 2022, the library's SCRC acquired the Appalachian Trail Conservancy Archives. Both the Myron Avery collection and the Arthur Perkins collection (Box 455) provided new insights into the extensive work that Masa did on behalf of the AT. Particularly valuable were Myron Avery correspondence, General 1930–1932 (Box 190) and General 1932–34 (Box 182); Avery maps (Box 189); Avery photo albums (Box 299) and photo collections (Box 648); miscellaneous photos (Box 645); and Avery Memory Book (Box 295). Other collections (e.g., Box 416, meetings 1–11) were consulted as well.

**HIL**    Hoover Institution Library and Archives, Stanford University. The Hoji Shinbun Digital Collection contains a wealth of Japanese-language newspapers including the *Rafu Shimpo* and the more obscure *Shin-Sekai*, a San Francisco-based Christian newspaper.

**HIGH**    Highlands Historical Society, Highlands, North Carolina. The Frank Cook Collection of photos includes more than a hundred well-preserved images made by Masa for Cook and his efforts to promote the Highlands.

**MD**    Miller Printing Collection, Daniels Graphics. This includes over a hundred images owned by Jami Daniels of Daniels Business Services. Her father, Jim Daniels, purchased the Miller Printing business in the 1970s. The company was a prominent printing operation through the years Masa was working in the region and the decades after. Miller Printing files contained many of Masa's "greatest hits" that were used in publications by the Asheville Chamber of Commerce and other promotional materials for many entities. By good fortune, Jami worked for Bonesteel Films in 2000 and 2001 doing research and production work on *The Mystery of George Masa* documentary film. Connecting the dots, she brought forth the images that have added significantly to the Masa archive.

**MHC**    McClung Historical Collection, Knox Public Library, Knoxville, Tennessee. The extensive files—correspondence, photos, and maps in particular—in the Paul Mathes Fink Collection (MSC 0123) were important to this study. These include correspondence between Fink and Masa and others like Kephart and Avery on topics ranging from the AT to nomenclature.

**MOFA**    Ministry of Foreign Affairs, Diplomatic Archives. Our research team conducted a thorough (and tedious) search of microforms on name variations of Masaharu Iizuka, Tsuru Iizuka, and Shoji Endo. Passport records for Shoji Endo were found for his passport application (Microform Roll 37, July–Sept 1904), returned passport (Roll 39, April–June 1905), and reissued passport (Roll 44, April–June 1906). The researchers reviewed the "Miscellaneous Collection Regarding Nationals Living Abroad, North America," July–December 1933 and January–June 1934 for details on the search for Masa's family.

**NA**    National Archives. Located in College Park, Maryland, these archives have several collections of importance to the Masa story, including the records of NPS Director Arno B. Cammerer (RG 79) and the Bureau of Investigation's Old German Files.

**NCSA**    North Carolina State Archive. This collection in Raleigh includes several files relating to the work of the Nomenclature Committee of North Carolina. It also holds files related to the North Carolina Council of Defense, of which Fred L. Seely was an active member.

**NDL**     National Diet Library. Research team members located microfilm copies of the *Taihoku Nippo* (the *Great Northern Daily News* published in Seattle) at NDL, along with other relevant periodicals and newspapers. A daily published Monday through Saturday, the *Taihoku Nippo* covered international news as well as news from Japan and the United States, including Japanese communities within the US.

**OGF**     Old German Files, Bureau of Investigation. Case 103402 in the microform collection provided details about the Bureau of Investigation's inquiry into George Masa and Giovanni Elia. These files are available through the National Archives.

**RA**     Rockefeller Archive Center. The Cultural Interests Collection, Great Smoky Mountains National Park, 1924–1930, holds correspondence between Cammerer and Rockefeller (and his associates) along with letters to other philanthropists, including Henry Ford, regarding funding the national parks. The archive is located in Sleepy Hollow, New York.

**UNCA**     University of North Carolina at Asheville, Ramsey Library, Special Collections and University Archives. With its focus on local and regional material, the Ramsey Library has a wealth of information and photographs. Collections of importance to Masa's story include the Carolina Mountain Club Archive (M2002.2), E. W. Grove Papers (M2018.10), the Bill and Alice Hart Collection (M2022.02), and the Fred Loring Seely Papers (M2018.07). A major collection of Masa's work is included in the Ewart M. Ball Photographic Collection. Donated by Ewart Ball III in 1977, this includes thousands of photos from the years when Masa owned Plateau Studios along with corresponding notebooks and inventories. In 1992, the Ball collection became part of the Special Collections in the D. Hiden Ramsey Library. For years, it was unclear exactly the scope Masa's body of work in this collection, as the photo numbering system and records were not clearly discernable and Ball continued to operate as Plateau Studios for decades after Masa's sale. But through the work of Angelyn Whitmeyer and the sleuthing of others, the George Masa database now provides a clearer delineation between Masa's work and Ball's. In 2024, hundreds of Masa's images that were previously in the *Asheville Citizen-Times* archive were donated by Gannett Publishing to the University of North Carolina at Asheville's Special Collections thanks to the work of Executive Editor Karen Chávez and head of special collections Gene Hyde, adding to this already extensive collection.

**UNCCH**     University of North Carolina at Chapel Hill, Wilson Special Collections. This collection (PO102) consists of two photograph albums originally created by Jewell King relating to her hiking adventures and the activities of the Carolina Mountain Club of Asheville, North Carolina, in the 1930s. Some of Masa's own photos are included in the album, and he appears in several group photographs taken by King. These albums were found and purchased by Robert Brunk and donated to this collection.

**UTN**     University of Tennessee, Special Collections. The Jim Casada Collection of Horace Kephart and George Masa (Collection 3452) provided documents related to Margaret Gooch and her correspondence with Masa, Kephart, and others.

**WCU**     Western Carolina University, Hunter Library, Special and Digital Collections. The Horace Kephart collection is extensive, containing

correspondence, clippings, and photographs. This collection has been enhanced through additional contributions by descendants of the Kephart family and through related collections, which have been acquired through the diligence of archivists. The George Masa Collection (MSS-80-29) includes photographs, photo albums, newspaper clippings, scrapbooks, notebooks, and his library of books. Of particular importance to this study is the notebook we refer to as "the diary," a record from 1915, some notations written in Japanese, others in English (MSS 80-29, Box 6, Folder 7). The 2024 gift of Masa material (correspondence, postcards, photographs, brochures, and other ephemera containing Masa photographs or related to Masa places—e.g., Grove Park Inn, Biltmore, Mount Mitchell, and photographs) to Hunter Library by William A. Hart Jr. and Alice Huff Hart is a major new contribution to Masa research.

# SELECTED SOURCES

Albright, Horace M. *Creating the National Park Service: The Missing Years.* Norman: University of Oklahoma Press, 1999.

Albright, Horace M. *Report of the Director of the National Park Service to the Secretary of the Interior for the Fiscal Year Ended June 30, 1929–31 and the Travel Season 1929–31.* Washington, DC: Government Printing Office, 1929–31.

Ambler, A. Chase, Jr. "The First Movement for the Great Smoky Mountains National Park, 1885–1923." Boone, NC: Appalachian State University, 2005. A. Chase Ambler book collection, Appalachian State University Special Collections Research Center.

American Protective League. *American Protective League: Organized with the Approval and Operating under the Direction of the United States Department of Justice, Bureau of Investigation.* Washington, DC: American Protective League, 1918.

Anderson, Larry. *Benton MacKaye: Conservationist, Planner, and Creator of the Appalachian Trail.* Baltimore: Johns Hopkins University Press, 2002.

Arthur, John Preston and Daughters of the American Revolution. *Western North Carolina: A History from 1730–1913.* Raleigh, NC: Edwards and Broughton Printing Company, 1914.

Asheville Board of Trade. *Asheville, North Carolina: America's Beauty Spot in the Land of the Sky: Health, Pleasure, Profit.* Asheville, NC: Asheville Board of Trade, 1912.

*Asheville, North Carolina City Directory.* Asheville, NC: Piedmont Directory Company, 1915–.

Askins, Robert. *Saving the World's Deciduous Forests: Ecological Perspectives from East Asia, North America, and Europe.* New Haven: Yale University Press, 2014.

Atkinson, David C. *The Burden of White Supremacy: Containing Asian Migration in the British Empire and the United States.* Chapel Hill: University of North Carolina Press, 2016.

Atlas, James. *The Shadow in the Garden: A Biographer's Tale.* New York: Pantheon Books, 2017.

Avery, Myron H. "Progress of the Appalachian Trail." *Mountain Magazine* 9, no. 2 (June 1931): 1–11.

Avery, Myron H., and Kenneth S. Boardman. "Arnold Guyot's Notes on the Geography of the Mountain District of Western North Carolina." *The North Carolina Historical Review* 15, no. 3 (July 1938): 251–318.

Azuma, Eiichiro. *Between Two Empires: Race, History, and Transnationalism in Japanese America.* New York: Oxford University Press, 2005.

Barnhill, William. "Pioneer Life in Western North Carolina." *Life*, October 16, 1970. See also: loc.gov/pictures/item/2004681274/.

Barry, John M. *The Great Influenza: The Story of the Deadliest Pandemic in History.* New York: Penguin Books, 2005.

Bernanke, Ben. *Essays on the Great Depression.* Princeton, NJ: Princeton University Press, 2000.

Bishir, Catherine W. *A Guide to the Historic Architecture of Western North Carolina.* Chapel Hill: University of North Carolina Press, 1999.

Bonesteel, Paul, dir. *The Mystery of George Masa.* Asheville, NC: Bonesteel Films, 2002.

Bridges, Anne, Russell Clement, and Ken Wise. *Terra Incognita: An Annotated Bibliography of the Great Smoky Mountains, 1544–1934*. Knoxville: University of Tennessee Press, 2014.

Brunk, Robert S. *May We All Remember Well: A Journal of the History and Culture of Western North Carolina* 1 and 2 (1997; 2001).

Campbell, Joseph. *The Hero with a Thousand Faces*. 3rd ed. Novato, California: New World Library, 2008.

Carolina Mountain Club. *Carolina Mountain Club Bulletin* 3, no. 7 (July 1933).

Catton, Theodore. *A Gift for All Time: Great Smoky Mountains National Park Administrative History*. October 10, 2008. Report prepared for Great Smoky Mountains Association and Great Smoky Mountains National Park. npshistory.com/publications/grsm/adhi.pdf.

Catton, Theodore. "J. Ross Eakin: First Superintendent of Great Smoky Mountains National Park." *Smokies Life* 2, no. 2 (Fall 2008): 87–93.

Constantz, George. *Hollows, Peepers, and Highlanders: An Appalachian Mountain Ecology*. 2nd ed. Morgantown: West Virginia University Press, 2004.

Cresswell, Tim. *Place: An Introduction*. 2nd ed. Chichester, West Sussex (UK): Wiley Blackwell, 2015.

Cronon, William. *Tangled Roots: The Appalachian Trail and American Environmental Politics*. Seattle: University of Washington Press, 2013.

Daniels, Roger. *Asian America: Chinese and Japanese in the United States since 1850*. Seattle: University of Washington Press, 1988.

Daniels, Roger. *Coming to America: A History of Immigration and Ethnicity in American Life*. 2nd ed. New York: HarperCollins, 2002.

D'Anieri, Philip. *The Appalachian Trail: A Biography*. Boston: Houghton Mifflin Harcourt, 2021.

Davis, Ren, and Helen Davis. *Land of Everlasting Hills: George Masa, Jim Thompson and the Photographs That Helped Save the Great Smoky Mountains and Complete the Appalachian Trail*. Athens: University of Georgia Press, [forthcoming].

Dodge, William Waldo, Jr. "Architect as a Craftsman." *The American Architect* 134, no. 11 (1928): 595–60.

Ellington, Douglas D. "The Architecture of the City Building, Asheville, North Carolina." *Architectural Record* 64, no. 2 (August 1928): 89–93; 125–35.

Ellison, George. *High Vistas: An Anthology of Nature Writing from Western North Carolina and the Great Smoky Mountains*. Charleston, SC: History Press, 2011.

Ellison, George, and Janet McCue. *Back of Beyond: A Horace Kephart Biography*. Gatlinburg, TN: Great Smoky Mountains Association, 2019.

Fink, Paul M. "Trails of the Great Smokies." *Appalachia* 18, no. 1 (June 1930): 63–69.

Fink, Paul M., and Myron H. Avery. "Arnold Guyot's Explorations in the Great Smoky Mountains." *Appalachia* 21 (December 1936): 253–61.

Fink, Paul M., and Myron H. Avery. "The Nomenclature of the Great Smoky Mountains." *Publications of the East Tennessee Historical Society* 9 (1937): 53–64.

Fitts, Robert K. *Issei Baseball: The Story of the First Japanese American Ballplayers*. Lincoln: University of Nebraska, 2020.

Frazier, Kevan D. "Outsiders in the Land of the Sky: City Planning and the Transformation of Asheville, North Carolina, 1921–1929." *Journal of Appalachian Studies* 4, no. 2 (1998): 299–316.

Fritzell, Peter A. *Nature Writing and America: Essays upon a Cultural Type*. Ames: Iowa State University Press, 1990.

Frost, Stanley. *The Challenge of the Klan*. Indianapolis: Bobbs-Merrill, 1923.

Galbraith, John Kenneth. *The Great Crash 1929*. 3rd ed. Boston: Houghton Mifflin, 1972.

Gordon, Linda. *The Second Coming of the KKK: The Ku Klux Klan of the 1920s and the American Political Tradition*. New York: Liveright, 2017.

Gray, Asa. "Analogy between the Flora of Japan and that of the United States." *American Journal of Science and Arts* 2, no. 2 (Nov. 1846): 135–36.

Greater Western North Carolina Association. *Greater Western North Carolina: Summer Season, 1914*. Asheville: Greater Western North Carolina Association,1914. hdl.handle.net/2027/uiuo.ark:/13960/t53f9pn0s.

Gregory, Thomas Watt. *Annual Report of the Attorney General of the United States*. Washington, DC: Government Printing Office, 1917.

Guyot, Arnold. "On the Appalachian Mountain System." *American Journal of Science and Arts* 3, 92 (March 1861): 157–87.

Hane, Mikiso, and Louis G. Perez. *Modern Japan: A Historical Survey*. 5th ed. Boulder, CO: Westview Press, 2013.

Harlan P. Kelsey, Inc. *Aristocrats for the Garden*. Boxford, MA: Kelsey-Highlands Nursery, 1932. biodiversitylibrary.org/item/260181#page/27/mode/1up.

Harshaw, Lou. *Asheville: Mountain Majesty*. Fairview, NC: Bridge Mountain Books, 2007.

Hart, William A. Jr. "George Masa: The Best Mountaineer." *May We All Remember Well: A Journal of the History and Culture of Western North Carolina* 1 (1997): 249–75.

Hart, William A. Jr. "George Masa: Smoky Mountains Photographer and Patriot." *Smokies Life* 2, no. 2 (Fall 2008): 76–85.

Henion, Leigh Ann. "A Behind-the-Scenes Visit to Biltmore." *Our State*, February 28, 2011. ourstate.com/biltmore-insiders-tour.

Herman, Gerald. *The Pivotal Conflict: A Comprehensive Chronology of the First World War, 1914–1919*. New York: Greenwood Press, 1992.

Houk, Rose. *Pictures for a Park: How Photographers Helped Save the Great Smoky Mountains*. Gatlinburg, TN: Great Smoky Mountains Association, 2016.

Hubbard, Bert. "A Hotel with a Soul." *Roycroft* 1, no. 4 (December 1917): 109–11.

Hurd, Marjorie [M. H.]. Review of *Guide to the Great Smoky Mountains National Park* by George Masa and George McCoy. *Appalachia* 19, no. 4 (December 1933): 633.

Ichioka, Yuji. *A Buried Past: An Annotated Bibliography of the Japanese American Research Project Collection*. Berkeley: University of California Press, 1974.

Ichioka, Yuji. *Before Internment: Essays in Prewar Japanese American History*. Edited by Gordon H. Chang and Eiichiro Azuma. Stanford, CA: Stanford University Press, 2006.

Ichioka, Yuji. *The Issei: The World of the First Generation Japanese Immigrants, 1885–1924*. New York: Free Press, 1988.

Ichioka, Yuji, and Eiichiro Azuma. *A Buried Past II: A Sequel to the Annotated Bibliography of the Japanese American Research Project Collection*. Los Angeles: Asian American Studies Center, 1999.

Ito, Kazuo. *Issei: A History of Japanese Immigrants in North America*. Seattle: Japanese Community Service, 1973.

Jackson, Kenneth T. *The Ku Klux Klan in the City 1915–1930*. New York: Oxford University Press, 1967.

James, Paul. "The Photographic Conservationist: The Surprising Legacy of Jim Thompson." In *Knoxville Lives II*, 43–68. Knoxville, TN: Knoxville History Project, 2020.

Jensen, Joan M. *The Price of Vigilance.* Chicago: Rand McNally, 1969.

Johnson, Bruce E. *Built for the Ages: A History of the Grove Park Inn.* Rev. ed. Asheville, NC: The Grove Park Inn Resort and Spa, 2004.

Johnson, Thomas R. *From Dream to Reality: History of the Appalachian Trail.* Harpers Ferry, WV: Appalachian Trail Conservancy, 2021.

Kephart, Horace. *Camping and Woodcraft.* Gatlinburg, TN: Great Smoky Mountains Association, 2011.

Kephart, Horace. "Kephart Writes of Odd Names in Smoky Mountains." *Asheville Times*, March 2, 1930.

Kephart, Horace. "The Last of the Eastern Wilderness." *World's Work* 51, no. 6 (April 1, 1926): 617–632.

Kephart, Horace. *Our Southern Highlanders.* Gatlinburg, TN: Great Smoky Mountains Association, 2014.

Kiernan, Denise. *The Last Castle: The Epic Story of Love, Loss, and American Royalty in the Nation's Largest Home.* New York: Touchstone, 2017.

Kindleberger, Charles P. *The World in Depression, 1929–1939.* Rev. ed. Berkeley: University of California Press, 1986.

Kneebone, John T. "Publicity and Prejudice: The *New York World*'s Exposé of 1921 and the History of the Second Ku Klux Klan." Virginia Commonwealth University, VCU Scholars Compass, 2015. scholarscompass.vcu.edu/cgi/viewcontent.cgi?article=1014&context=hist_pubs.

Knights of the Ku Klux Klan. *Constitution and Laws of the Knights of the Ku Klux Klan.* Atlanta, GA: Knights of the Ku Klux Klan,1921. hdl.handle.net/2027/uc1.31175035252793.

Knights of the Ku Klux Klan. *Papers Read at the Meeting of Grand Dragons at Their First Annual Meeting Held at Asheville, North Carolina, July 1923.* N.p.: Knights of the Ku Klux Klan, 1923. hdl.handle.net/2027/dul1.ark:/13960/t8sb8xs3j?urlappend=%3Bseq=5.

Knowles, David L. "Days When Futures Passed: Confronting the Great Depression in Asheville, North Carolina, 1929–1933." MA thesis, East Tennessee State University, 1997.

Kraft, Barbara S. *The Peace Ship: Henry Ford's Pacifist Adventure in the First World War.* New York: Macmillan, 1978.

Lathrop, Virginia T. "The Little Jap." *The State*, September 5, 1953.

Lee, Shelley Sang-Hee. *Claiming the Oriental Gateway: Prewar Seattle and Japanese America.* Philadelphia: Temple University Press, 2011.

Lopez, Barry. "A Literature of Place." *Portland* (Summer 1997): 22–25.

Love, Lola M. "Japanese Photographer Is Artist with Camera." *Asheville Citizen*, August 25, 1929.

MacCorkle, William Alexander. *The White Sulphur Springs; The Traditions, History, and Social Life of the Greenbrier White Sulphur Springs.* New York: Neale Publishing, 1916.

MacKaye, Benton. "An Appalachian Trail: A Project in Regional Planning." *Journal of the American Institute of Architects* 9 (October 1921): 325–30.

MacKaye, Benton. "Harlan Page Kelsey." *Cosmos Club Bulletin* 12, no. 5 (June 1959): 2–3.

Martin, Brent. *George Masa's Wild Vision: A Japanese Immigrant Imagines Western North Carolina.* Spartanburg, SC: Hub City Press, 2022.

Mask, Deidre. *The Address Book: What Street Addresses Reveal about Identity, Race, Wealth, and Power.* New York: St. Martin's Griffin, 2021.

Mason, Robert Lindsay, and Myron H. Avery. "A Bibliography for the Great Smokies." *Appalachia* (June 1931): 271–277.

Mather, Stephen. *Report of the Director of the National Park Service to the Secretary of the Interior for the Fiscal Year Ended June 30, 1917–23 and the Travel Season 1917–23.* Washington, DC: Government Printing Office, 1917–23.

McCoy, George W., and George Masa. *Guide to the Great Smoky Mountains National Park.* Asheville, NC: Inland Press, 1933.

Modell, John. *The Economics and Politics of Racial Accommodation: The Japanese of Los Angeles, 1900–1942.* Urbana: University of Illinois Press, 1977.

Muir, John. *Our National Parks.* San Francisco: Sierra Club Books, 1991.

Naylor, Jackie. "'As Always You Prove Your Loyalty to Us Girls': Fred Seely's Attitude Towards Woman in the Workforce and in Education." BA thesis, University of North Carolina at Asheville, 2004.

Nolen, John. *Asheville City Plan.* Asheville, NC: Asheville City Commission, 1922. hdl.handle.net/2027/coo1.ark:/13960/t86h5478k.

North American Times. *The North American Times Yearbook.* No. 3. Seattle: North American Times, 1912. dl.ndl.go.jp/pid/767438/1/1.

Odo, Franklin. *The Columbia Documentary History of the Asian American Experience.* New York: Columbia University Press, 2002.

Oharazeki, Kazuhiro. *Japanese Prostitutes in the North American West, 1887–1920.* Seattle: University of Washington Press, 2016.

Pierce, Daniel S. *The Great Smokies: From Natural Habitat to National Park.* Knoxville: University of Tennessee Press, 2000.

Platt, Elizabeth T. "Portrait of America: Guidebooks and Related Works." *Geographical Review* 29, no. 4 (1939): 659–64. doi.org/10.2307/209835.

Potomac Appalachian Trail Club. *Potomac Appalachian Trail Club Bulletin* (July 1932).

Reeves, Bradley, and Louisa Trott. "Itinerant Filmmaking in Knoxville in the 1920s: A Story Told through Unseen Movies." *The Moving Image* 10, no. 1 (December 8, 2010): 126–43.

Rhine, Zoe. *Hidden History of Asheville.* Charleston, SC: History Press, 2019.

Roberts, Helen Lefferts. *Putnam's Handbook of Etiquette: A Cyclopaedia of Social Usage, Giving Manners and Customs of the Twentieth Century.* New York: G.P. Putnam's Sons, 1913.

Searle, G. J., Thomas Alexander, and George Masa, eds. *Touring the Great Smoky Mountains National Park and the Southland.* Asheville, NC: Southland Tourist, 1933.

Seely, Fred L. Jr. "Seely, Fred Loring." In *Dictionary of North Carolina Biography,* vol. 5, edited by William S. Powell, 313–14. Chapel Hill: University of North Carolina Press, 1994. ncpedia.org/biography/seely-fred-loring.

Shankland, Robert. *Steve Mather of the National Parks.* New York: Knopf, 1951.

Smith, Robert J. *Japanese Society: Tradition, Self and the Social Order.* New York: Cambridge University Press, 1985.

Snell, Charles W. *Formation of the National Park Service, 1913–1929.* Prepared for the National Survey of Historic Sites and Buildings. Washington, DC: National Park Service, 1963.

Starnes, Richard D. "'A Conspicuous Example of What Is Termed the New South': Tourism and Urban Development in Asheville, North Carolina, 1880–1925." *The North Carolina Historical Review* 80, no. 1 (2003): 52–80.

Starnes, Richard D. *Creating the Land of the Sky: Tourism and Society in Western North Carolina*. Tuscaloosa: University of Alabama Press, 2005.

Streitmatter, Rodger. *Mightier than the Sword: How the News Media Have Shaped American History*. 4th ed. Boulder, CO: Westview Press, 2016.

Steurer, Peter M. *History of the Carolina Mountain Club: Commemorating the 70th Anniversary, 1923–1993*. Asheville, NC: Carolina Mountain Club, 1993. carolinamountainclub.org/view/assets/uploadedAssets//CMC%20 History%2070th%20Anniversary.pdf.

Strong, Douglas. *Dreamers and Defenders: American Conservationists*. Lincoln: University of Nebraska Press, 1988.

Stupka, Arthur. *Great Smoky Mountains National Park: North Carolina and Tennessee*. Washington, DC: Government Printing Office, 1960.

Szarkowski, John. *The Photographer's Eye*. New York: Museum of Modern Art, 1966.

Szarkowski, John, ed. *The Photographer and the American Landscape*. New York: Museum of Modern Art, 1963.

Takami, David A. *Divided Destiny: A History of Japanese Americans in Seattle*. Seattle: University of Washington Press, 1998.

Thomas, Gordon. *The Day the Bubble Burst: A Social History of the Wall Street Crash of 1929*. Garden City, NY: Doubleday, 1979.

Thompson, Frank. *Asheville Movies Volume 1: The Silent Era*. Asheville, NC: Men with Wings Press, 2017.

Tripp, Erin A., James C. Lendemer, and Bobbi Angell. *Field Guide to the Lichens of Great Smoky Mountains National Park*. Knoxville: University of Tennessee Press, 2020.

Tufte, Edward R. *Visual Explanations: Images and Quantities, Evidence and Narrative*. Cheshire, CT: Graphics Press, 1997.

United States Department of the Interior. *Final Report of the Southern Appalachian National Park Commission to the Secretary of the Interior: June 30, 1931*. Washington, DC: Government Printing Office, 1931.

Wicker, Elmus. "A Reconsideration of the Causes of the Banking Panic of 1930." *The Journal of Economic History* 40, no. 3 (September 1980): 571–83.

Williams, Florence. *The Nature Fix: Why Nature Makes Us Happier, Healthier, and More Creative*. New York: W.W. Norton, 2017.

Wilson, Edward O. *Biophilia*. Cambridge, MA: Harvard University Press, 1984.

Young, Kevin W. *The Violent World of Broadus Miller: A Story of Murder, Lynch Mobs, and Judicial Punishment in the Carolinas*. Chapel Hill: University of North Carolina Press, 2024.

# INDEX

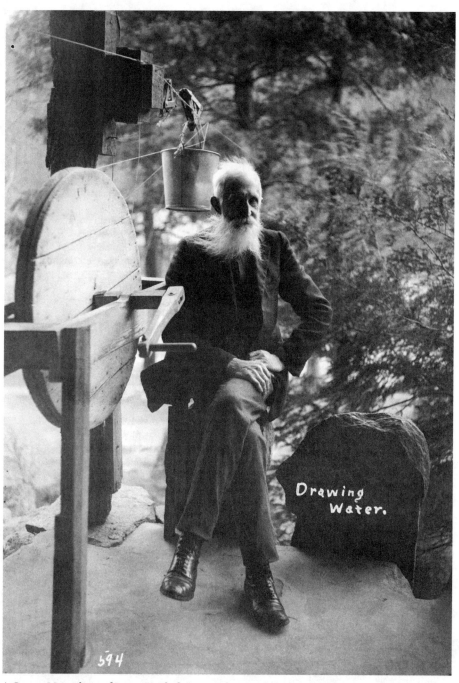

A George Masa photo of James M. Flack "on porch at Inn." *Buncombe County Special Collections, Pack Memorial Public Library, Asheville, North Carolina*

# ACKNOWLEDGEMENTS

*George Masa: A Life Reimagined* is not only a partnership between co-authors and their subject but a collaboration within the research community and with the friends and family members who supported us through these many years. Nonetheless, as biographers we recognize the "hazard of the trade." As James Atlas reminds us, "You could never get it all down. The story would always remain unfinished."

We'd like to thank Linda Harms Okazaki for leading our team of researchers, some of whom worked in Japan and others who delved into West Coast archives. Linda's dedication and her knowledge of Japanese genealogy and archival resources were excellent, as were her leadership and communication skills. In Japan, Megumi Kanazawa, Mizuho Takagi, and Nagomi Onda were invaluable members of the team. Their creativity, curiosity, and dogged determination led to new discoveries at Tokyo's Ministry of Foreign Affairs, the Baseball Hall of Fame and Museum, and the National Diet Library. Equally important was our West Coast bilingual research team—Caitlin Oiye Coon, Mami Kikuchi, and Naoko Tanabe—who scoured archives from Vancouver to Los Angeles, transcribed documents into modern Japanese, and translated dozens of newspaper and magazine articles for us. Others provided new clues in various repositories, including Geri Auerback, who helped locate divorce records; Marlee Goto, who conducted archival research at UCLA; Koichi Muro, our land records expert; Ben Pease, our map consultant; and Kaoru Ueda, who shared her knowledge of specialized newspapers. We are grateful to Cornell University's Podell Endowment Award for Research and Scholarship, which allowed us to hire researchers with the language expertise required for this biography.

Much of the early research for this book took place during COVID restrictions. Expanded access to digitized resources through HathiTrust was invaluable, as was digitizing done by Luke Bonesteel to expand our Dropbox bounty. Even more important were the archivists who went beyond the call of duty to help us locate documents when institutions were closed to the public. To illustrate the level of help we received from our research collaborators, we quote Matthew Hanson, the archivist at the Franklin D. Roosevelt Presidential Library, who "looked high and low for that [Masa photo] album,

including the photograph collection, book collection, folios, scrapbooks, textual collections, and every other straw I could think of to grasp at."

Archivists and librarians throughout the United States were our partners. This included Jill Hawkins and Lori Garst at Biltmore; Carissa Pfieffer, Jenny Bowen, and Katherine Calhoun Cutshall at Buncombe County Special Collections; Elias Larralde at the Center for Creative Photography; Michael Aday at the Collections Preservation Center in the Smokies; Cornell colleagues Eisha Neely and Dan McKee; Joanna Bouldin of the East Tennessee History Center McClung Collection; Mieko Palazzo at George Mason University's SCRC with invaluable assistance from Stephanie Martinez; Randolph Shaffner and Lance Hardin with the Highland Historical Society; Peggy Tran-Le and Abby Bridge at the San Francisco Museum of Modern Art; Regan Murphy Kao at Stanford University; Lauren Murphree at the State Archives of North Carolina; Neil Hodge and Juliana Jenkins at University of California Los Angeles Special Collections; Gene Hyde at University of North Carolina at Asheville; Jason Brady at Hunter Library, Western Carolina University; Sarah Downing at Western Regional Archives; and Jennifer Navarre of Williams Research Center, Historic New Orleans Collection. To have experienced this level of dedication from the West Coast to the East was truly a gift.

Outside of institutional archives, we are grateful to colleagues whose passion led to a deep expertise in a particular subject. This includes William A. Hart Jr., who generously shared his knowledge and his archive of Masa material with us (while he and his wife, Alice, graciously hosted a traveling researcher at their home multiple times); Bruce Johnson, whom we relied on for his expertise in all things related to the Arts and Crafts movement and the Grove Park Inn; the Forest Ecologist Emeritus at Cornell with University of Tennessee roots, David Weinstein; Kazuhiro Oharazeki, who shared his research and knowledge of the experiences of Japanese women in the immigrant communities of the North American West; Angelyn Whitmeyer, who developed and continues to grow her database of George Masa photographs; Jan Zeserson and Kelly Dietz, who attempted to give us a crash course in Japanese pronunciation; Libby Kephart Hargrave and the Horace Kephart Foundation, who provided a travel grant to North Carolina; Tina LeFreniere, founder and chief executive officer of Related Faces, who donated her time

and her company's expertise with facial recognition software; and Frank Thompson, whose research on Masa's motion-picture projects was an excellent contribution to our work. We also are grateful to those careful readers who reviewed chapters or the whole shebang, spotting typos, errors, and misunderstandings. These reviewers include Helen and Render Davis, William A Hart Jr., Ashley Miller, Linda Harms Okazaki, Robert Kibbee, and Ken Wise.

Along with Hart's article, the story of Masa was rediscovered and amplified in the 1990s and early 2000s by others including George Ellison, Rob Neufeld, Bob Brunk, Zoe Rhine, Anne Wright, Jami Daniels, Geoffrey Cantrell, Tom Alexander Jr., Judy Coker, Benjamin Porter, and Gil Leebrick. Fusako Kudo Krummel, who was Bonesteel's initial connection to Japanese history and culture, masterfully translated the Masa journals and then the "Yama" letters years later. Her painstaking work transcribing cryptic scribbles from diary entries and deciphering faint Japanese characters on photocopied letters and poetic renderings resulted in translations that were nuanced and insightful. Her work compared favorably with later transcriptions and translations that benefited from software enhancements.

Yet even a manuscript that has gone through many drafts and more readers still needs to be refined and shaped by a skilled team of editorial and design specialists. We've been graced by the first-rate Smokies Life team and inspired by the leadership of CEO Laurel Rematore. First and foremost, we are grateful to Frances Figart, director of creative services for Smokies Life, who encouraged and supported the publication of this book, wielded her digital red pen, smoothed the rough edges, and strengthened the narrative. Lead Editor Aaron Searcy then refined the manuscript, overlaid a consistent style, and never once grew impatient as we continually amended the text. And it was graphic designer Lisa Horstman who made the book beautiful. From the selection of the fonts to the quality of the images, Lisa's creativity and design aesthetic entice a reader to delve into Masa's story.

And lastly, but not leastly, to our spouses, Wyndy Bonesteel and the late Boj Kibbee, who knew Masa almost as well as we and who supported our passion to research his life and write his story. And to Georgia and Peter Bonesteel, whose love and encouragement were endless, and our respective children, Jonah and Luke Bonesteel and Matthew and Andrew Kibbee. To all of them, our love and our gratitude.

N. L. Snelson with ginseng plants near Bryson City, North Carolina. Photo by George Masa.
*James McClure Jr. Collection, Southern Appalachian Archives, Mars Hill University*

*On the trail again...*
*walking deeper*
*into myself.*

~Tom Clausen, haiku first published in *Frogpond*
(Summer 1994)

# ABOUT THE AUTHORS

**Janet McCue** is a writer, researcher, avid hiker, and co-author with the late George Ellison of *Back of Beyond: A Horace Kephart Biography*, which won the Thomas Wolfe Memorial Literary Award shortly after its release in 2019. She collaborated with Ellison on several other publications, including the biographical chapter in *Horace Kephart: Writings* (2020). In the 1970s, McCue and her husband began exploring the Great Smoky Mountains on extended backpacking trips; her interest continues today through her work on George Masa, Kephart, and the Smokies Life board of directors. For three decades, McCue was a librarian at Cornell University where she specialized in library administration and digital library development. She lives in the Finger Lakes region of upstate New York, writing regularly about the beauty and bounty of the area.

**Paul Bonesteel** is a filmmaker, writer, and passionate lover of the outdoors. Bonesteel's first experience in the Smokies was a 1972 hike up Mount Le Conte when he was seven years old. His filmmaking, research, and writing have informed the conversation and celebration of George Masa since his making *The Mystery of George Masa* film in 2002. Other award-winning films include *The Great American Quilt Revival*, *The Day Carl Sandburg Died*, *America's First Forest: Carl Schenck and the Asheville Experiment*, *Muni*, and the four-part *Shadow of a Wheel*. He grew up hiking, biking, fishing, and exploring the mountains around Hendersonville, North Carolina, and has lived in Asheville for 25 years with his wife, Wyndy, and two sons, Jonah and Luke.

*Author photos by Camillla Calnan*